KT-482-772

TREASURES *from* THE NATIONAL TRUST

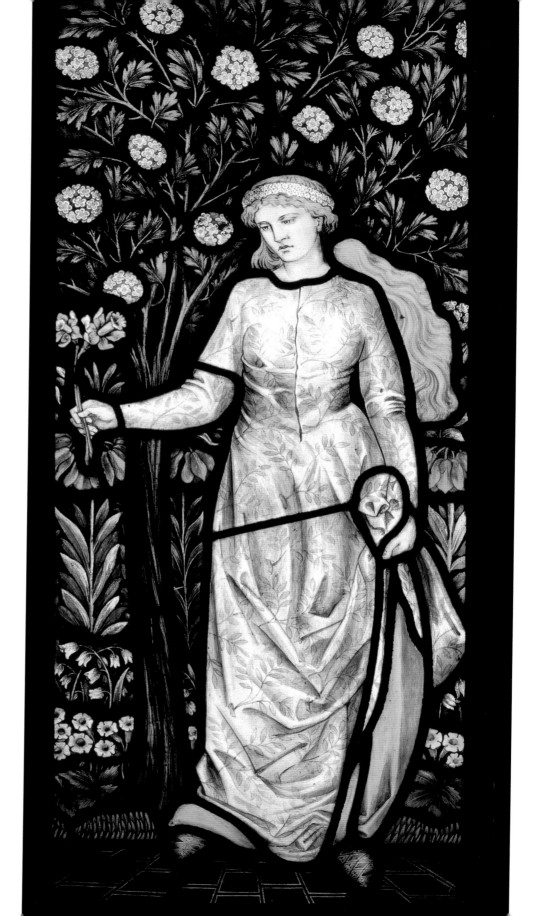

William Morris stained-glass panel
at Cragside, Northumberland
(see page 326).

TREASURES *from*
THE NATIONAL TRUST

THE NATIONAL TRUST

First published in 2007 by

National Trust Books
10 Southcombe Street
London W14 0RA

An imprint of Anova Books Ltd

Copyright © National Trust Books 2007
Text © The National Trust 2007

The moral rights of the authors have been asserted.

All rights reserved. No part of this publication may be reproduced, stored in a retrieval
system, or transmitted in any form or by any means, electronic, mechanical, photocopying,
recording or otherwise, without the prior written permission of the copyright owner.

ISBN 978 19054 0045 4

A CIP catalogue record for this book is available from the British Library.

15 14 13 12 11 10 09 08 07
10 9 8 7 6 5 4 3 2 1

Book Design by Lee-May Lim
Layout by SCW

Reproduction by Spectrum Colour Ltd, Ipswich
Printed and bound by Artes Gráficas Toledo

This book can be ordered direct from the publisher at the website: www.anovabooks.com,
or try your local bookshop. Also available at National Trust shops.

*Note: objects portrayed in this book may not be on permanent display for conservation reasons. All
reasonable efforts are made by the National Trust and Anova Books to ensure the accuracy of the
information at the time of going to press.*

*Many of the chattels featured in this book have been allocated to the National Trust by HM
Government and were accepted in lieu of Inheritance Tax.*

Contents

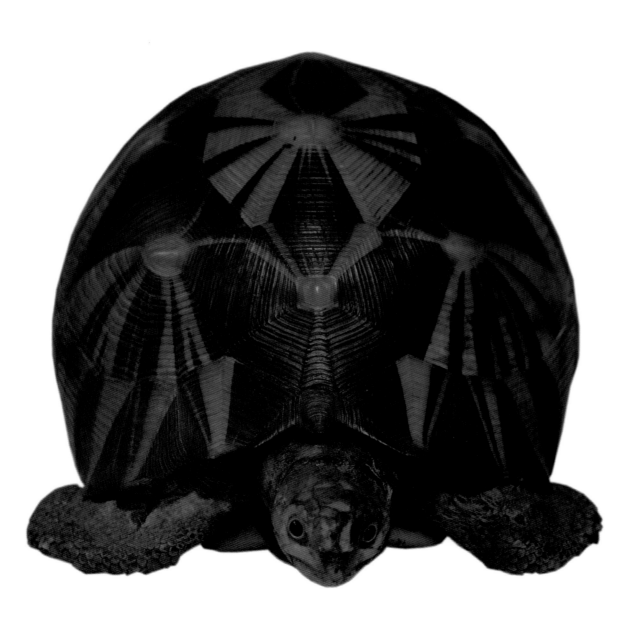

Stuffed Tortoise

Lady Wilson's Cabinet of Curiosities was formed by Dame Jane Wilson (1749–1818) of Charlton House in Greenwich. Her collection of curiosities was inherited by her daughter Maria, who married Sir John Trevelyan, 5th Baronet, in 1791. The Trevelyans had set up the collection as a museum by 1827, when the Rev. John Hodgson described the contents of the room in his *History of Northumberland*. Other curios found in the room are cases of stuffed birds, fossils, narwhal tusks, a model of the Church of the Holy Sepulchre in Jerusalem, geological specimens, a plaster bust, toys and dolls and appliqué needlework panels. *Wallington, Northumberland*

Foreword

My own personal National Trust treasure will always be a carefully preserved
tortoise who lurks in the 18th-century cabinet of curiosities at Wallington.
Although it must be twenty years since we last met, if I close my eyes I can still see
him (if he is a 'him'). His black, bead-like eyes peer out reproachfully from
beneath a shell so elaborately patterned that it looks more like a piece of
marquetry than a work of nature.

I couldn't tell you why that tortoise has left such a lasting impression on me: he
isn't the finest, the rarest, the most precious object to grace a National Trust
property. I like him, that's all – just as I like the centrally heated billiard table at
Tyntesfield, with its electrically operated scoreboard, and Clive of India's life-size
Roman statue of a cat at Powis Castle. They make me smile to think of them. I
feel the world is a better place because they are in it.

Exactly what constitutes a 'treasure' is something that changes with fashion,
with cultural trends and with individual taste. The Elizabethans valued the new
and discarded the old; the Georgians tended to do just the opposite. We each of
us have our own personal favourites among the treasures in the National Trust's
colossal cabinet of curiosities, our own ideas about what we'd like as a luxury item
on our desert island. And isn't that the joy of it? Your choice might be more
serious, less whimsical than mine: Nicholas Hilliard's stately portrait of Elizabeth I
at Hardwick, perhaps; the Grinling Gibbons carvings at Dunham Massey; or
Turner's exquisite landscapes at Petworth. It doesn't matter, because the National
Trust has something for every imaginable taste: state coaches and armour
helmets, Victorian photographs and Tudor stained glass; garters, fans and
Meissen monkeys.

We don't have to agree. It would be a miracle if we did, because the most
cursory glance through the pages of this delightful book will show you that there
is no common denominator linking all the items it describes, no common thread
– beyond, of course, the simple fact that the Trust protects everything described

here. Any definition of 'treasure' that embraces the atom bomb at Orford Ness and Chastleton's collection of Jacobite drinking glasses, Graham Sutherland's portrait of Edward Sackville-West at Knole and the Kirckman harpsichord in the Benton Fletcher collection at Fenton House is broad indeed.

And that is the really astonishing thing about the treasures so lavishly illustrated in the following pages. They demonstrate that like some great Renaissance prince striving to create a microcosm of the universe, the Trust has – almost unwittingly – brought together a truly encyclopaedic collection of collections. Most of us are aware of the range of National Trust properties – the big country houses and picturesque cottages, the industrial sites and medieval manors and precious coastal habitats. It is somehow harder to appreciate the wealth of rare and curious objects that they contain. This book is a timely reminder that the Trust has assembled an eclectic group of rarities which ranks among the biggest and best in the world.

Revel in the riches of this treasure-house. Cheer when you read about something familiar; throw up your hands in exasperation when you find that your own particular favourite has been missed out. But don't stop there. Go out and discover the enormous range of National Trust treasures for yourself, in all their glory.

And if you happen to visit the cabinet of curiosities at Wallington, remember me to the tortoise. He's an old friend.

Adrian Tinniswood, 2007

Introduction

'I have not bought things because they were rare or valuable; there are many things of everyday use in the past of small value, but of interest as records of various vanished handicrafts.'

Charles Paget Wade (1883–1956), of Snowshill Manor, Gloucestershire, 1945

Acquisitiveness and curiosity run through human nature like veins through marble. The passion for possessions, whether for reasons of utility or due to notions of beauty, has driven people throughout history and across continents. The earliest tentative trading links led inevitably to the foundation of political and commercial empires, often backed by military muscle and fuelled by the Industrial Revolution. Society's consuming desire to consume, to own, to enjoy art and artefacts, whether mass-produced goods or *objets d'art*, is driven by ever-changing appreciation of fashion, novelty or beauty. How we dress, what we own, the objects that furnish our lives, speak eloquently about our hopes, beliefs and aspirations.

Our possessions gratify our sense of self, and in addition what we own tells others about us – the place we hold in society, our status, our cultural assumptions, and how we want others to regard us. And after we have gone, the physical legacy we leave behind intrigues later generations. Our 'treasures', whether glorious or relatively humble, are a testament to the people we were, the values we held, the things we used, admired and loved.

The National Trust now cares for more than 300 historic houses and gardens open to the public, and almost all of the houses are complete with their

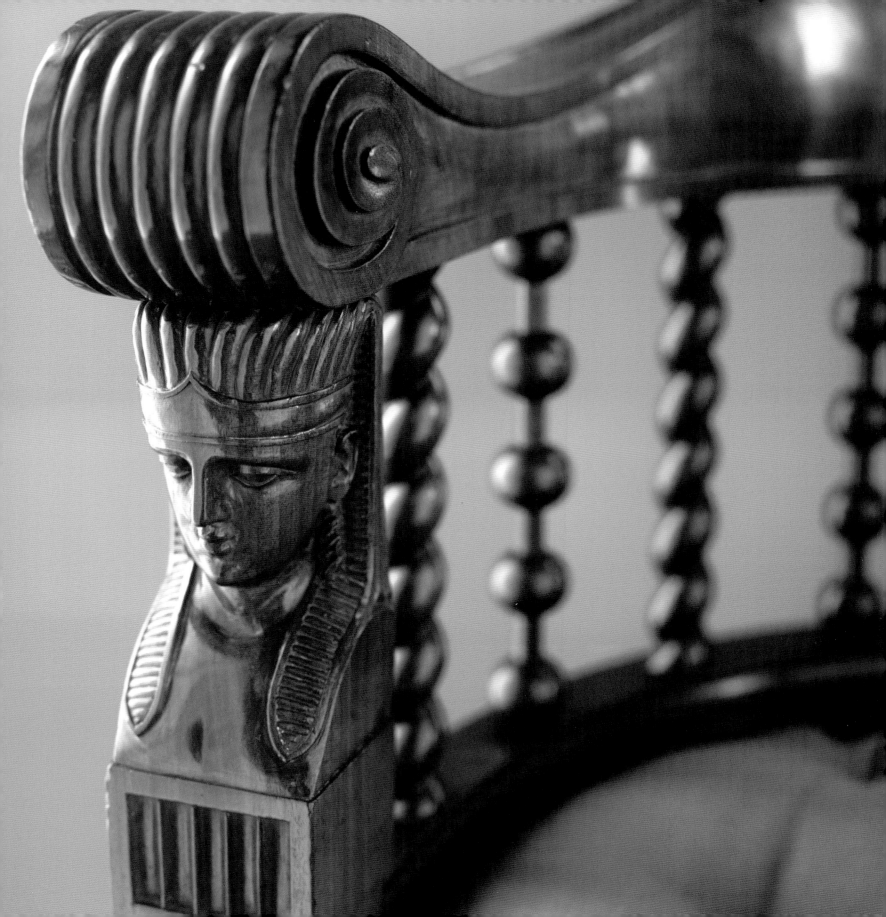

magnificent cornucopia of contents – from doll's houses to doorknobs, miniatures to maiolica, tapestries to gasoliers. Over a million objects are cared for and shown, nearly always displayed in the settings for which they were acquired, and only very rarely behind glass. The figures are staggering; some 75,000 pieces of ceramics and glass are included on the inventories, ranging from the most utilitarian kitchenware to objects of the greatest rarity and unparalleled beauty. There are 130 historic libraries containing over 220,000 books, making the charity one of the largest holders of rare and historic books in the country, and unique because it conserves whole libraries, varied in scale and packed with books of all kinds – an important part of the story of each historic property. There are 224 animal-drawn vehicles, the largest British collection in public or museum ownership. The Trust also cares for what is certainly the largest collection of furniture in the country, and possibly in the world, ranging from late medieval pieces to exemplars of 20th-century Modernism. But the best-known treasures constitute one of the world's greatest fine and decorative art collections. The special strengths of the National Trust's picture collections lie in portraiture; some 80% of the pictures in National Trust houses are family portraits.

Like one of its own collections, the Trust has evolved over decades. Contrary to popular belief, the National Trust does not see itself as a 'collector' of historic properties – on the contrary, the Trust only gets involved if a place of significance is under threat of destruction or ruinous development, and even then steps in if no other acceptable 'angel' can be found. It sees itself as the 'charity of last resort', fully appreciating the enormous commitment and cost required to rescue a building and its contents, and to care for them, for ever, for everyone.

The charity did not set out to acquire and care for houses and their chattels –

Detail of Thomas Chippendale the Younger armchair from Stourhead, Wiltshire (see page 131).

indeed, it was established in 1895 to care for 'places of historic interest and natural beauty.' The great outdoors, in other words, not the great indoors. Founders Octavia Hill, Canon Rawnsley and Sir Robert Hunter can have had no idea that within decades of the Trust's inception, so many of the great houses and historic buildings generally assumed to be safe in the care of their private owners would come under threat of destruction or abandonment. Previously wealthy landed families were to suffer depressed agricultural rents, aggravated by the collapse of the entailed heirloom system, the rise in death duties and progressive taxation. In some cases, successive heirs were lost during the Great War, and the increasing wages of servants undermined the support system on which so many had relied in running and maintaining complex, labour-intensive estates. In many cases, changing circumstances made it impossible for a great house to stay in private ownership. Public alarm led to a change in the National Trust's status in 1937, making it possible for the charity to rescue and endow historic houses with their chattels still intact, and care for them in perpetuity.

Further support came in 1977 when Sir Brinsley Ford, the chairman of the National Art Collections Fund (now known as The Art Fund), added the National Trust to its list of potential beneficiaries, so that works of art might remain in, or be returned to, the historic collections in the Trust's care. And for the last decade, the National Heritage Memorial Fund and the Heritage Lottery Fund have been crucial in enabling the Trust to take on such diverse projects as Tyntesfield in Somerset and the Back to Backs in Birmingham.

Acquiring a building and its contents is merely the start of a never-ending story. The Trust is committed to caring for its collections in perpetuity, and to providing access to them for the public. High curatorial and conservation standards ensure

Dragon's-head *buccin* (trombone) from the Charles Paget Wade collection at Snowshill Manor, Gloucestershire (see page 209).

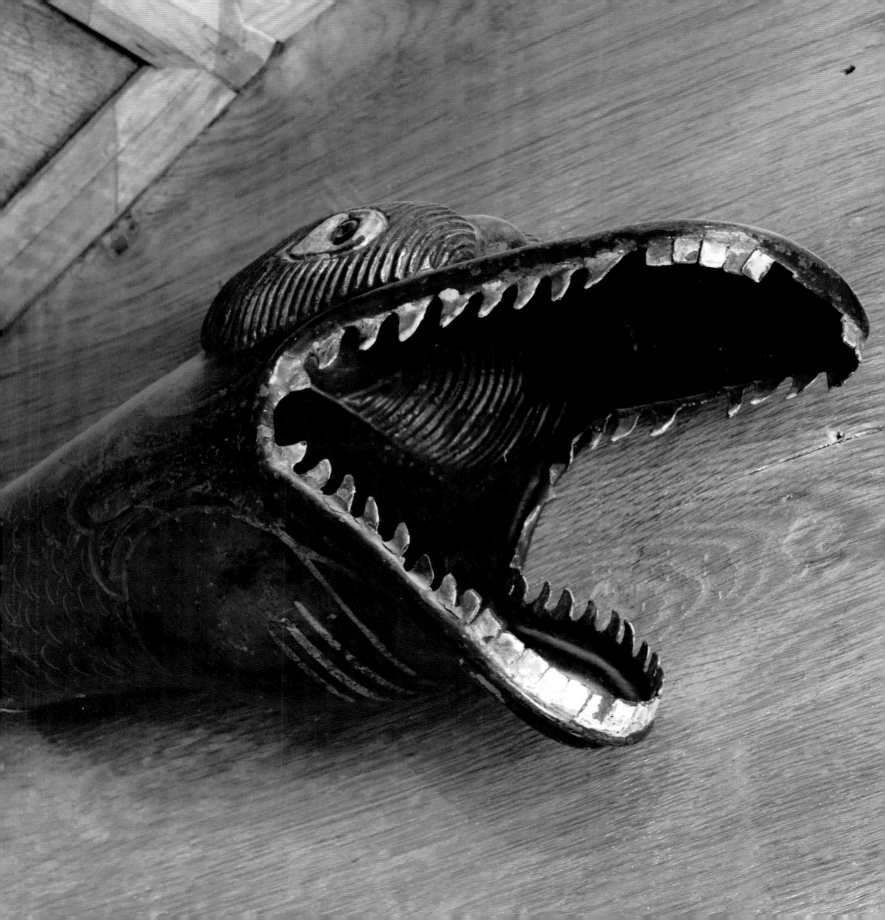

the survival of venerable and fragile artefacts for the future. During the winter months, when would-be visitors are disgruntled to find a National Trust property closed, they are usually mollified to discover that behind the 'Closed' sign a veritable army of conservation and property staff, assisted by thousands of volunteers, are busy cleaning, conserving and condition-checking every item in their collections. Inevitably, sometimes there is conflict between the Trust's mission to care for its holdings and its commitment to providing access for all.

The first 'big house' to be owned by the National Trust – Barrington Court in Somerset – was acquired in 1907 with no contents. Taking on a property with little or no contents was subsequently seen to be a mistake. There is a growing appreciation that chattels of all kinds should be presented in their historic context, and in this respect the Trust is fortunate in often having the active support of descendants of the original families. 'Donor families', as they are known, are in many cases generous enough to lend works of art and other material to the place in which their ancestors lived, but the boom in the art market and the tax regime can sometimes generate pressure on them to sell. The Acceptance In Lieu scheme (which enables taxpayers to transfer important works of art and other heritage objects into public ownership in full or part payment of inheritance tax) can occasionally enable the Trust to accept a major artefact, and when that is not possible, the Trust tries to maintain the integrity of its collection by buying critical pieces from owners who are forced to sell. However, like all charities it cannot save everything, and there is a constant challenge to the organisation's limited resources.

There are three main types of collections in the care of the National Trust. The first type might be termed the 'visionary' collections, the deliberate accumulation

of objects that please, fascinate or inspire, by a single individual or a like-minded couple. The fervent eclecticism of Charles Paget Wade of Snowshill Manor in Gloucestershire led to a house stuffed to the rafters with more than 26,000 'treasures', from samurai armour to coachman's boots. The ardent collector moved into a tiny cottage next to the Manor House to allow as much space as possible for his collections, and for entertaining awestruck visitors. Similarly, the spinster cousins Jane and Mary Parminter devoted years of their lives to the meticulous crafting of a delightfully eccentric little sixteen-sided home, at A La Ronde in Devon. The exquisite collections of the great treasure houses of Hardwick Hall, Knole and Petworth need little explanation. There are places where the entire building and its contents are the fulfilment of a specific ideal, such as William Morris's home, Red House in Bexleyheath, London. And there are the eccentric but appealing collections, such as the infinite variety of cast-iron firebacks at Petworth in West Sussex, or the miniature rooms at Nunnington Hall in North Yorkshire, which bear witness to the various obsessions of singular individuals or the fashions of a particular period in history.

Then there are the treasures which were acquired to impress, to provide a 'stage setting' to imply taste, discernment and cultural awareness on the part of the owners. Henry Hoare 'the Magnificent' (1705–1785) transformed the garden at Stourhead in Wiltshire into a classical idyll, and furnished the interior of his father's house with its opulent Pope's Cabinet. Many of the treasures in the care of the Trust were acquired by the young scions of landed families, who were bankrolled by their families to embark upon the Grand Tour. From the 16th century onwards, these sons would be despatched to the Continent, usually with a tutor and a healthy budget, to complete their graduation to fully fledged

gentlemen by acquiring a little polish, some interesting experiences, and a large amount of fine art, furniture and antiquities.

Other families devoted themselves to acquiring the 'treasures' of older, more distant civilizations, such as the Greek vases at Charlecote Park in Warwickshire, or the Sèvres and French gilt bronze mounted Chinese porcelain and glorious pre-Revolutionary French furniture at Waddesdon Manor in Buckinghamshire. But it wasn't essential to be born with a silver spoon in one's mouth to be privileged. Despite her humble and obscure origins, brewery heiress Margaret Greville lavished 'new' money and infinite care on her home, Polesden Lacey in Surrey, to create a setting suitable for the royalty she was determined to entertain – from Fabergé cigarette boxes to Raeburn portraits, she 'bought in' treasures to attract and amuse the highest of high society.

Finally, there are those collections which have been accumulated by a process of gradual accretion, silted up over centuries by diverse individuals to meet their everyday needs. Mr Straw's House in Nottinghamshire, for example, is a microcosm of middle-class Edwardian life, containing objects as diverse as underwear and old newspapers, while Chastleton House in Oxfordshire is remarkable for its mixture of rare and everyday objects, furniture and textiles, collected since its completion in 1612. The two houses could hardly be more different, yet both have a palpable atmosphere of habitation by the same family for many years. Every object you see when you walk around a National Trust house has a story to tell. The people have gone, but their 'treasures' remain, and they speak eloquently to the present-day visitor.

The last word on treasures should go to that indefatigable treasure hunter and compulsive collector, Charles Paget Wade of Snowshill Manor in Gloucestershire:

'A room can be filled with innumerable things and yet have a perfect atmosphere of repose, if they are chosen with thought and care so as to form one harmonious background. The furniture should not stand out as a series of silhouettes, but merge into the background, the highlights being sufficient to show its form. This collection, not a museum, will be a valuable record in days to come.'

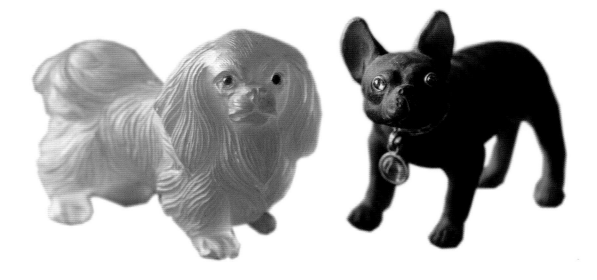

Jewelled miniature dogs from Polesden Lacey, Surrey (see page 166).

Arms & Armour

From Sutton Hoo to Samurai

Reproduction helmet and spears The richly decorated helmet (left) has a face mask arranged like a winged dragon, crested with a serpent. The spears (above) are for thrusting and throwing. The originals were unearthed in 1939 at the Anglo-Saxon burial site at Sutton Hoo and are in the British Museum. *Sutton Hoo, Suffolk*

Print of Samurai (right). Japanese print by Kuniyoshi showing a warrior in full armour. *Standen, West Sussex*

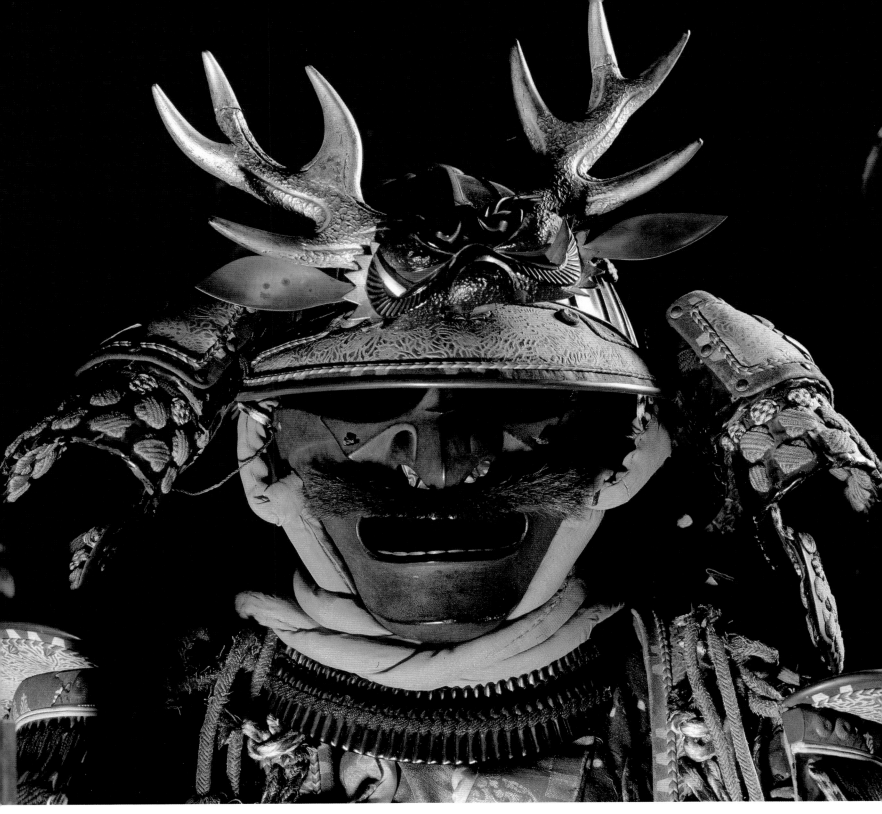

Samurai warrior armour This helmet and face mask are part of a remarkable collection of 27 suits of Japanese Samurai armour dating from the 17th to 19th centuries. The suits are on display in the Green Room, arranged to give the impression of a gathering of warriors. *Snowshill Manor, Gloucestershire*

Medieval to Civil War

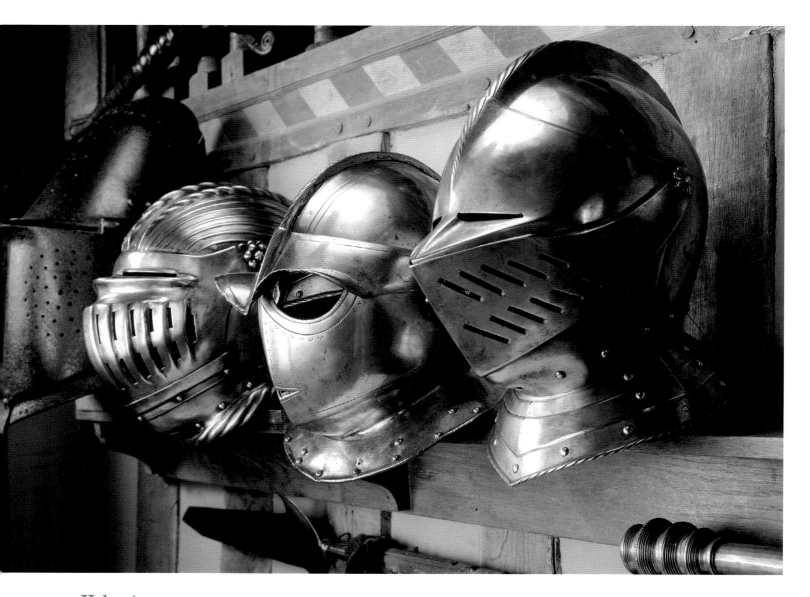

Helmets These fine helmets, dating from the 16th and 17th centuries, hang on the wall in Dragon. The second from the left is a Maximilian German helmet dated 1525–1600, and to its right is a Savoyard helmet of 1602. The curious name of this room derives from the fire that Snowshill Manor's last owner, Charles Paget Wade (1883–1956), kept burning in the great fireplace. *Snowshill Manor, Gloucestershire*

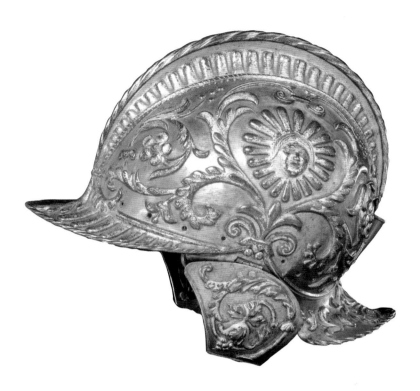

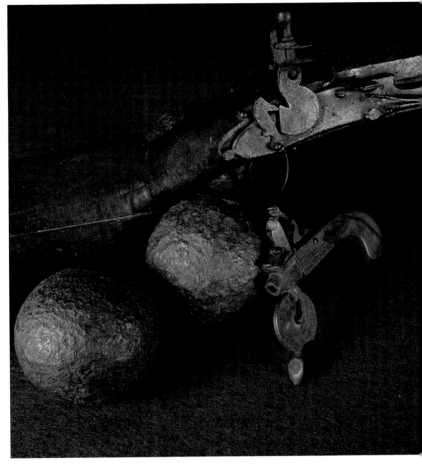

Charles V helmet This burgonet helmet reputedly belonged to Emperor Charles V, Holy Roman Emperor between 1530 and 1556. The burgonet was a style of helmet popular towards the end of the 16th century and was designed for parade use. It was designed with no visor, so the wearer could get a good view around, but was still protected against heavy blows to the head by the comb on its top. It was made by Carolemo Modrone of Mantua, and given by the Duke of Mantua to Charles I of Spain (1516–1556), who established the Habsburg dynasty, and as Charles V became Holy Roman Emperor in 1530. *Waddesdon Manor, Buckinghamshire*

Musket and cannonballs This mid-17th-century musket bears three sets of initials, one of which refers to Colonel Luttrell, the then owner. The powder tester beside it dates from the late 18th century, while the cannonballs are from the siege of the castle in 1645–1646 during the English Civil War. *Dunster Castle, Somerset*

From Defence to Display

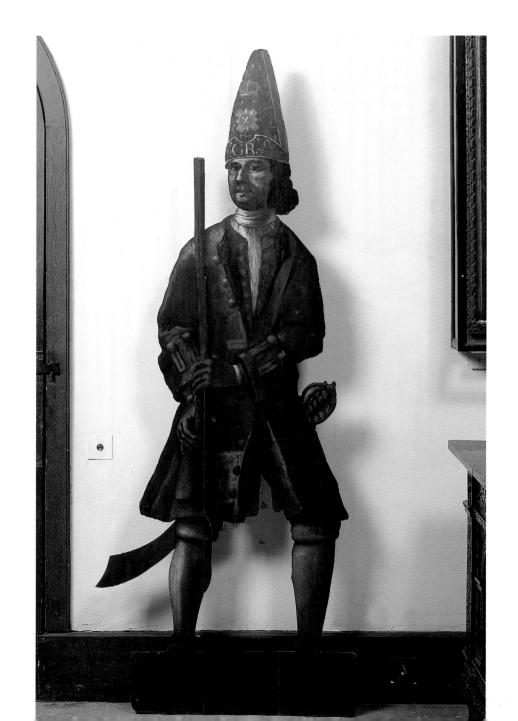

Trophy of arms (above). This trophy of arms on the east wall of the Gothick drawing room was painted by Rex Whistler about five years before he was killed in action in 1944. *Mottisfont Abbey, Hampshire*

Dummy guardsman (right). This well-armed Scots Guardsman stands in the Great Hall. He is believed to have been painted by Elizabeth Creed between 1715 and 1717. *Canons Ashby, Northamptonshire*

Cotehele collection (opposite page). The armour in the Hall is mainly 17th century, although some pieces are as old as late 15th century. The two large flags, which date from the Napoleonic Wars, are those of the 4th (Royal South Middlesex) Militia. *Cotehele, Cornwall*

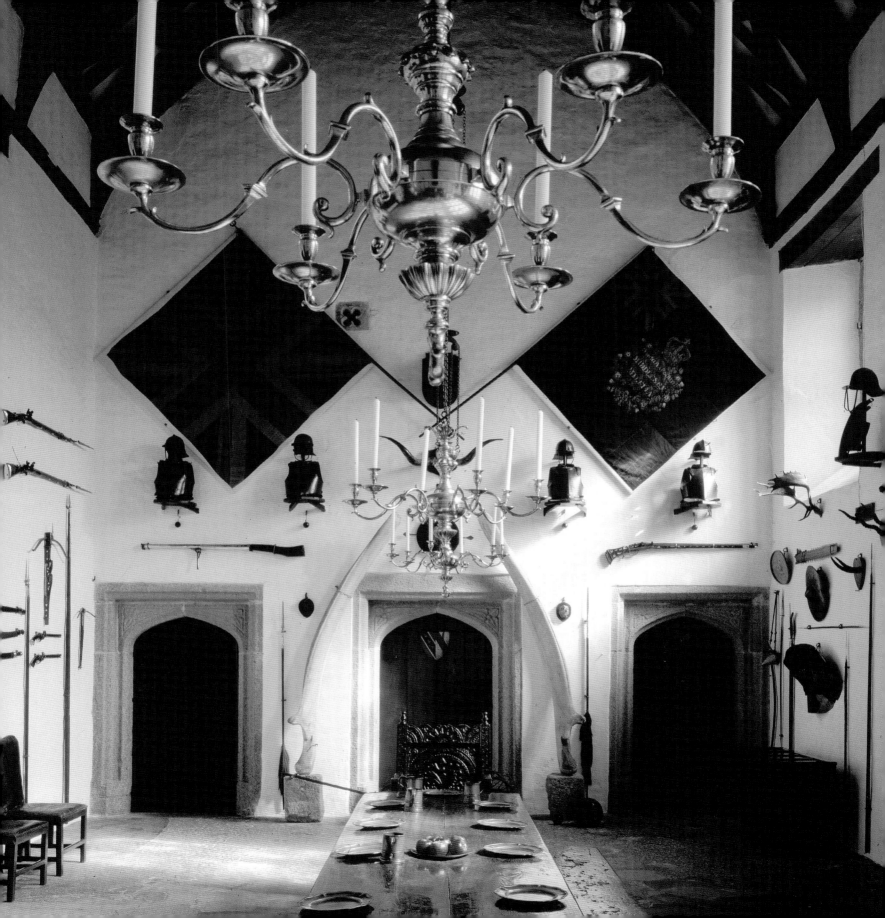

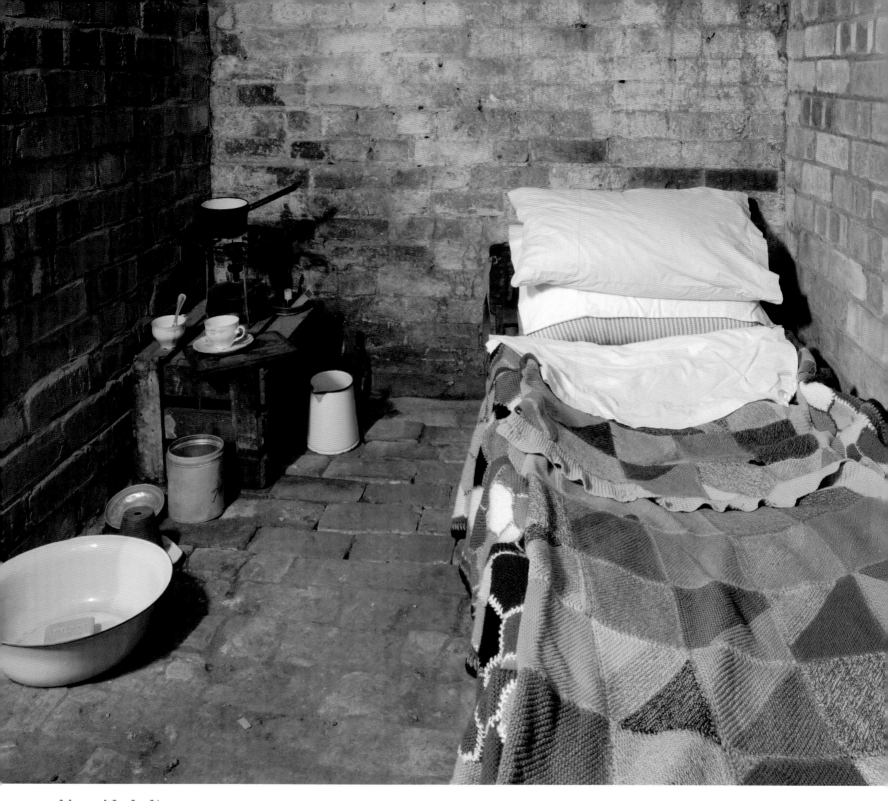

Air-raid shelter This World War Two shelter, reconstructed at the Birmingham Back to Backs, is typical of the period. Families would have taken refuge here to avoid the bombs, sometimes staying for hours at a time. It contains no more than the basic necessities of life – a bed with a simple knitted blanket, plus an enamel bowl for washing and cups and a primus stove on a wooden crate. *Birmingham Back to Backs, West Midlands*

20th-Century Warfare

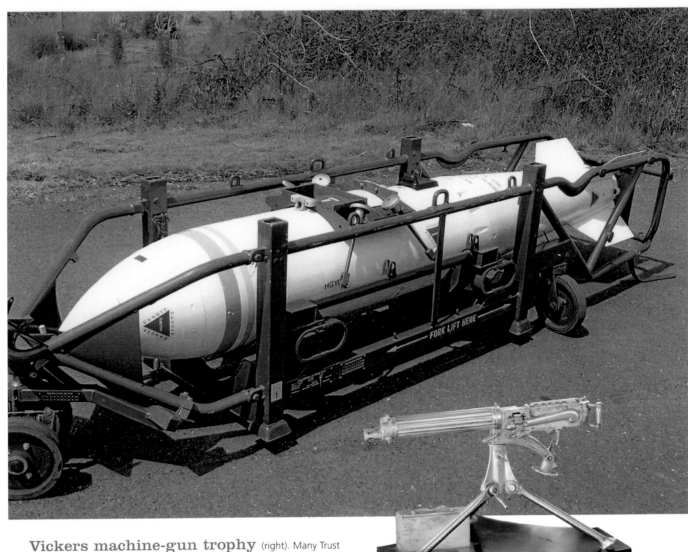

Decommissioned atomic bomb casing (right). Orford Ness was a secret military test site from 1913 until the mid-1980s. This bomb casing at Orford is on loan from the Ministry of Defence via the Atomic Weapons Establishment. Part of a family containing both parachute-retarded and free-fall nuclear weapons, the WE177A was developed to provide low-level tactical delivery capability and was withdrawn from RAF service in 1998, since when all such weapons have been dismantled. *Orford Ness, Suffolk*

Vickers machine-gun trophy (right). Many Trust properties helped the war effort by volunteering to help in what became the Home Guard. The Trerice unit were known as the 'Choughs' after the bird featured on the county flag under which they drilled on the parade ground in front of the manor house. To commemorate their service during World War Two, members of the unit were presented with this silver replica of a Vickers machine gun. *Trerice, Cornwall*

Books & Book
Illustration

Manuscripts

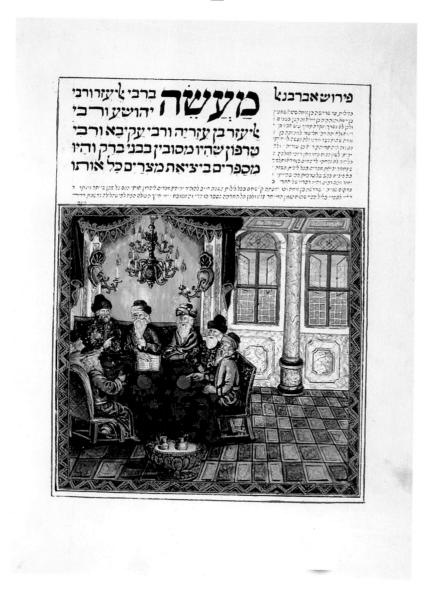

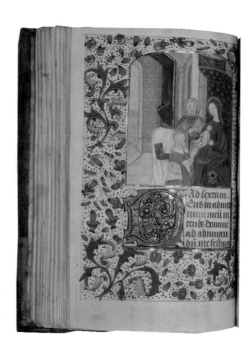

Haggadah (Altona, 1739–1740) (left). The Blickling Haggadah was made by Joseph ben David of Leipnik (today the Czech town of Lipnik Nad Becvou), the most accomplished Jewish manuscript illuminator of the 18th century. Its 41 vellum leaves tell the story of the Exodus, and would traditionally have been read at the family table on the first and second nights of Passover. There are 66 colour images, while the text is a traditional compendium from Biblical and Rabbinic sources. This manuscript is one of a small group of Hebrew illuminated manuscripts imported into England for Gentile collectors in the early 1740s. It belonged to the scholarly Baronet Sir Richard Ellys (1682–1742), and was moved to Blickling Hall from his town house in Piccadilly shortly after his death. *Blickling Hall, Norfolk*

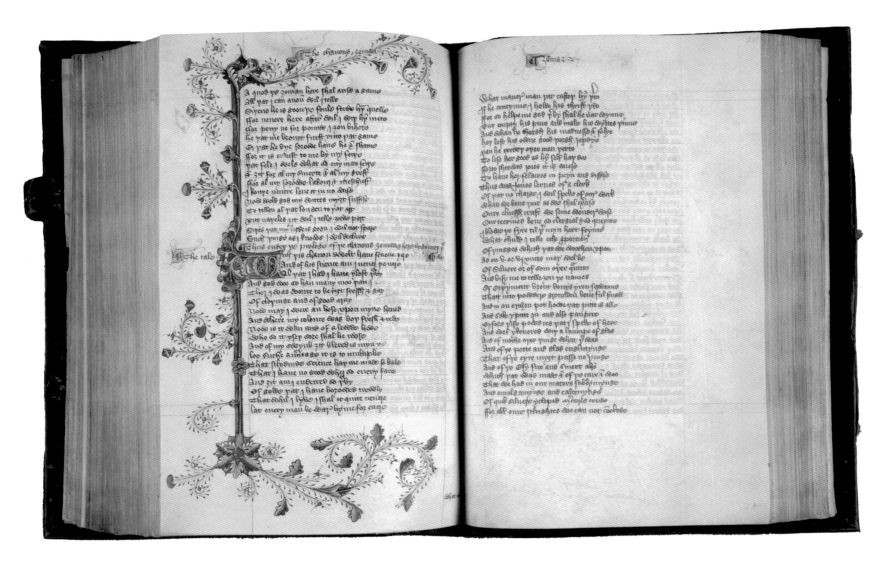

Book of Hours (England, before 1480) (left). Books of Hours were immensely popular in late medieval Europe; devotional books based around the structure of monastic offices, but used by lay people (women as well as men) as the focus for personal devotion. One of seven medieval manuscripts at Coughton, this example has a special resonance – not a collector's item bought by an 18th- or 19th-century connoisseur, but a 'holy book' associated with a Catholic family. *Coughton Court, Warwickshire*

Geoffrey Chaucer, *The Canterbury Talis in Inglysshe* (England, c.1420–1430) (above). There are more than eighty 15th-century manuscripts of the *Canterbury Tales*, but the Petworth Chaucer is one of the most important. It may have been made for the 3rd Earl of Northumberland (1421–1461) or for the 2nd Earl (1394–1455), who was married to Eleanor Neville, Chaucer's great-niece. Towards the end of the 15th century the arms of the 4th Earl, together with the insignia of the Order of the Garter, were painted in at the foot of the final leaf. It is not difficult to spot that they were later additions, but they show that the book belonged to the 4th Earl at some time between 1474 (when he received the Garter), and his death in 1489. The manuscript seems to have been at Petworth for at least four hundred years. *Petworth House, Sussex*

Books for Scholars

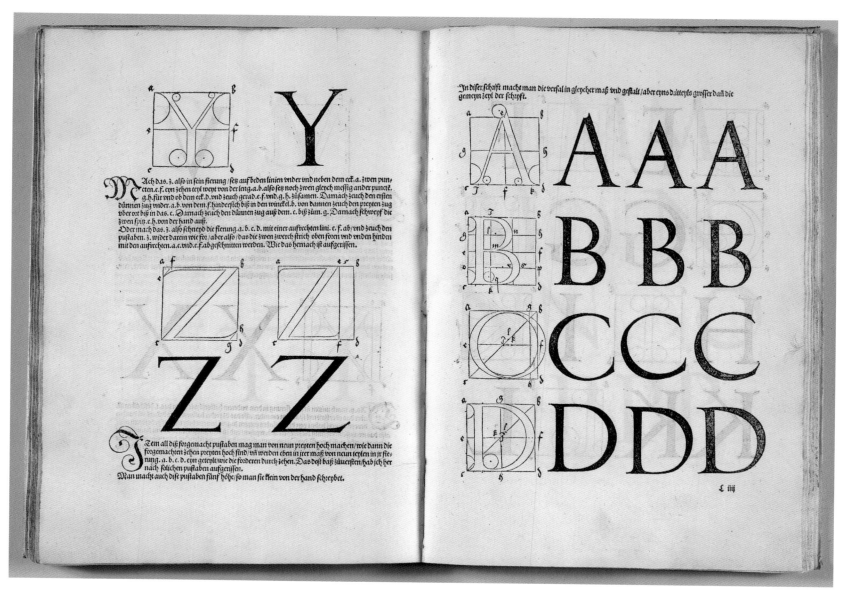

Albrecht Dürer, *Vnderweysung der Messung, mit dem Zirkel Vnn Richtsscheyt* (Nuremberg, 1525) Only the second work in German on mathematics, this famous treatise on measurement was intended to demonstrate the use of geometry and perspective in design. The text shown here deals with the proportions of letter-forms – a subject which would have been of great interest to the bibliophile Sir Richard Ellys (1682–1742), who bought this copy at auction in Amsterdam in 1729. *Blickling Hall, Norfolk*

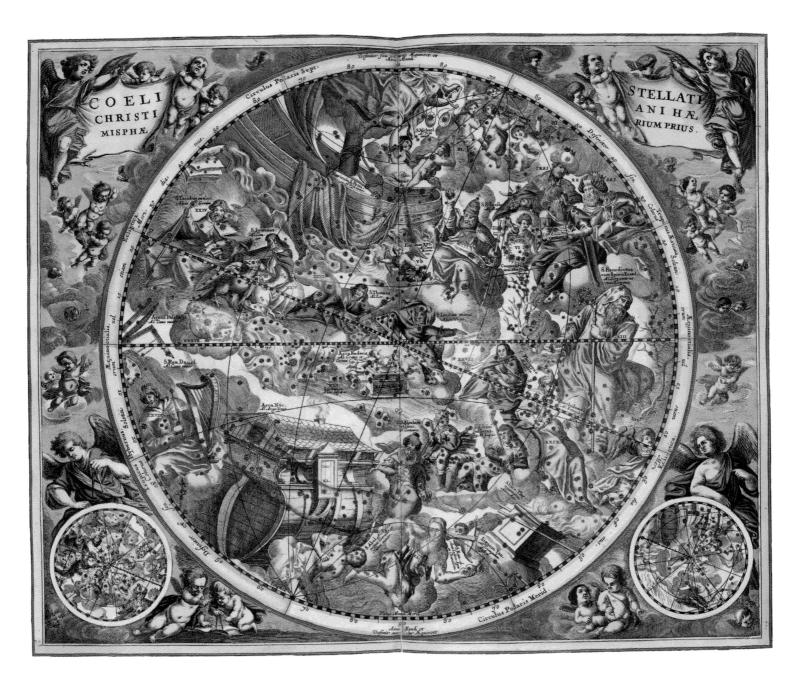

Andreas Cellarius, *Harmonia Macrocosmica seu Atlas Universalis et Novus* (Amsterdam, 1661)

Visitors to the 2nd Earl of Warrington's Library at Dunham Massey are invariably struck by his scientific instruments – the executive toys of the 18th century. It seems appropriate that the grandest books in the collection are a set of Dutch atlases, no doubt used in conjunction with the telescope and the orrery kept close by. *Dunham Massey, Cheshire*

Fine Bindings

Theodore Zwinger,
Theatrum Vitae
***Humanae* (Basel,**
1565) Zwinger's Theatrum is a
sort of universal encylopedia, but
the binding of this copy is one of
the most magnificent English
bindings of the 16th century. Made
by the Huguenot binder Jean de
Planche (at work in London by 1567
– eight bindings by him survive), it
was done for Sir Nicholas Bacon
(1509–1579), whose arms are
painted in the central panel.
Kingston Lacy, Dorset

Gaius Suetonius Tranquillus, *Opera* **(Venice, 1521)** This very beautiful little book is one of seven at Blickling from the library of the Renaissance bibliophile Jean Grolier (1479–1565). The tooling on the binding incorporates Grolier's motto: 'For Grolier and for his friends'. *Blickling Hall, Norfolk*

Philippe Moreau, *Le Tableau des Armoires de France* **(Paris, 1609)** Parts of the library at Charlecote date back to Elizabethan times, and this splendid livery binding was made in Paris for Sir Thomas Lucy III (1585–1640). Sir Thomas's intellectual interests were immortalized by Nicholas Stone, who carved his tomb in Charlecote church, showing Sir Thomas reclining in front of a set of shelves of his favourite Greek and Latin authors, Homer, Virgil, Cato, and Xenophon, as well as an unidentified book called 'Winters Ayres'. *Charlecote Park, Warwickshire*

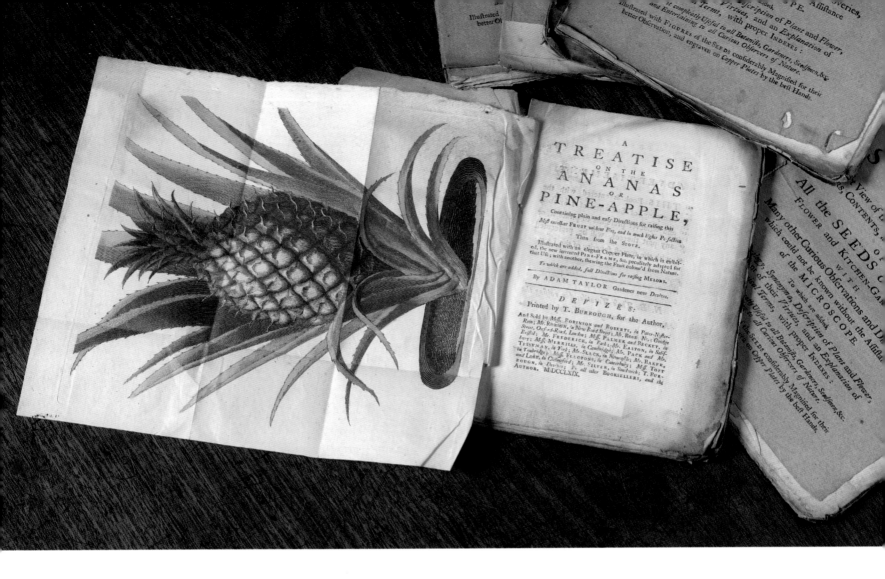

Adam Taylor, *A Treatise on the Ananas or Pine-Apple, Containing Plain and Easy Directions for Raising this Most Excellent Fruit* (Devizes, 1769) While their neighbours pursued exotic and rare books, successive owners of Dunham Massey focused steadfastly on what one contemporary commentator called 'usefull books' – ordinary, everyday publications of obvious practical value. One of the most notable features of the Dunham library is its vast collection of unbound pamphlets, covering everything from swimming to prison reform and the manufacture of false teeth. But pineapples were a particular favourite at Dunham in the 18th century. *Dunham Massey, Cheshire*

Ordinary Books

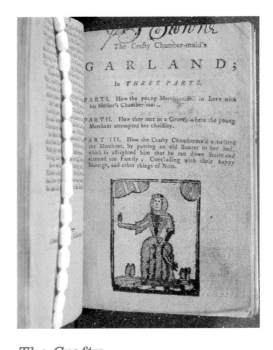

Isaac Barrow, Five Volumes of Sermons, with Fore-Edge Titles The library at Townend is one of the Trust's most remarkable collections of books, assembled by a family of prosperous Lakeland farmers between the 1590s and the 1940s. Like many of the earlier Townend books, these 17th-century sermons have their titles written in ink onto their fore-edges. They would have been stored in cupboards or chests – backwards, to our way of thinking. *Townend, Cumbria*

The Crafty Chambermaid's Garland **(Newcastle, c.1770)** The Townend library is particularly rich in chap books – the cheap popular literature of the day, and consequently now very rare. The three-part story tells of the courtship between a merchant and his 'Mother's chambermaid', her attempted seduction by him and their later marriage. *Townend, Cumbria*

Illustrated Books

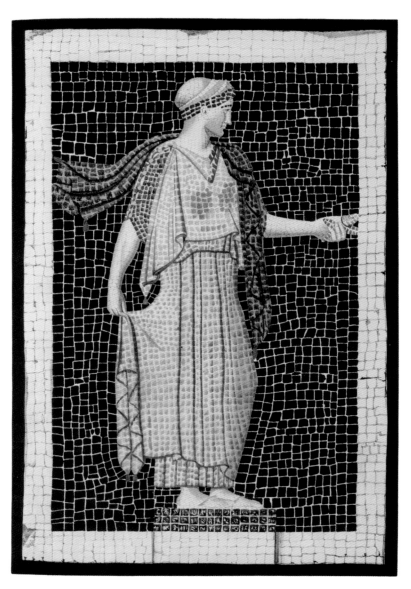

Mark Catesby, *The Natural History of Carolina* (London, 1754) Born in 1683, the botanical pioneer Mark Catesby travelled twice to America, living in Virginia from 1712 to 1719, and in South Carolina from 1722 to 1726. On his return to England, he spent seventeen years preparing his Natural History, the first plate book on the exotic flora and fauna of what later became the United States. *Blickling Hall, Norfolk*

Desiré Raoul-Rochette, *Peintures Antiques Inedites* (Paris, 1836) Calke Abbey has two large and entirely separate libraries. The Harpur-Crewe family collection goes back to the early years of the 18th century, but the second collection, bequeathed by Egyptologist Sir John Gardner Wilkinson (1797–1875), is kept upstairs. For more than a hundred years the books were simply dumped on the floor by Calke's eccentric owners; they include not only books on Egypt, but rich collections of material on classical archaeology, as well as a good number of oddities. *Calke Abbey, Derbyshire*

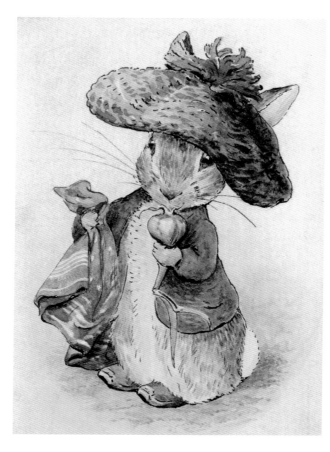

The Tale of Benjamin Bunny (London, 2002)

(above). Written and illustrated by Beatrix Potter (1866–1943), *The Tale of Benjamin Bunny* features one of her many animal characters inspired by her pets, presumably in this case her first rabbit, named Benjamin, whom she described as 'an impudent, cheeky little thing'. The cover has changed little since the book was first published in 1904. The story tells how Benjamin Bunny, cousin of Peter Rabbit, helps his cousin to rescue the clothes left by Peter in Mr McGregor's garden and the subsequent adventures that befall the pair. Potter had struggled to find a publisher for her first book, *The Tale of Peter Rabbit*, but was finally accepted by Frederick Warne & Co in 1902. She eventually published 23 books. *Hill Top, Cumbria*

Sir William Hamilton, *Campi Phlegraei. Observations on the Volcanoes of the Two Sicilies* (Naples, 1776)

(right). Sir William Hamilton, British ambassador in Naples and husband of Nelson's lover Emma, had two great passions: vases and volcanoes. His famous collection of Greek vases was commemorated in print by Pierre d'Hancarville in 1766 – the Trust has four copies – but the volcanoes had to wait another decade. In ancient times the Phlegraean Fields were thought to be the entrance to Hades. Their extraordinary volcanic landscape fascinated 18th-century travellers, who were both intrigued by their geology and mindful of the discoveries then being made at Herculaneum and Pompeii, destroyed by the eruption of Vesuvius in AD 79. Hamilton himself penned a series of letters to the Royal Society on the 1767 eruption, publishing them in 1772. This extraordinary folio then followed (the copy belonged to Lord Hardwicke at Wimpole), with hand-coloured engravings based on gouaches by Hamilton's own artist Pietro Fabris. *Wimpole Hall, Cambridgeshire*

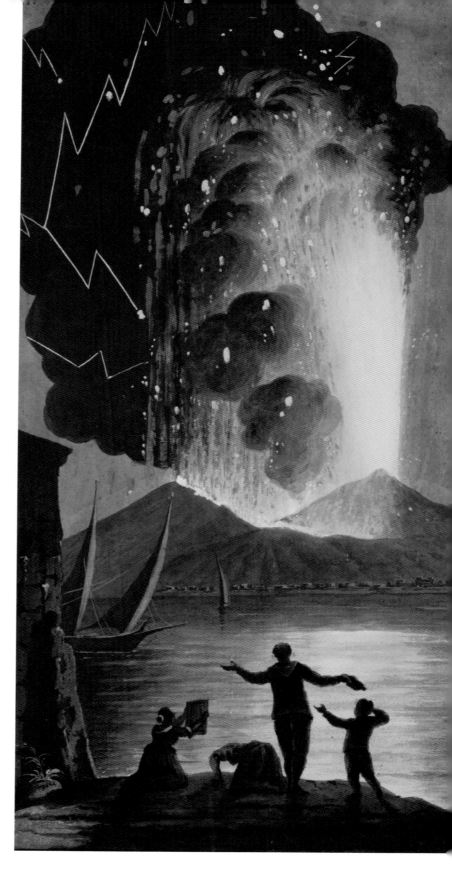

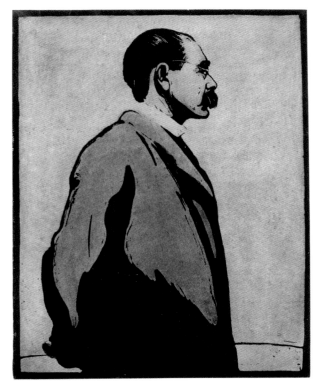

Changing Worlds

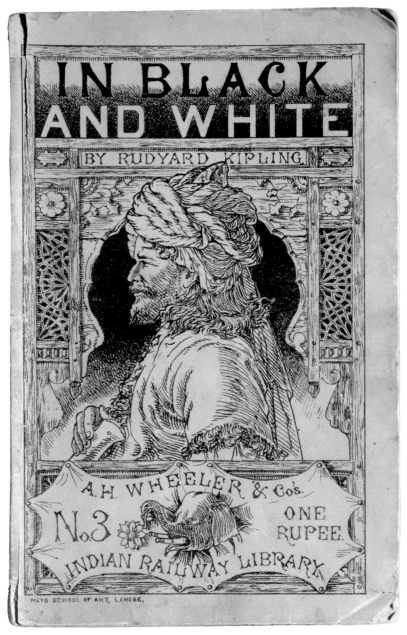

***In Black and White* (Allahabad, 1888)** This edition,
No.3 of The Indian Railway Library series, collects eight short stories by Rudyard
Kipling (1865–1936) that were originally published in *The Week's News* over the
course of 1888. The stories were later collected into what became *Soldiers Three and
Other Stories* in 1895. A H Wheeler and Co, a bookseller set up by the French
author Emile Moreau and Indian businessman T K Bannerjee, launched their Indian
Railway Library in 1888. *Bateman's, East Sussex*

Rudyard Kipling Copy of a woodcut by the artist William
Nicholson (1872–1949), a friend of Kipling, from a series made for the
publisher William Heinemann (1863–1920). *Twelve Portraits* (1900) included
depictions of Queen Victoria and Mark Twain. Kipling has often been viewed, in
George Orwell's words, as a 'prophet of British imperialism'. His early popularity,
including a Nobel prize for literature in 1907, faded as many saw prejudice in
his writing. Recently, there has been a certain re-evaluation of Kipling; more
people are coming to appreciate his craftsmanship as an author of poetry, prose
and the short story. His wife gave Bateman's, the family home in East Sussex, to
the National Trust in 1940. *Bateman's, East Sussex*

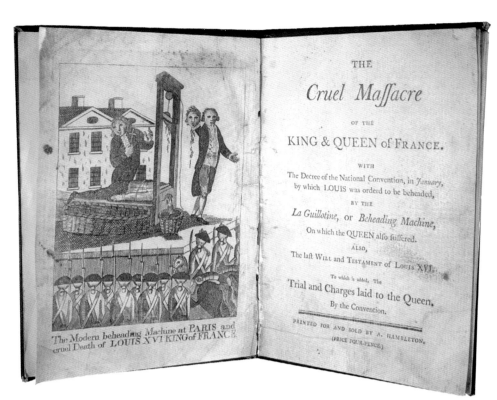

The Cruel Massacre of the King and Queen of France (London, 1793) This little chap-book pamphlet survives in only two other copies. They were crudely printed on the cheapest grade of paper, often recycling type and woodblock illustrations which had been used in other work. Stories were frequently from recent history or the traditional orally told storytales. *Townend, Cumbria*

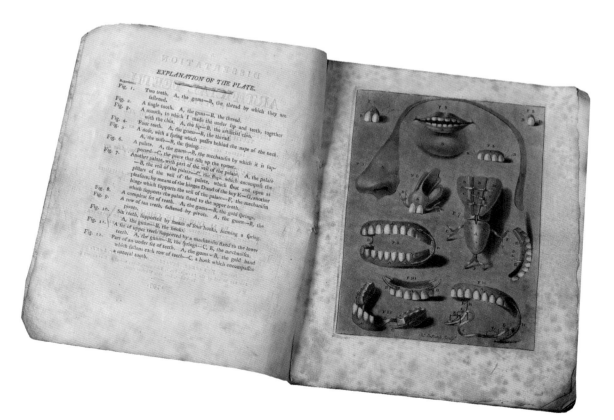

A Dissertation on Artificial Teeth in General (London, 1797) The lengthy subtitle of this book reads: 'Exposing the Defects and Injurious Consequences of all Teeth made of Animal Substances, the Corruptibility and Dangers of which are at Present Acknowledged by the Faculty; the Superior Advantages of Teeth made of a Mineral and Incorruptible composition are Fully Demonstrated.' *Dunham Massey, Cheshire*

Ceramics

Greek and Etruscan Vases

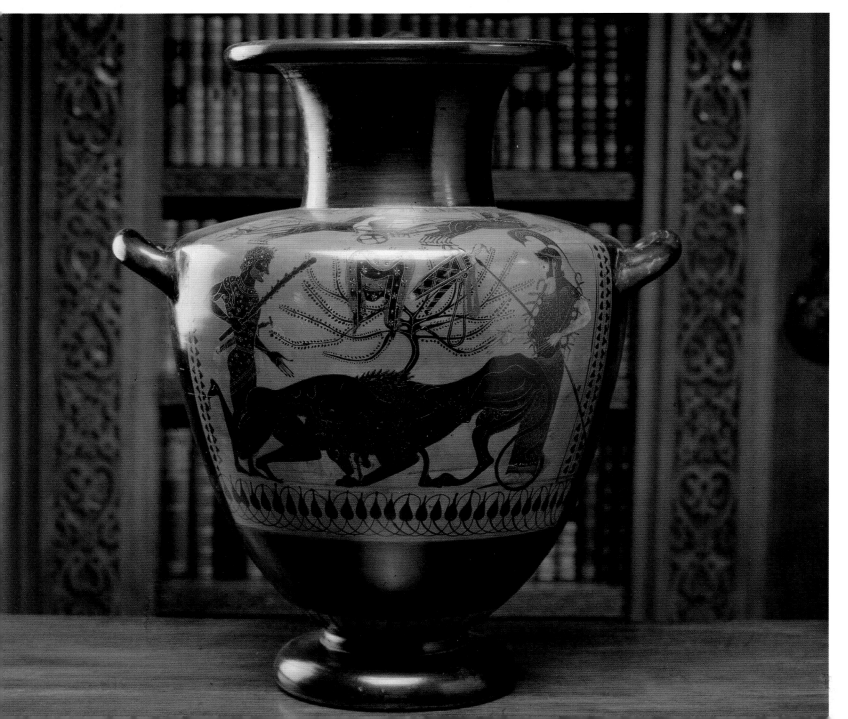

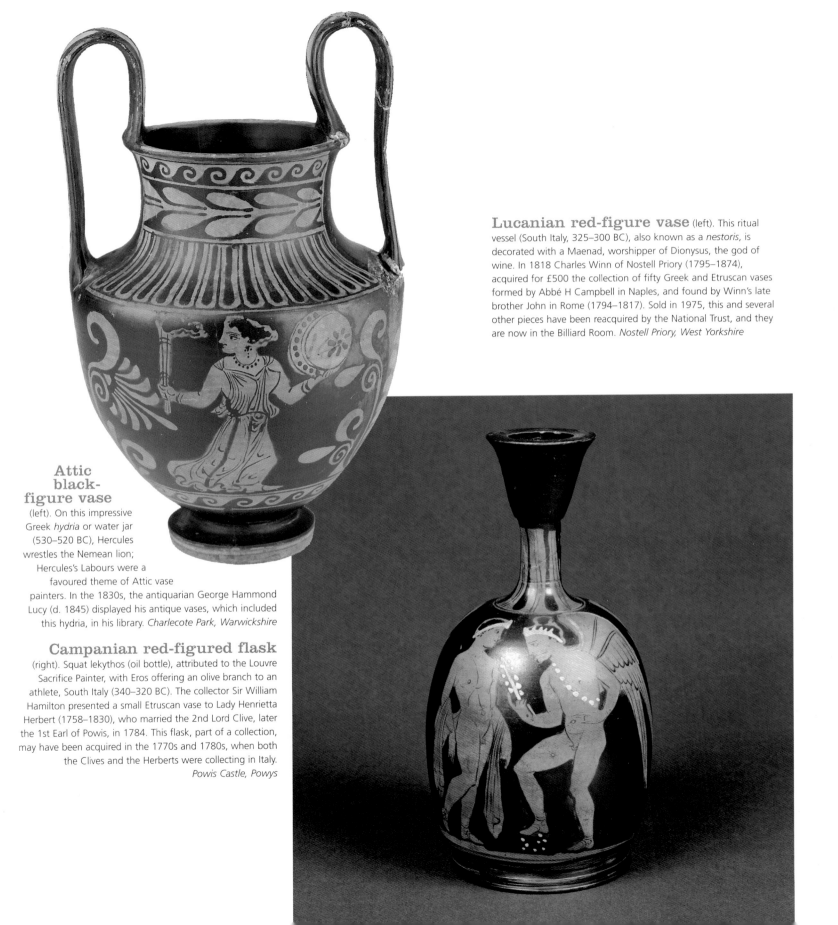

Lucanian red-figure vase (left). This ritual vessel (South Italy, 325–300 BC), also known as a *nestoris*, is decorated with a Maenad, worshipper of Dionysus, the god of wine. In 1818 Charles Winn of Nostell Priory (1795–1874), acquired for £500 the collection of fifty Greek and Etruscan vases formed by Abbé H Campbell in Naples, and found by Winn's late brother John in Rome (1794–1817). Sold in 1975, this and several other pieces have been reacquired by the National Trust, and they are now in the Billiard Room. *Nostell Priory, West Yorkshire*

Attic black-figure vase (left). On this impressive Greek *hydria* or water jar (530–520 BC), Hercules wrestles the Nemean lion; Hercules's Labours were a favoured theme of Attic vase painters. In the 1830s, the antiquarian George Hammond Lucy (d. 1845) displayed his antique vases, which included this hydria, in his library. *Charlecote Park, Warwickshire*

Campanian red-figured flask (right). Squat lekythos (oil bottle), attributed to the Louvre Sacrifice Painter, with Eros offering an olive branch to an athlete, South Italy (340–320 BC). The collector Sir William Hamilton presented a small Etruscan vase to Lady Henrietta Herbert (1758–1830), who married the 2nd Lord Clive, later the 1st Earl of Powis, in 1784. This flask, part of a collection, may have been acquired in the 1770s and 1780s, when both the Clives and the Herberts were collecting in Italy. *Powis Castle, Powys*

Medieval and Tudor Tiles

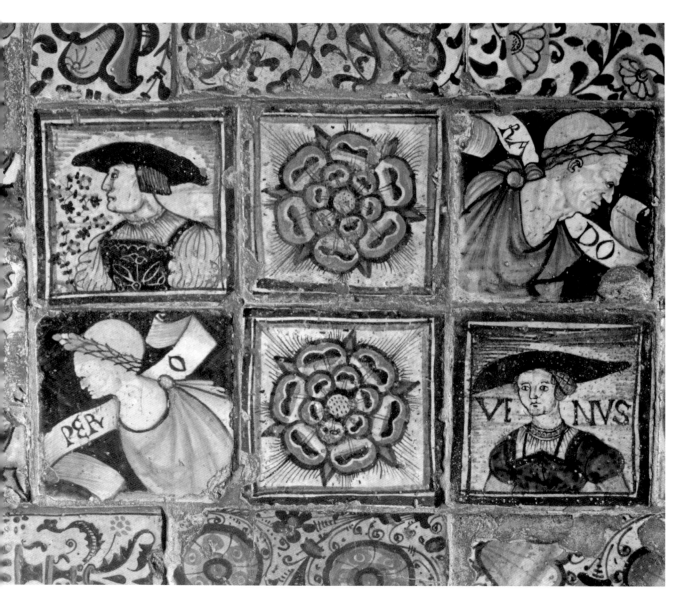

Flemish tiles

Heroic and royal portraits are depicted in these maiolica (tin-glazed earthenware) floor tiles made by Guido Andries (Guido di Savino) in Antwerp, c.1520–1522. They were probably imported at great expense by William, 1st Lord Sandys (c.1470–1540) of The Vyne, Henry VIII's lord chamberlain, while in Calais. Similar tiles were found at the palatial residence of Cardinal Thomas Wolsey (1471–1475) at York Place in Central London, which became the palace of Whitehall.

The Vyne, Hampshire

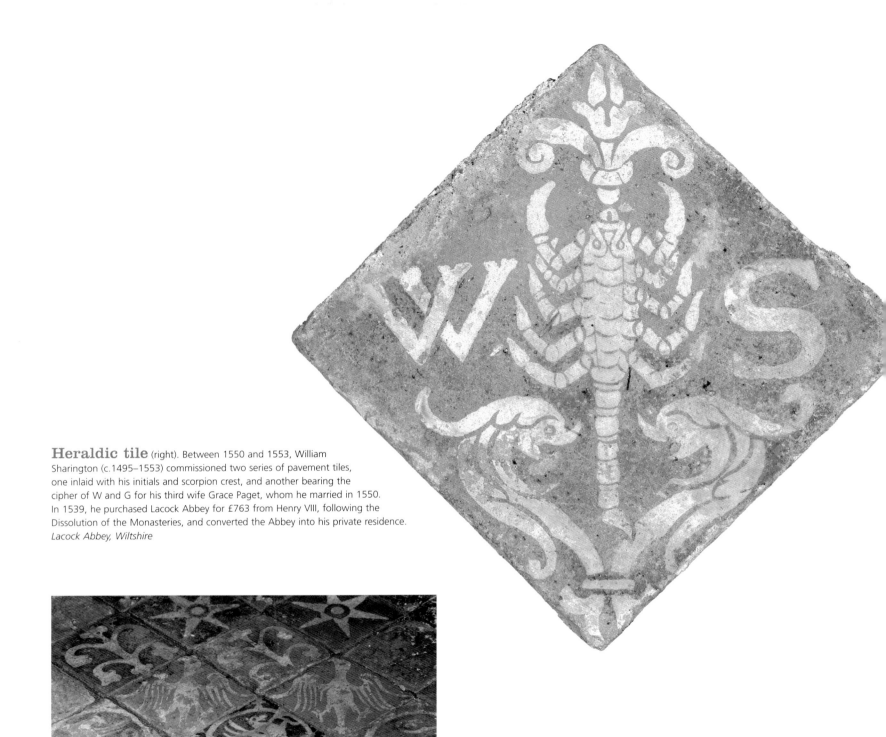

Heraldic tile (right). Between 1550 and 1553, William Sharington (c.1495–1553) commissioned two series of pavement tiles, one inlaid with his initials and scorpion crest, and another bearing the cipher of W and G for his third wife Grace Paget, whom he married in 1550. In 1539, he purchased Lacock Abbey for £763 from Henry VIII, following the Dissolution of the Monasteries, and converted the Abbey into his private residence. *Lacock Abbey, Wiltshire*

Medieval tiles (left). Mid-13th-century heraldic designs on well-worn pavement tiles in this former Augustinian priory, which have survived because the pattern was inlaid. A design was stamped into the red clay and filled with slip (liquid clay) in a contrasting colour, the excess slip was scraped off, and the tile was fired. *Mottisfont Abbey, Hampshire*

Italian Renaissance Maiolica

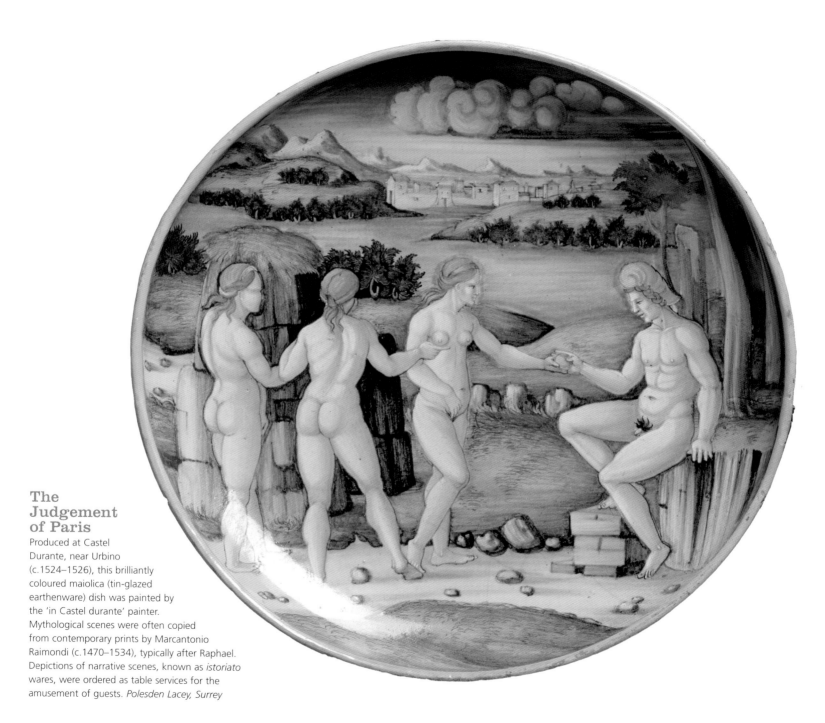

The Judgement of Paris

Produced at Castel Durante, near Urbino (c.1524–1526), this brilliantly coloured maiolica (tin-glazed earthenware) dish was painted by the 'in Castel durante' painter. Mythological scenes were often copied from contemporary prints by Marcantonio Raimondi (c.1470–1534), typically after Raphael. Depictions of narrative scenes, known as *istoriato* wares, were ordered as table services for the amusement of guests. *Polesden Lacey, Surrey*

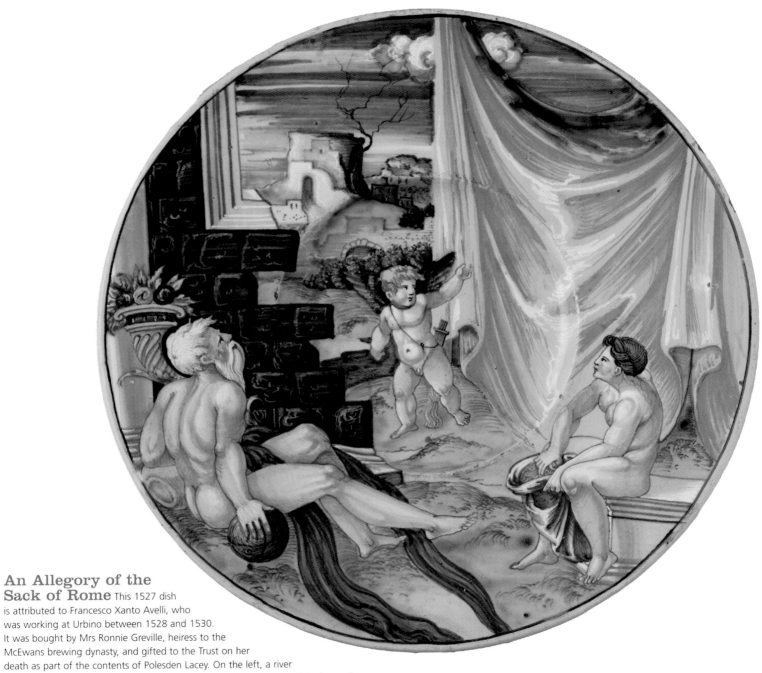

**An Allegory of the
Sack of Rome** This 1527 dish
is attributed to Francesco Xanto Avelli, who
was working at Urbino between 1528 and 1530.
It was bought by Mrs Ronnie Greville, heiress to the
McEwans brewing dynasty, and gifted to the Trust on her
death as part of the contents of Polesden Lacey. On the left, a river
god holds a cornucopia, while opposite, a woman holds an open sack in front of a
curtain. The apparent loose morality of the nude holding open a sack invites divine retribution,
in contrast to the prosperity of the cornucopia. The curtain is thought either to be a decorative
feature or to hide the resulting vengeance of the Gods. *Polesden Lacey, Surrey*

Early Chinese Pottery

Guardian tomb figure

(above). This winged, lion-like 'earth spirit' warded off demons entering the tomb. The lead glaze is splashed in green and amber on the low-fired earthenware body (7/8th century) The period of the Tang Dynasty is regarded as a high point in ancient Chinese civilization, and was a golden age for the arts. *Upton House, Warwickshire*

Tang dish

(left). Sumptuous Tang burials included brilliantly coloured lead-glazed earthenware, often painted over a white slip. The impressed design on this dish imitates stamped and chased designs on contemporary metalwork, a clever substitute for costly silver and gold plate. *Ascott, Buckinghamshire*

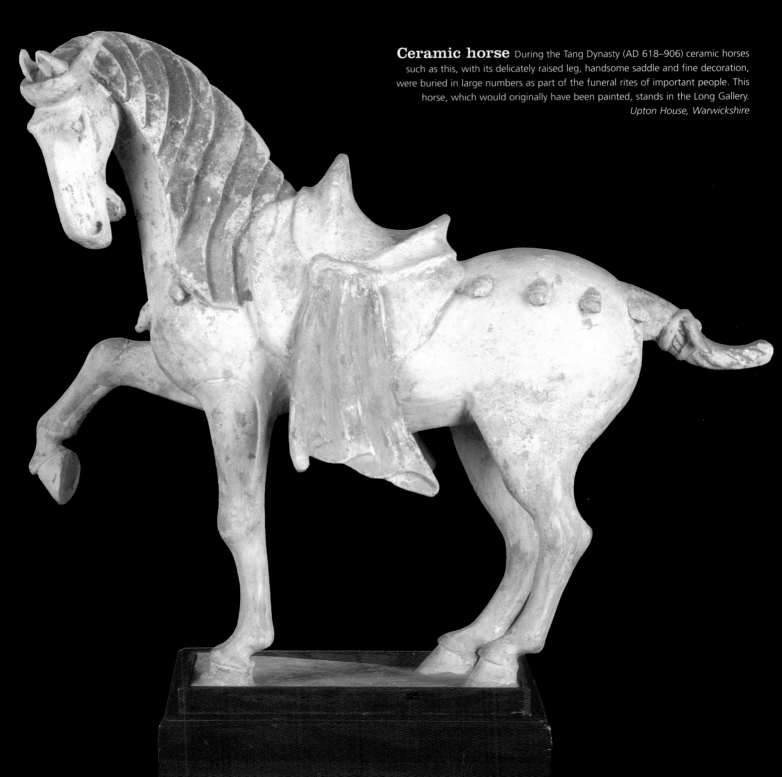

Ceramic horse During the Tang Dynasty (AD 618–906) ceramic horses such as this, with its delicately raised leg, handsome saddle and fine decoration, were buried in large numbers as part of the funeral rites of important people. This horse, which would originally have been painted, stands in the Long Gallery.

Upton House, Warwickshire

Chinese Porcelain

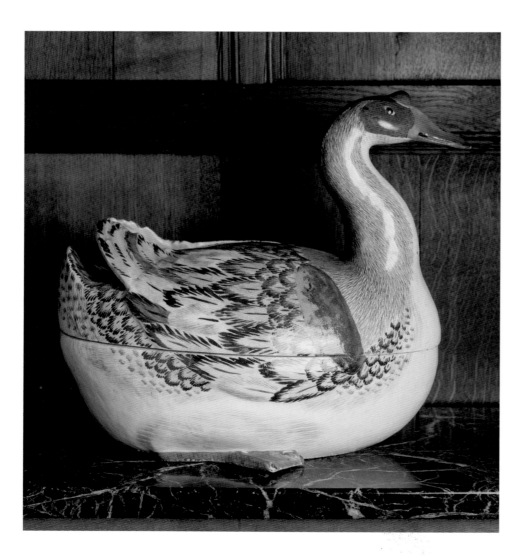

Goose tureen (left). One of a pair, this goose tureen from the Qianlong period (c.1780) is among the most spectacular animal models made for the Western market. *Polesden Lacey, Surrey*

Armorial plate (opposite, top left). *Famille rose* service, with the crest of a woman of Bengal and the motto '*Sapiens Qui Assiduus*' ('Wise is he who is industrious'), c.1765–1770. Ordered by Francis Sykes (1731–1804), a newly wealthy 'nabob', when the East India Company's Resident at the Court of the Nawab of Bengal. He was created a baronet in 1781. *Basildon Park, Berkshire*

Teapot (opposite, top right). This teapot was made in South China's Fujian province (c.1650–1675), and applied with English silver-gilt mounts (c.1660–1680). It was once owned by the Duchess of Lauderdale (1626–1698). In the 17th century, tea was boiled in ceramic teapots placed over a spirit lamp or brazier. A 1679 inventory describes the teapot as 'One Indian furnace for tee garnish'd wt silver'; East Asian objects were often identified as Indian. It was presented in 1994 to the National Trust through the NACF (the Art Fund) by the late Ronald Lee in memory of his wife. *Ham House, Surrey*

***Famille rose* fish bowl** (opposite, bottom left). This colourful fish bowl or cistern (c.1745) has stood in the Saloon since 1767, when Arthur Young (1741–1820), an early country-house visitor and travel writer, observed that 'in one corner of the room is a noble china cistern'. In the 19th century it was used as a fern pot. *Wallington, Northumberland*

Pair of 'Dragoon' jars (opposite, bottom right). In 1717, Augustus the Strong, King of Poland and Elector of Saxony (1670–1733) traded 600 of Saxony's finest dragoons (cavalrymen) for 151 pieces of Chinese porcelain, among which were several dozen monumental jars similar to these, which were acquired by the 6th Duke of Somerset (1662–1748), known as the 'Proud Duke', in the 1690s. The jars are decorated with scenes of Chinese court life. *Petworth, Sussex*

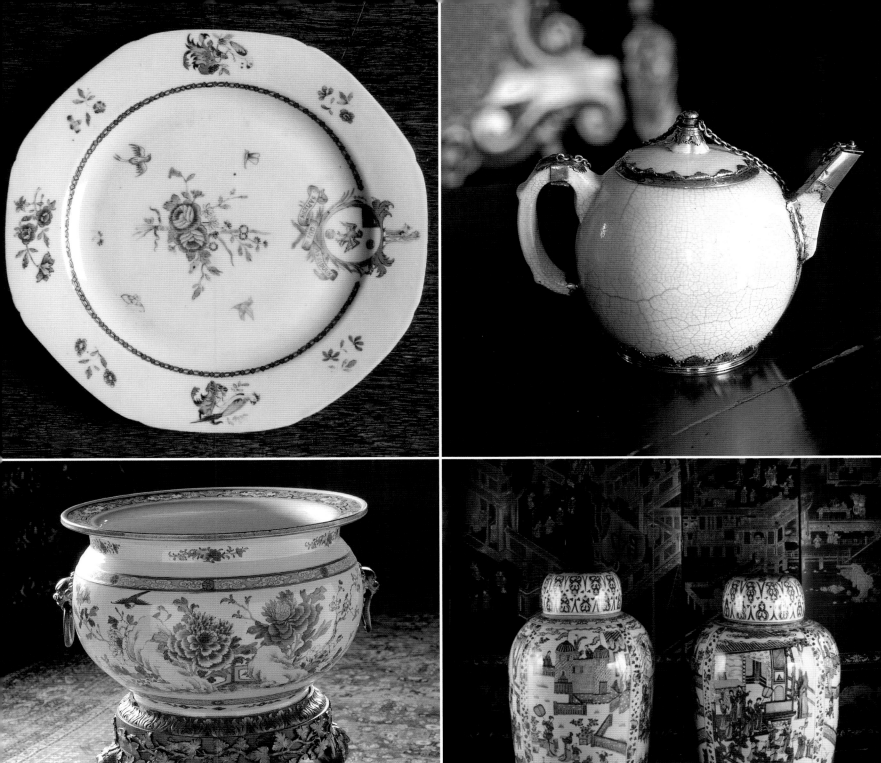
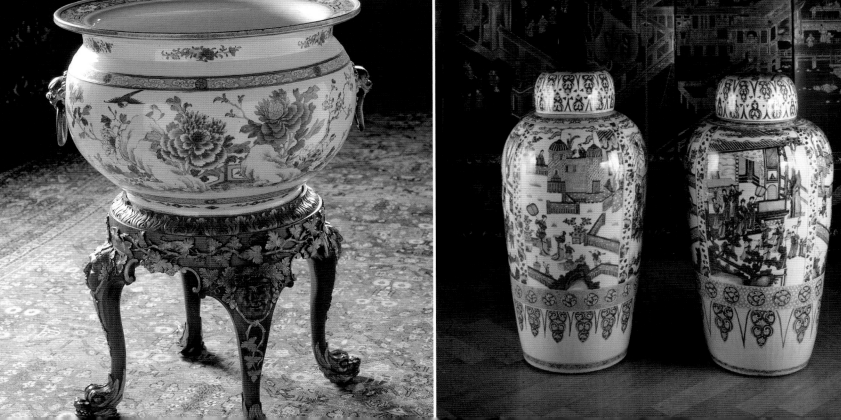

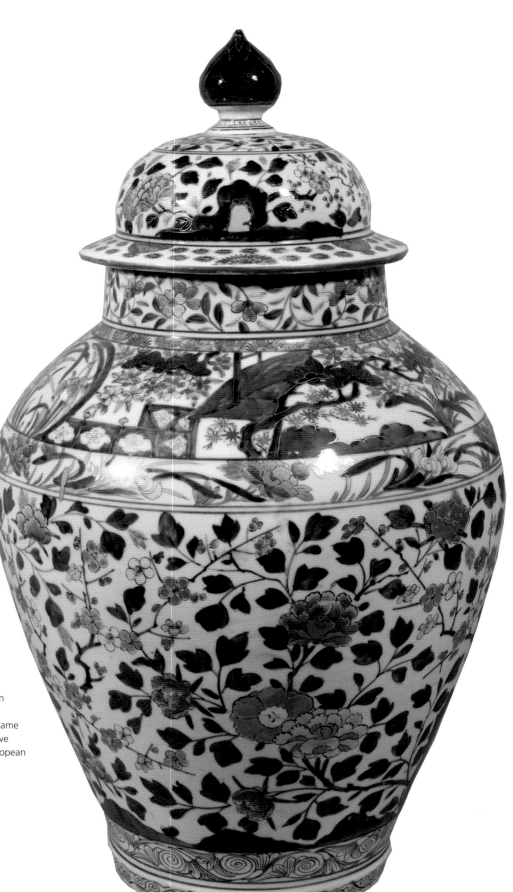

Japanese Porcelain

Imari jar This large jar, one of a pair, was made at Arita, a town on the island of Kyushu, in Southern Japan (c.1690–1710). Wares with this colour palette of blue, red and gold are known as *Imari* after the name of the Japanese port from where they were first exported. The distinctive design catered to European tastes, and was later much imitated by European potters. *Belton House, Lincolnshire*

Leaping carp vase (right).
This vase was made in Arita, about 1700,
with ormulu mounts and candle arms with
Vincennes porcelain flowers, about 1750.
In Japan, the carp symbolizes perseverance
and stamina. In 1768, a similar porcelain
carp leaping successfully against the
powerful current of a rocky waterfall was
included in the Paris sale of M. Gaignat.
Clandon Park, Surrey

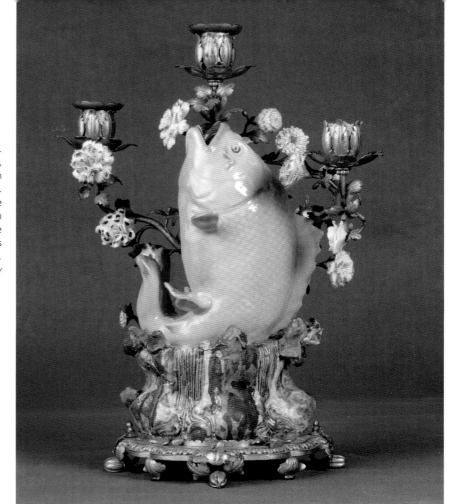

Imari bowl (right) This
exceptionally large bowl for serving punch
was made at Arita specifically for export.
The mountains and pavilions on the exterior
were inspired by contemporary Japanese
ink painting, specifically the Kano school. A
1688 inventory of Belton, at the time of Sir
John Brownlow, 3rd Baronet (1659–1697),
records 'one Jappon punch boule with a
frame'. *Belton House, Lincolnshire*

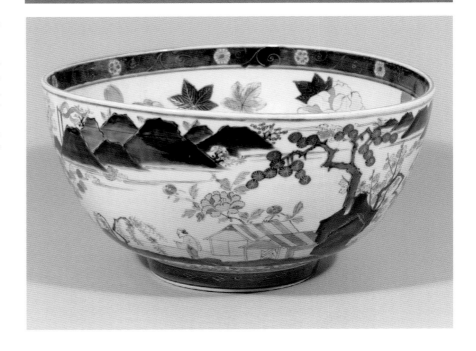

Earthenware

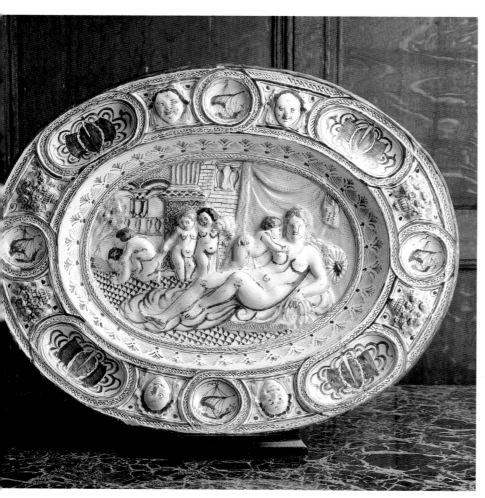

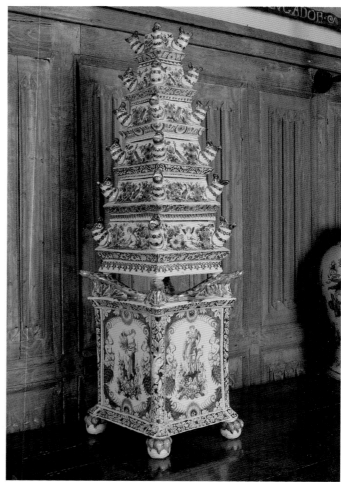

'Fecundity' dish This delftware (tin-glazed earthenware) dish (c.1650), was made in London, probably at the Pickleherring pottery in Southwark. The design copies lead-glazed earthenware dishes traditionally attributed to the French potter Bernard Palissy (1510–1589). Over forty of these 'Fecundity' dishes survive. *The Vyne, Hampshire*

Tulip vase Dutch Delft pyramid vase by Adrianus Kocx (1687–1701). Each of the sections in this vase could be filled with water and used to display cut tulips and other flowers. Around the base of the vase are female figures representing Prudence, Charity, Hope and Justice. *Lytes Cary Manor, Somerset*

Fireplace tiles

Delftware tiles transfer-printed with *chinoiserie* after engravings by Pillement, the 'Tithe-pig' and other scenes, by John Sadler and Guy Green, Liverpool (1765–1775). These tiles were part of the redecoration of Croft Castle in 1765 by the Shrewsbury architect Thomas Farnolls Pritchard (1723–1777), to whom is credited the inventive Gothick style at the castle.
Croft Castle, Herefordshire

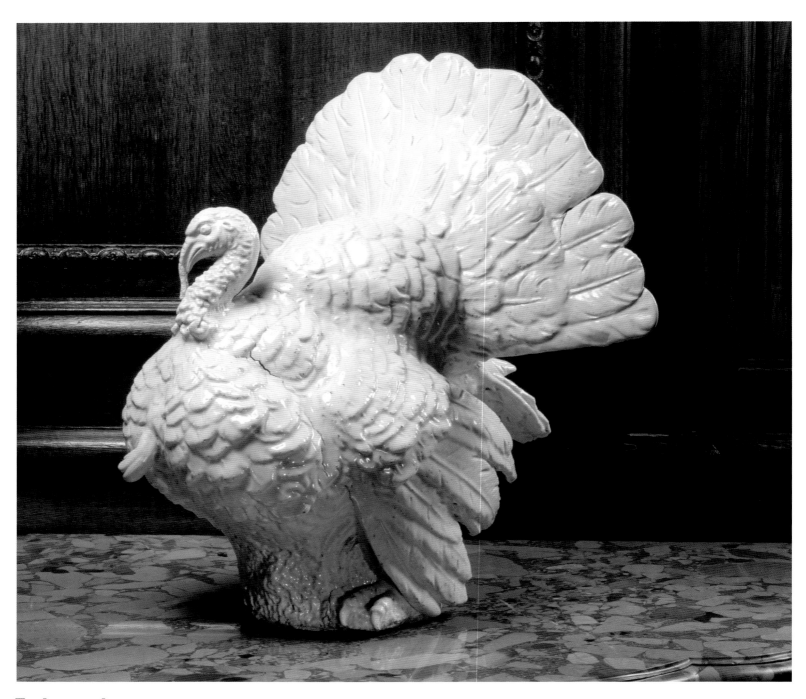

Turkey cock This extraordinary life-sized model of a turkey cock (*Truthahn*), was made at Meissen in 1733. Modelled by the sculptor Johann Joachim Kändler (1706–1775) in January 1733, it was intended for the ambitious porcelain menagerie in the Japanese Palace of Augustus the Strong in Dresden. The menagerie was a tour de force, not only in the daring firing of large-scale objects in porcelain, but also in the realistic portrayals, which Kändler based on the close study of real animals in Augustus the Strong's collection. The bird was supposed to be painted in its natural colours, but the plan was abandoned because of the risk of collapse through additional firing of the enamels. Several hundred animals from the menagerie survive, a testament to Augustus's determination and Kändler's genius. *Waddesdon Manor, Buckinghamshire*

Early Meissen Porcelain

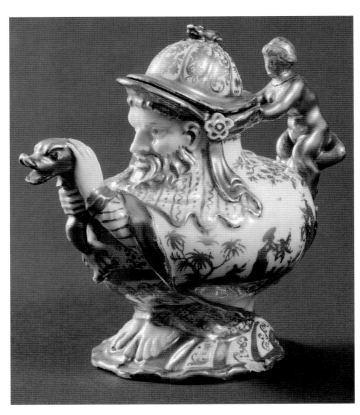

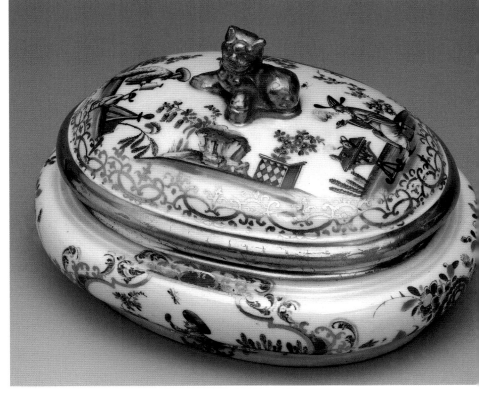

Grotesque teapot Based on a design by Jacques Stella (1596–1657), this teapot (c.1719–1727) may have been modelled by the goldsmith Johann Jacob Irminger (1635–1724), or sculptor Gottlieb Kirchner (1706–1768). The design was added in the Seuter brothers' workshop in Augsburg. *Fenton House, London*

Sugar box Designed as part of a tea or coffee service (c.1723–1725), the decoration of colourful *chinoiserie* inside elaborate scrollwork-framed panels was designed by Meissen's artistic director Johann Gregor Höroldt (1696–1775). *Saltram, Devon*

Meissen Porcelain

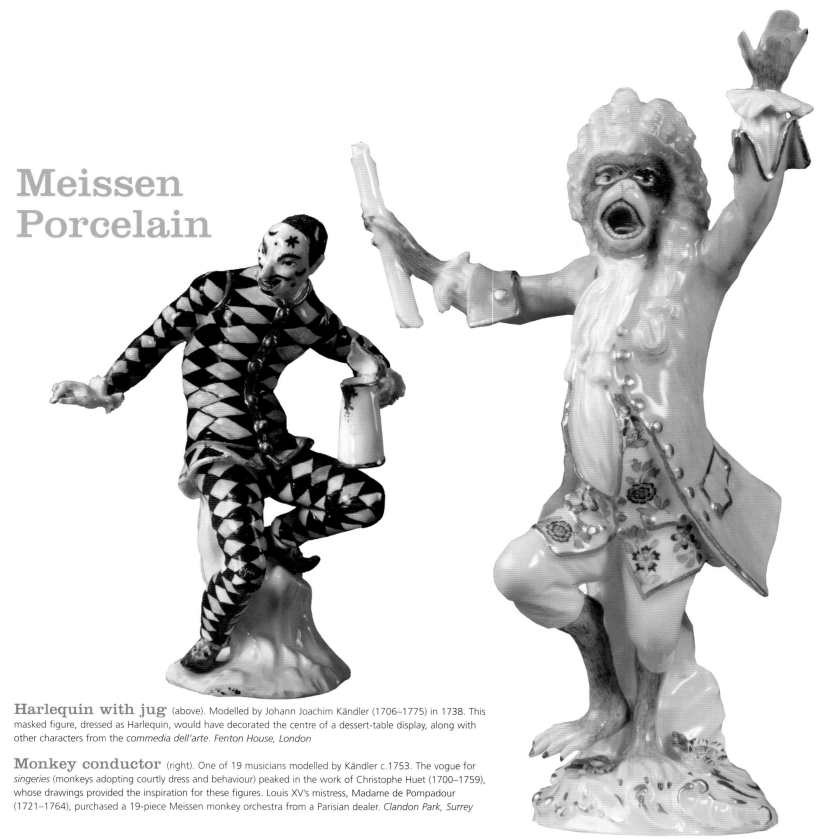

Harlequin with jug (above). Modelled by Johann Joachim Kändler (1706–1775) in 1738. This masked figure, dressed as Harlequin, would have decorated the centre of a dessert-table display, along with other characters from the *commedia dell'arte*. *Fenton House, London*

Monkey conductor (right). One of 19 musicians modelled by Kändler c.1753. The vogue for *singeries* (monkeys adopting courtly dress and behaviour) peaked in the work of Christophe Huet (1700–1759), whose drawings provided the inspiration for these figures. Louis XV's mistress, Madame de Pompadour (1721–1764), purchased a 19-piece Meissen monkey orchestra from a Parisian dealer. *Clandon Park, Surrey*

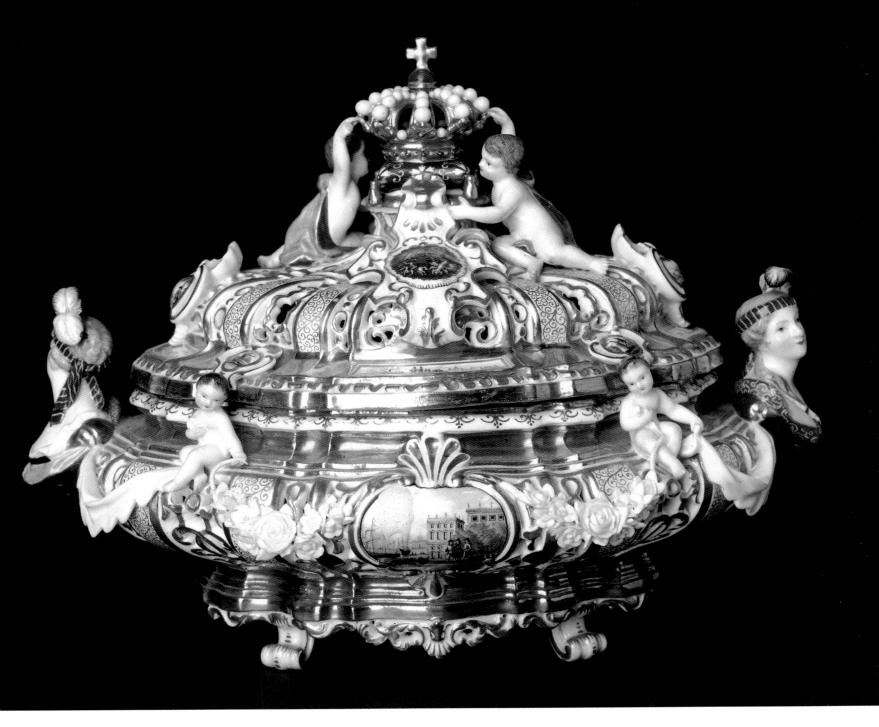

Oval bowl (above). Meissen oval bowl and cover modelled with bust portraits and seated figures of children in high relief, suspended drapery and floral festoons, scrolls and foliage, painted with figures, buildings and landscapes in shaped medallions. The domed cover is surmounted by children supporting a crown, with shields and arms of the Elector of Saxony and Kings of Poland and similar medallions painted with figures. The interior is gilded and the cover is modelled with flowing stems in low relief. *Hinton Ampner, Hampshire*

Sèvres Porcelain

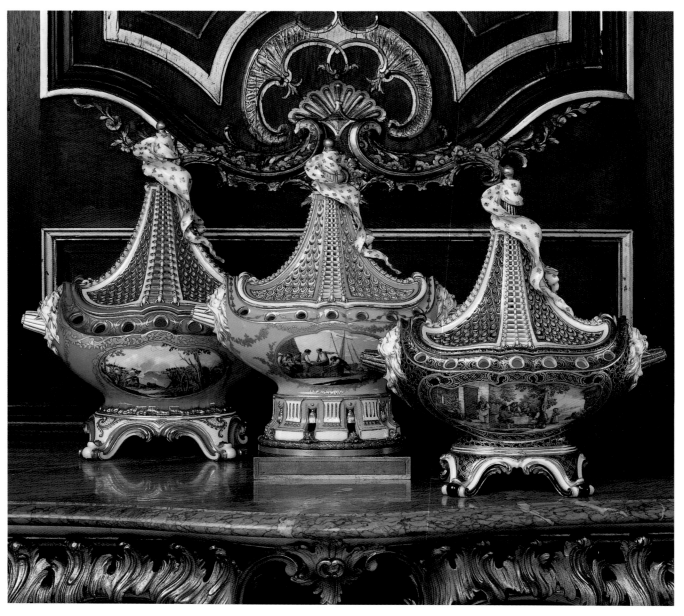

Pot-pourri vases These boat-shaped vases, also known as *pot pourri à vaisseau* or *pot pourri en naivre*, were possibly modelled in 1761 by the sculptor and court goldsmith Jean-Claude Duplessis, *père* (1695–1774). They may commemorate French naval victories in the Seven Years' War (1756–1763). The painted scenes depict a battle, a harbour view and another after Teniers, each displaying one of Sèvres' glorious ground colours. Only eleven examples are known of this rare form, and three are at Waddesdon. *Waddesdon Manor, Buckinghamshire*

Dinner service (right). Close-up of a Sèvres table service, ordered in 1802 as a diplomatic gift for the British Foreign Secretary, Robert Banks Jenkinson, 2nd Earl of Liverpool (1770–1828), for negotiating the Treaty of Amiens (27 March 1802), which led only to a brief one-year period of peace. The pattern, described as *écaille arabesque*, features a rare *faux* tortoiseshell ground. *Lyme Park, Cheshire*

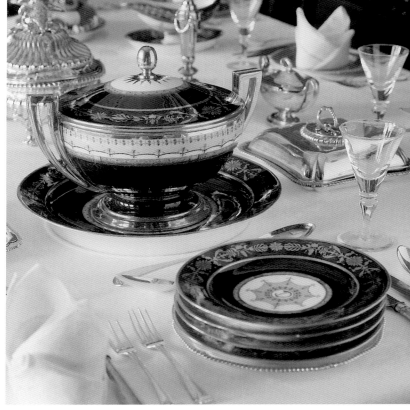

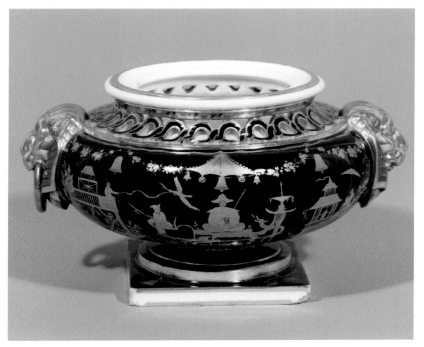

Pot-pourri vase (left). Delicate Pillement *chinoiserie* applied in gold and platinum in the spirit of Japanese lacquer contrasts with the solemn Egyptian lion's-head handles on this vase, made in 1791. This is one of seven exceptionally rare Sèvres pieces at Belton House. *Belton House, Lincolnshire*

Ewer and basin (left). Birds painted by Etienne Evans and gilding by E-H Le Guay, *ainé*, *père*, 1780. Much of the French porcelain at Knole was acquired by John Frederick Sackville, 3rd Duke of Dorset (1745–1799). This covered jug and basin with a matching broth bowl is painted with a roseate spoonbill and other exotic birds. *Knole, Kent.*

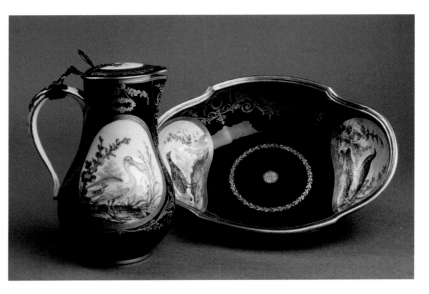

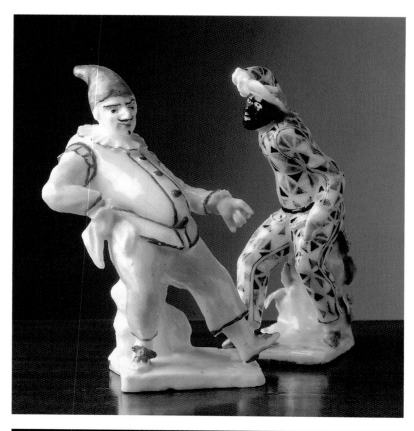

Early English Porcelain

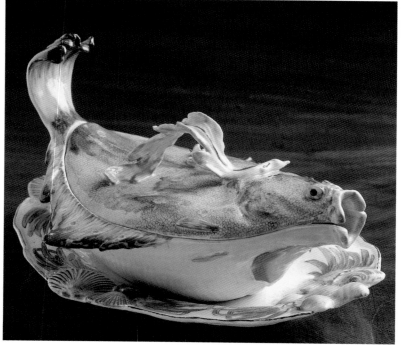

Commedia dell'Arte figures (top right). Pulchinello and Harlequin produced in London's Bow factory (c.1750–1754). The figures, dressed in their traditional costume, are typical of Bow's output. *Wallington, Northumberland*

Plaice sauceboat (bottom right). Plaice sauceboats are first mentioned in the 1756 Chelsea porcelain sale catalogue. Novel animal, bird and fish tureens were a speciality of the factory during their 'Red Anchor' period (c.1752–1756). The 1789 Erddig inventory records '2 Stands and two Carp Sauce Boats 6 pieces in all'. *Erddig, Wrexham*

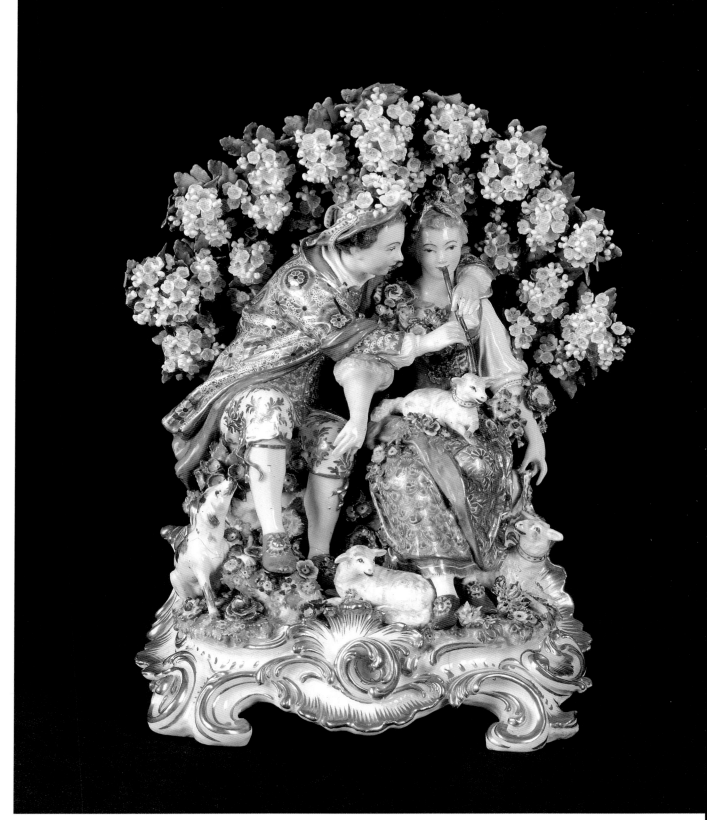

The Music Lesson This charming group (c.1765) is typical of Chelsea porcelain at its most exuberant. It shows the fine-quality gilding, the richly brocaded costumes and profusion of flowers so popular during the factory's 'Gold Anchor' period (1756–1769). The piece was modelled from a print called *L'Agréable Leçon*, engraved by Robert Gaillard after a painting by François Boucher. *Upton House, Warwickshire*

Worcester Porcelain

Chamberlain Worcester (right). Within the Ionic Temple at Rievaulx, the Dining Room is set with a Chamberlain Worcester service. The Chamberlain factory quickly established a reputation for the production of extremely finely painted porcelain. *Rievaulx Terrace & Temples, North Yorkshire*

Floral trio (below). These three pieces show the exquisite designs and lavish application of gilding that made Worcester so famous. *Knole, Kent*

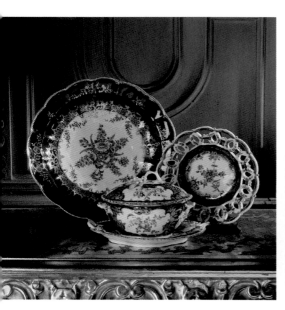

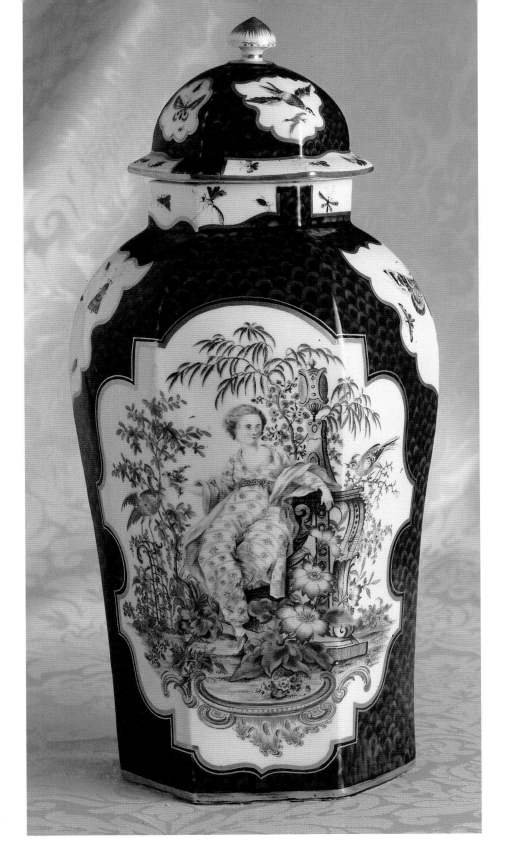

Hexagonal jar Worcester's innovative scale-blue ground was applied in a fish-scale pattern in an attempt to prevent the colour from bleeding during firing. The technique, introduced in 1765, is beautifully balanced with colourful panels of *chinoiserie* figures derived from Pillement prints on this jar (c.1768–1770). *Fenton House, London*

Wedgwood and his Imitators

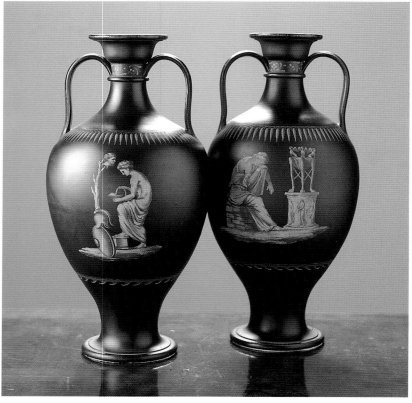

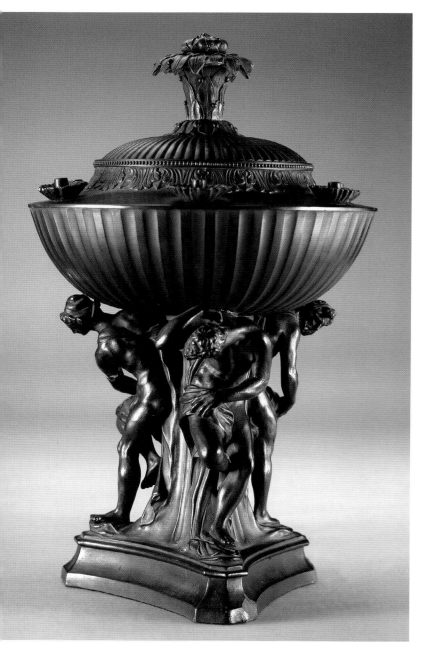

Pair of vases (above). Josiah Wedgwood (1730–1795) formed a partnership with his good friend Thomas Bentley (1730–1780) in 1769, to produce ornamental ware, especially black basalt, a stoneware. Wedgwood called it 'Etruscan' ware, a misnomer as the fine ceramics excavated in Pompeii that inspired the style were soon discovered to be Greek. These rare vases (c.1780–1785) are based on antique Greek models. *Saltram, Devon*

Oil lamp (left). Wedgwood's design for this black basalt lamp (c.1772–1780) was based on a Hellenistic bronze lamp and a late-16th-century crucifix at one time attributed to Michelangelo. John Parker, 1st Lord Boringdon (1735–1788), purchased a pair for Saltram, and other examples of this fashionable model can be found at The Vyne in Hampshire and Stourhead in Wiltshire. *Saltram, Devon*

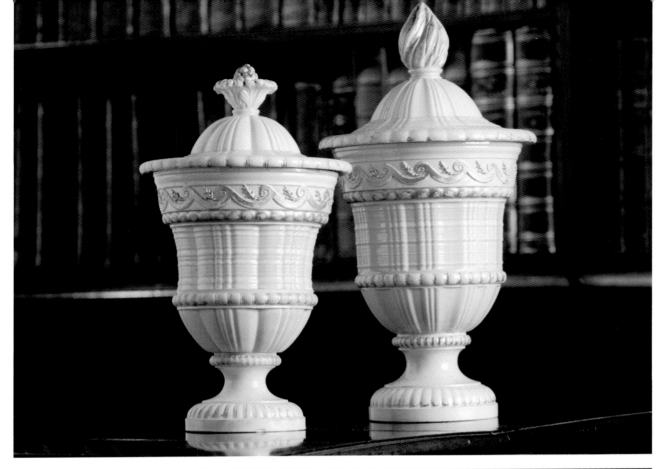

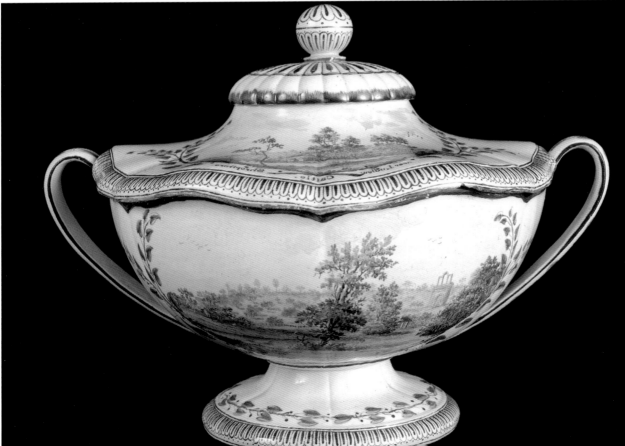

Engine-turned vases (top left). Creamware, unfired gilding, about 1764–1768. In 1765, Wedgwood sent a similar set of 'vases, Creamcolour engine turn'd' to Queen Charlotte, wife of George III. Matthew Boulton, the Birmingham industrialist, inspired his adaptation of an 'eccentric' or 'rose' engine-turning lathe for surface decoration on pottery; Boulton also owned a similar set. However, the elegant design of these vases, originating from two different garnitures (sets of vases), owes more to the ivory-turned vases favoured by European aristocrats. *Saltram, Devon*

Queensware tureen (bottom left). In 1766, when Wedgwood was appointed 'Potter to Her Majesty the Queen' (Charlotte, Queen Consort to George III), he renamed his cream-coloured earthenware 'Queen's ware'. This tureen (c.1774), which matched the Frog service made for Catherine the Great of Russia, is the only known example in polychrome. It is decorated with views of Shugborough Hall, including the triumphal arch, and scenes near Richmond Castle in North Yorkshire and Ludlow Castle in Shropshire. *Shugborough Hall, Staffordshire*

William Morris and Minton

William Morris (1834–1896) is credited as being the founder of the Arts and Crafts movement. Originally destined to be a clergyman, Morris changed direction after meeting Edward Coley Burne-Jones at Oxford. The pair were greatly influenced by Dante Gabriel Rosetti, who encouraged them to become artists. Morris used the decoration of his home, Red House in Bexleyheath, London, as an opportunity to try out numerous new designs.

The Minton factory was founded in 1793, by Thomas Minton (1765–1836) in Stoke-on-Trent. Originally famous for bone china and blue-printed earthenware, as well as Parian porcelain, which imitated marble statuary, the factory produced stunning 'art' porcelain during the Victorian period under the management of Herbert Minton. Famous names associated with Minton during this period include A W N Pugin, Sir Henry Cole and Prince Albert, an important patron.

William Morris, painted by Cosmo Rowe c.1895.

Hearth tiles (right). Minton encaustic tiles in the hearth floor in the Billiard Room fireplace, c.1868–1872. Inspired by the Gothic Revival, Herbert Minton (1793–1858), Thomas Minton's son, first experimented with inlaid or 'encaustic' tiles in 1828. The fashion was popularized by A W N Pugin, who designed Minton tiles for his projects. *Dunster Castle, Somerset*

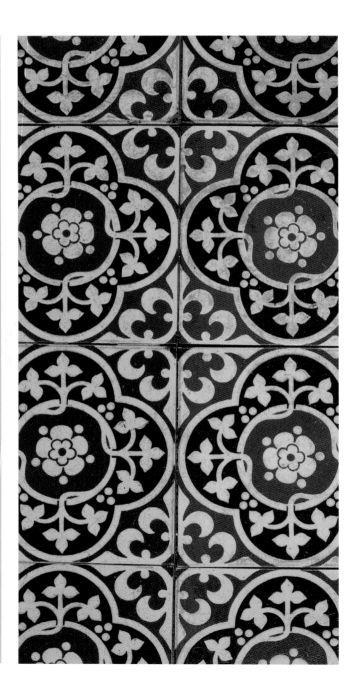

Minton and Morris Tiles

Morris tile (top). 'Si je puis', inscribed on this tile, translates as 'If I can', which was William Morris's motto. *Red House, Bexleyheath, London*

'Tulip and Trellis' tile (centre). These tiles were designed by Morris, c.1872–1876, and made by the De Morgan pottery. William de Morgan (see overleaf) was a lifelong friend of Morris, and together they were central figures in the Arts and Crafts movement. *Wightwick Manor, West Midlands*

Heraldic floor tile (bottom left). Minton encaustic floor tile showing the coat of arms of the Legh family, in the Orangery, which was constructed c.1862. The coat of arms was granted to Sir Peter Legh I (1360–1399) by Richard II in 1397. *Lyme Park, Cheshire*

Minton tiles (bottom right). Encaustic tiles incorporating the Myddelton Biddulph monogram and glazed tiles printed with their wolf's-head erased crest (1847). From 1845–1848, A W N Pugin (1812–1852) Gothicized Chirk Castle's neo-classical interiors, designing wallpaper and these tiles for the private apartments of the then owner, Colonel Robert Myddelton Biddulph (1805–1872). Pugin's work was controversial, and much of it has since been undone by later generations. *Chirk Castle, Wrexham*

De Morgan vase (right). William de Morgan (1839–1917) was a key figure in the Arts and Crafts movement. He began by designing stained glass, but eventually moved on to pottery. His knowledge of chemistry enabled him to experiment with different glazes. Around 1875–1876 he developed his distinctive 'Persian' colours.
Standen, West Sussex

Framed tile (below). The framed tiles in the Billiard Room at Standen, of which this is one, were produced between 1872 and 1882, while de Morgan was based in Chelsea. The design is almost directly copied from a 16th-century Iznik tile made in Turkey.
Standen, West Sussex

William de Morgan

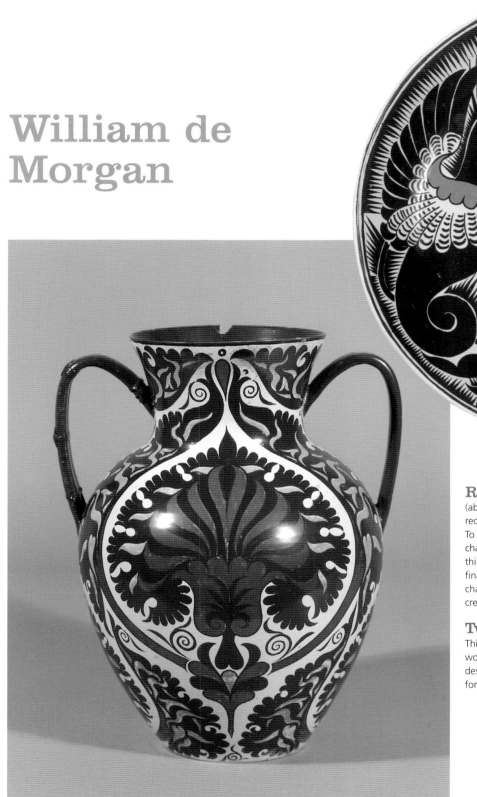

Ruby lustre charger
(above). William de Morgan effectively rediscovered the art of lustre decoration. To achieve the iridescent sheen characteristic of lustre ware, he added a thin film of dissolved metal oxide in the final firing. This spectacular ruby lustre charger is decorated with mythical creatures. *Standen, West Sussex*

Two-handled vase (left).
This lustre-ware vase is decorated with wonderfully bold Persian-influenced floral designs. De Morgan often looked to Persia for inspiration. *Standen, West Sussex*

Aesthetic Movement

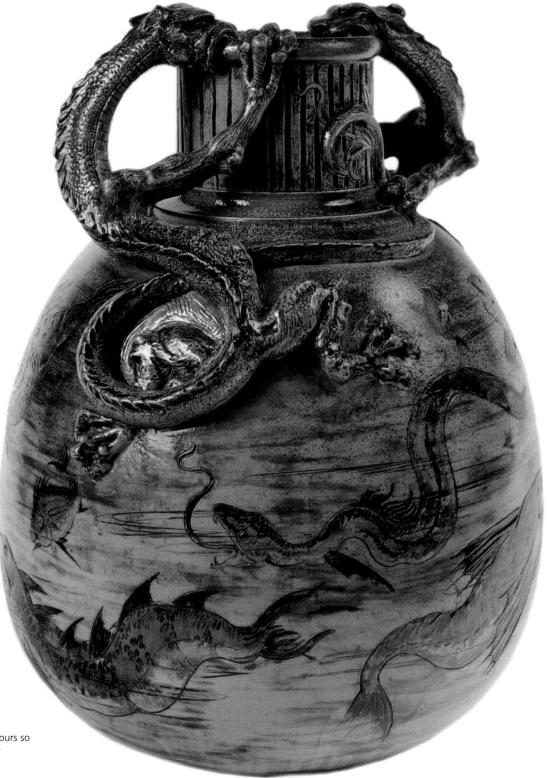

Martin Brothers vase The Martin Brothers pottery was founded c.1873 by the eldest of the four Martin brothers. They specialized in salt-glazed stoneware, the style of which was influenced by the Gothic Revival, a movement that was, in turn, influenced by the architecture of the Middle Ages. Every piece they produced was unique and individually signed and dated. This 1887 vase is decorated with a fish design and has handles shaped like dragons, both recurring themes, and is executed in the muted colours so characteristic of their pottery. *Blickling Hall, Norfolk*

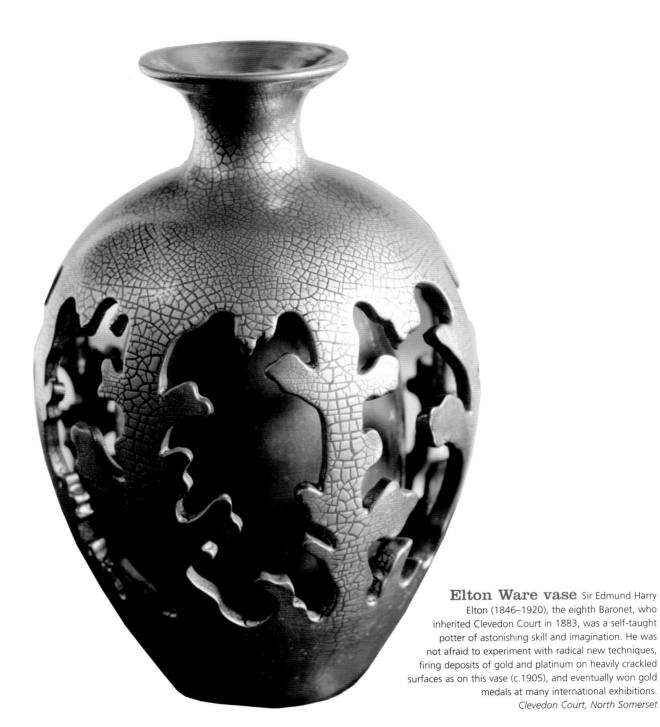

Elton Ware vase Sir Edmund Harry Elton (1846–1920), the eighth Baronet, who inherited Clevedon Court in 1883, was a self-taught potter of astonishing skill and imagination. He was not afraid to experiment with radical new techniques, firing deposits of gold and platinum on heavily crackled surfaces as on this vase (c.1905), and eventually won gold medals at many international exhibitions.
Clevedon Court, North Somerset

Clocks and Barometers
Medieval and Renaissance

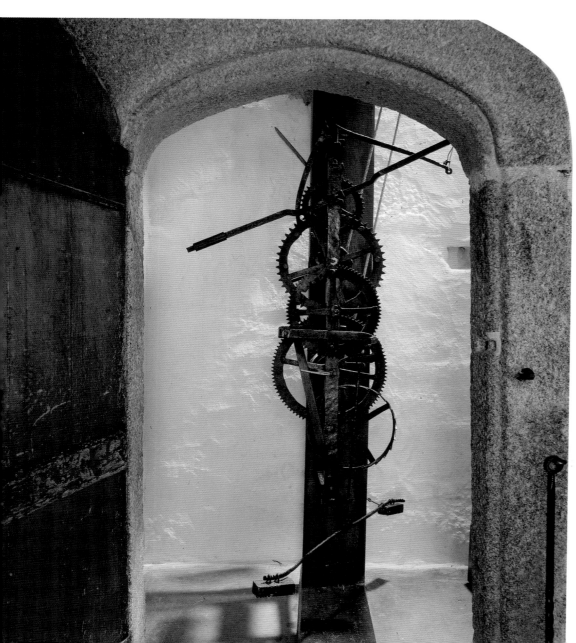

Chapel clock

(left). The earliest mechanical clock in its original state in Britain, this pre-pendulum clock is still working perfectly. Installed in the late 15th century, the clock has no dial; instead it is connected to the bellcote (a structure housing the bells) above, which contains a bell to strike the hours and another which can be tolled manually for services. The original striking bell is still in place, although the tolling bell has been replaced. Made from wrought iron, the clock is mounted firmly on a sturdy vertical oak beam. Its movement is driven by two heavy stone weights.
Cotehele, Cornwall

Table clock

(right). Made in Augsburg in Germany, c.1600, this table clock shows why Bavaria was considered the European centre of excellence for goldsmiths and all forms of metal work during this period. The delicacy and detailing are exquisite. *Croft Castle, Hereford and Worcester*

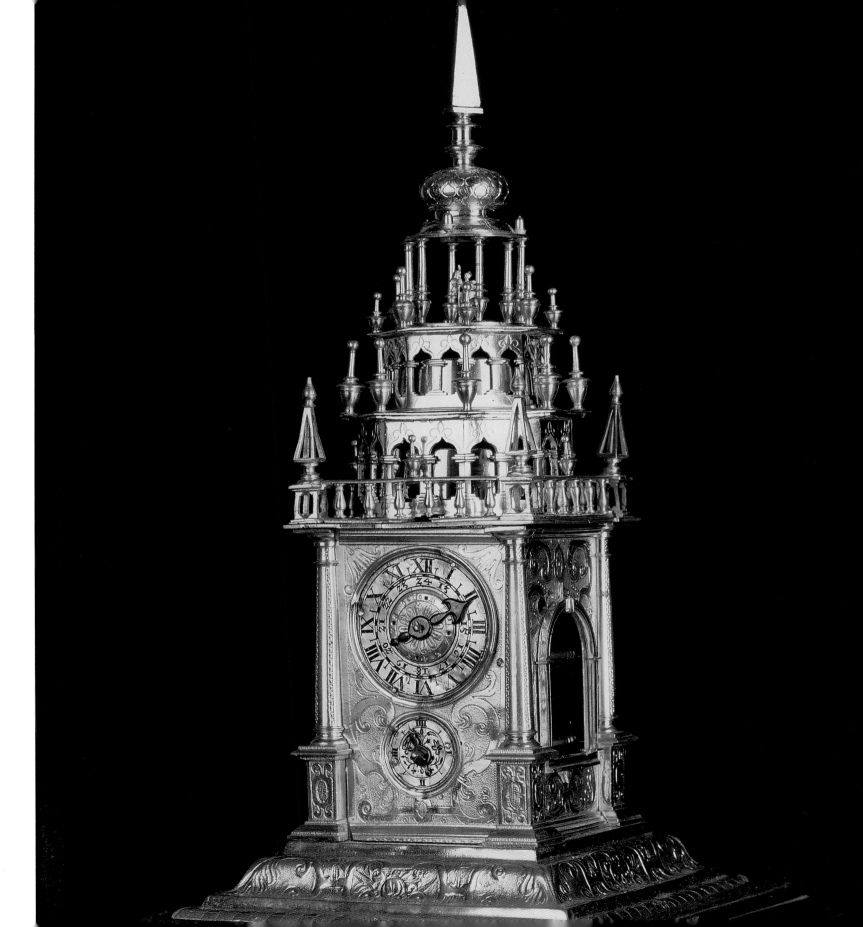

English
Longcase
Clocks

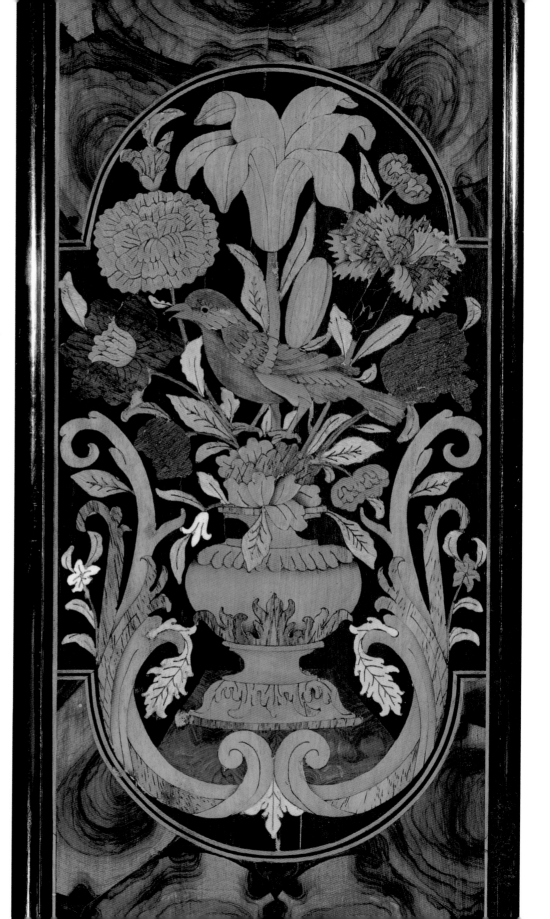

Floral marquetry Detail of
the exquisite marquetry on the front of the
longcase clock, c.1680, shown opposite. It
is signed by Thomas Tompion
(c.1639–1713), who has been described as
the father of English watchmaking.
Tompion joined the Clockmakers'
Company in London in 1672 and in 1676
was commissioned to create two clocks,
for the newly founded Royal Observatory
at Greenwich, that would only need
winding once a year.
Powis Castle, Powys

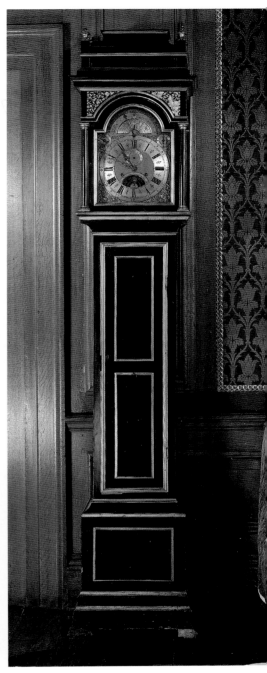

Anglo-Dutch style The case of this late-17th-century clock is veneered with walnut, with ebony and boxwood stringing and panels of floral marquetry in the Anglo-Dutch style. The clock has a typical silvered-brass chapter ring on the dial, which is signed 'Ben Merriman – London'. *Treasurer's House, York*

Tompion clock Full shot of the Thomas Tompion clock shown opposite. Tompion's clocks are renowned for their robust construction and innovative design. He devised a serial numbering system for his clocks and watches that was unique for the period and which makes it easier to date his work. *Powis Castle, Powys*

Ebonized case Made by the highly respected London clockmaker Daniel Delander (c.1678–1733) in the early 18th century, this clock has an *equation of time* indication, showing the difference between 'solar time' (sundial time) and mean time (clock time). *Belton House, Lincolnshire*

English Lantern and Table Clocks

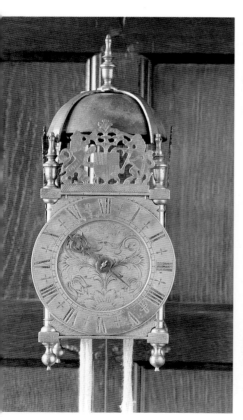

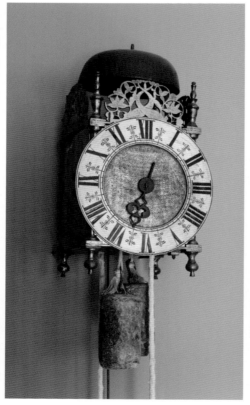

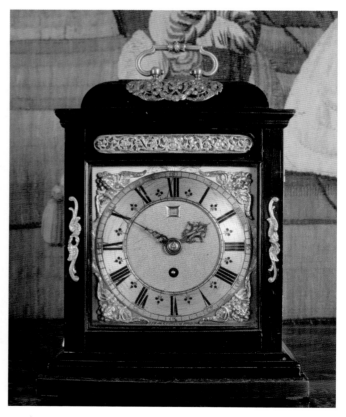

Dyde lantern clock
This handsome brass clock was made by the London clock maker Thomas Dyde, about 1685. *East Riddlesden Hall, West Yorkshire*

Striking lantern clock
This is a 30-hour English striking lantern clock. Such a clock was described in an inventory of 1689 as 'One little brasse Clocke at one pound tenn shillings.' *Rufford Old Hall, Lancashire*

Knibb clock Made by Joseph Knibb (c.1640–1711) this ebony table clock has a finely finished silver mount. One of a famous family of clockmakers originating from Oxford, Knibb moved to London in 1670, possibly to take over from his cousin, Samuel. He became very successful, later supplying clocks to Charles II. *Trerice, Cornwall*

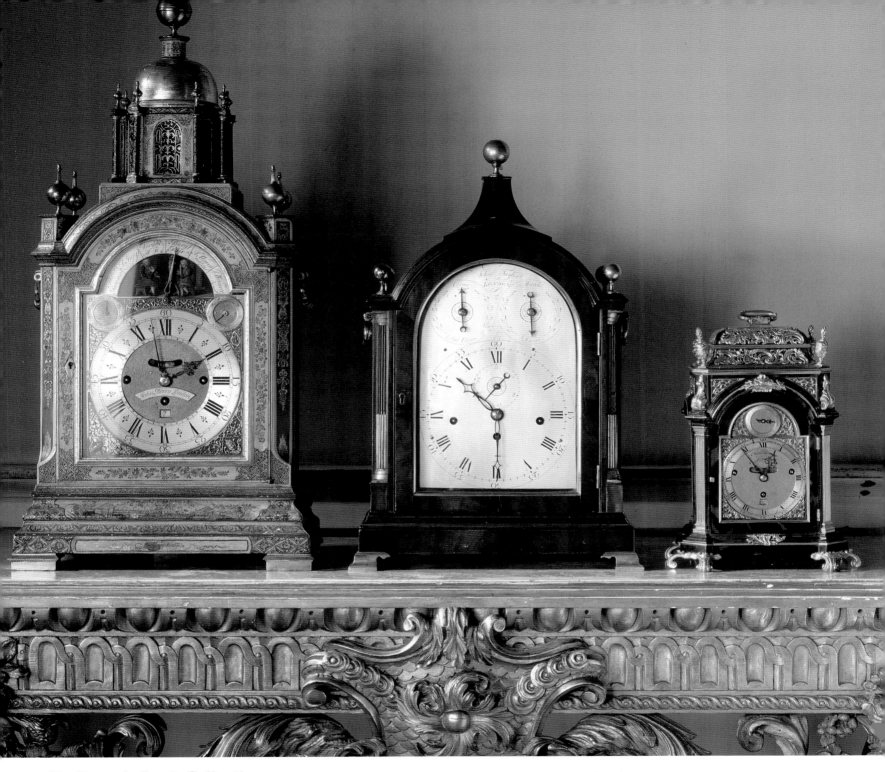

Sir Francis Legh Collection This extensive collection illustrates the development of English clockmaking from the time when the first pendulum clocks were developed in the 1650s to the end of the 18th century. Throughout this period clocks had come to be considered pieces of furniture, rather than simply timepieces, reaching great heights of decoration and sophistication. The clocks in the collection were acquired and bequeathed by the Hon. Sir Francis Legh (1919–1984), the youngest son of the owner of Lyme Park, the 3rd Lord Newton. The clock on the left is a rare eight-day musical clock, made by the London clockmaker John Berry, c.1735. *Lyme Park, Cheshire*

Boulle Clocks

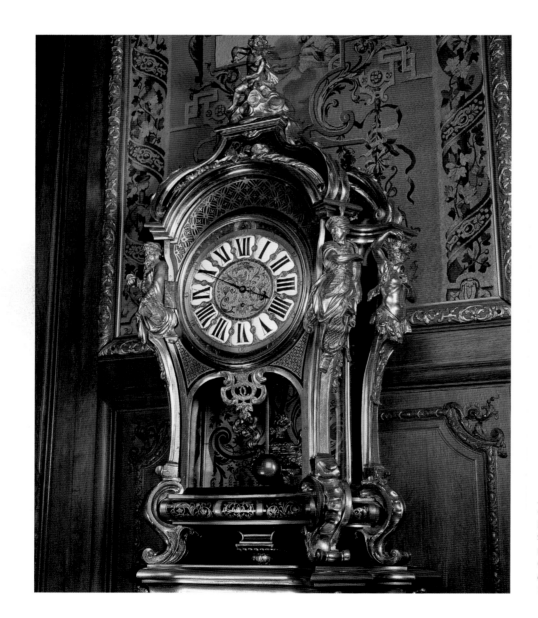

Boulle pedestal clock Exceptional French pedestal clock from the first quarter of the 18th century, supplied to the Earl of Chesterfield and having an English movement provided by the celebrated maker George Graham (c.1673–1751), successor to Thomas Tompion. The case has mounts depicting the four continents.
Waddesdon Manor, Buckinghamshire

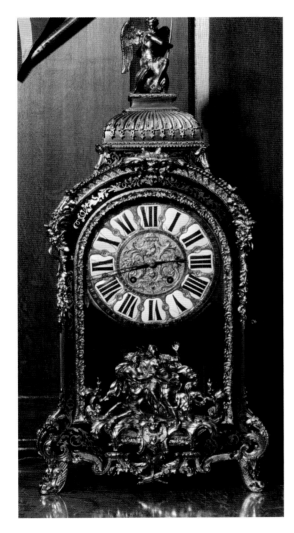

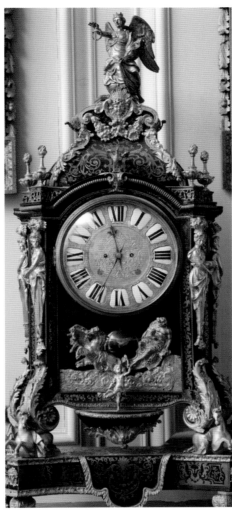

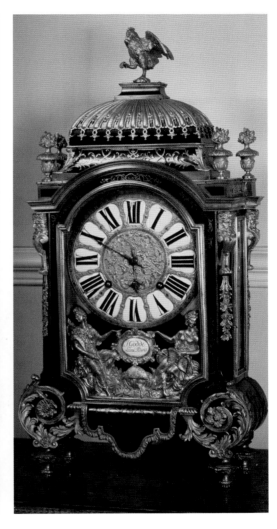

Bracket clock Dating from c.1715, this Boulle bracket clock sits in the Hall at Antony House, the home of the Carew family for almost 600 years. *Antony House, Cornwall*

Boulle clock This Boulle clock is French and was made in c.1715. It is of oak veneered with ebony and Boulle marquetry, gilt bronze and enamel. The movement was replaced c.1830–1840 by Thwaites and Reed of Clerkenwell, London. This is probably the Boulle clock supplied by Daval of Paris in 1819 to Sir Harry Fetherstonhaugh. *Uppark, West Sussex*

18th-century clock Bracket clocks usually consisted of two matching pieces, the clock and the small decorative shelf it sat on. The clocks were not confined to their bracket, and were sometimes placed on a side table. This highly ornate clock, dating from c.1715, is signed J Godde. *Shugborough Hall, Staffordshire*

Late Georgian and French Empire Clocks

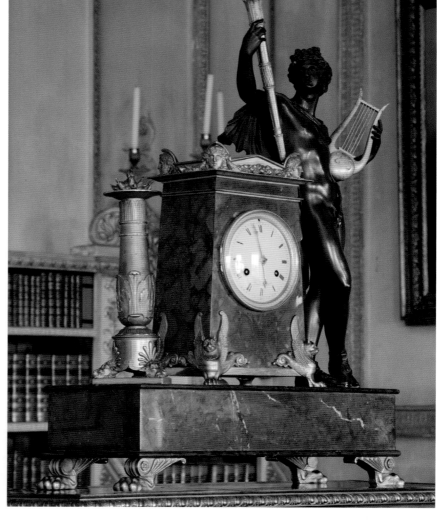

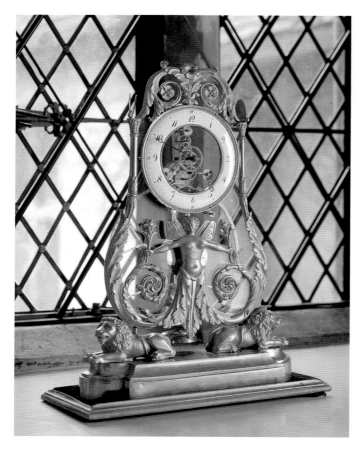

Apollo clock (above). French, c.1803. Patinated and gilt bronze on red *griotte* marble base with a movement by Charles-Guillaume Manière (*maître* 1778, d. after 1812), the rest attributed to the *bronzier* Thomire. Supplied – with a pair of patinated and gilt-bronze candelabra on matching bases – in 1803 by the Parisian dealer Martin-Eloi Lignereux to Sir Harry Fetherstonhaugh. *Uppark, West Sussex.*

Skeleton clock (left). French Empire 'skeleton' clock in the Windsor corridor of Anglesey Abbey. The Abbey is famous for its collection of English and French clocks, the majority of the pieces being late 18th- or early 19th-century and neo-classical in style. *Anglesey Abbey, Cambridgeshire*

Pagoda clock (opposite). At three o'clock every afternoon, this exotic gilt-metal automata clock with enamel sides plays a tune while the flowers on each of its tiers revolve. Shaped like a pagoda, the clock was made c.1790. The musical movement was made by Henry Borell (1795–1841), who is known to have made a number of automata clocks. The detailing takes elements of Chinese, Moorish, Gothic and classical styles, mixing them together into a synthesis of all four. *Anglesey Abbey, Cambridgeshire*

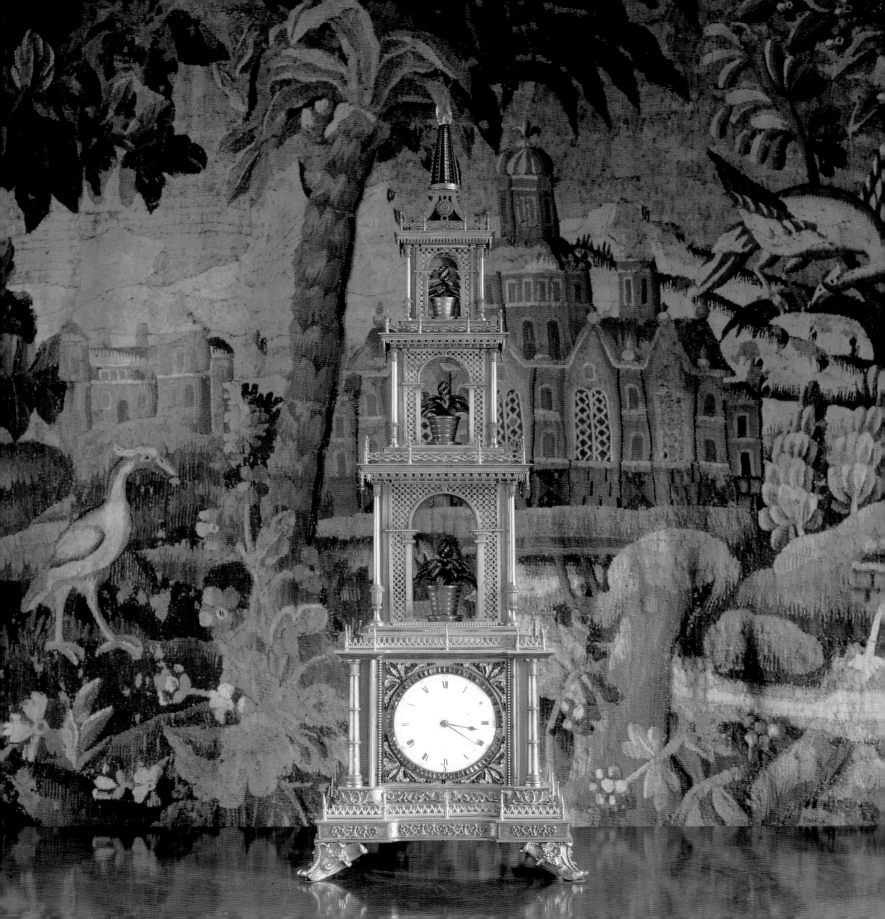

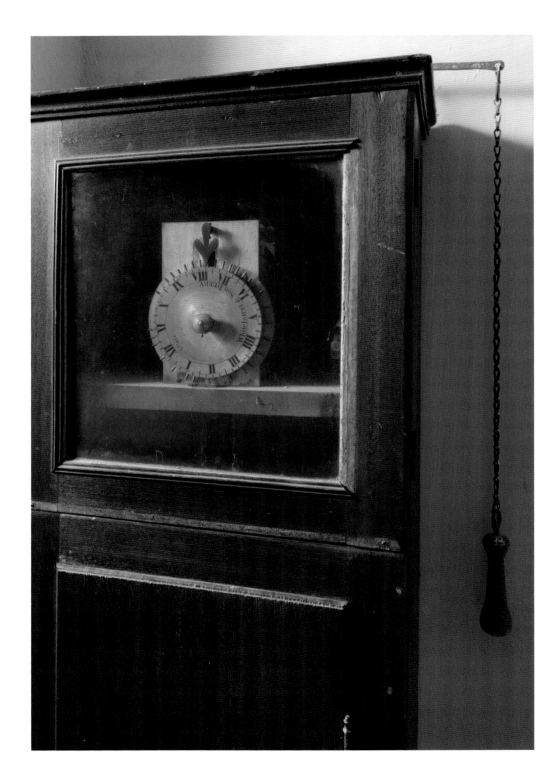

Estate Clocks

Nightwatchman's clock This clock was used to record the movements of the nightwatchman. Every quarter of an hour, when he did his rounds, he would pass the clock and pull the chain, thus recording his visit to prove he had been carrying out his duties and not sleeping on the job. *Belton House, Lincolnshire*

Water-tower clock (left). This clock adorned the water tower designed by architect Henry Clutton (1819–1893) at Cliveden. The cast-bronze surrounds of the clock, as well as the bronze urns on the balconies and the carved keystones and stone urns on the loggia, are all embellishments commissioned by the 1st Lord Astor. They are attributed to the American sculptor Thomas Waldo Story (1855–1915), who had produced his sculpture *Fountain of Love* for Cliveden in 1894–1896. The 100ft (30.5m) high water tower was completed in 1861 and has a capacity of 17,000 gallons (77,282l). It is still in use today. *Cliveden, Buckinghamshire*

Servant Ringing the Clock Bell (right). The clock house at Chirk Castle, as shown in this painting of c.1730 (artist unknown), projects out on corbels from the inner side of Adam's Tower, the least altered of all the medieval towers at Chirk. In the 19th century the clock house was rebuilt, and the 17th-century baluster rail, which once encircled the courtyard, was replaced and partly removed. The servant tugging on the bell rope has been identified as the castle scullion, Welch Wilkes. *Chirk Castle, Wrexham*

Gauging the Weather

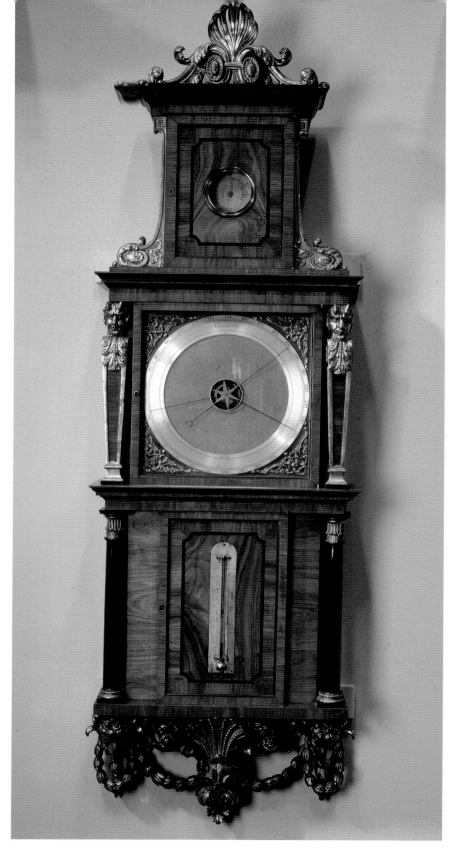

Vulliamy barometer

This barometer was made by Justin Vulliamy (1712–1797) while the fine tulip wood case, with its rich carving and gilt, was made by Thomas Chippendale between 1768 and 1769 and cost £25. Vulliamy, who worked between the 1730s and 1790s, was a Swiss emigré, and the first of a line of well-known craftsmen of that name. After he moved to London in the 1730s, he became the partner of the celebrated watchmaker Benjamin Gray, who was watchmaker in ordinary to George II. His work was renowned for its extremely high quality and, as he was known to produce very expensive pieces, owning a Vulliamy clock, watch or barometer was a conspicuous indicator of wealth.
Nostell Priory, West Yorkshire

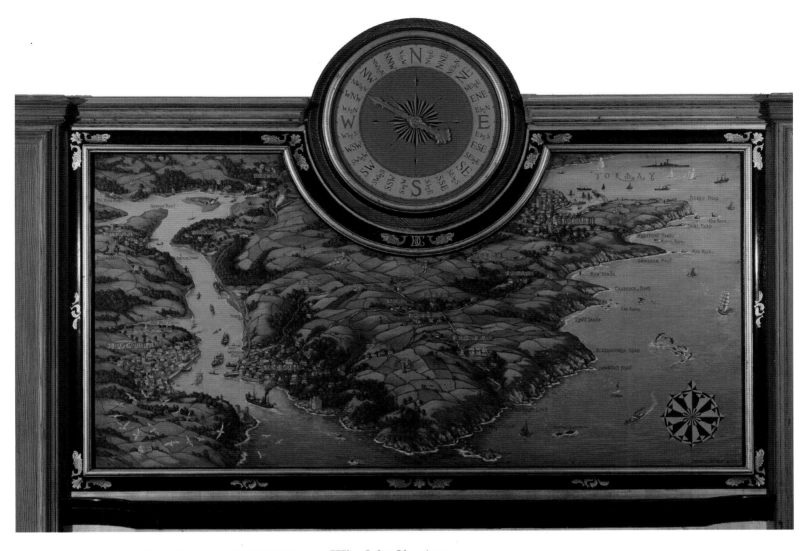

Wind indicator (above). A mural above the fireplace in the library shows Coleton Fishacre, Dartmouth, Kingswear, Brixham and the Dart Estuary. The indicator is linked to a weather vane to show the current wind direction. *Coleton Fishacre, Devon.*

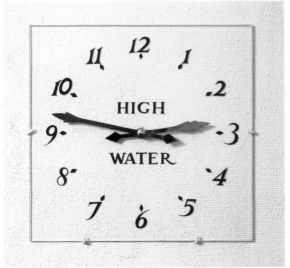

Tide clock (left). Close-up of the high-water clock at the home of the hotelier, restaurateur and proprietor of the D'Oyly Carte Opera Company, Rupert D'Oyly Carte, and his wife Lady Dorothy. Their house, Coleton Fishacre, is on the Devon coast and D'Oyly Carte (1876–1948) was a keen sailor, so needed to be aware of the high tides. The clock is set manually every morning in accordance with the tide tables and registers the high water in Pudcombe Cove, the cove below the house where the family yacht was moored. *Coleton Fishacre, Devon*

Costume

Medieval and Tudor

Garter ribbon (above). This Garter was bestowed on the Holy Roman Emperor Maximilian I in 1489 by Henry VII. It is believed to be the oldest surviving example. Lord Fairhaven, who gave Anglesey to the National Trust, was an ardent royalist, amassing a large collection of views of Windsor Castle, the home of the Order of the Garter. *Anglesey Abbey, Cambridgeshire*

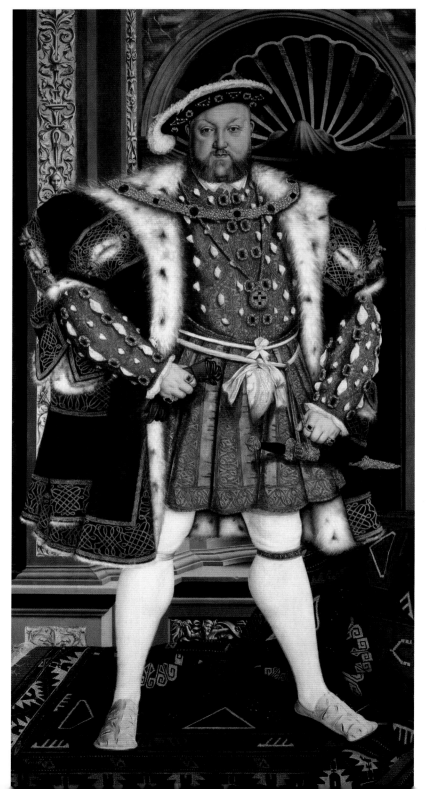

Fit for a king (left). This portrait of Henry VIII (1491–1547) from the workshop of Hans Holbein the Younger shows his taste for highly decorative, flamboyant dress. The amount of rich gold braid and the heavy collar of jewels underline his position as monarch of one of the richest and most influential countries in the world. In addition, the padding and cut of his clothes are also designed to emphasize his upper body, with the puffed-up sleeves of his doublet and wide fur overmantle making his shoulders look broader than they are, giving him an imposing air of power and authority. On the other hand, his pale, fitted hose and garter draw attention to his calves which, at this point in his life, were still relatively slender and shapely. *Petworth House, West Sussex*

Cloth of gold Remains of late 15th- and early 16th-century vestments. The background is patterned cloth of gold with raised loops. Fragments of the original embroidery remain, including half an arch, plus part of a figure holding a book. Just enough of the embroidery has survived to give an idea of how splendid the piece must have been when new. *Hardwick Hall, Derbyshire*

Queen's cope Detail from the yoke of the magnificent early 16th-century cope (ceremonial cloak) belonging to Catherine of Aragon, Henry VIII's first wife. The Queen and her ladies-in-waiting are believed to have embroidered this tender scene, showing the Blessed Virgin Mary with a very young Jesus. Careful conservation has restored the original glowing colours. *Coughton Court, Warwickshire*

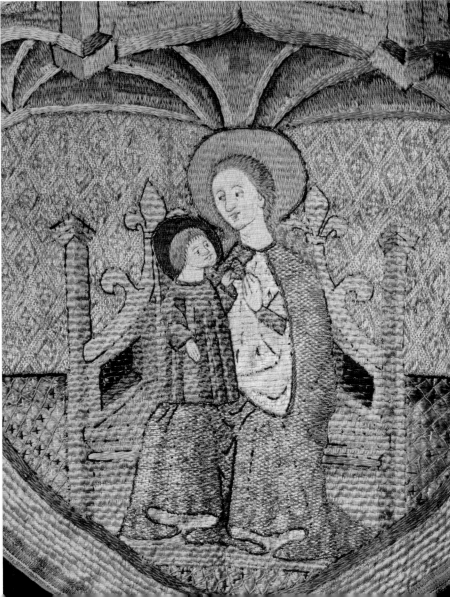

17th-Century Costume

Gauntlet mittens
(right). These Elizabethan gauntlet mittens show how much effort was put into even the humblest item of clothing. The mittens are made from crimson silk velvet worked in satin- and split-stitch with sequins, gilt thread and floss silk. No expense has been spared – even the colour of the velvet was expensive and the floss silk, used in the embroidery, has been dyed with 12 different colours. Floss silk – untwisted silk fibres – was very fluffy and soft. This made it extremely difficult to embroider with. This characteristic, however, also gave it a very lustrous appearance. The detailing is exquisite and the reproduction of the flowers is amazingly true to life. *Dunham Massey, Cheshire*

Elizabeth, Lady Craven (opposite). Painted in the early 1630s by an unknown artist, this portrait of Elizabeth, Lady Craven shows the changes in fashion at that time, where the jacket or waistcoat has become a more comfortable alternative to a rigid bodice. The jacket (usually lined) has the same flared basque and sloping wing as the bodice but can be beautifully embroidered, as here, with a coiling pattern encircling various flowers, insects and fruit. *Powis Castle, Powys*

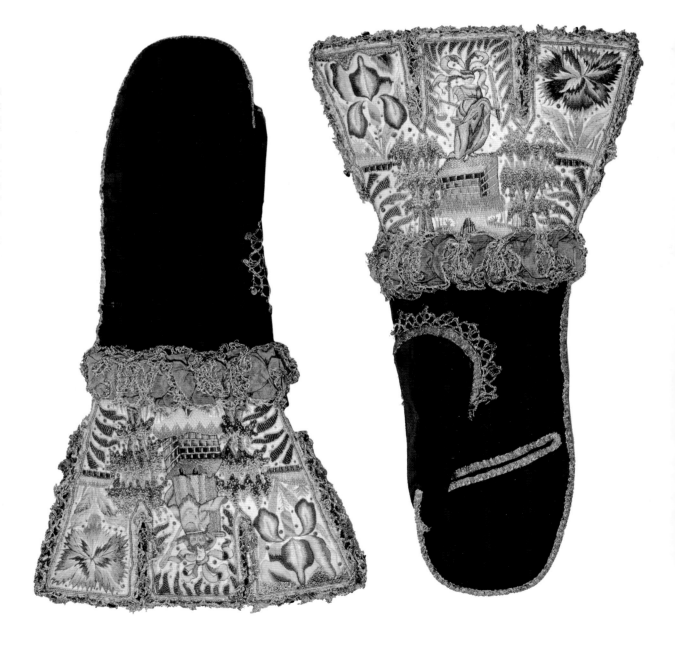

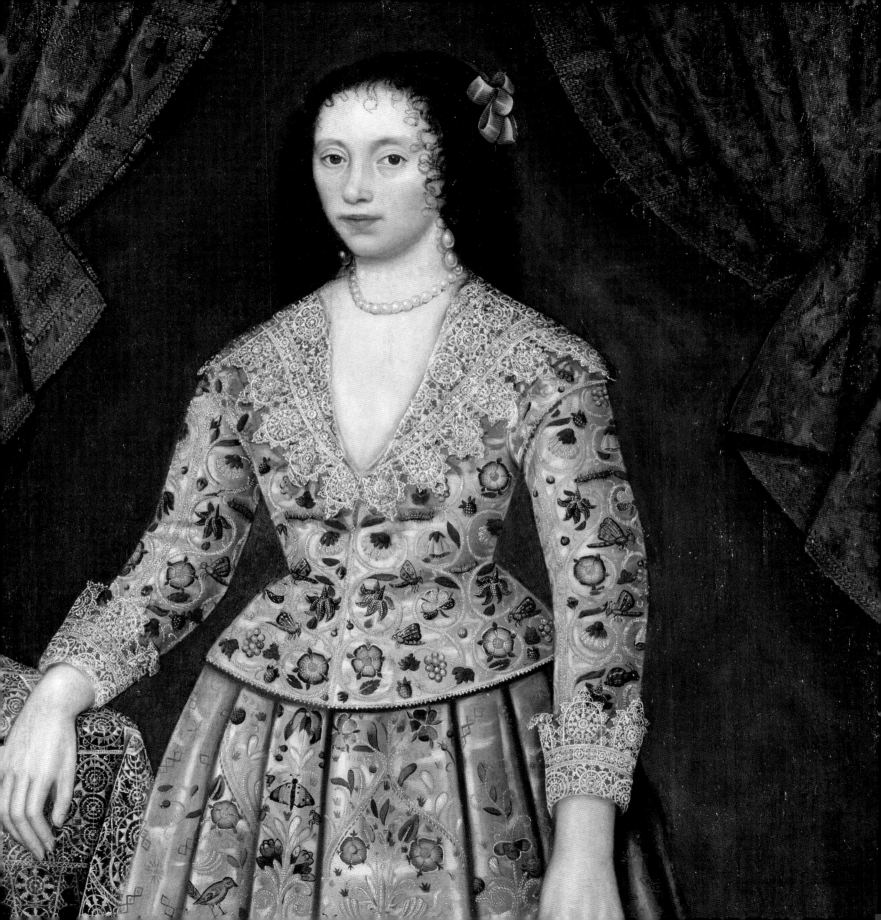

18th-Century Costume

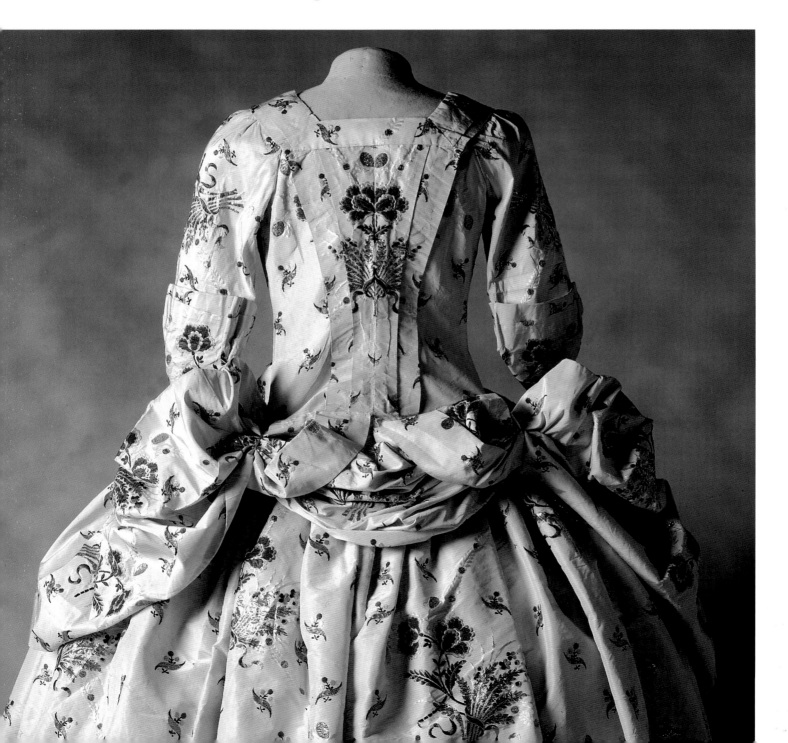

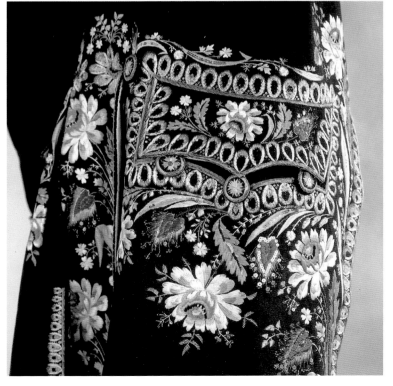

Court Mantua (left). Back of a silk-brocade court mantua dress. The mantua first appeared in the late 17th century, having evolved from loose, informal nightgowns, while the court mantua took the train of the sack gown and fastened it up in elaborate folds. The gilt thread used in this embroidery would have glittered in the dazzling candlelight of the court. *Springhill, County Londonderry*

Remade brocade (top left). The blue and silver brocade of this 1780s dress dates from an earlier time, implying that it was remade into this fitted boned dress with its tight, nipped-in waist and mass of narrow pleats, which create the fuller skirt. *Killerton, Devon*

French silk sack gown (top right). This view of an early 1770s *robe à la française*, more colloquially referred to as the sack gown, shows how the box pleats falling from the wide neckline create an elegant, flattering train. The style was made fashionable by Madame de Pompadour, Louis XV's mistress. *Berrington Hall, Herefordshire*

Court coat (right). Detail of a 1780s court coat, sumptuously embroidered with delicate flowers and grasses in multi-coloured silk, chenille and metal thread, all highlighted with sequins and spangles. Men would wear court coats for social occasions, and struggled to outdo each other in the quantity and quality of embroidery. *Berrington Hall, Herefordshire*

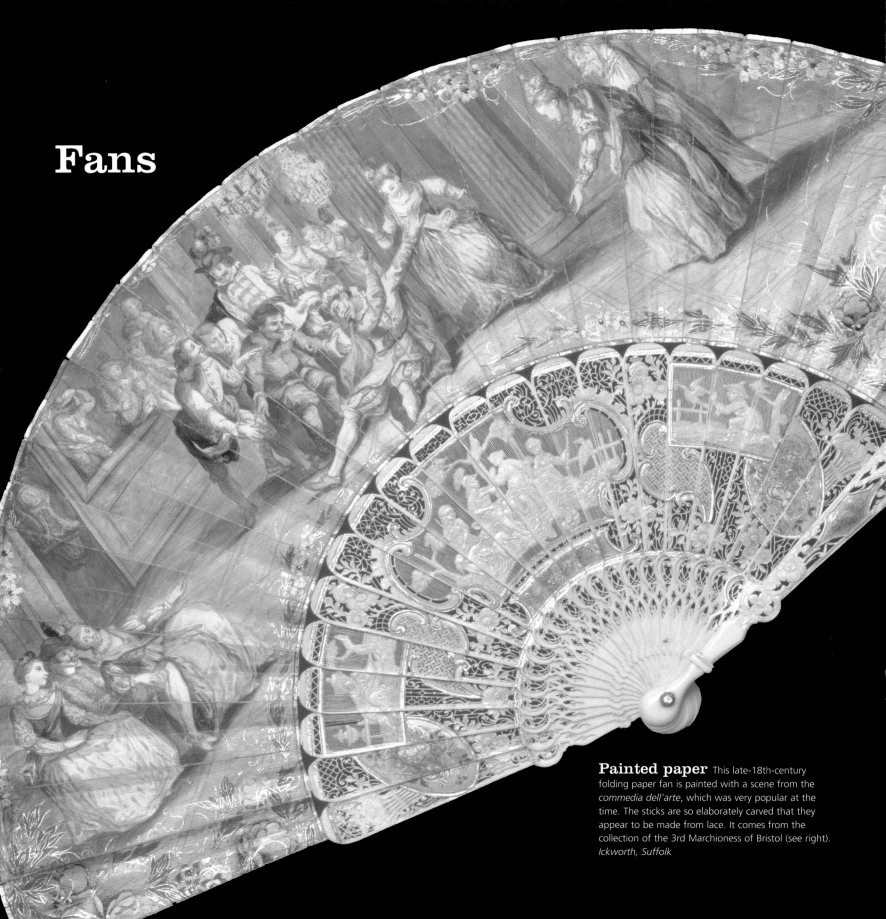

Fans

Painted paper This late-18th-century folding paper fan is painted with a scene from the *commedia dell'arte*, which was very popular at the time. The sticks are so elaborately carved that they appear to be made from lace. It comes from the collection of the 3rd Marchioness of Bristol (see right). *Ickworth, Suffolk*

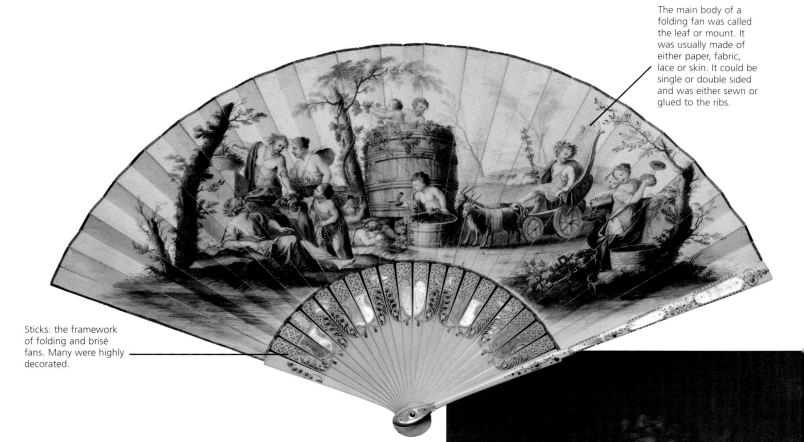

The main body of a folding fan was called the leaf or mount. It was usually made of either paper, fabric, lace or skin. It could be single or double sided and was either sewn or glued to the ribs.

Sticks: the framework of folding and brisé fans. Many were highly decorated.

Wine-making fan (above). Dating from the early 18th century, this paper fan depicts a Bacchanalian group making wine. The process is illustrated from its very beginning. On the left the grapes are being picked, while in the centre there are two putti in the vast vat crushing the grapes to make the wine, which is seen pouring from the bottom of the vat. *Ickworth, Suffolk*

Avid collector (right). This portrait of Geraldine, the 3rd Marchioness of Bristol (c.1844–1927), is by Henry Graves and dates from 1870. The 3rd Marchioness was well known in her day for her extensive collection of fans, and here she is painted holding one of her finest examples. *Ickworth, Suffolk*

The Language of Fans

The folding fan originated in the Far East. From there fans came to Italy, then spread throughout the rest of Europe. Initially they were used by both men and women, although by the start of the 19th century they were becoming the preserve of ladies. Like any accessory, the choice of design and materials from which a fan was made reflected the owner's wealth and status, but fans had the ability to communicate a great deal besides how rich or fashionable someone was. In fact, by Victorian times (when the fan was a staple of a lady's wardrobe), quite an elaborate language had developed around them. Not surprisingly this language was mainly to do with flirting and soon the fan had become what a contemporary writer described as a 'perfidious weapon of coquetry'. These are a few of the most common meanings:

Placing the fan against the right cheek: yes.
Placing the fan against the left cheek: no.
Hiding the eyes behind an open fan: I love you.
Touching a finger to the tip of the fan: I wish to speak with you.

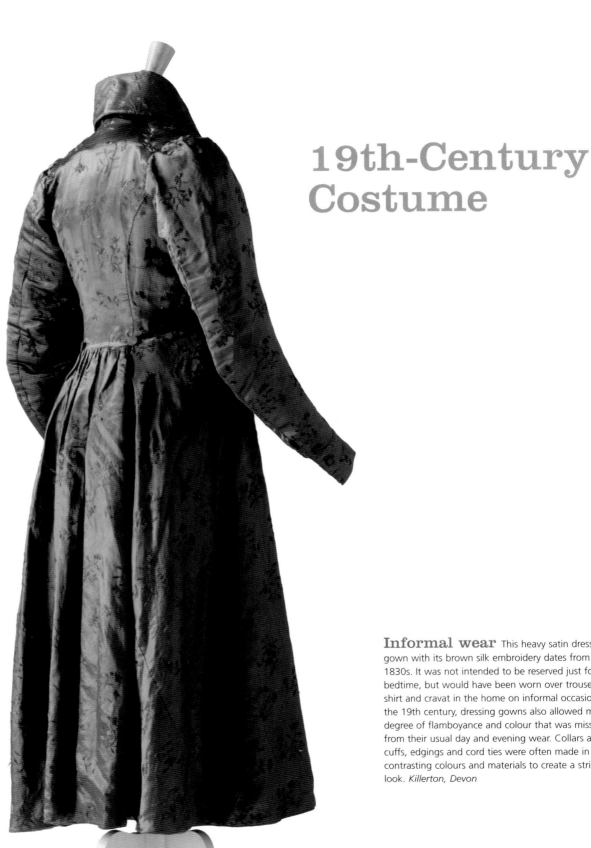

19th-Century Costume

Informal wear This heavy satin dressing gown with its brown silk embroidery dates from the 1830s. It was not intended to be reserved just for bedtime, but would have been worn over trousers, a shirt and cravat in the home on informal occasions. In the 19th century, dressing gowns also allowed men a degree of flamboyance and colour that was missing from their usual day and evening wear. Collars and cuffs, edgings and cord ties were often made in contrasting colours and materials to create a striking look. *Killerton, Devon*

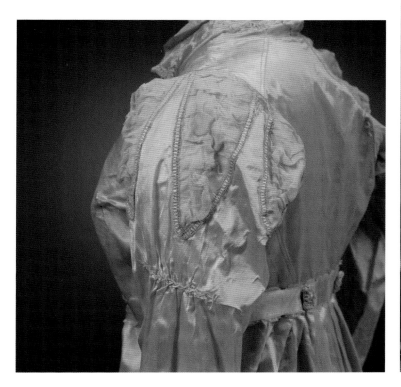

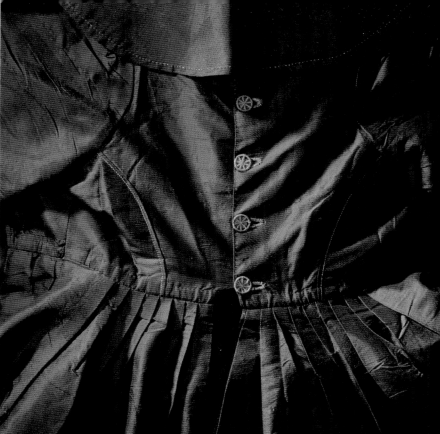

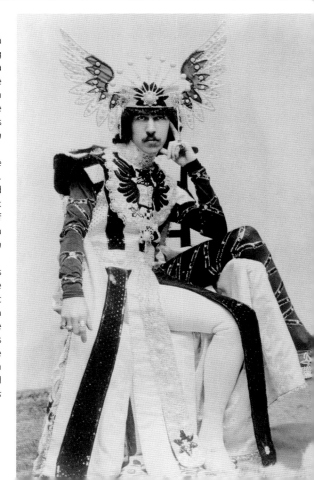

Satin pelisse (above left). Part of the sleeve and bodice of a pelisse worn by a bride at her wedding in 1814. A pelisse was a long fitted coat, or sometimes a coat-dress, which was worn over a matching gown. Here the sleeve is ruched in three places to create triangular bands, edged with chenille embroidery. These bands contain silk gauze, which has been inserted in soft gathers to resemble the slashes that Tudor dressmakers made in sleeves in order to reveal folds of the undershirt. *Killerton, Devon*

Shocking pink (above right). At the beginning of the 19th century the fashion was for pure white, simple muslin gowns. This style, however, soon gave way to more exuberant colours and complicated tailoring. The view of the back of this 1810 vivid pink silk dress shows a wide, curved collar and detailed stitching. The use of contrasting coloured silk for the buttons, waistline and darts is an especially stylish touch. *Killerton, Devon*

Costume drama (right). Henry Cyril Paget, 5th Marquess of Anglesey (1875–1905), was well known for his love of the theatre and penchant for dressing up. In 1901 he founded his own dramatic company, converting the chapel at Plas Newydd in order to stage lavish productions which were free to all to attend. He was also passionate about jewellery and clothes and spent his inheritance liberally. This extravagance, however, was to prove his downfall, and by 1904 he had exhausted his enormous income and was forced to embark upon a huge sale of his possessions, which lasted 40 days and included 17,000 lots. *Plas Newydd, Anglesey, Wales*

20th-Century Costume

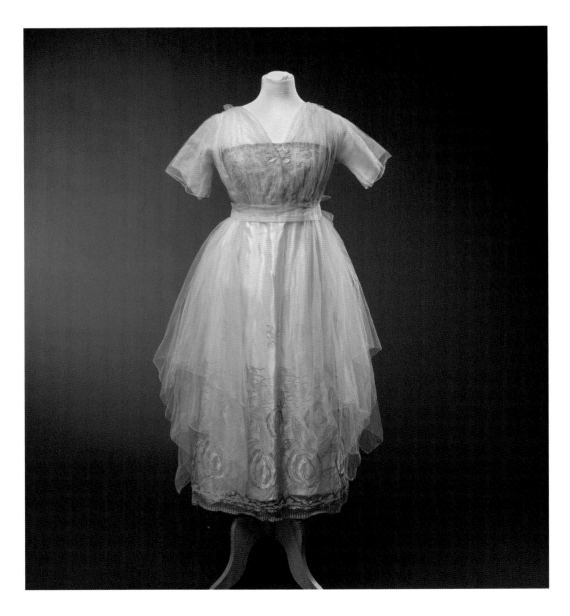

Wedding dress The fine tulle of this 1920 wedding dress is softly gathered to form a bodice, pulled in tight at the waist then arranged in 'panniers' at the sides and allowed to fall away in gentle folds. Underneath this gauzy overdress there is a boned, cotton-lined bodice and net skirt – machine embroidered in a striking floral pattern with a cream silk lining. The dress comes to the mid-calf, a very modern length for the time.
Killerton, Devon

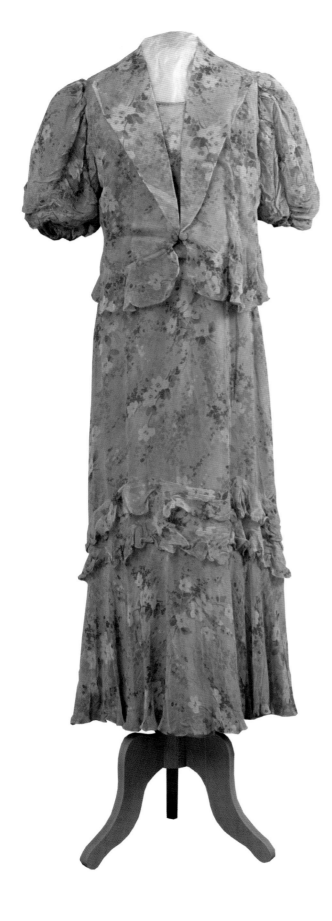

Practical style (left). Not all 20th-century wedding dresses were in traditional white. This 1937 georgette dress, decorated in a soft pastel floral pattern, was made for a summer wedding. It has a loose, flowing skirt and bloused, front-fastening bodice. *Killerton, Devon*

1970s tailoring (below). The half-finished jacket on this tailor's dummy was being made by George Saunders, the last occupant of a traditional Birmingham workshop. Saunders, who came to England from the West Indies in 1958, specialized in military dress and made all the breeches for the Horse Guards. *Birmingham Back to Backs, West Midlands*

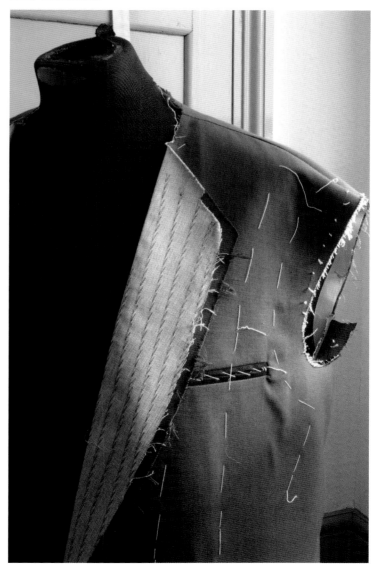

Furniture

Tudor Woodwork

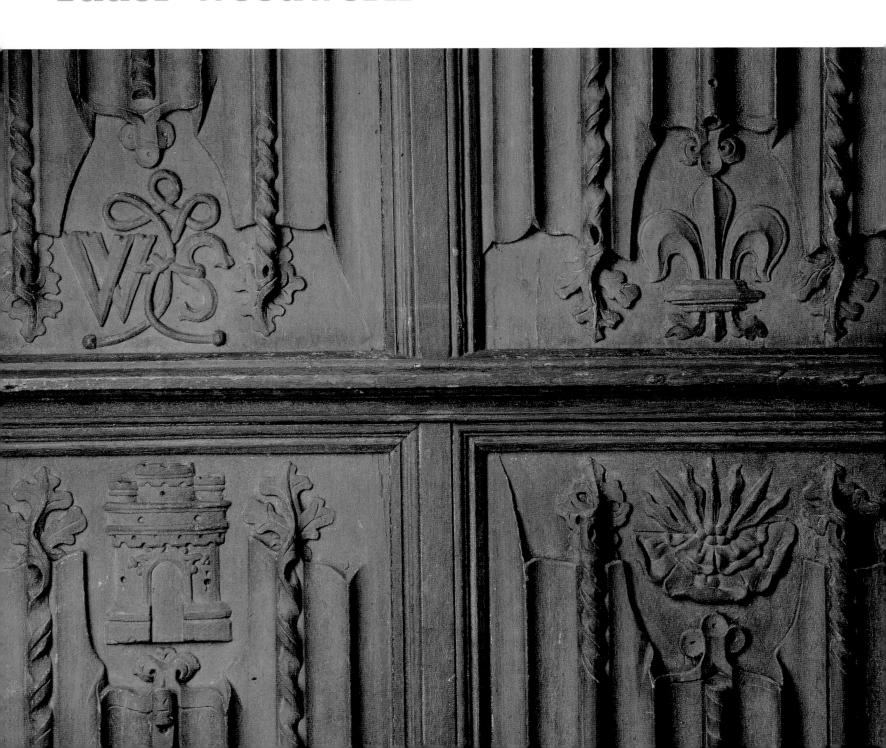

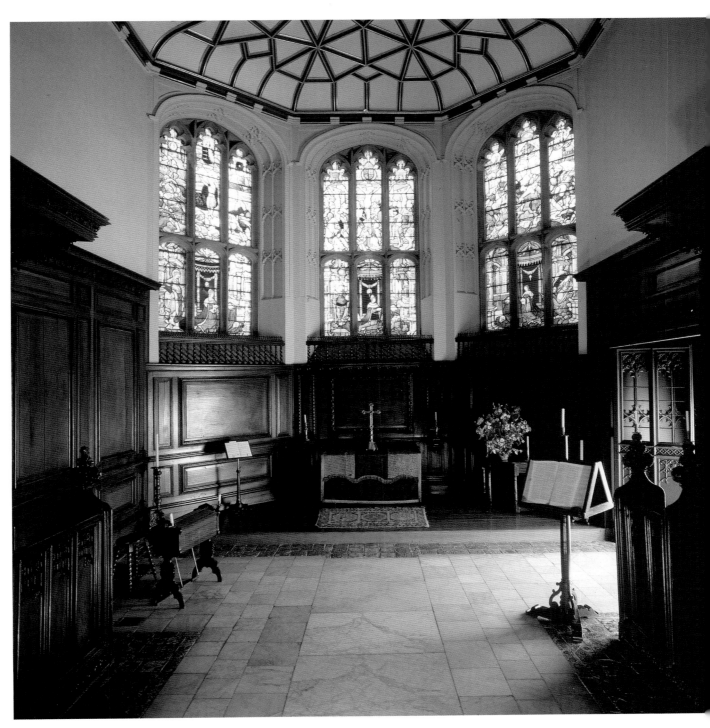

Linenfold panelling

(left). Close-up of the fine carved panelling in the Oak Gallery of The Vyne, installed by the owner of the house, William, Lord Sandys, c.1525. Such Tudor galleries were designed for walking in wet weather, and were furnished with tapestries and portraits. Lord Sandys is represented in the woodcarving by a ragged cross, the initials WS, his crest and badge (a rose merging with the sun). Other details show emblems and devices significant to other great figures of the time, such as Catherine of Aragon and Cardinal Wolsey.
The Vyne, Hampshire

Chapel stalls

(right) Interior of the Chapel at The Vyne, c.1525, showing the stalls. These are among the last of a superb series of stalls produced in early Tudor England. They are made up of two tiers of enriched panels with cusped heads, with poppy-head-style finials at each end which show a woman and three acrobats. The extremely colourful stained-glass windows are of Flemish origin and also date from the early 1520s.
The Vyne, Hampshire

Elizabethan Tables

'Sea-dog' table Detail of the top of the elaborate 'Sea-Dog' or 'Chimera' table in the State Withdrawing Room at Hardwick Hall showing the fine marquetry and inlaid stones. The table, which was listed in an inventory of 1601, and so must have been part of the original acquisitions for the house made by Bess of Hardwick (1527–1608), may well be French in origin, and has been attributed to the eminent French designer Jacques Androuet du Cerceau (c.1515–1584). This theory is supported by the fact that many details of the piece are based on Androuet du Cerceau's engraved designs. The bulbous frame and rectangular top of the table are supported by four finely carved winged dogs with fishes' tails (the 'sea dogs' that give the table its name). *Hardwick Hall, Derbyshire*

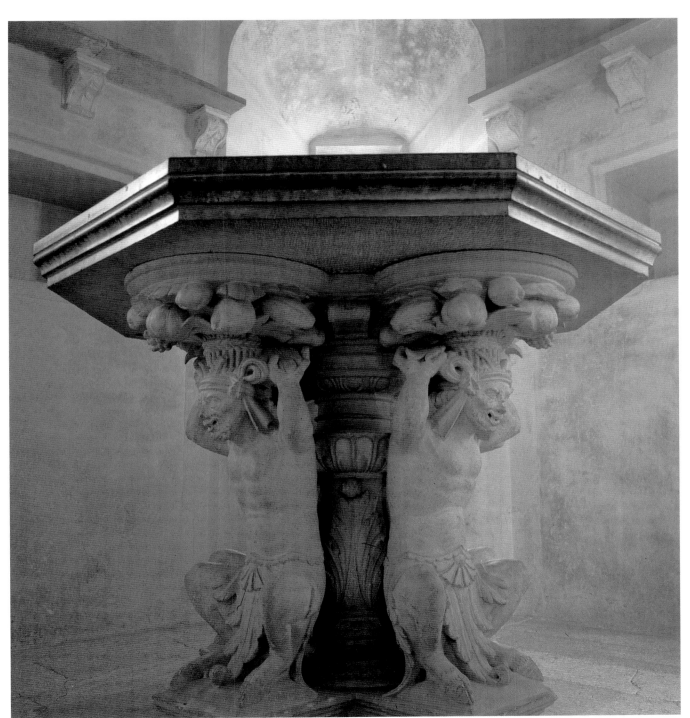

Octagonal table

Close-up of the remarkable carved stone table, c.1550, in Sharington's Tower. The table is supported on the shoulders of four satyrs carrying baskets of fruit and is decorated with the Sharington scorpion crest. William Sharington (c.1495–1553) acquired Lacock in 1539 after the Abbey was dissolved. He was a profiteer, so his crest is particularly appropriate. It is believed that the table was the work of the stonemason John Chapman. *Lacock Abbey, Wiltshire*

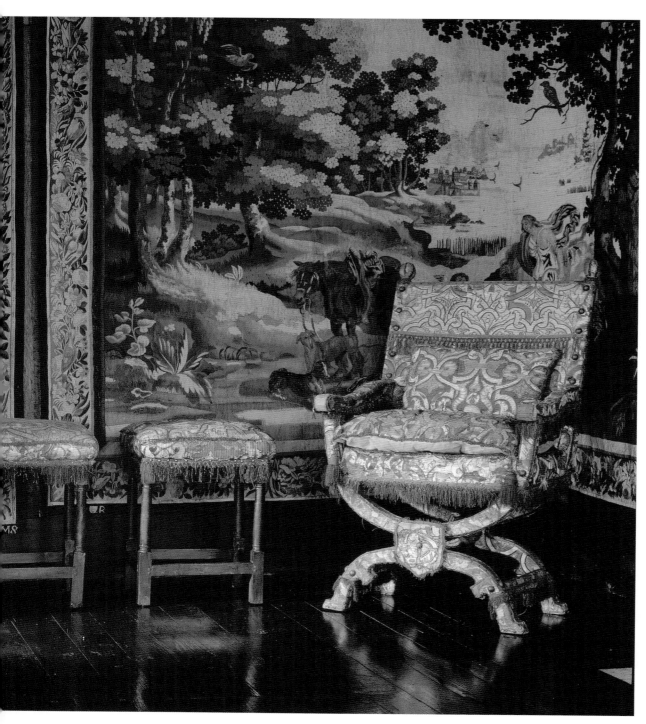

Chairs

'Chair of state' (left). This cross-framed chair, c.1610–1620, and stools were probably among the royal furnishings acquired by the 6th Earl of Dorset (1638–1706) as a perquisite of his office of Lord Chamberlain. *Knole, Kent*

Hall chair (opposite, top left). One of a set of six early 17th-century *sgabello* hall chairs in the Stone Gallery. *Sgabello* is the Italian word for this type of armless wooden side chair, which was supported at the front and back by solid boards cut into an ornamental shape. Chairs like this one were brought back from Italy by English travellers. *Lacock Abbey, Wiltshire*

Canopy (opposite, top right). Originally erected in the early 17th century, this canopy in the High Great Chamber bears the arms of the 2nd Earl and Countess of Devonshire. *Hardwick Hall, Derbyshire*

'Sleeping chayre' (opposite, bottom left). One of a pair of 'sleeping chayres, carved and guilt frames covered with crimson and gould stuff with gold fringe', as they were described in 1679. *Ham House, Surrey*

Brocade armchair (opposite, bottom right). Covered with gold and silver brocade, this armchair is carved with doves and cupids holding bows and quivers. It is believed to have been produced to celebrate the marriage of James II to Mary of Modena in 1673. It was made in Paris and is part of the furniture that goes with the Louis XIV state bed on page 106. *Knole, Kent*

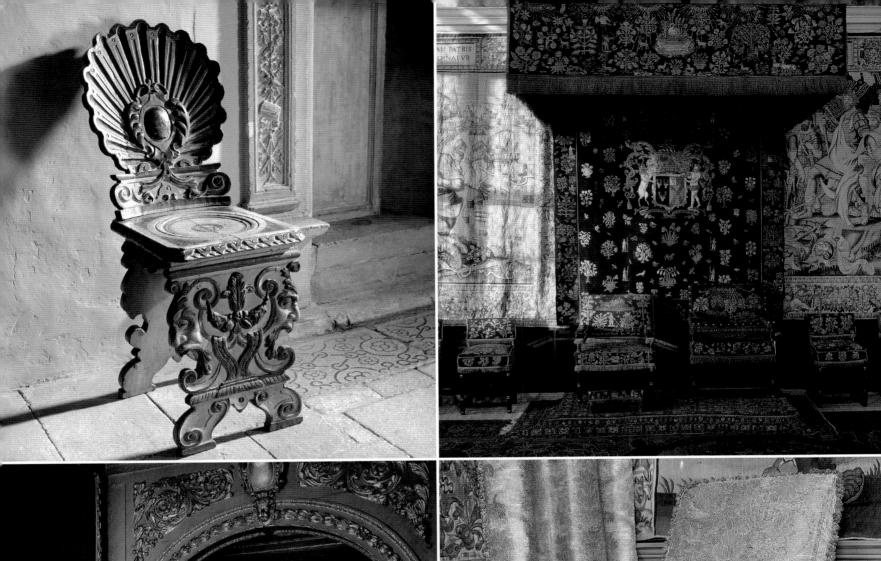

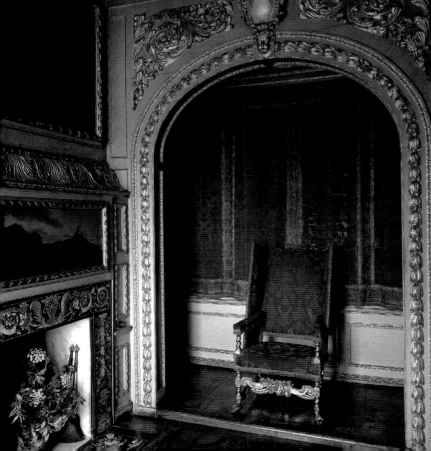

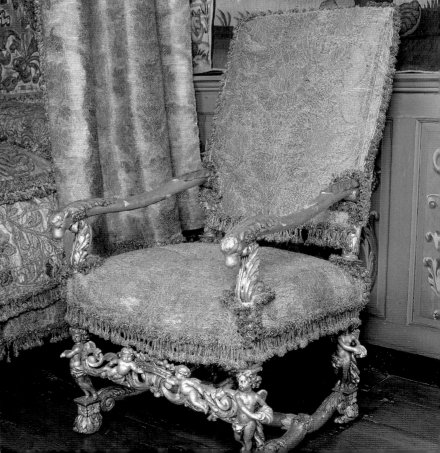

State Beds

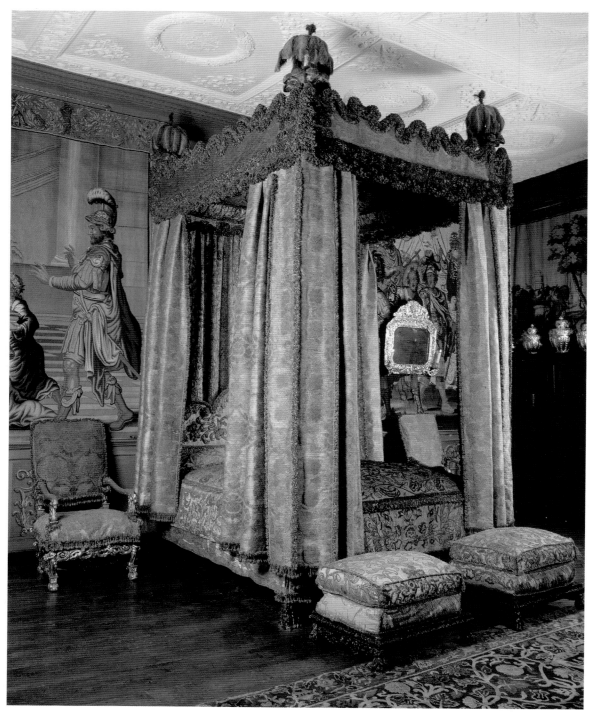

Louis XIV style (above). So splendid are the 1673 Louis XIV bed and and suite of furniture in the aptly named King's Room at Knole that they have featured in many paintings, including the 1863 *Eve of St Agnes* by Sir John Everett Millais (1829–1896). *Knole, Kent*

Venetian Ambassador's Bedroom (opposite, top left). Bearing the arms and monogram of James II, this bed came to Knole between c.1688 and 1706, when it was first listed as being there. The bed is probably from the palace of Whitehall; it is unlikely that it remained there or in any other royal palace after the Glorious Revolution of 1688–1689. *Knole, Kent*

Baroque bed (opposite, top right). Draped in crimson damask, this state bed was probably made after 1697 for Viscount Scudamore of Holme Lacy, Herefordshire, possibly by the French upholsterer Francis Lapière (1653–1714) in the Baroque style. *Beningbrough Hall, North Yorkshire*

Chinese embroidery (opposite, bottom left). The immaculate condition of this state bed, c.1715, is due to the fact that it was not assembled until the 20th century. Discovered in 1984 in boxes in a housemaid's room, it may have been lent to an 1870s exhibition by the family, then forgotten about. *Calke Abbey, Derbyshire*

Embroidered canopy (opposite, bottom right). This elaborately fringed and tasselled canopy, c.1710, is embroidered with a floral motif. *Clandon Park, Surrey*

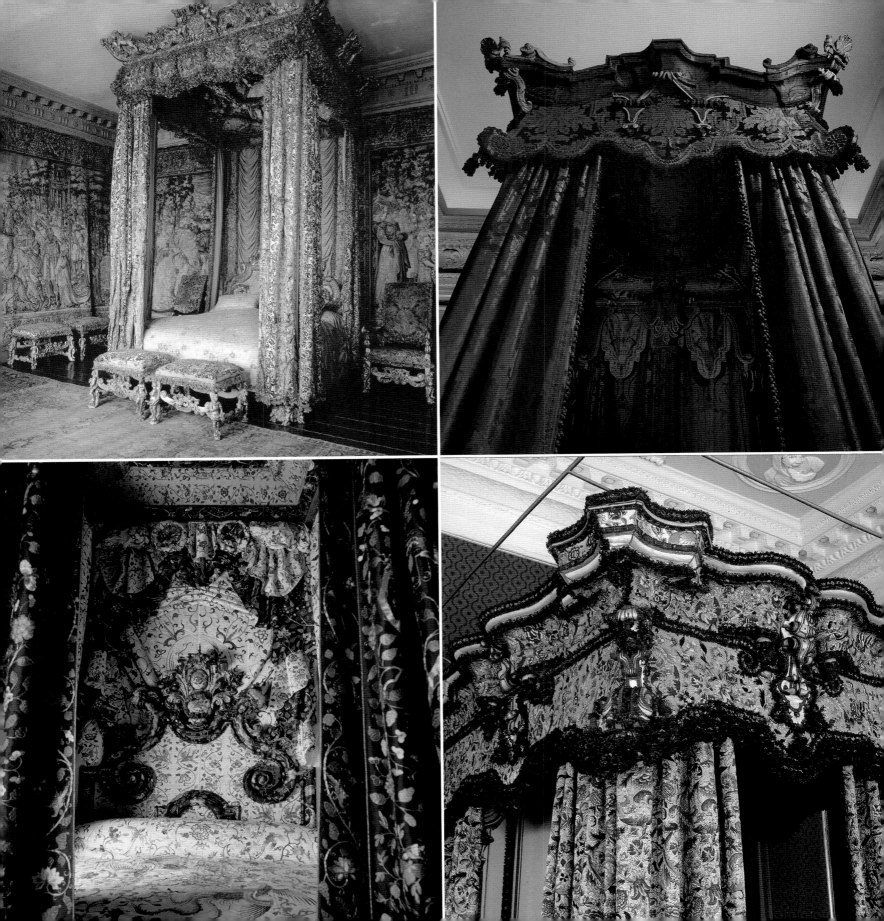

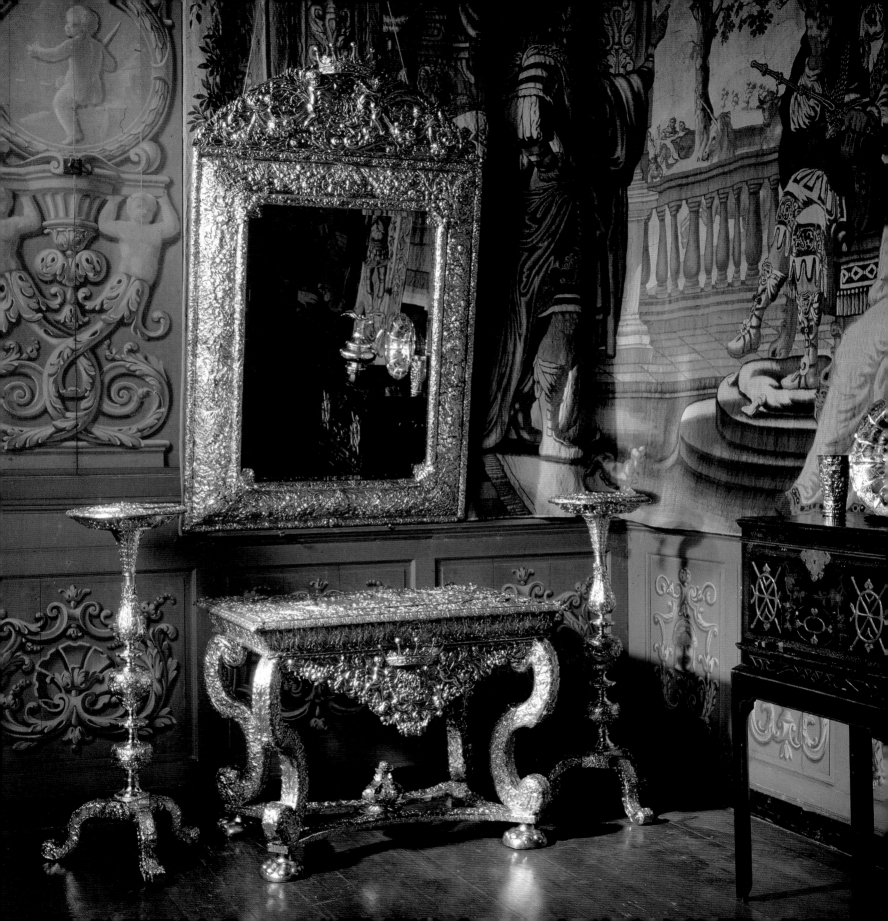

Silver Furniture

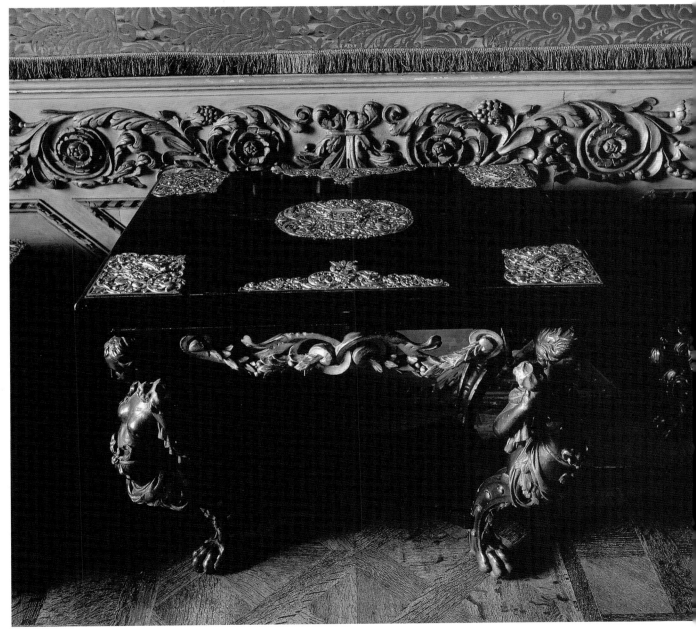

Silver group (left). This set of furniture, dating from 1676–1680/1, consists of a mirror, table and pair of candlesticks. The fashion for extravagant silver furniture was started by Louis XIV in France, and such furniture was made in England from c.1660–1710. This furniture is not, however, solid silver: silver was applied to the wooden carcass in thin sheets, unlike the solid silver furniture of Versailles melted by Louis XIV to pay for his wars. *Knole, Kent*

Ebony and silver (right). This silver-mounted ebony table stands on caryatid supports similar to its neighbouring stools (a caryatid is a sculpted figure serving as a support). The top of the table bears the monogram of Elizabeth, Countess of Dysart (1626–1698) and may have been produced c.1670. Its design derives from engravings by Jean le Pautre (1618–1682), which brought European Louis XIV style to the attention of a wider audience. *Ham House, Surrey*

Grand Cabinets

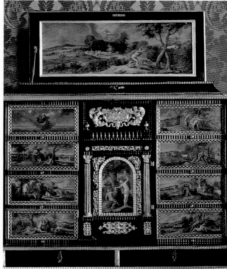

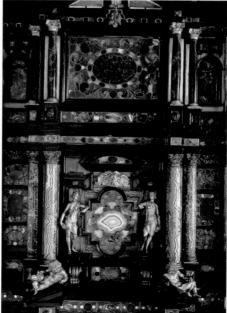

The Pope's cabinet (far left) This monumental Roman cabinet, made in Italy in c.1585 for Pope Sixtus V, was acquired in 1741–1742 by Henry Hoare II (1705–1785). Nicknamed 'the Magnificent', Henry Hoare II was the creator of Stourhead's garden and an avid collector of furniture and pictures. The cabinet is decorated with ebony and gilt bronze ornaments and inlaid with pietra dura (see right). The stand is a later addition, made in England c.1742 by John Boson. *Stourhead, Wiltshire*

Biblical theme (top left). The finely painted pictures decorating this early 17th-century Flemish ebony cabinet in The Queen's Room take Biblical subjects as their theme. There are depictions of Creation, the Fall of Man and Cain and Abel, all painted on copper by Frans Francken the Younger (1581–1642). This Flemish artist specialized in very small pictures like these. *Sudbury Hall, Derbyshire*

Pietra dura marquetry (bottom left). Detail of the upper half of the Pope's Cabinet. The marquetry technique of pietra dura (which literally translates as 'hard stone') was highly skilled and extremely time-consuming. *Stourhead, Wiltshire*

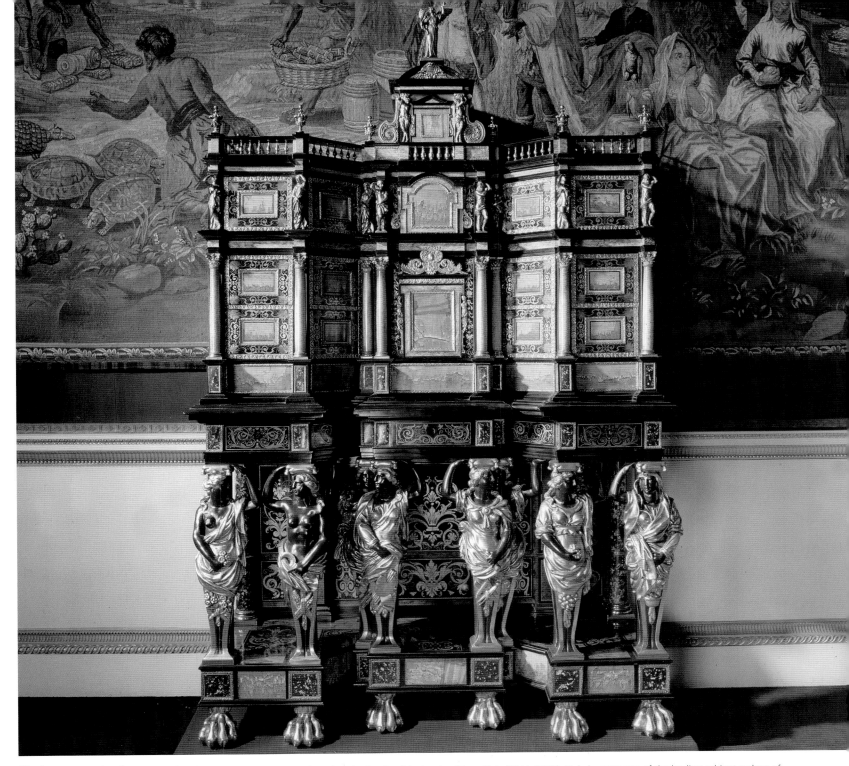

Gole marquetry This magnificent ebony cabinet is attributed to the Dutch cabinet maker Pierre Gole (1644–1684). Gole became one of the leading cabinet makers of the early part of Louis XIV's reign, and was eventually appointed *ébéniste du roi* (cabinet maker to the King). He practised the technique of Boulle marquetry, which is made up of an oak carcass veneered with ebony, within which marquetry of brass, tin and tortoiseshell (or bone) is set in *première-* or *contre-partie*, and took its name from its most noted practitioner, Gole's son-in-law, André Charles Boulle. The drawers of this cabinet are faced with pietra dura and it is supported by carved ebony figures draped in gilt robes. Family papers reveal that this treasure came to the house in 1780 via Sabine Louise d'Hervart, the Swiss-born wife of Sir Rowland Winn, the fifth baronet (1739–1785). *Nostell Priory, West Yorkshire*

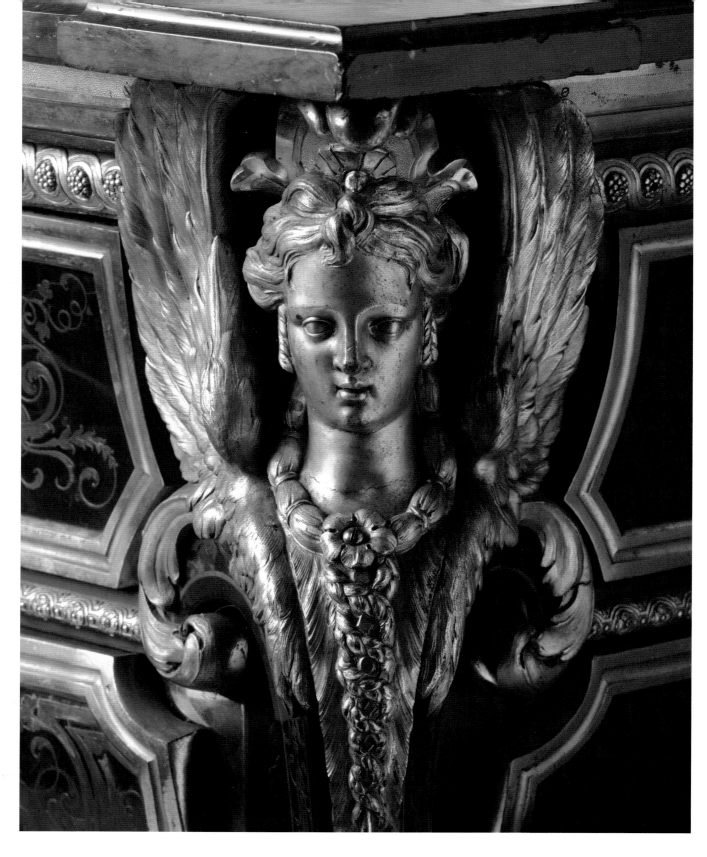

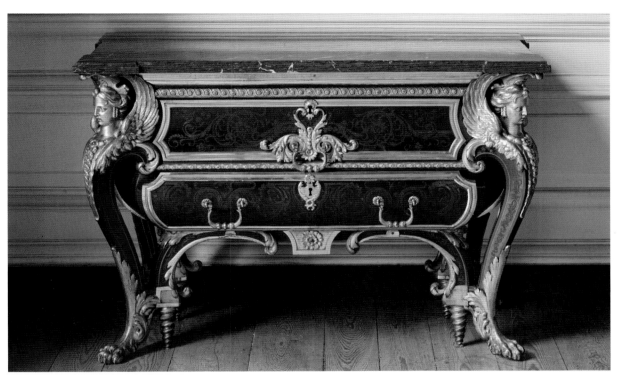

Commode (left and above). This Boulle commode, c.1710, in the Red Room is very similar to a pair at Versailles of 1708–1709 and is close to Boulle's own engraved designs. It was purchased at the Hamilton Palace sale in 1882 (sold by the 12th Duke of Hamilton) but its earlier history is unclear. *Petworth House, West Sussex*

Desk detail (right). Detail of a mid-19th-century French bureau. Boulle pieces are notoriously difficult to date, as the technique was extremely fashionable in France throughout the 18th century, and then innumerable excellent copies were made during the 19th century – this is one of them. English country house owners embraced the style whole-heartedly. *Petworth House, West Sussex*

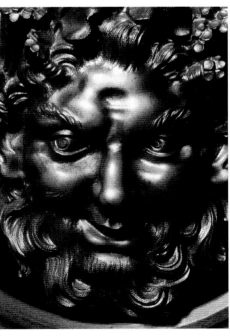

Boulle

Roll-Top Desks

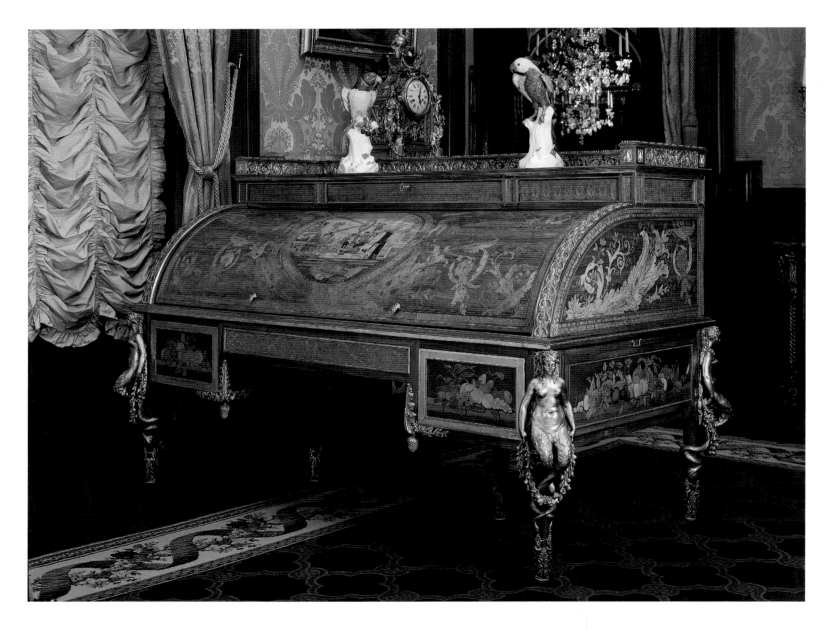

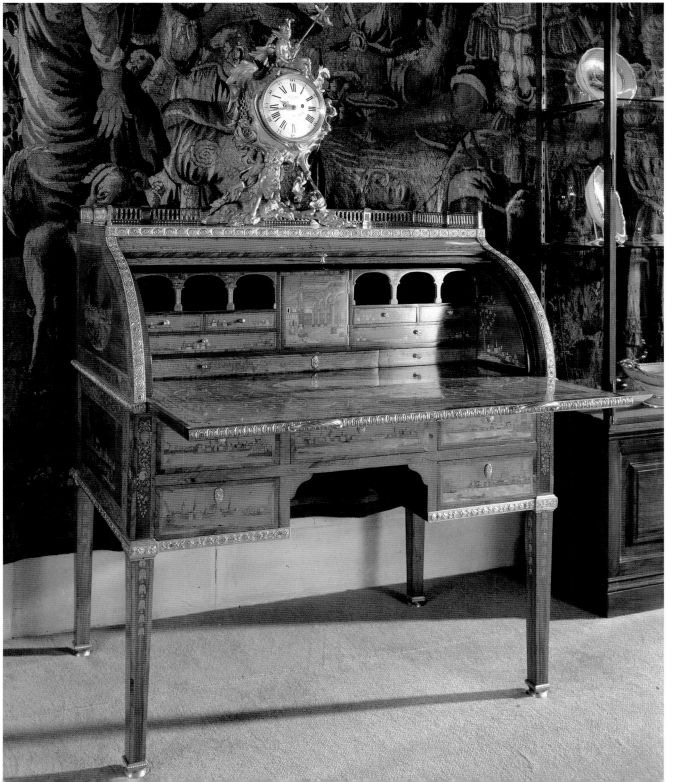

Beaumarchais desk (far left) According to tradition, this huge desk in the Baron's Room was given c.1777–1781 by friends to P-A Caron de Beaumarchais (1732–1799), author of *The Marriage of Figaro* and *The Barber of Seville*. The titles of two of his political pamphlets are worked into the marquetry of the desk's writing flap. The desk contains a number of ingenious mechanical devices, controlling secret drawers, rising shelves and a number of complicated locks. It was offered for sale by lottery in Paris in 1831. One of the lottery tickets, costing 50 francs, is preserved in a frame on the side of the desk. *Waddesdon Manor, Buckinghamshire*

Bureau à cylindre (near left). Made c.1785 for one of the St Petersburg palaces of Tsar Paul I of Russia, this desk is decorated with satinwood marquetry depicting Russian or Italian townscapes. The style and quality of the ormulu mounts and the marquetry is typical of Russian furniture of the time. The desk was formerly attributed to David Roentgen (1741–1809). *Anglesey Abbey, Cambridgeshire*

Inlay and Marquetry

Royal gift (left and right). This gilt table is thought to have been given by Louis XIV to the 6th Earl of Dorset in 1670–1671, when he went as an ambassador to France to congratulate the King on the completion of the secret Treaty of Dover (1670) with Charles II. The gilding of the carved wooden frame was executed by David Dupré, the matching pair of torchères by Mathieu Lespagnandelle and the tin and brass inlaid top was probably supplied by the renowned Dutch cabinet maker Pierre Gole (c.1620–1684). *Knole, Kent*

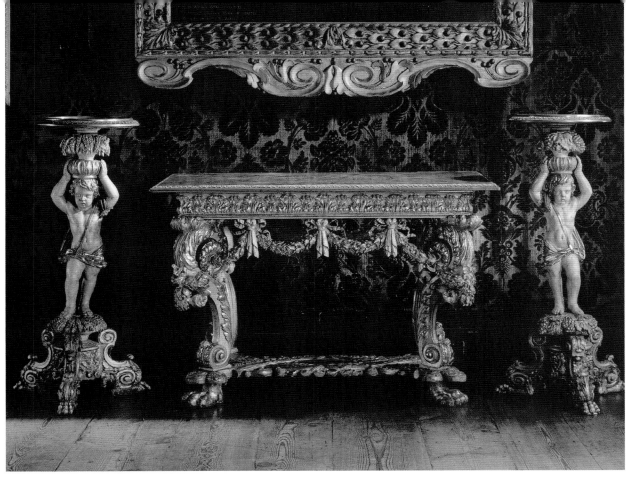

Cabinet door (far left). The inside of this cabinet door shows intricate marquetry in a seaweed design. The cabinet is believed to be by Gerrit Jensen (fl. c.1680–d.1715), cabinet maker to Charles II, James II, William III and Queen Anne, who was active as a furniture designer from 1680 to 1715. Jensen, who may have been of Dutch or Flemish descent, was heavily influenced by Pierre Gole. *Canons Ashby, Northamptonshire*

Jan van Mekeren (left). Detail of the left-hand panel of a Dutch cabinet, c.1690, showing fine floral marquetry. It is believed to be by the Amsterdam cabinet maker Jan van Mekeren (1658–1733). Van Mekeren is particularly associated with spectacular floral marquetry cabinets such as this. The designs were derived from Dutch still-life paintings and used various coloured veneers to achieve brilliant *trompe l'oeil* effects. *Charlecote Park, Warwickshire*

Walnut and Limewood

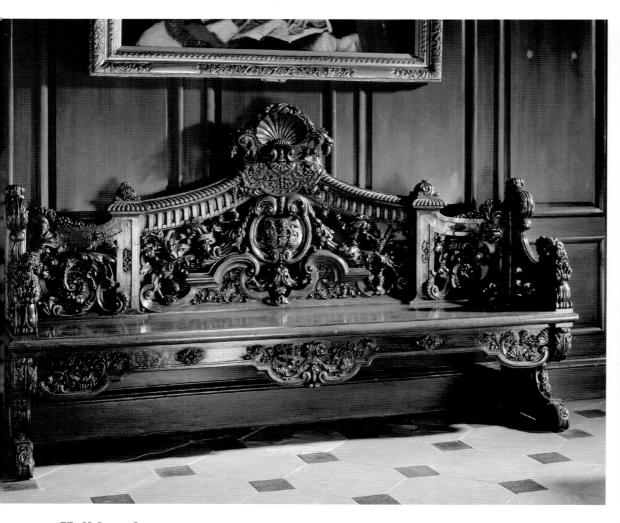

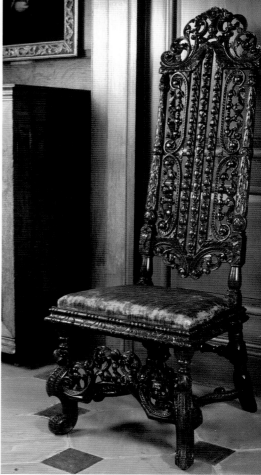

Hall bench This massive Dutch walnut hall bench, c.1695, is the most elaborate of a series of benches acquired in the early 19th century. It features lions on the arms and a central medallion showing the arms of the Booth family (the house was rebuilt by George Booth, 2nd Earl of Warrington). Originally adapted to stand in the window bays of the Great Hall, the benches were displaced by radiators in the early 20th century. *Dunham Massey, Cheshire*

High-backed chair One of a set of Franco-Dutch-style, richly carved chairs with steeply raked backs, c.1690, believed to have been acquired by the 1st Earl of Warrington in 1694. *Dunham Massey, Cheshire*

Grinling Gibbons (above) Born in Rotterdam, Gibbons (1648–1721) came to England in the 1670s and his talent for carving was recognized and promoted by his patrons, including Christopher Wren, Charles II and George I. Working mainly in limewood, Gibbons's trademark cascades of fruit, leaves, flowers, foliage, fish and birds were applied to panelling, furniture, frames and walls. This portrait, from Petworth House, is by George Clint (1770–1854).

Classical style (right). Part of a limewood carving showing classical vases, c.1692. Executed by the great 17th-century woodcarver Grinling Gibbons, who went on to work on St Paul's Cathedral and was appointed a master carver to George I. The Carved Room at Petworth, of which this is a feature, is one of his masterpieces. *Petworth House, West Sussex*

The Crucifixion (right). This is the earliest known work of Grinling Gibbons. The relief is based upon an engraving of a Tintoretto (1518–1594) painting, and is the piece that Gibbons was working on when he was discovered by chance by the diarist John Evelyn in 1671. Evelyn recorded the meeting: 'I saw the young man at his carving, by the light of a candle. I saw him to be engaged on a carved representation of Tintoretto's *Crucifixion*, which he had in a frame of his own making.' The carving was bought by the 2nd Earl of Warrington (1675–1758), an astute collector, who placed the relief in his inner sanctum, the Library, set up like an altarpiece over the chimney. *Dunham Massey, Cheshire*

William Kent

Pier-glass This English giltwood pier-glass, c.1730, is in the style of William Kent. The mirror frame, with lugged corners, was often adopted for picture frames at this period. The broken pediment is decorated with the monogram and coronet of the 2nd Earl of Warrington. *Dunham Massey, Cheshire*

Giltwood settee One of a pair copied from a set designed c.1740 for the famous Double Cube Room at Wilton House near Salisbury, Wiltshire. The settees feature a pair of carved sphinxes on the aprons and a female mask on the back rails. *Rievaulx Terrace and Temples, North Yorkshire*

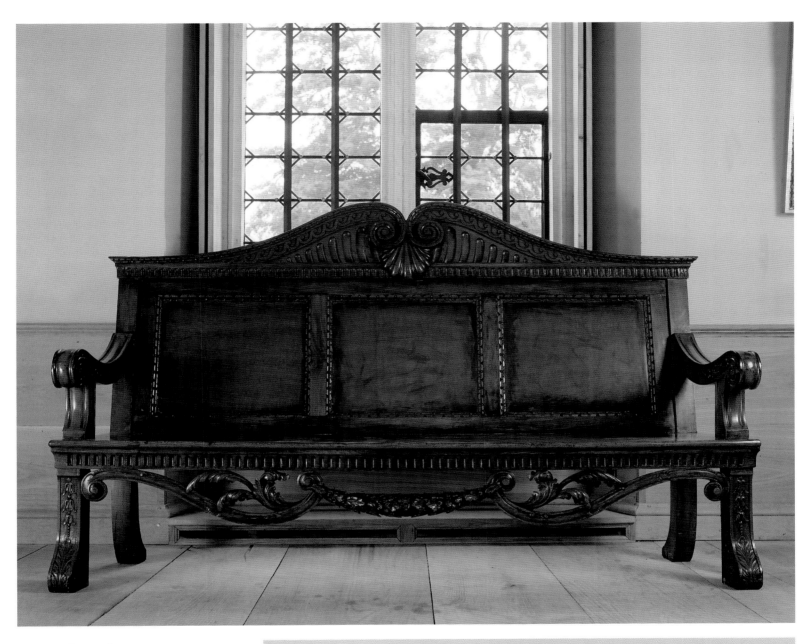

Moore bench (above). One of a pair of mahogany benches made in 1731 by James Moore the Younger (c.1690–c.1734) to a design by William Kent. In 1728 Sir John Dutton asked Kent to supervise the repair and partial refurnishing of his Gloucestershire home as well as his Lodge, and the accounts of 1731 show a payment of £30 to Moore for 'two Mohoggony Settees for ye Dining Room at ye Lodge Carved'. Documented Kent furniture is very rare. *Lodge Park, Gloucestershire*

William Kent

William Kent (1684–1748) was an influential architect and versatile interior designer whose furniture formed an integral part of his designs. Born in Yorkshire, he went to Rome in 1709 to study painting. The architecture he saw during his time in Italy made a great impression upon him, and when he returned to England in 1719 he was extremely influential in introducing the style of the 16th-century Italian architect Andrea Palladio to this country. His work includes the interiors of both Chiswick and Burlington House, the Gothic screens at Westminster Hall and Gloucester Cathedral, and the famous gardens at Stowe House in Buckinghamshire.

Lacquer

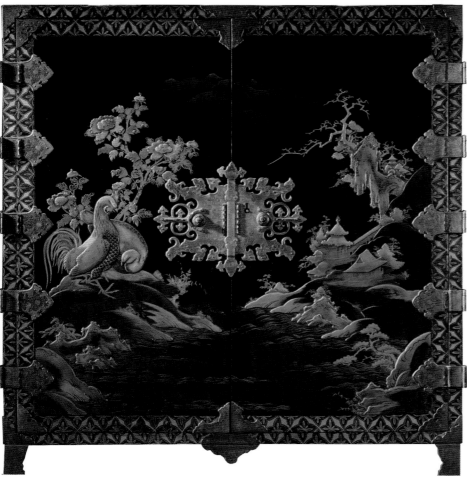

Japanese chest (above). Detail of the inside of a Japanese chest, c.1600, showing a tiger intricately decorated with lacquer and mother of pearl. The chest is covered in shagreen (shark skin) and is believed to have been acquired by Sir Thomas Myddelton (1550–1631), the first Myddelton owner of the castle. He had strong links with the Far East, being an adventurer and one of the founders of the East India Company. *Chirk Castle, Wrexham*

Lacquered cabinet (left). This 17th-century Japanese cabinet (shown without its English early 18th-century giltwood stand) is decorated with landscapes executed in gold against a black background. Lacquer was made using the secretions of the lac insect (hence the name) and was practised in ancient China as long ago as 700 BC. The finish has a beautiful sheen and is very hard and durable. Imported lacquer cabinets were very fashionable in the 17th century, when the cargoes of the East India Company created a general craze for artefacts from the East. *Petworth House, West Sussex*

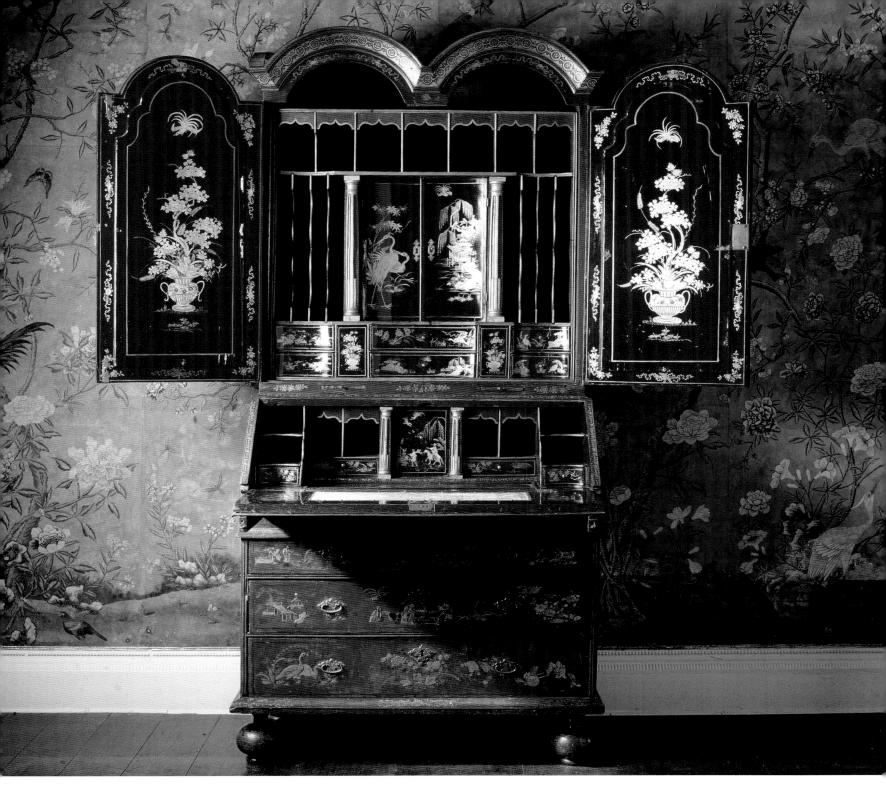

English japanned bureau With the ever-increasing popularity of things Far Eastern in the early 17th century, supply could not keep up with demand, so it became necessary to make similar objects in England – hence the start of Japanning, imitation Asian lacquerwork. This spectacular scarlet bureau-cabinet was probably bought in the 1720s from John Belchier (fl. 1717–d. 1753), who supplied most of the early 18th-century fine furniture for Erddig, by its original owner, John Meller. It is listed in an inventory of 1726 as being in the 'Blew Mohair Room'. The exterior is rather faded, though the vibrant interior gives an idea of how dazzling it must have once been, especially in its original surroundings. *Erddig, Wrexham*

Thomas Chippendale

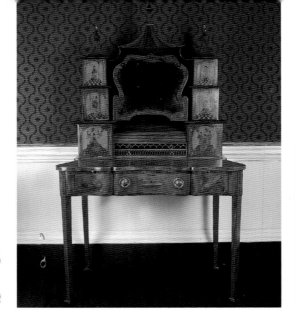

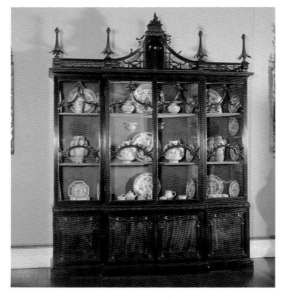

Pier-glass (opposite page). Supplied in 1771, this ornate pier-glass in the State Bedroom at Nostell was described in Chippendale's bill as being set 'in a very large border'd Chinese frame Richly Carv'd and finish'd'. It hangs directly above another Chippendale piece, a green lacquer commode. *Nostell Priory, West Yorkshire*

Chinoiserie pattern (top). This graceful Chippendale-influenced satinwood writing and dressing table shows the influence of Chinese style, which was so popular among fashionable Georgian society. Fitted with a writing compartment and boxes for a lady's toilet, the piece is inlaid with *chinoiserie* marquetry and has unusual pagoda crestings. *Clandon Park, Surrey*

'Chinese' cabinet (middle). The elegant lines and understatement of this Chippendale-style display cabinet makes it ideal for showing off fine china. It is described by C. Gilbert, author of the standard work on Chippendale, as 'a spectacular Victorian translation of Chippendale's design'. *Shugborough Hall, Staffordshire*

Library desk (bottom). The library at Nostell was the first room to be designed in 1766 by Robert Adam in the newly fashionable neo-classical style. This library desk was designed by Chippendale at a cost of £72 10s, the most expensive item designed for Nostell at the time. *Nostell Priory, West Yorkshire*

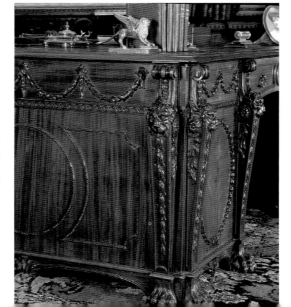

Thomas Chippendale

Thomas Chippendale the Elder (1718–1779) was a furniture designer and cabinet maker from West Yorkshire who became one of the most successful English furniture makers of the 18th century. The son of a joiner, he moved to London in the 1740s to advance his career. His name has become almost synonymous with neo-classicism and mid-Georgian style largely because of the important pattern book published by him in 1754. *The Gentleman and Cabinet-maker's Director* achieved two firsts. It was the first pattern book to concentrate solely on furniture, and it was also the first to be published by a cabinet maker. Yet it did so well that it went into three editions and spawned numerous imitations.

From the mid-1760s, Chippendale was producing his finest pieces, including many large commissions for stately homes, among them Harewood House and Nostell Priory, both in West Yorkshire. The pieces supplied for the latter have been recognized as his most representative collection of furniture.

Chippendale had close connections with the neo-classical architect Robert Adam. In fact Adam and Chippendale worked for the same patrons at least a dozen times, and there may well have been a commercial contract between them, with Adam recommending Chippendale for projects. Chippendale's furniture certainly complemented Adam's elegant interiors perfectly.

Chippendale was designing in an age when English architecture, furniture and interior design reached a new degree of excellence. Among the most important of his contemporaries were William and John Linnell, George Hepplewhite and Thomas Sheraton.

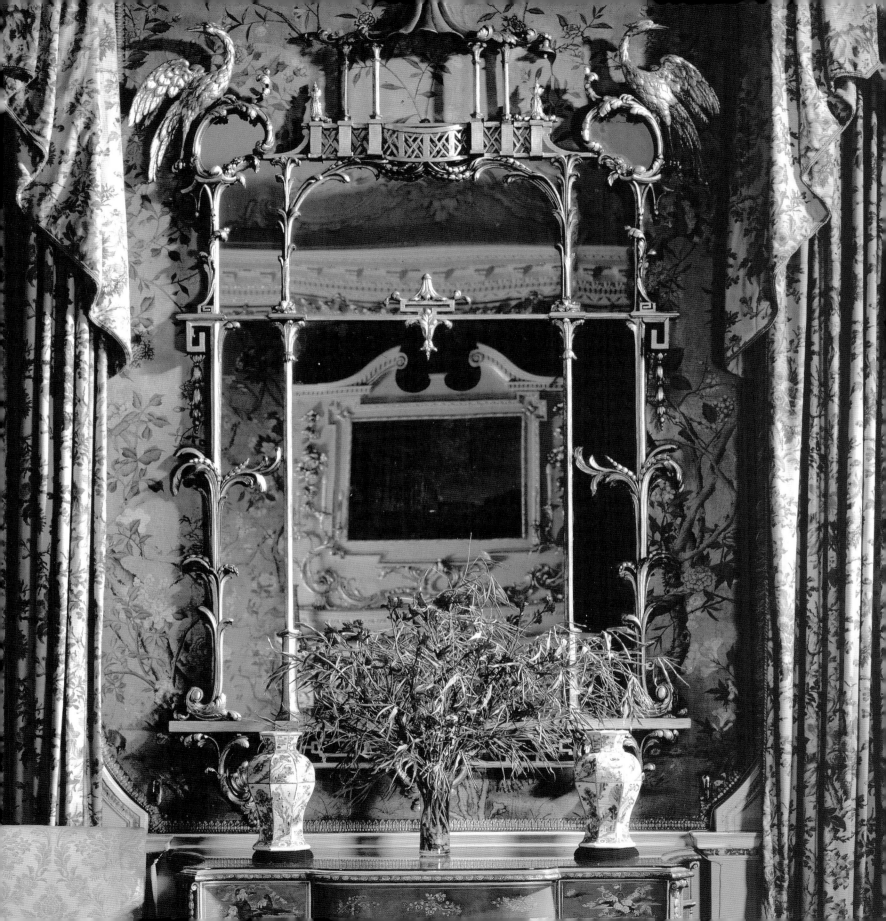

Gothick

Gothick style (left). Close-up of the back of one of the dark oak Gothick chairs, c.1770, in the Gallery at Croft Castle. The backs are ogee-shaped with quatrefoil piercing and crocketed finials, all elements used in medieval church architecture. Gothick style was the first, 18th-century phase of the Gothic Revival (it carried on into the next century with Victorian Gothic). The style took the Gothic arch as one of its main themes, although it sometimes contained elements of the curling ornamentation so typical of Rococo.
Croft Castle, Herefordshire

'Tudor' chair (right). In the 18th century, this kind of carved ebony chair was thought to be Tudor. In fact, it was made in India in the 17th century. *Tyntesfield, North Somerset*

Ebony chairs (below). Part of a set of ebony chairs that may have been introduced to the house to create a sense of antiquity and so enhance Cotehele's romantic appeal. They feature prominently in the detailed lithographs of the house by the Plymouth artist Nicholas Condy (1793–1857), which were done around 1840. *Cotehele, Cornwall*

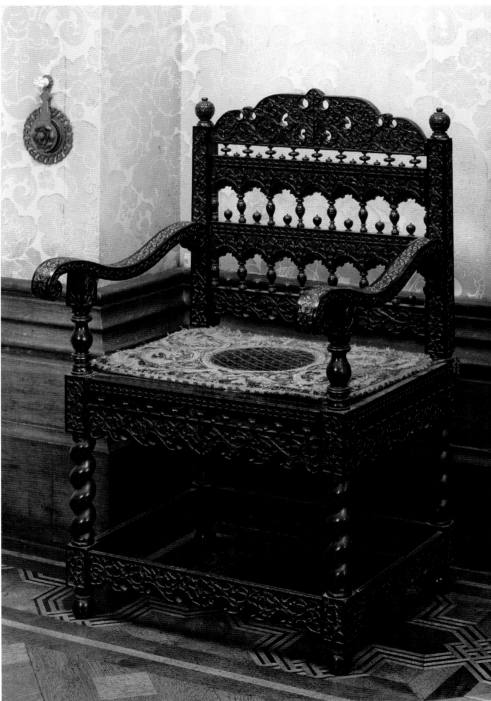

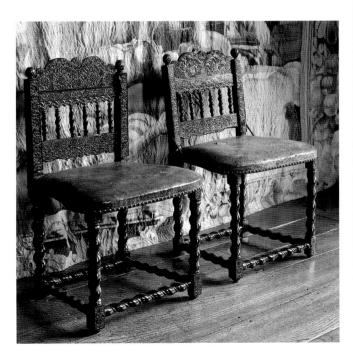

Neo-Classical

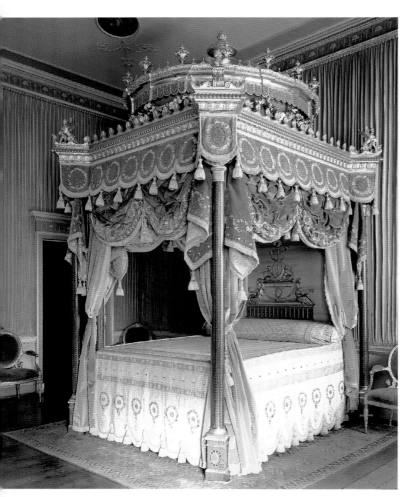

State bed (left). Inspired by the Temple of Venus, as found in many classical gardens, this extravagant bed was designed by Robert Adam in 1775–1776. Adam (1728–1792) was the most celebrated architect of fashionable society and so became the most prominent English country-house architect in Georgian England. He is seen as one of the greatest exponents of neo-classicism, and developed a truly individual style characterized by light, elegant lines unrestricted by strict classical proportions. He saw furniture as integral to his design schemes. *Osterley Park, London*

Hall armchair (below). Almost certainly designed for Castle Coole by the neo-classical architect James Wyatt (1746–1813), who also designed the house, this elegant chair bears the crest of the Belmore family. Wyatt was greatly influenced by Robert Adam, in fact to such a degree that there were occasional accusations of plagiarism. *Castle Coole, County Fermanagh*

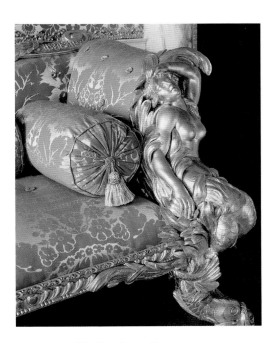

Sofa detail (above). The mermaids and dolphins of this sofa echo the maritime theme of the room it was designed for. Made in 1765 by the London furniture maker John Linnell, it interprets a Robert Adam design. John Linnell, whose work rivalled Chippendale's, was trained by his father and partner, William, and was greatly influenced by Adam, with whom he worked by 1762. *Kedleston Hall, Derbyshire*

Pier-glass and table (right). This monumental gilt pier-glass and table, c.1780s, is one of a pair. The tops of the pier-tables feature spectacular marquetry and are supported by female figures inspired by those on the Erechtheum on the Acropolis in Athens. The mirrors are crested with winged griffins and have ewers with dolphin handles at each corner – a design element derived from the Theatre of Marcellus in Rome, a place which inspired the architect and designer William Chambers. Chambers (1723–1796) was a major rival to Robert Adam in English neo-classicism. *Basildon Park, Berkshire*

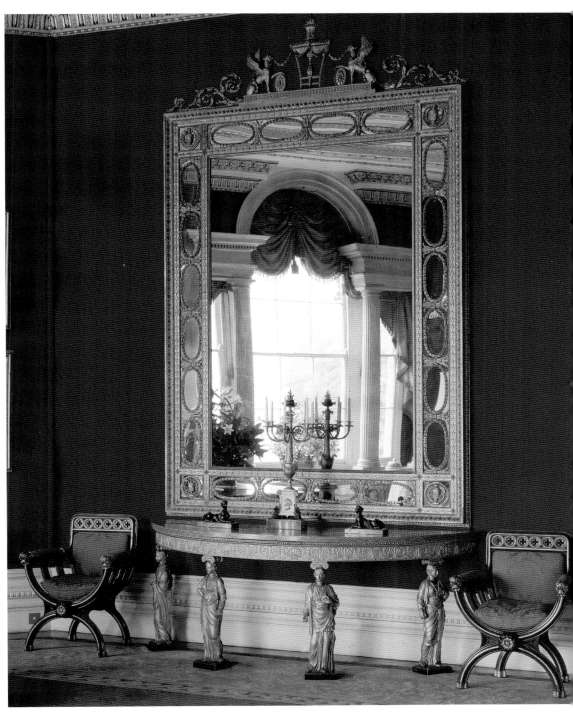

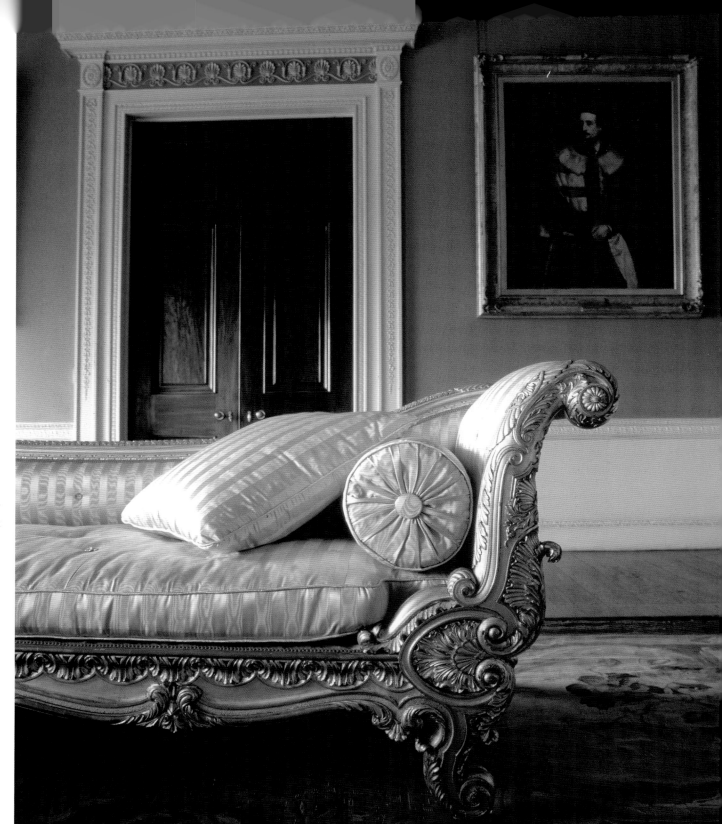

'Grecian' couch The rich gilt of this opulent couch, c.1816, is typical of the Regency style but more elaborate than the neo-classical style of this house, designed by the architect James Wyatt (1746–1813). Supplied by the Dublin upholsterer John Preston, the couch is one of a pair which cost £49, a not inconsiderable amount at the time. Altogether the 2nd Earl of Belmore spent a total of c.£30,000–35,000 on furnishings from Preston, which gives an indication of just how costly Castle Coole was. In fact the whole project virtually ruined him. *Castle Coole, County Fermanagh*

Regency

Chippendale detail (right).
Arm of a Thomas Chippendale the Younger armchair decorated with a carved Egyptian head, 1805. Thomas Chippendale the Younger (1749–1822) took over his father's business in 1779 and, despite going bankrupt in 1804, was supported by many loyal patrons, including the owner of Stourhead, Sir Richard Colt Hoare (1758–1838), who commissioned this piece.
Stourhead, Wiltshire

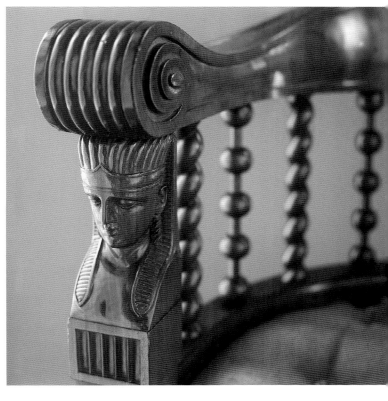

Elbow chair (left). This elegant and understated armchair was made by Thomas Chippendale the Younger in 1812 and is part of a set designed specifically for the Music Room at Stourhead. Chippendale refurnished the house between 1795 and 1820, equipping the Picture Gallery and new Library – in fact the design of this chair derives from that of some single chairs made for the Library in 1805. Its style echoes French furniture of the time, with the rich mahogany being highlighted by the gilding and gilt-brass moulding.
Stourhead, Wiltshire

Neo-Norman

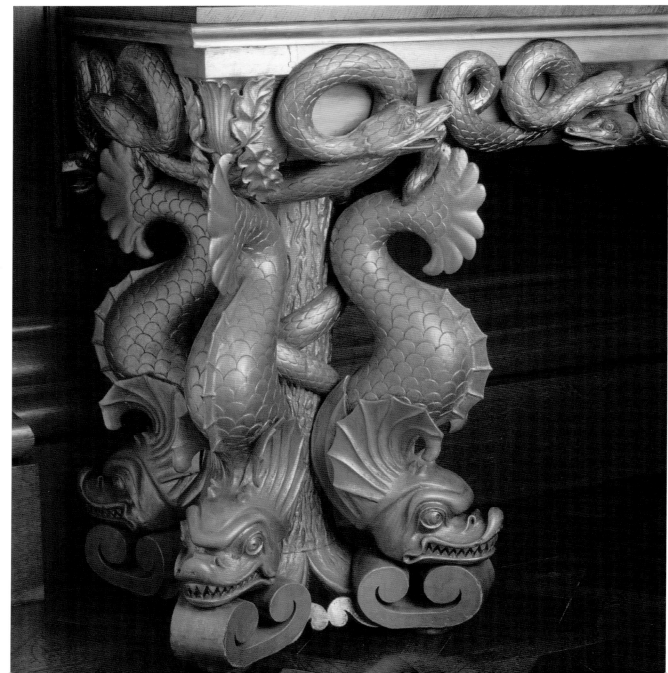

Dolphin table leg Detail of a carved and giltwood side-table. Its sides are adorned with writhing snakes, and sharp-toothed dolphins support the table top, which is inlaid with brass stringing. The maker is unknown, although it is believed to have been designed by Thomas Hopper (1776–1856), the architect of the house, who used dolphins as a particular theme. *Penrhyn Castle, Gwynedd*

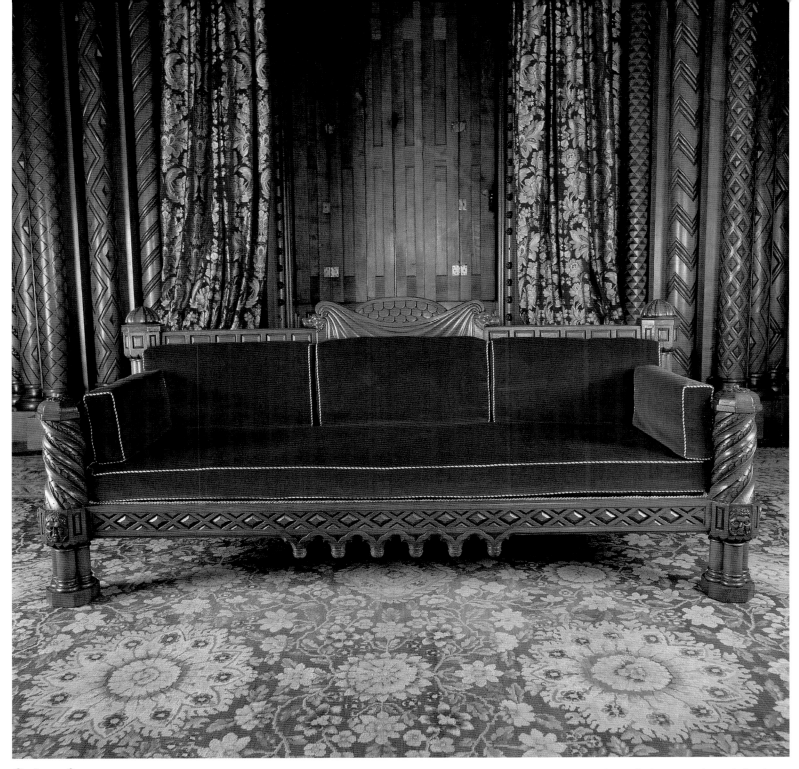

Oak sofa This massive oak sofa was designed for neo-Norman Penrhyn Castle by Thomas Hopper, who believed that it was 'an architect's business to understand all styles and to be prejudiced in favour of none'. He was one of the leading London architects of the first half of the 19th century and also built Gosford Castle in County Armagh, Northern Ireland, in a similar Norman-revival style. Hopper's Norman style was characterized by a feeling of weight and gravity that is very apparent in this piece. Since this picture was taken, the sofa has been re-covered with magnificent brocade, matching the curtains behind it. The original silk was found underneath the plain coverings shown here. *Penrhyn Castle, Gwynedd*

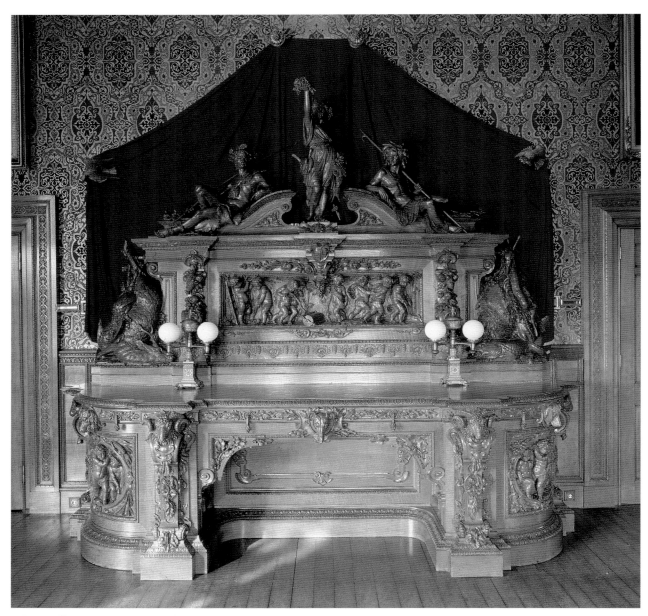

The Charlecote buffet This massive sideboard was made specifically for the house and cost £1,600 in 1858. The carvings were done by James Morris Willcox and his apprentices of the Warwick school of virtuoso carvers. They take the fruits of nature as a theme, and feature figures of a hunter and fishermen. The central panel depicts the progress of agriculture, with the goddess of corn, Ceres, above, dominating the scene. The sideboard was originally used to display silver plate. *Charlecote Park, Warwickshire*

Gilt chair Chair painted with a romantic scene and decorated with gilding, in the Organ Lobby. *The Argory, County Armagh*

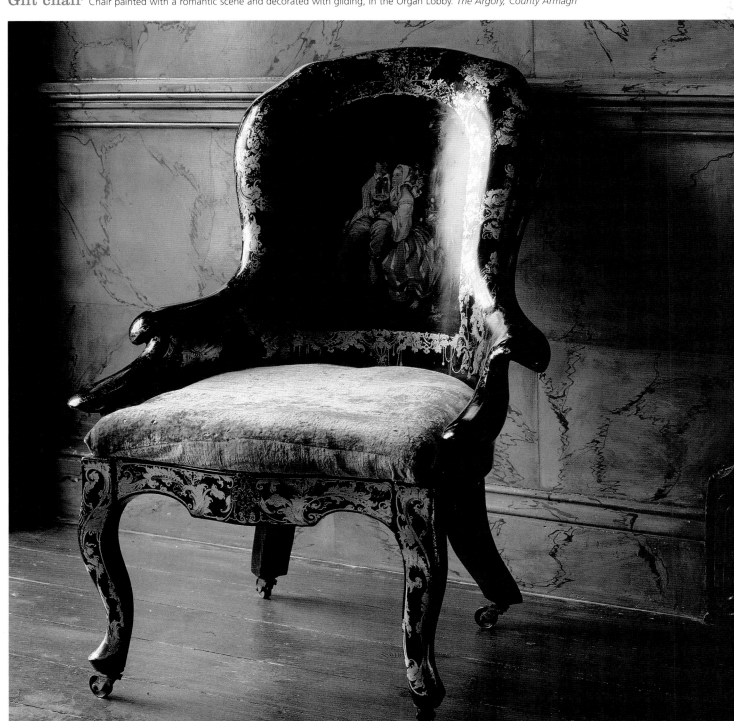

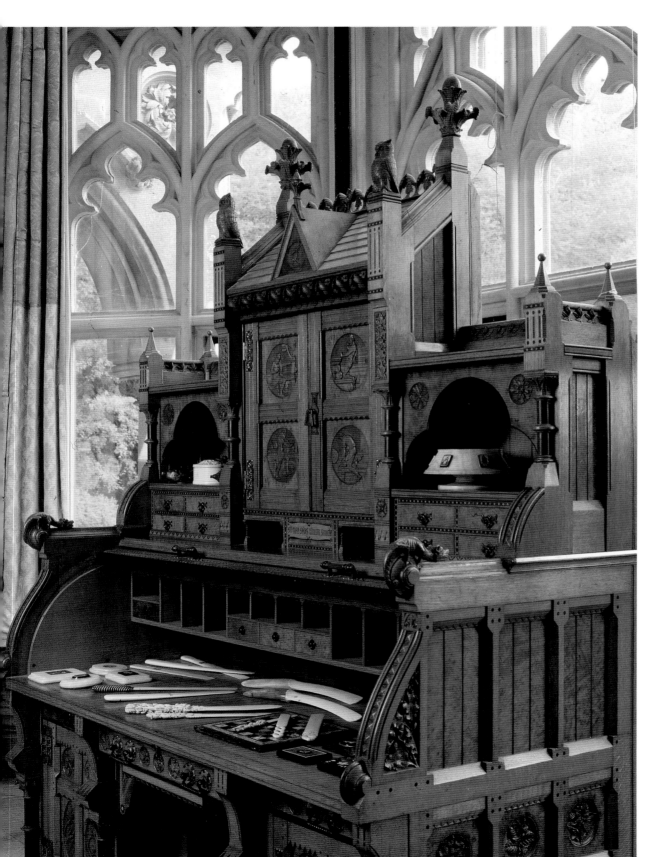

Gothic Revival

Collier & Plucknett desk (left). The outstanding Warwick and Leamington Spa firm of cabinet makers Collier & Plucknett made this architectural roll-top desk. The four panels on the door depict ancient crafts, such as pottery and carpentry, and the various drawers and compartments were designed to house letter openers, paperweights and other paraphernalia. It is believed to have been commissioned for the businessman William Gibbs (1790–1875), who built the house, with the roll-top being added later – at the request of his son, Antony – by the same company. *Tyntesfield, North Somerset*

Inlaid teapoy (right). Flower garlands and dog roses decorate the front of this exquisitely inlaid teapoy (a lockable box used for storing precious tea). Made to match an accompanying octagonal table, the teapoy was designed by the architect Augustus Pugin (1812–1852) for Janet Kay-Shuttleworth around 1850, and has her monogram carved into the rosewood trestle ends. The top is burr walnut. The son of a French draughtsman, Pugin developed his interest in the Gothic through the work he did with his father illustrating and publishing books on Gothic architecture. He went on to design the interior of the Houses of Parliament. *Gawthorpe Hall, Lancashire*

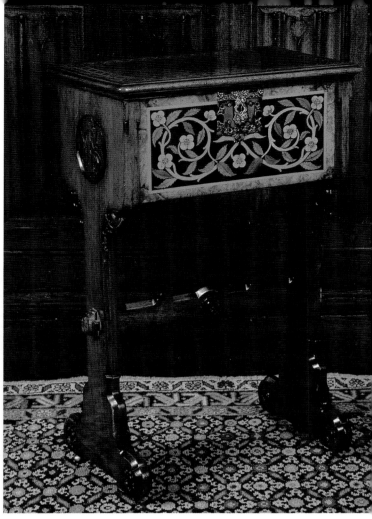

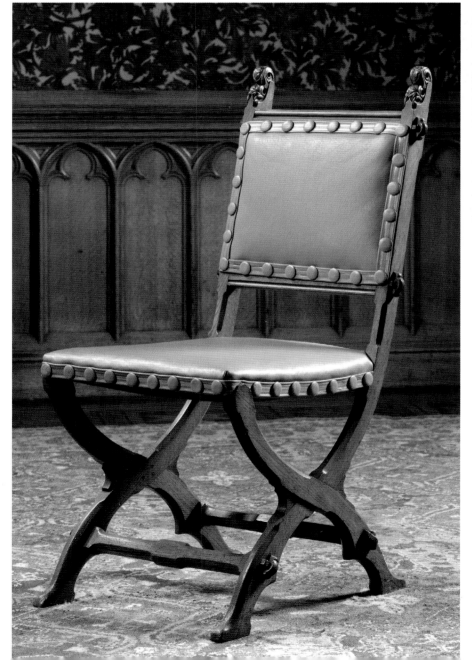

Crace chair (left). One of a set of four Pugin-inspired oak cross-framed chairs supplied to Tyntesfield by John G Crace (1809–1889), c.1855. Crace worked closely with Pugin on furnishing the new Houses of Parliament, as well as on the Medieval Court at the Great Exhibition of 1851. Pugin's stylistic influence can be clearly seen in the design of this chair. *Tyntesfield, North Somerset*

Arts and Crafts and Bloomsbury

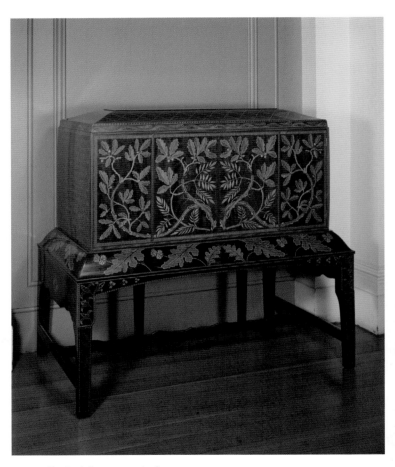

Omega-style chair (left). Painted by the artists Vanessa Bell and Duncan Grant in the 1930s, the style of this chair is reminiscent of their earlier work for the Omega Workshops, which were run by Roger Fry from 1913–1919 and produced innovative and influential designs. *Monk's House, East Sussex*

Inlaid secretaire (above). The exquisite leaf-patterned marquetry of this secretaire, c.1906, was executed by George Jack, one of the principal designers at Morris & Co. This company had been set up by William Morris, one of the founders of the Arts and Crafts movement. The movement, dismayed by the quantity of mass-produced, poor quality machine-made items, encouraged the revival of traditional crafts. *Ickworth, Suffolk*

Embroidered chair back (right). Embroidered by Duncan Grant and Vanessa Bell, c.1932, this chair is one of a set of six they produced for Bell's sister, the writer Virginia Woolf, and her husband Leonard. The Woolfs bought Monk's House in 1919 and it soon became a popular retreat for London-based members of the Bloomsbury Group. *Monk's House, East Sussex*

Lacquered dresser This huge 'ox-blood' dresser was designed by the architect Philip Webb (1831–1915) for the Dining Room of Red House, the home he designed for William Morris (1834–1896), the artist, craftsman, poet and social reformer. Webb had become a great friend of Morris when they were both apprenticed to the architect G E Street, and they conceived the idea of the Red House together, with Morris officially commissioning Webb in 1859. *Red House, Bexleyheath, London*

Modern Movement

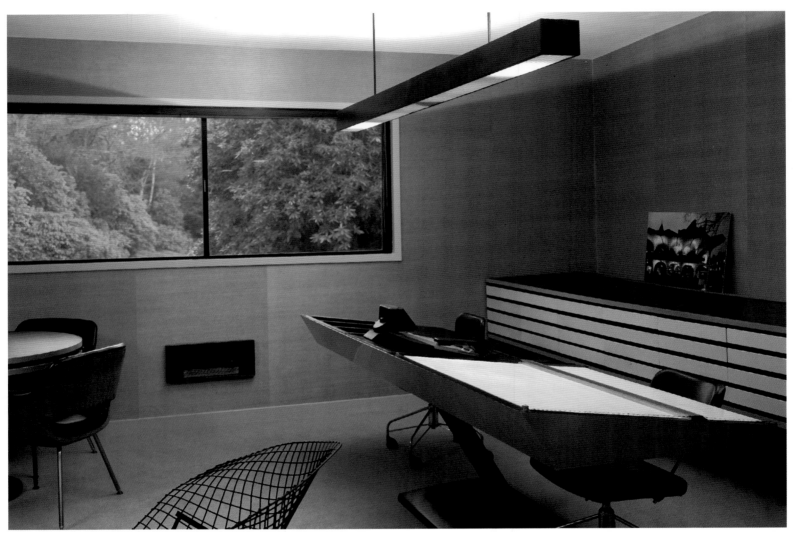

Gwynne study (above). The architect Patrick Gwynne (1913–2003) originally designed this study for his father. In the 1960s he remodelled it for his own use, adding this elegant desk and drawer unit. *The Homewood, Surrey*

Wall units (opposite, top left). Made of Indian laurel, the bar table swings out from the wall of the Drawing Room. Above and below sliding doors conceal a drinks cabinet, serving hatch and built-in hi-fi. *The Homewood, Surrey*

Steel-framed chair (opposite, top right). This chair is typical of the style of its designer, Ernö Goldfinger (1902–1987). A key member of the Modern Movement, Goldfinger built a terrace of three houses in 1939, keeping number 2 as his family home. *2 Willow Road, London*

Nursery chair (opposite, bottom left). The vivid colours of this Goldfinger-designed armchair, made from bent and laminated plywood, matches the decor of the house. As only two of these chairs were ever made, it is probably a prototype. *2 Willow Road, London*

Sideboard (opposite, bottom right). Detail of a Goldfinger-designed sideboard showing the feet, made from steel I-beams. *2 Willow Road, London*

Glass

Venetian

Heraldic goblet Part of the Renaissance collection at Waddesdon, this is a brownish transparent glass goblet with a bowl of ogee profile on a pedestal. The bowl is painted in polychrome enamels and there is some gilding on the base of the bowl above the stem. The arms of the Sernardi family of Siena are represented on the bowl. Filippo Sernardi was created Abbot in the diocese of Strigonia in Hungary in 1494, and it is thought that the goblet was made for him. *Waddesdon Manor, Buckinghamshire*

Lattimo plates This pair of Lattimo plates (also known as Murano ware) show clearly the distinctive milky-white finish for which this ware is famous. The technique was first used in the 16th century and relies on the manufacturer creating microcrystals in the clay by adding various compounds. A chemical reaction then takes place during the heating and cooling process, and the result is that the microcrystals do not absorb light but reflect it – accounting for the colour and opaque appearance. These plates are a rare souvenir of the Grand Tour made by the future owner of The Vyne, John Chute (1701–1776). In June and July 1741 Chute, accompanied by his great friends Horace Walpole and the Earl of Lincoln, visited the Murano glassworks. They each ordered two dozen plates of Venetian glass depicting views of the city (taken from 1703 etchings by Marieschi and 1735 engravings by Visentini, which in turn followed works by Canaletto). *The Vyne, Hampshire*

Jacobite Glass

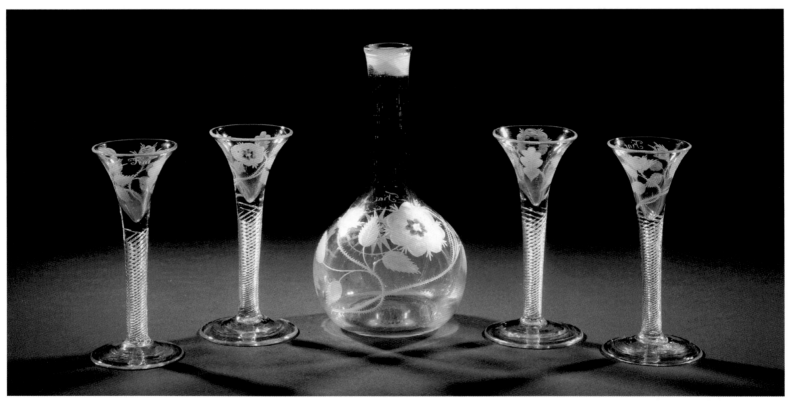

Decanter set (above). Engraved with the symbols of the Jacobite movement – oak leaves and a rose – this decanter and glasses were originally owned by Henry Jones IV (c.1700–1761), the president of the Cycle Club of Gloucestershire. This curiously named organisation, so called to disguise its Jacobite leanings, founded in 1657, was one of the oldest established Jacobite clubs. The Jacobites were determined to restore the deposed Stuart kings to the thrones of England and Scotland. They supported James II of England (James VII of Scotland) until his death in 1701, when they took up the cause of his son, James Francis Edward Stuart, the 'Old Pretender'. *Chastleton House, Oxfordshire*

Jacobite rose (left). Detail of the decanter above showing the engraved Jacobite rose surrounded by oak leaves. The White Rose of York was adopted by the Jacobites as a sign of support for the Stuart kings after their exile. *Chastleton House, Oxfordshire*

Bonnie Prince Charlie (right). Miniature of the Young Pretender (Prince Charles Edward), otherwise known as Bonnie Prince Charlie, whom the Jacobites pledged to crown king of England and Scotland. This is one of a set of four 'Stuart Miniatures', all painted by the same artist on ivory. It is believed to date from about the period of the second Jacobite Rebellion, when the 25-year-old Prince sailed to Scotland to try to regain the throne of Britain for his father. *Gunby Hall, Lincolnshire*

Glass urn (left). This two-handled bowl is inscribed 'God Bless Prince Charles 1745' and dates from the time of the Jacobite rebellion. It would have been used secretly by supporters of the exiled Bonnie Prince Charlie to toast the prince. Glasses would be passed over the top of the liquid-filled bowl and then raised in celebration of the prince forced to live 'over the water' on the continent. *Trerice, Cornwall*

Drinking Glasses

Beer glass (left). In this 'Portrait of the Wolryche Fool as an Old Man', the Fool is apparently holding the same outsize glass filled with beer that appears in an earlier portrait, entitled 'Portrait of the Wolryche Fool as a Young Man'. Both were painted by a local artist, George Alsop. The fool's cap is in the red and blue livery of the Wolryche Hunt.
Dudmaston, Shropshire

Turnbull Collection (below). Selection of rare 18th- and 19th-century glasses from the Turnbull Collection. This important collection of English glasses was bequeathed to the National Trust by O G N Turnbull and consists of more than 400 pieces, ranging from delicate cordial glasses with air-twist stems to huge goblets. *Mompesson House, Salisbury*

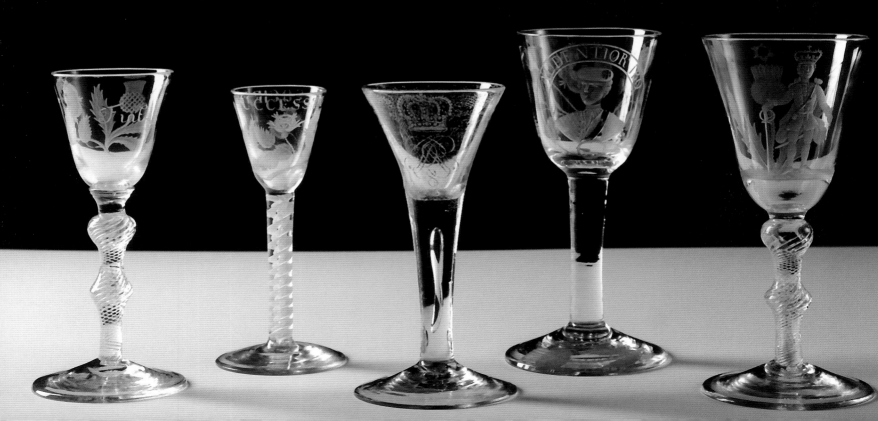

Porcelain monteith (left). Late-18th-century cut-glass wine glasses resting in a monteith decorated with vines. Monteiths would be placed on the dining table and filled with cold water to allow glasses to be cooled. The scalloped edge was designed to hold the stems in place. The French faïence (tin-glazed earthenware) monteith was made at the Veuve Perrin factory in Marseilles and bears the crest of Montagu Edmund Parker (1737–1813) of Whiteway, who ordered the service c.1765–1770. *Saltram, Devon*

Jacobite cause (below). Rare mid-18th-century glasses commemorating the Jacobite cause from the Turnbull Collection. They are decorated with naturalistic images, including fruits, trailing tendrils and ears of corn, and some are engraved with political symbols and slogans such as verses from the Jacobite National Anthem and a portrait of the Young Pretender. See also pages 144–145. *Mompesson House, Salisbury*

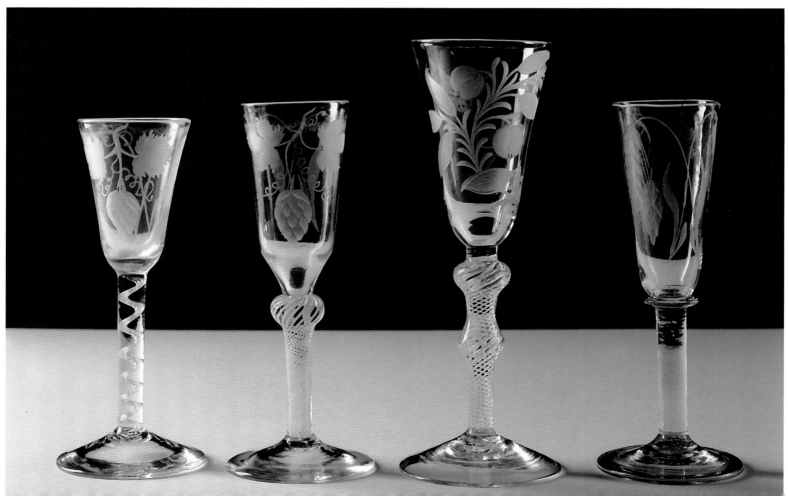

Nailsea Glass

Walking sticks (near right). These glass canes are from the fine collection of 19th-century glassware amassed by Dame Dorothy Elton (the wife of Sir Ambrose Elton, the 9th Baronet) and her son, Ralph. They lived at Clevedon Court, only four miles away from the Nailsea Glassworks. These works opened in 1788 and by the 1830s had become one of the four largest in the country. They produced either plain clear glass with a slight green tint or glass in varying shades of dark green. Often the glass was decorated with white or coloured splashes or white lines, sometimes pulled or combed to give a feathered effect, as these walking sticks show. *Clevedon Court, Somerset*

Rolling pins (far right). The word 'Nailsea' is often used as a general term to describe 19th-century coloured and decorative glass. It was unusual for the Nailsea Glassworks to have produced such brightly coloured pieces as these, although the works did make many utilitarian items, including rolling pins that were filled with cold water to cool pastry. *Clevedon Court, Somerset*

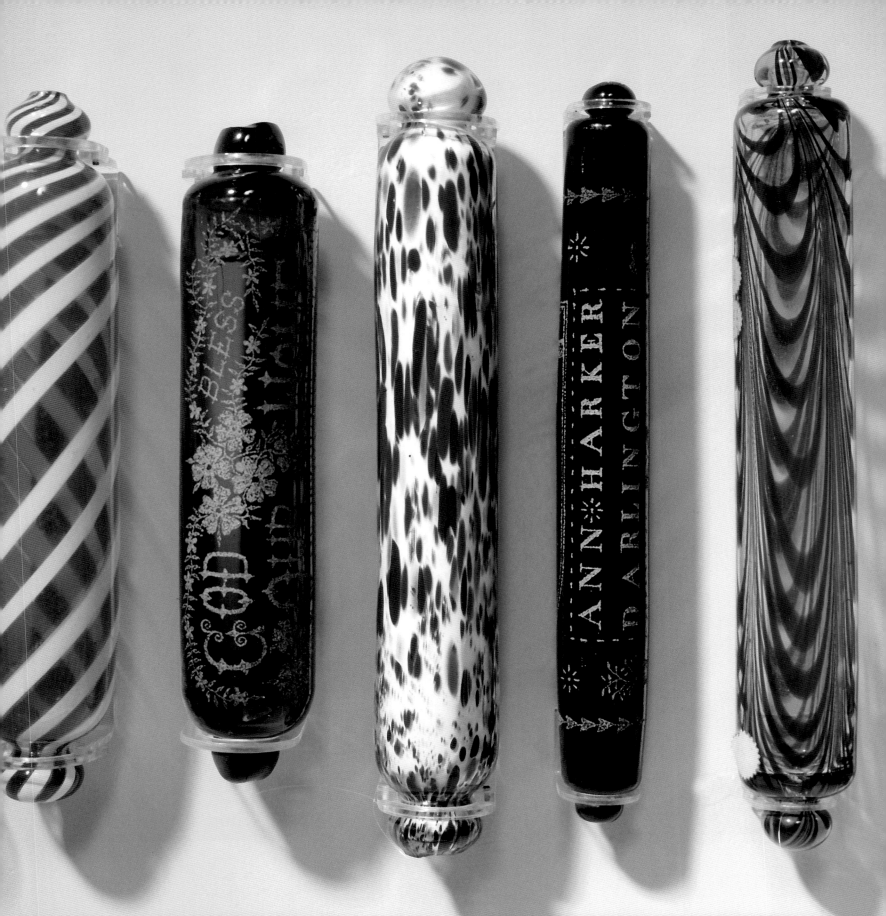

Modern Glassware

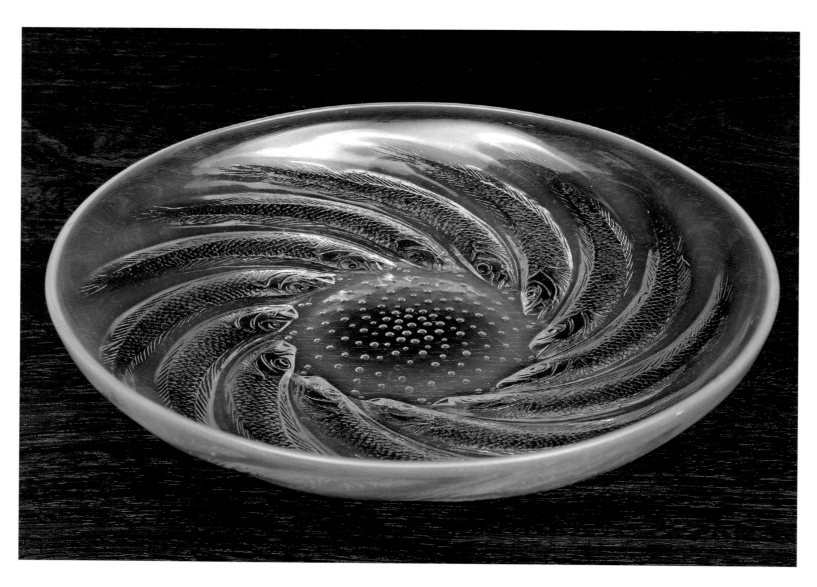

Fish dish (left). Made by Lalique, c.1928, this beautiful blue-tinted glass plate contains a swirling circular pattern of fish with air bubbles coming out of their mouths. René Jules Lalique (1860–1946) was one of the greatest glass makers and jewellery designers of the 20th century – his Art Nouveau and Art Deco pieces were especially prized. He was hugely influenced by the natural world and was especially skilled at creating a sense of movement and flowing lines, as shown here. *Killerton, Devon*

Whistler goblet (right). This goblet is engraved by the poet and artist Laurence Whistler (1912–2000). Whistler was passionate about glass engraving, and much of his work is on goblets such as this. He often used his own poetry, although sometimes he was inspired by the writings of others, as here. The words 'Omega Point' refer to a theory by the French Jesuit priest Pierre Teilhard de Chardin, who used these words to describe the ultimate state of human evolution, when mankind reaches its highest level of consciousness and merges into a 'final unity' (the 'Omega Point'). *Dudmaston, Shropshire*

Monogrammed tumblers (below). The tumblers on this glass tray are engraved with the initials of Charles Henry Robinson. Robinson, of Portland, Maine, USA, bought Ightham Mote in 1953 and donated it to the National Trust in 1985. He had first come across this moated manor house when he was a young man and had fallen in love with it. Finding it for sale many years later he could not resist the opportunity to own it, even though he lived on the other side of the Atlantic. *Ightham Mote, Kent*

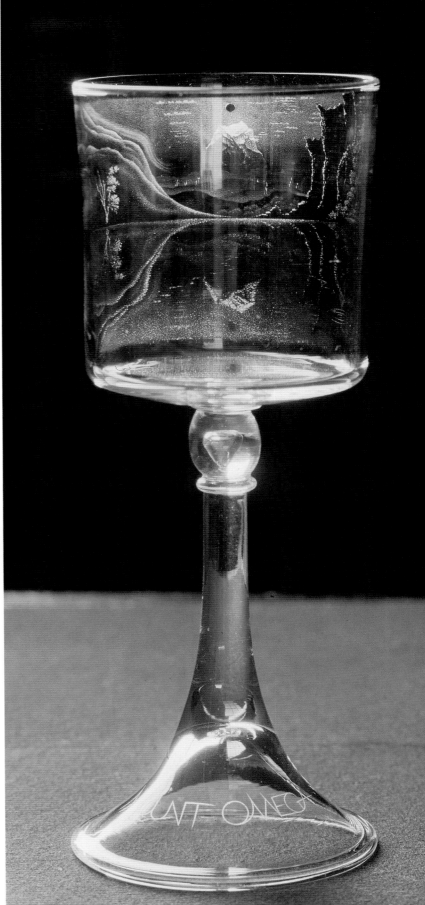

Gold and Silver

17th Century

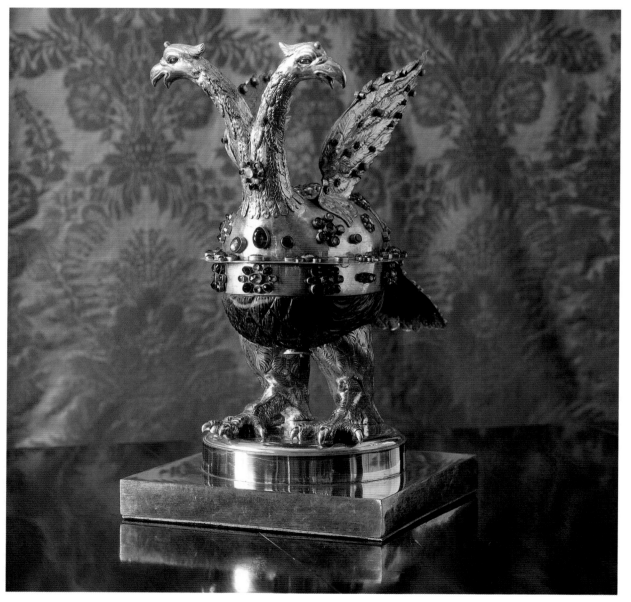

Double-headed eagle (left). Made of silver gilt studded with semi-precious stones and agate, this magnificent 17th-century centrepiece is fashioned in the form of a two-headed imperial eagle. The eagle is the emblem of the Hoare family, the builders and owners of Stourhead. The Hoares were perceptive collectors and amassed a wide range of fine-quality art, furniture, silver and books. The eagle was used as a salt cellar and was made in Augsburg, Germany. *Stourhead, Wiltshire*

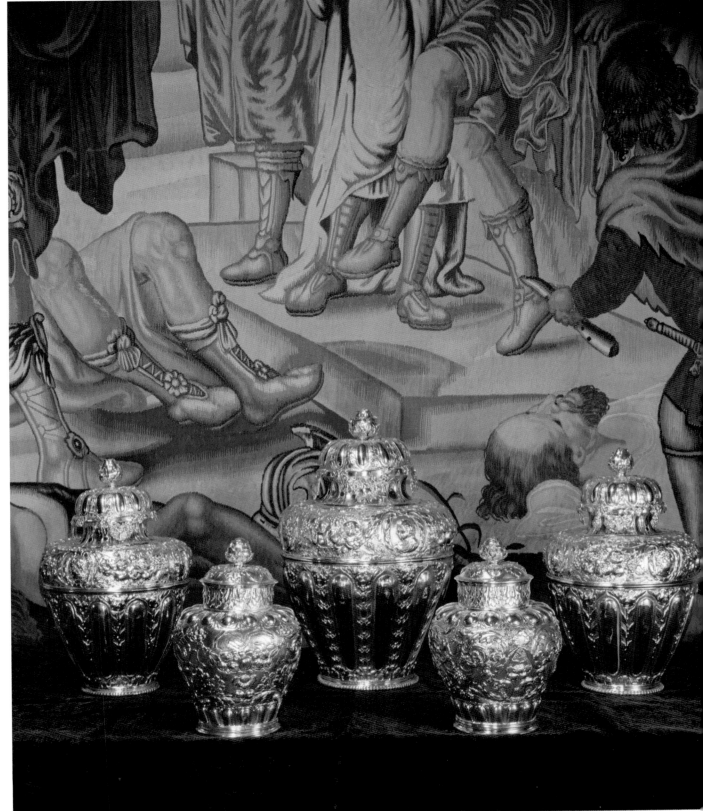

Silverware The three large 'ginger' jars, heavily embossed and fluted, are of the Charles II period. Their shape resembles that of a Chinese porcelain ginger jar, hence the misleading name. The two smaller vases are believed to be early 17th-century Portuguese altar vases. *Knole, Kent*

Dunham Massey Silver

18th-century silverware (right). Selection of 18th-century silverware at Dunham Massey, including octagonal boxes, a bell, a snuffer and tray and glimpses of candlesticks and a ewer and basin. The collection at Dunham Massey was amassed by George Booth, the 2nd Earl of Warrington (1675–1758), who had inherited the estate at the age of 19. The Earl discovered that there were enormous debts owing, but he managed to pay all of them off within 21 years and decided to invest in vast quantities of silver as security for the future. The Earl favoured Huguenot craftsmen, partly because they shared his Protestant religion, but mainly because they offered high-quality work at a reasonable price. This collection forms part of 'My Lady Stamford's Toilet Plate' and is said to have been a gift from Lord Warrington to his daughter, Lady Stamford, on her 50th birthday in 1754. *Dunham Massey, Cheshire*

Egg-cup frame (top left). These 10 egg cups and their silver frame were made c.1740 by the distinguished Huguenot goldsmith Peter Archambo, who was George Booth's major supplier. Each cup is marked below its rim with a date letter, a crowned leopard's head, lion passant and Archambo's mark. It is certainly the earliest egg-cup frame in England, if not the world. *Dunham Massey, Cheshire*

Chamber pot (bottom left). Dunham Massey boasted an unusually high number of silver chamber pots, 15 in all. This chamber pot would have almost certainly been part of a toilet set. *Dunham Massey, Cheshire*

Demi-boar cistern (far left). The handles of this massive cistern, c.1701, are believed to have been added later, c.1728, possibly to match another piece of plate. The demi-boars on the handles were the heraldic emblems of the Warrington family. The cistern would have been used to wash glasses during a meal. *Dunham Massey, Cheshire*

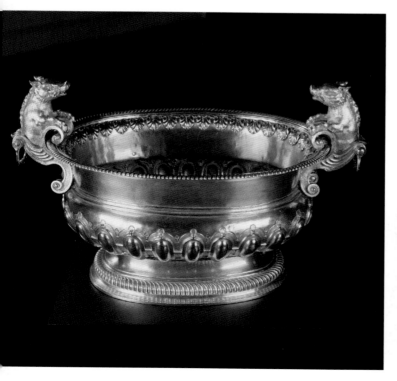

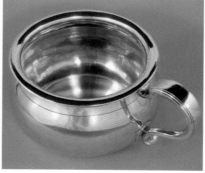

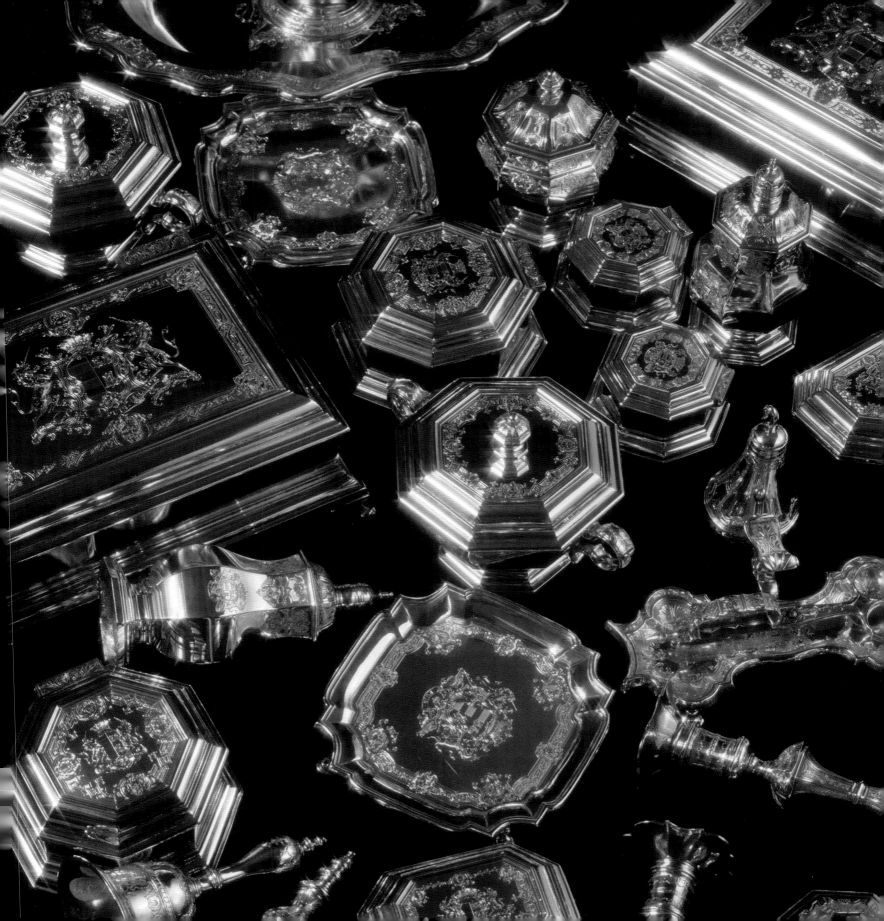

Rococo and Neo-Classical

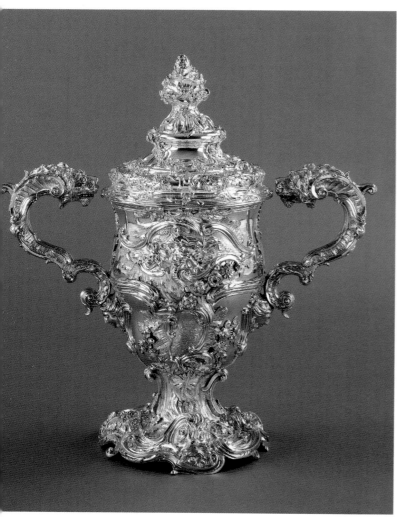

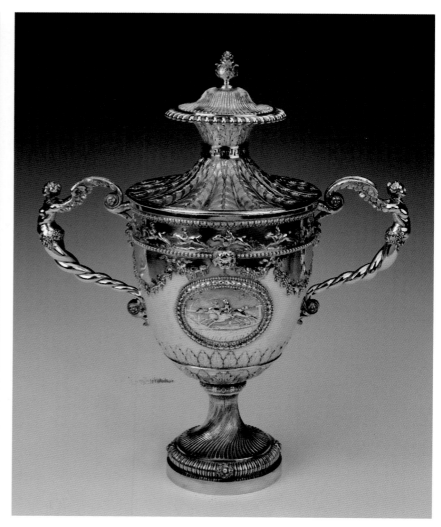

1740s silver cup The Rococo style was characterized by a mass of decoration and liquid curves, while neo-classical designs were simpler and drew on classical myths and architecture for inspiration. This mid-century cup has a sense of movement and slight asymmetry in its design – elements which show the influence of French style. *Anglesey Abbey, Cambridgeshire*

Cup and cover Neo-classical silver-gilt cup designed by Robert Adam in 1764. Adam (1728–1792) was an architect, but also designed entire decorative schemes, including furniture and fittings. This cup reflects his ideas about combining classical elements in a way that is precise, controlled and perfectly balanced. Every element of the design is kept separate, whereas in Rococo design the elements tend to merge with one another. *Anglesey Abbey, Cambridgeshire*

Edwards' silver-gilt work (top right). This silver-gilt egg boiler, spirit lamp and accompanying timer was made by John Edwards c.1802. They were acquired by William Hill, 3rd Lord Berwick (1773–1842), who amassed a large collection of silver, much of it when he was ambassador to Sardinia, Savoy and Naples (but the silver was supplied to him by the Crown). The simple, elegant design is accentuated by the handle of the egg boiler, with its entwined, writhing snakes. *Attingham Park, Shropshire*

Kandler tureen (centre right). The owner of Ickworth, Lord Bristol, the 4th Earl (1730–1803) collected a great deal of silver, including this tureen, c.1752, which is topped with the Hervey emblem, the snow leopard. The Earl particularly favoured the work of the London silversmith Charles Frederick Kandler, who was active between 1735 and 1773. Kandler produced some of the finest examples of English Rococo silver. *Ickworth, Suffolk*

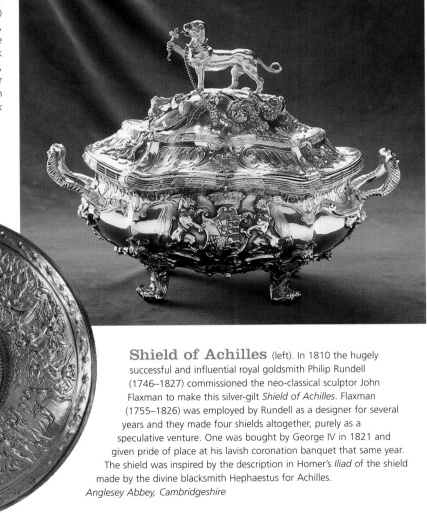

Shield of Achilles (left). In 1810 the hugely successful and influential royal goldsmith Philip Rundell (1746–1827) commissioned the neo-classical sculptor John Flaxman to make this silver-gilt *Shield of Achilles*. Flaxman (1755–1826) was employed by Rundell as a designer for several years and they made four shields altogether, purely as a speculative venture. One was bought by George IV in 1821 and given pride of place at his lavish coronation banquet that same year. The shield was inspired by the description in Homer's *Iliad* of the shield made by the divine blacksmith Hephaestus for Achilles. *Anglesey Abbey, Cambridgeshire*

Home and Abroad

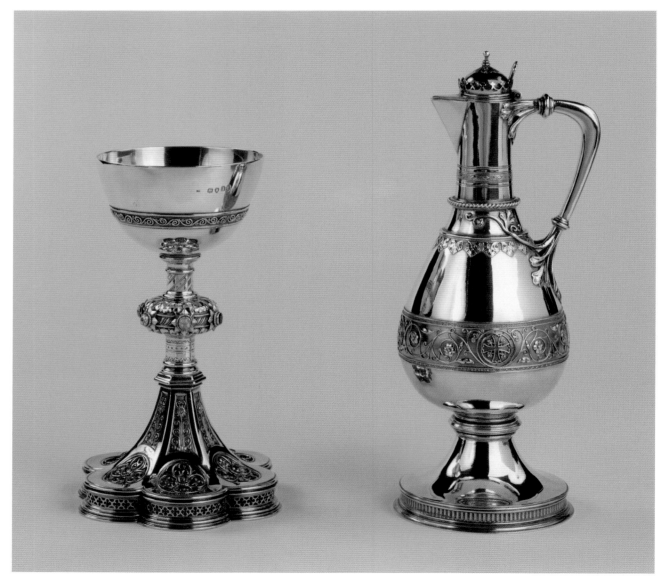

Chalice and flagon The prominent Gothic-Revival architect William Butterfield (1814–1900) designed the Tyntesfield chalice and altar flagon in 1876. They were made by Joss Barkentin, the 'Danish Cellini'. The chalice is studded with rubies, sapphires, opals, emeralds and diamonds, which have been set in an understated manner in keeping with its ecclesiastical function. The set was bought by the Art Fund from the estate of the 2nd Lord Wraxall, the final private owner of the house, who died in 2001, and presented to the National Trust. Both pieces are kept in the chapel, where their design perfectly matches its fine ecclesiastical craftsmanship and High Victorian, High-Church Anglican style.
Tyntesfield, North Somerset

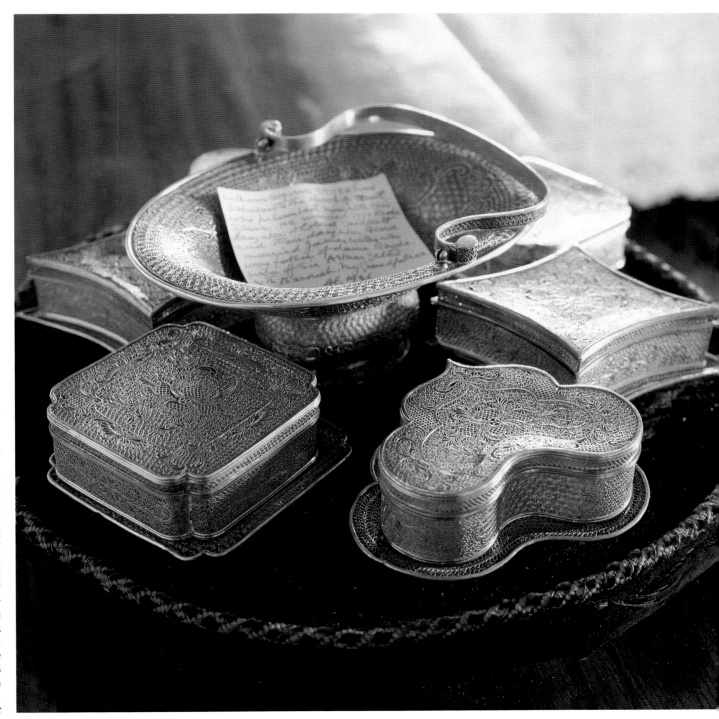

Indian filigree silverware

This 'pan' set would have contained an after-dinner digestive, such as nuts or fruits, which would be passed around after a meal. Boxes such as these were often given to the British by Muslim dignatories, and had been made on the sub-continent for many centuries with little change in the design. The silver filigree work is typically Islamic and probably came to India with the Moguls. The handwritten note (dated 1946) reads: 'William Wynch born 1750 was Secretary to the Nabob of Arcot who presented him with this silver. He married (1775) Rhoda daughter of Colonel Crockett and their daughter Flora married James Willis who was father of Dame Rhoda, wife of Sir Arthur Elton, my grandfather. A E 1946 (Arthur Elton 10th Baronet).' *Clevedon Court, Somerset*

Arts and Crafts and Beyond

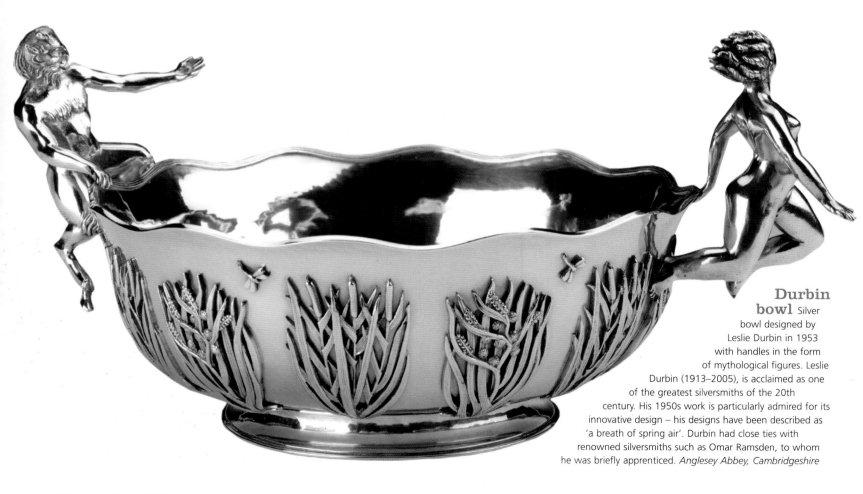

Durbin bowl Silver bowl designed by Leslie Durbin in 1953 with handles in the form of mythological figures. Leslie Durbin (1913–2005), is acclaimed as one of the greatest silversmiths of the 20th century. His 1950s work is particularly admired for its innovative design – his designs have been described as 'a breath of spring air'. Durbin had close ties with renowned silversmiths such as Omar Ramsden, to whom he was briefly apprenticed. *Anglesey Abbey, Cambridgeshire*

Sporting cup Omar Ramsden (1873–1939) made this large silver cup for Lady Heathcoat-Amory (1907–1997) of Knightshayes Court. The cup commemorates her astonishing achievement, while she was still Miss Joyce Wethered, of winning the British Ladies' Open Golf Championship four times in the 1920s (she is considered to be one of the best female golfers of all time). Ramsden was one of the leading English silversmiths of the period. After winning a competition to design a mace for the city of Sheffield, which he made with the silver designer Alwyn Carr (1872–1940), the pair went into partnership specializing in fine 'art' silver. This included pieces adapted from Gothic and Renaissance designs, as well as Arts and Crafts-style articles, which were very fashionable at the time. Their particular trademark was Celtic-style pieces. *Knightshayes Court, Devon*

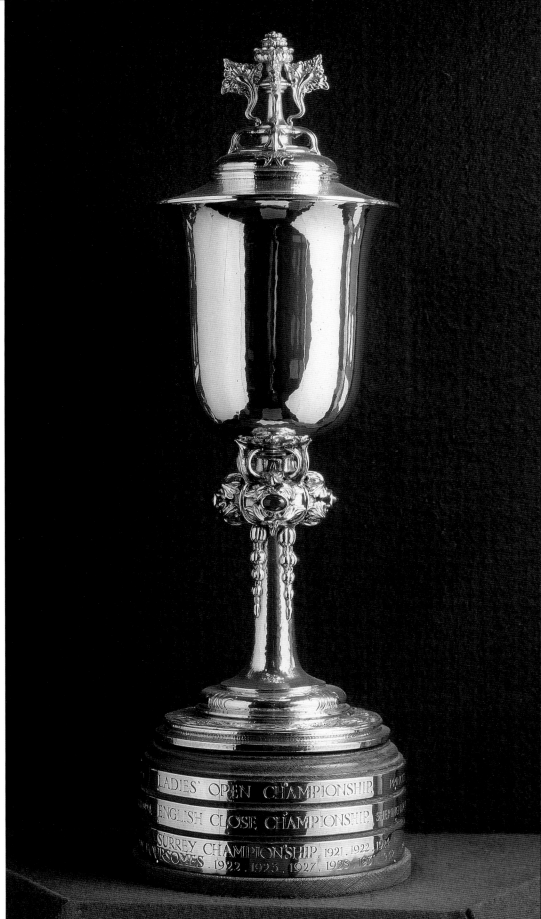

Jewellery

Objects of Vertu from Rome to Renaissance

Roman ring Made of solid gold, this 4th- or 5th-century ring was discovered at Silchester, Hampshire in 1789. The faceted, ten-sided band has a Latin inscription engraved on it, which reads: 'O Senicianus, may you live prosperously.' The fearsome-looking head, once thought to be that of a lion, has now been identified as that of the goddess Venus. A couple of decades after the ring was found, a Roman lead tablet was uncovered at the site of a temple in Gloucestershire, bearing an inscription referring to this same ring, cursing the person who had stolen it. There has been some suggestion that the story of this curse came to the attention of J R R Tolkien, who had been advising on finds at the temple, and that this ring was the inspiration for his *Lord of the Rings* trilogy. *The Vyne, Hampshire*

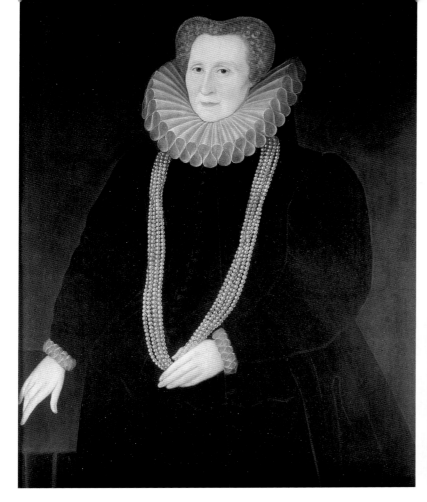

String of pearls (left). Attributed to the English painter Rowland Lockey (c.1566–1616), this 1590s portrait of Elizabeth Hardwick, Countess of Shrewsbury (1527–1608), shows her during the last of her four widowhoods. The individual pearls that make up this magnificent string were bought by Bess one at a time, with all the purchases being carefully recorded in her early account books.
Hardwick Hall, Derbyshire

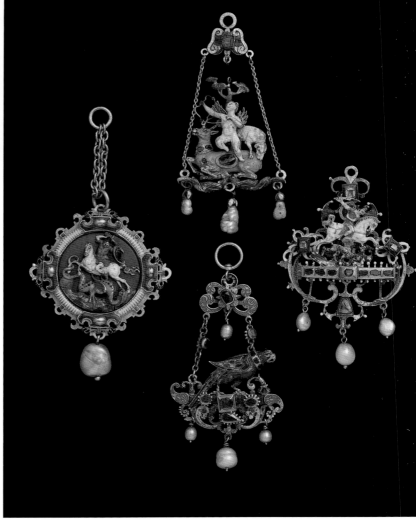

16th- and 19th-century jewellery A selection of 16th-century jewellery, some with 19th-century additions, typical components of the 19th-century collector's cabinet. Clockwise from left: Medallion of St George and the Dragon, 16th century with 19th-century additions; pendant of Diana on a stag with a hound, 16th century with 19th-century additions; pendant of St George and the Dragon, 16th century; pendant in the form of a parrot on a branch, 1600–1625.
Waddesdon Manor, Buckinghamshire

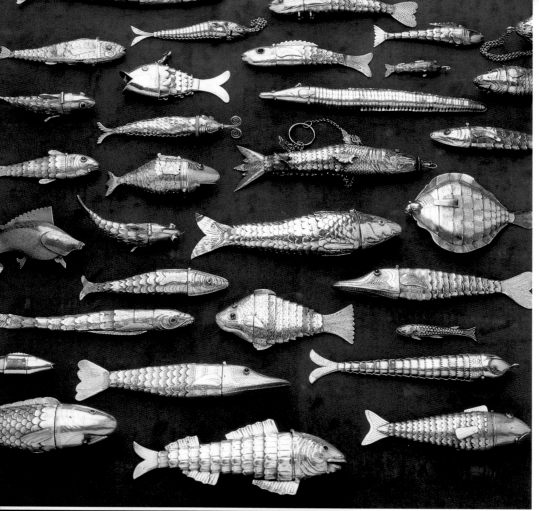

Cross Currents

Silver fish (left). Part of Geraldine, 3rd Marchioness of Bristol's unique collection of silver fish, some of which had unusual functions such as scent containers or vinaigrettes. *Ickworth, Suffolk*

Collection of crosses (right). Close-up of part of the collection of mainly 19th-century crosses amassed by Cara Broughton (1867–1939), the mother of Huttleston Broughton (1896–1966), joint owner of Anglesey Abbey. Cara Broughton was a former New York heiress who was made 1st Lady Fairhaven when her husband, Urban Hanlon Broughton, died in 1929. The crosses are mainly 19th century and are made from gold, silver and gilt metal and set with either semi-precious stones or paste. *Anglesey Abbey, Cambridgeshire*

Electric jewellery (left). Made in Paris in 1884, these Trouves Electric Jewels were used as hair adornments, scarf pins and walking-stick jewels. Small electric bulbs were enclosed in red and white glass beads so that when they were illuminated they gave the appearance of rubies and diamonds. They were powered by a small battery, designed to be concealed among clothing or hidden by hair. *Cragside, Northumberland*

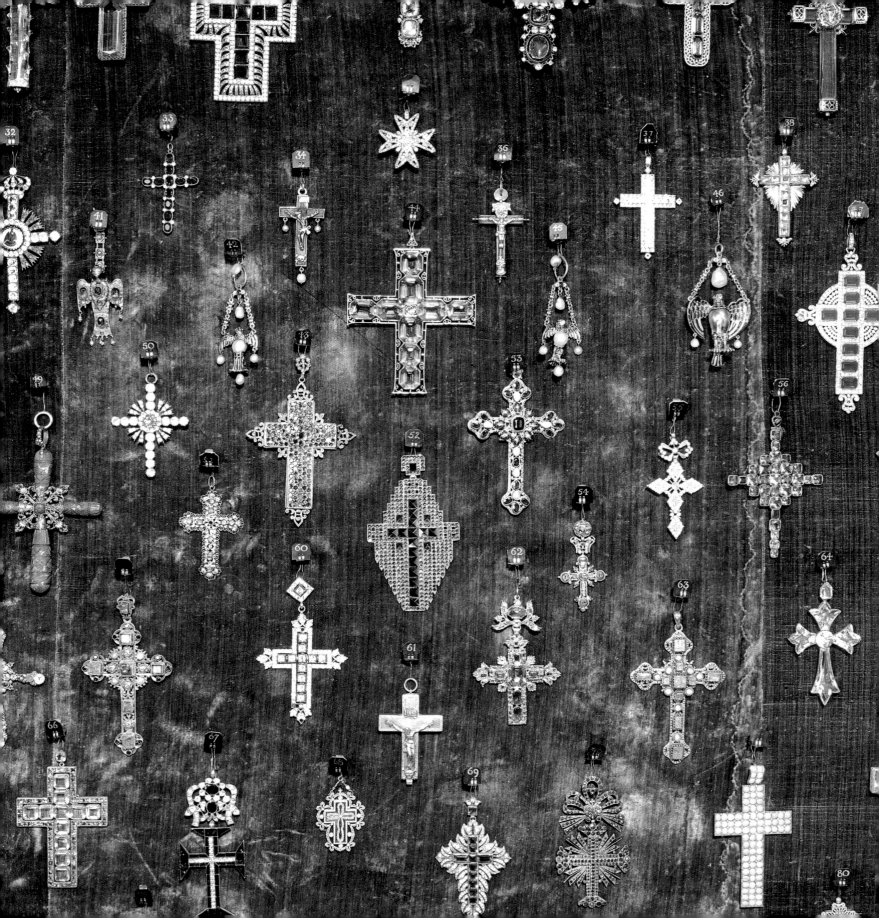

Fabergé and Fashion

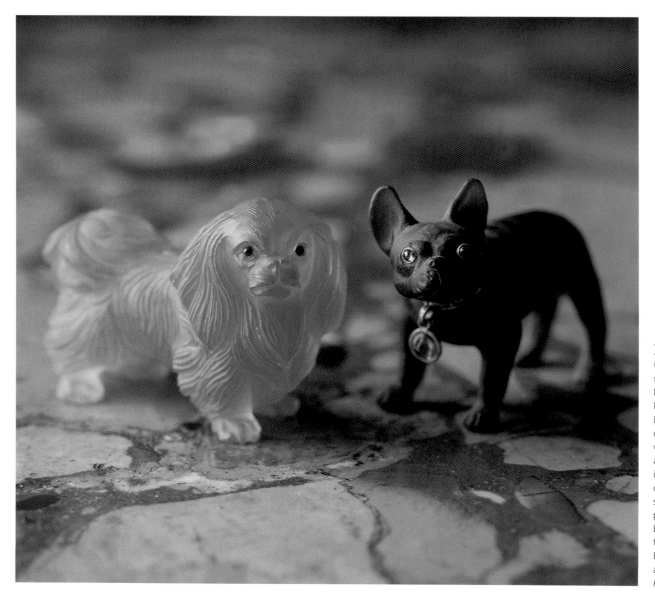

Miniature dogs (left). Two miniature dogs in the Drawing Room at Polesden Lacey. The Pekinese on the left is carved from rock crystal with inset rubies for eyes, and is by Cartier. The pug is by Fabergé, the company famous for its stunning Easter eggs, producing two each year between 1885 and 1917 for Tsar Nicholas II of Russia – one for his wife and one for his mother. *Polesden Lacey, Surrey*

Ellen Terry's earrings (right). These handsome earrings in their shaped red leather box are made from gold set with turquoises, and were presented to the actress Ellen Terry (1847–1928) by Marie Corelli (born Mary Mackay, 1855–1924), a talented musician who turned to writing and became a hugely successful novelist and celebrity. *Smallhythe Place, Kent*

Fashion collection (left). Items on display in a showcase in the Drawing Room include a watch, snuff boxes and miniatures in ivory, enamel and other materials. *Berrington Hall, Herefordshire*

Lighting

Candlesticks

Chelsea style (left). This Chelsea porcelain candlestick, c.1765, depicting a leopard and fox was inspired by Aesop's Fables. It was produced during the Gold Anchor period at Chelsea (1758–1769) – a time when the factory specialized in heavily gilded pieces with boldly modelled shapes and large clumps of flowers and foliage. *Upton House, Warwickshire*

Altar candlesticks (opposite, top left). Made from pewter in the Baroque style, this pair of pricket candlesticks have elegant turned-up tripod feet. They make up part of a large collection of pewter amassed by the last owner of Arlington Court, Miss Rosalie Chichester (1865–1949). Pricket, as opposed to socket, candlesticks had a simple spike upon which the candle was impaled. *Arlington Court, Devon.*

Georgian craftsmanship (opposite, top right). Made by the early 18th-century goldsmith Peter Archambo, these candlesticks are dated 1739. They are in the Rococo style, which Archambo was instrumental in introducing to England in the 1730s. *Dunham Massey, Cheshire*

Pewter pricket (opposite, bottom left). Simple pewter pricket candlestick with a grooved base from Miss Chichester's collection. The dull colour of this pewter is caused by oxidization. Pewter candlesticks were often made by turning on a metal lathe; this was possible because pewter is such a soft, malleable material. *Arlington Court, Devon*

Spring-loaded candlestick (opposite, bottom right). The cowled shade on this spring-loaded candlestick is designed to intensify and focus light, making it especially useful for reading. Spring-loaded candlesticks, where the candle was held in a fixed position and the flame was contained, were safer than conventional designs. *Arlington Court, Devon*

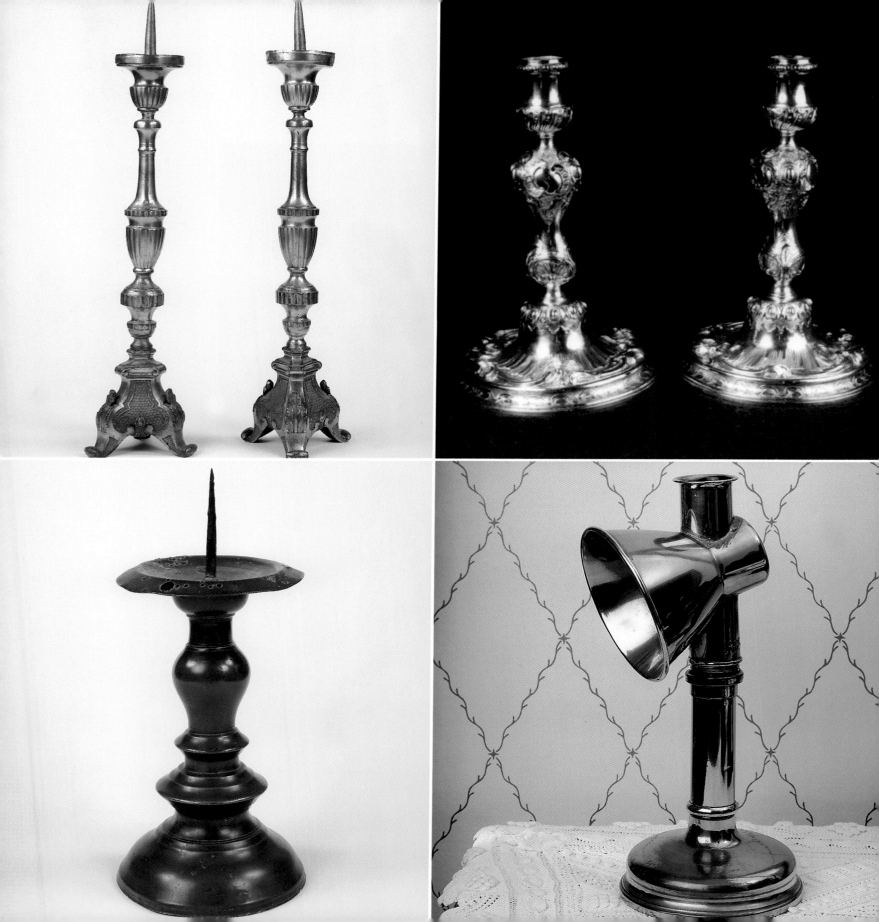

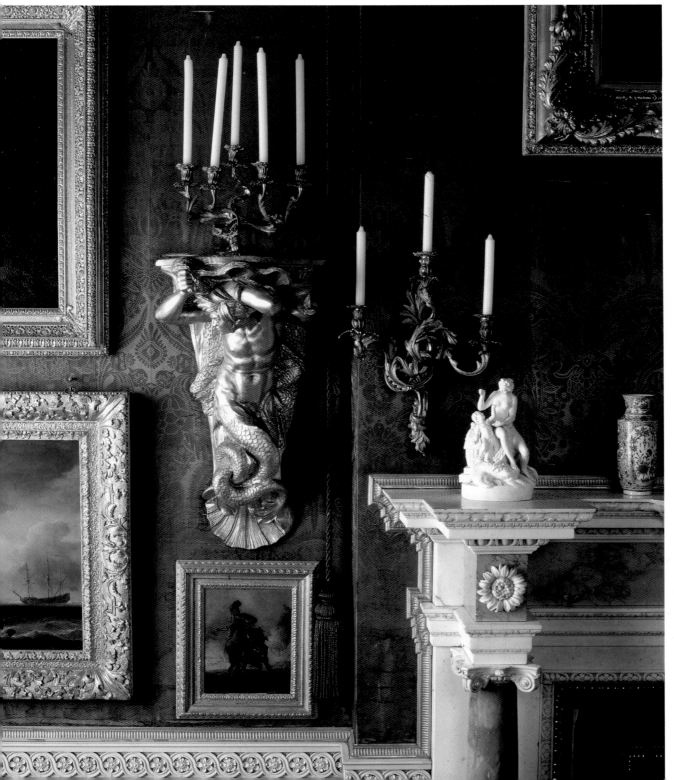

Wall Lights

Rococo style (left). This striking gilt plaster bracket in the form of a triton (male mermaid) is one of a pair flanking the fireplace. It dates from the 1750s and supports an ormolu candelabrum. There is an ormolu candle sconce attached to the wall beside it. The fabulously ornate design of these candle branches, full of curves and twists, is typical of the Rococo style. The word 'ormolu' derives from the French *or moulu* (which translates as 'ground or powdered gold'), and is used to describe 18th- and early 19th-century decorative objects or furniture mounts, made in cast brass, chased and gilded. *Felbrigg Hall, Norfolk*

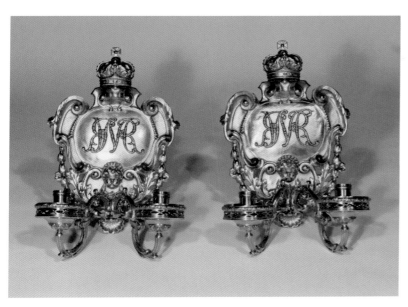

Royal sconces (above). Originally made for the crown (as is evident from the William and Mary monogram and coronets), this pair of sconces was given to the Royal goldsmiths Rundell, Bridge & Rundell by George IV to be melted down in order to make a new commission. The goldsmiths, however, sold the sconces and used other melt bullion to fulfil the King's order. The pair, which date from the late 17th century, came to Belton House in 1808. *Belton House, Lincolnshire*

Arts and Crafts (right). Repoussé copper sconce plate decorated with sunflowers, designed by Philip Webb (1831–1915) and made by John Pearson. The technique of repoussé was practised by many ancient civilizations. It involves creating relief designs by hammering out the back on an article by hand. It was a technique particularly in keeping with the Arts and Crafts movement's ethos, which championed high quality, hand-crafted goods. *Standen, West Sussex*

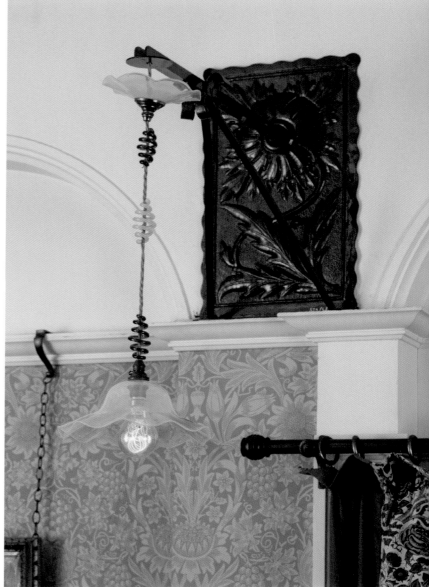

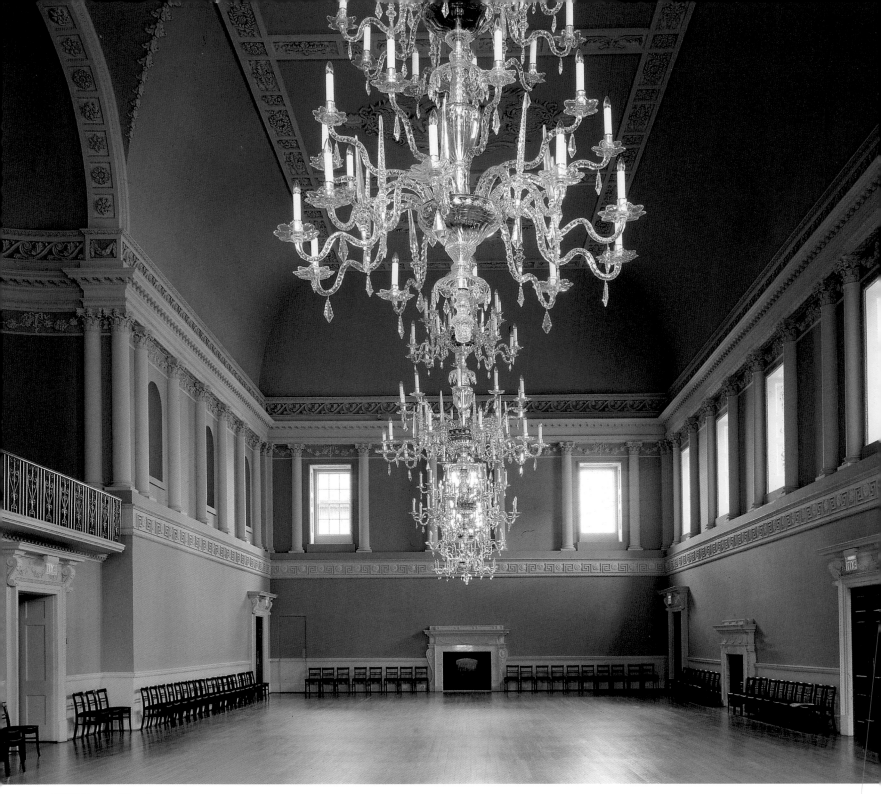

William Parker The magnificent cut-glass chandeliers in the Ballroom at Bath's Assembly Rooms were made by William Parker in 1771. Parker was one of the most famous chandelier makers of the day, carrying out commissions for the Prince Regent as well as Buckingham Palace. Many chandeliers from this period have survived in excellent condition, partly because candles were so expensive that even the rich were thrifty with them, meaning that some chandeliers were only lit very occasionally. *Assembly Rooms, Bath, Somerset*

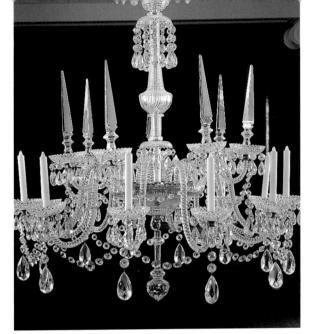

By Candlelight

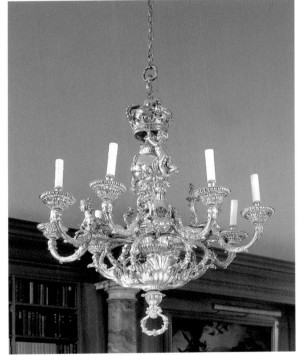

18th-century glass (top). The tall upright cut-glass prisms at the top of this chandelier served two purposes. They were extremely decorative, so relieved the bare appearance of any empty candle sockets, yet they also acted as light intensifiers. When the lower candles were lit, the light they threw would bounce off the numerous faces of the prisms, creating a bright, sparkling effect. The chandelier dates from the late 18th century and was made in Ireland of Waterford glass. *Arlington Court, Devon*

Georgian silver (centre). The prancing white horse beneath the crown at the top of this silver chandelier is the emblem of the House of Hanover. Indeed this chandelier, one of a set of five, was manufactured in 1736–1737 for George II's summer palace in Hanover. It was made by the Hanoverian court goldsmith, Balthasar Friedrich Behrens, to drawings by the eminent architect and designer William Kent (1684–1748), who helped to introduce the Palladian style of architecture into Britain. *Anglesey Abbey, Cambridgeshire*

Light intensifier (bottom). The purpose of this bowl of water is to act as a primitive light intensifier. The candle would be placed so that its light shone through the water, and as the water in the bowl acted like a lens, the light would be magnified. This meant that fewer candles needed to be used, which was important as even tallow candles, such as this one, were expensive. Tallow candles were made from animal fat and were cheaper than those made from wax, so they were the only candles most households burnt, although even the wealthy would have used them for everyday light. They had a very unpleasant smell. *Troutbeck, Cumbria*

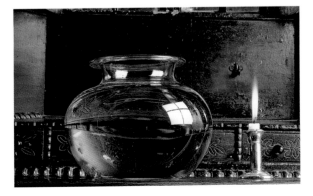

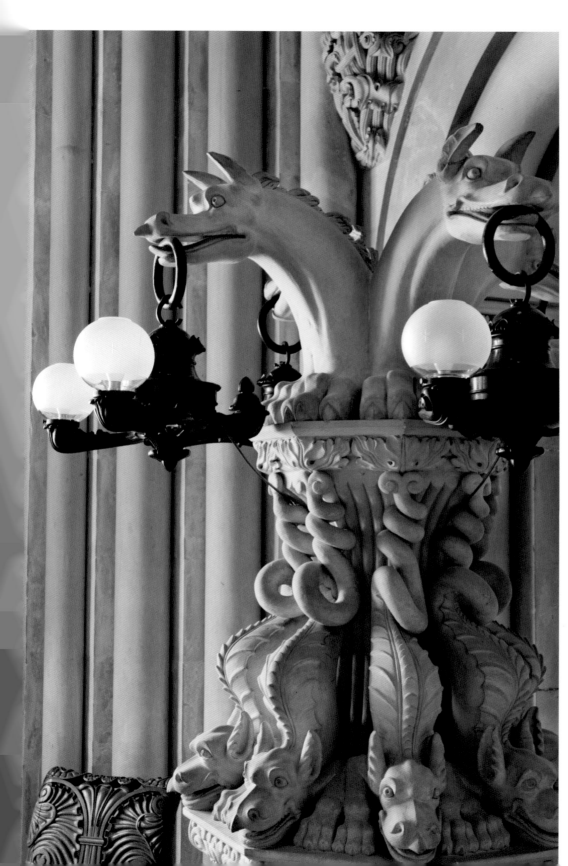

Oil and Gas Lighting

Neo-Norman luminaires (left). The pedestal from which these luminaires hang is supported by fantastical sea-serpents, while the lamps themselves are held up by equally striking dragons. The lamps have unusually large oil reservoirs and would have burnt vegetable oil.
Penrhyn Castle, Gwynedd

'Colza' lamp (below). Eventually converted to electricity, this bronze-coloured hand-held lamp was originally designed to burn colza, an oil extracted from the seeds of a plant, which is very similar to rapeseed oil. The lamp is believed to be Spanish.
Kingston Lacy, Devon

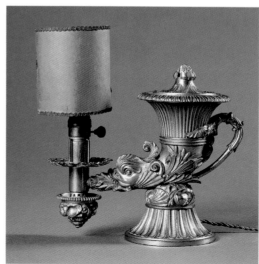

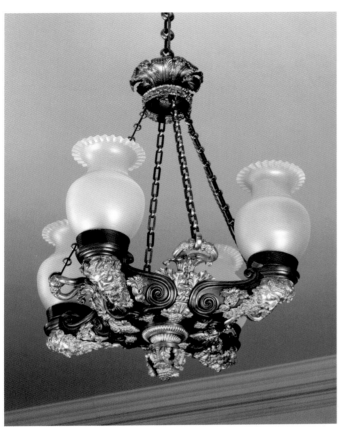

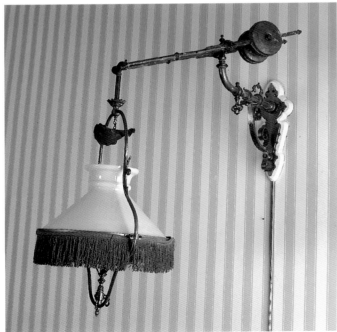

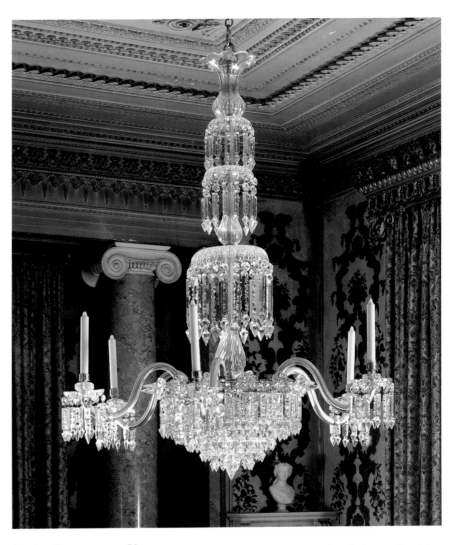

Cut-glass gasolier (above). Discovered in a boathouse on Lake Windermere, Cumbria, this ornate gasolier is believed to have once hung in the nearby Fell Foot manor house. It now hangs in the morning room at Arlington Court. With the advent of gas lighting some chandelier makers diversified to produce cut-glass gasoliers such as this for their wealthier clientele. Less well-off consumers had to rely on catalogues featuring over-ornate, uninspired designs. *Arlington Court, Devon*

Chandelier (top left). This chandelier was made c.1821 and is decorated with gilded philosopher's masks. It is an Argand lamp, a type of lamp invented by Aimé Argand in 1780 which had a circular wick mounted between a pair of cylindrical metal tubes so that air passed through both the centre and edges of the wick. This lamp was later converted to paraffin, which is much cheaper than whale oil, its original fuel. *Arlington Court, Devon.*

Wall bracket (left). Curiously named the 'Surprise', this wall fitting was designed in 1893 by Robert Hall Best, a Birmingham fittings manufacturer. There was also a ceiling version, which shared the ingenious construction that allowed it to be adjusted to different heights, as well as swung around to different positions. It proved very popular and its success was sealed when the Prince of Wales bought a 'Surprise' for the Library at Sandringham. *The Argory, County Armagh*

Electricity

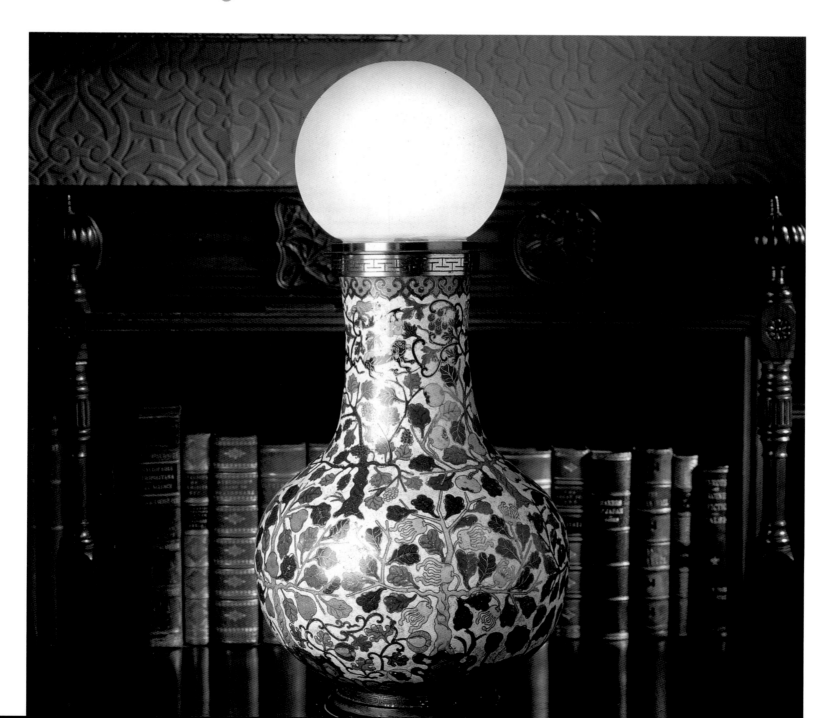

Vase conversion (left). The owner of Cragside, William Armstrong, the 1st Lord Armstrong (1810–1900), was an innovator who converted his house to electricity in 1878, making it the first house in the world to be lit in this way. This large cloisonné vase was made into a lamp in 1880, the date of Armstrong's second electric lighting scheme, which used the newly invented incandescent bulbs. *Cragside, Northumberland*

Wall bracket (right). Originally a gas light, c.1880, this fitting was converted to electricity as late as 1947. The wonderful Victorian design features a winged mermaid. *Sunnycroft, Shropshire*

Carbon lamp (below). This large lantern dates from the late 18th century and would originally have contained a candle. Later it was adapted to hold a carbon bulb with a 'hairpin' filament. Early owners of electric lights were keen that people should be able to see this miracle of science, so rarely shaded their lamps or else used clear glass. *Saltram, Devon*

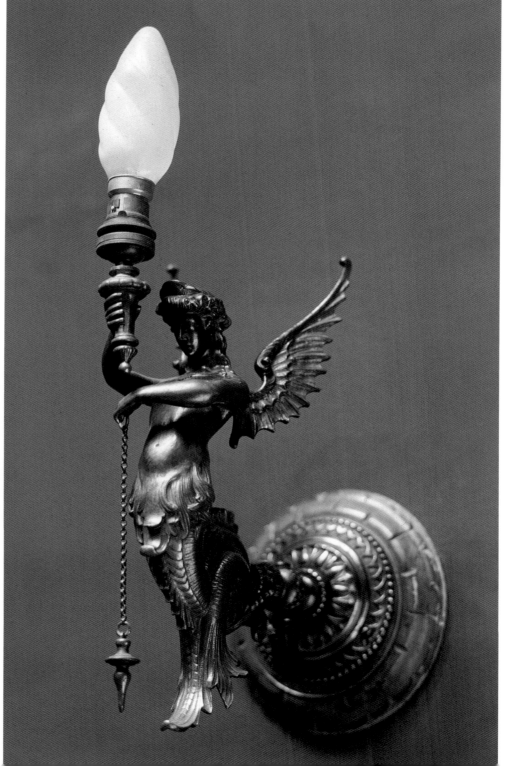

Modernist
Lighting

'Tulip' light This simple
yet elegant tulip-shaped light
fitting, c.1962, was designed by
the architect Patrick Gwynne
(1913–2003), for the Entrance
Hall of The Homewood. Gwynne
originally designed the house for
his parents, then took over the
property on their deaths a year
after it was completed. He paid
meticulous attention to every
single detail of the building,
including all the furniture and the
fittings, the design of which
shows a sophisticated Continental
approach to Modernism.
The Homewood, Surrey

Art Deco (top). Evoking the modernity of the Jazz Age, this octagonal ceiling light with its dangling tassels throws a soft, flattering light through its frosted shade, with its alabaster central section. The light fittings are a particular feature of the house, designed in 1925 for Rupert D'Oyly Carte, by the architect Oswald Milne (1881–1967). A former assistant to Sir Edwin Lutyens, Milne believed in the importance of simple design and expert craftsmanship.
Coleton Fishacre, Devon

Goldfinger wall brackets (bottom). All the light fittings at 2 Willow Road were designed by the house's architect and owner, the renowned Ernö Goldfinger (1902–1987). He intended them to be as unobtrusive as possible, as he believed there was too much emphasis on how light fittings looked, rather than on the quality of lighting they provided. These hinged wall-mounted uplighters have ribbed-glass reflector shades, more commonly used in an industrial environment. *2 Willow Road, London*

Metalwork

For the Fireplace

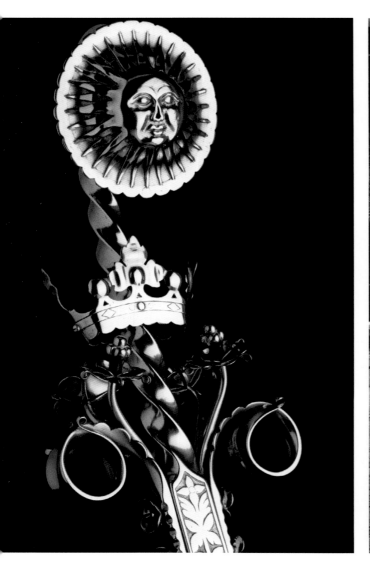

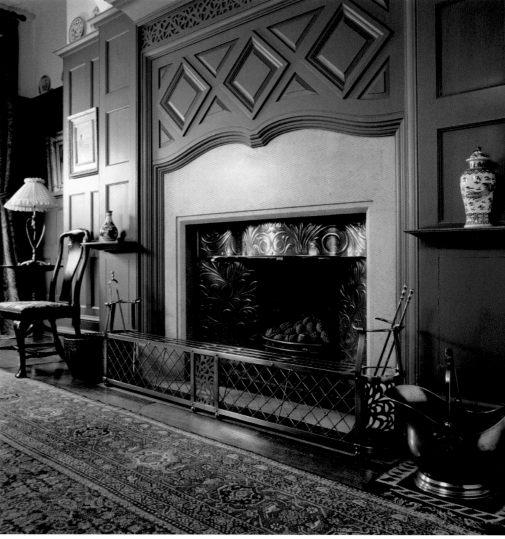

Firedog (far left). John Hungerford Pollen designed this firedog for William, the 8th Marquess of Lothian, in the early 1860s. The handle features the 'sun in splendour' from the Lothian coat of arms. J H Pollen was an adventurous architect and decorative painter who did a great deal of work for the Marquess, having become his friend at Oxford. The firedog was made by Joshua Hart & Sons. *Blickling Hall, Norfolk*

Webb fireplace (near left). This entire fireplace was designed as an ensemble by the architect and designer Philip Webb (1831–1915), who designed and built Standen for James Beale, a prosperous London solicitor, in 1892–1894. Webb was one of William Morris's closest friends, and his business partner and collaborator. Even the fender matches the scheme, with its trelliswork, plus central and side panels reflecting the forms in the overmantel and fretwork above. The design of the repoussé work on the smoke cowl and sides of the fireplace is based on curving plant forms. (Repoussé is a technique whereby metal is decorated by hammering on the reverse.) Webb was passionate about fine craftsmanship and used only the best materials. The fireplace was made up by Thomas Elsley, a London blacksmith Webb used frequently. *Standen, West Sussex*

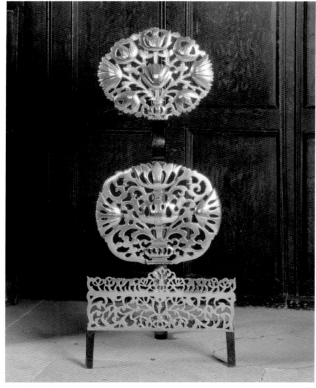

Housekeeper's fireplace (top). The large black cast-iron kettle and copper kettle with accompanying saucepan are sitting on the range in the Housekeeper's Room at Uppark. The mother of the writer H G Wells (1866–1946) was housekeeper at the house during the late 19th century and Wells has documented the daily ritual of afternoon tea there. He describes it as being long, repetitive and desperately dull. *Uppark, West Sussex*

Andiron (bottom). The cast and pierced brass plates mounted on the wrought-iron framework of this andiron are exceptionally detailed. Dating from c.1670, it stands in a room redesigned by the architect and designer A W Pugin (1812–1852) in the Gothic Revival style. Andirons were stands which were used to hold burning wood on the hearth. They were a common item of household equipment, but ones with such quality of craftsmanship and design are extremely rare. *Chirk Castle, Wrexham*

Keys and Locks

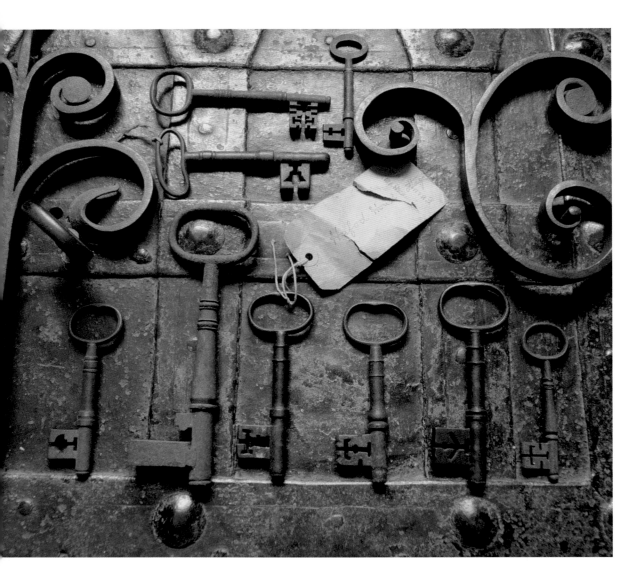

Agent's keys (left). Selection of old keys laid out on a chest in the Agent's Room. One key still has its original paper tag. The Agent was responsible for paying wages, keeping the accounts and organizing the work of the outdoor staff. *Erddig, Wrexham*

Door plate (opposite, top right). William Sandys (d. 1540), whose initials appear on this door plate, was Henry VIII's Lord Chancellor and the builder of The Vyne. Between 1518 and 1526 Lord Sandys commissioned major work to be done on the Oak Gallery, where this door hangs, and instructed that his initials, coat of arms and insignia be used wherever possible. *The Vyne, Hampshire*

Dower chest (opposite, top left). Bearing the initials and date 'WS 1571 AS', this ornamental lock is on an oak dower chest (one of a matching pair). The AS and WS stand for Alice and Walter Strickland. It was Walter (1516–1569) who was responsible for transforming the castle into a fashionable Elizabethan residence. Dower chests were used to hold clothes and bed linen and were presented to women upon marriage. It was common to incorporate significant initials or dates. *Sizergh Castle, Cumbria*

Lock and handle (opposite, bottom right). The architect George Frederick Bodley (1827–1907) remodelled the Oak Drawing Room at the castle for the 4th Earl of Powis in 1902–1904. His designs are in neo-Jacobean style and he paid great attention to every little detail – from the furnishing fabrics right down to this intricately decorated door handle and lock. *Powis Castle, Powys*

Front-door plate (opposite, bottom left). The ornate ironwork script on the entrance door to the hall shows the monogram of the owners, the Kay-Shuttleworth family. It was made by Hardman's of Birmingham in 1851 to a design by the great 19th-century neo-Gothic architect and designer A W N Pugin (1812–1852). *Gawthorpe Hall, Lancashire*

Handles and Hinges

Fingerplate (above). The architect Philip Webb designed this ornate pierced fingerplate. Matching plates can be found on both sides of all internal doors of the family side of the house, while the servants' wing has plain brass fingerplates. *Standen, West Sussex.*

Adam's design (left). This ornate gilded door handle in the Saloon is based on a design from the second volume of Robert Adam's *Works in Architecture* of 1779. This room was Adam's first commission for the house and he designed virtually everything himself to make certain that all the elements – from the plasterwork on the ceiling to the matching carpet and these door handles – would work together as a coherent scheme. *Saltram, Devon*

Arts and Crafts (above). Extremely simple yet supremely elegant, the hinge on this ox-blood lacquered dresser was designed by the architect of the Red House, Philip Webb (1831–1915). Webb was commissioned by William Morris to design his home in 1859. The Arts and Crafts movement was a reaction to the uniformity of the industrial age, and Webb and Morris believed in using the finest materials and most skilled craftsmen to create unique, high-quality pieces. *Red House, Bexleyheath, London*

Gothic Revival (top). Inscribed *'Litera scripta manet'* which translates as 'The written word remains', this hinge bar was designed by the architect of Tyntesfield, John Norton, in 1864. Norton was a friend of A W N Pugin and an advocate of the Gothic Revival style. He was very fond of inscriptions, and they appear all around the house. *Tyntesfield, North Somerset*

Medieval (bottom). This elaborate hinge is on a door to a medieval room in Stoneacre, a half-timbered yeoman's house in Otham, Kent. The house was rescued in 1920 by the writer and antiquarian Aymer Vallance (1862–1943), who embarked upon sensitive restoration following the ideals of the Arts and Crafts movement. *Stoneacre, Kent*

For the Table

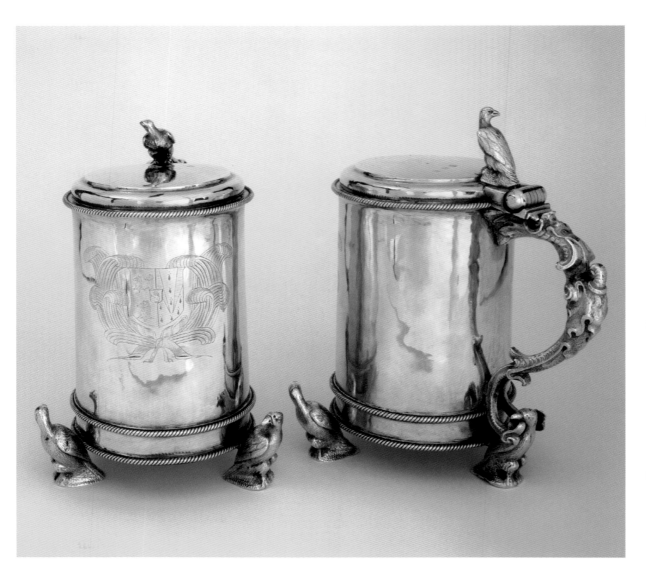

Silver tankards (left)
A pair of Charles II tankards by Thomas Jenkins, c.1671. The tankards are the only examples of 'heirloom' plate surviving at Dunham and were probably inherited from the 1st Lord Warrington's maternal grandfather, Sir James Langham, who died in 1699 and whose arms they bear. They were venerated by the family through the centuries and it was expressly stipulated in at least one of the family's wills that they should be preserved as the property of every subsequent owner of the house.
Dunham Massey, Cheshire

Arlington collection (right). Charger and spoons from the collection of pewter at Arlington Court. The two decorated spoons are possibly Flemish and possibly depict the head of Queen Anne, while the small spoon on the right is Dutch, mid-17th century. This type of spoon is often referred to as a 'schnapps' or 'bridal' spoon because they were used by ladies for wedding toasts.
Arlington Court, Devon

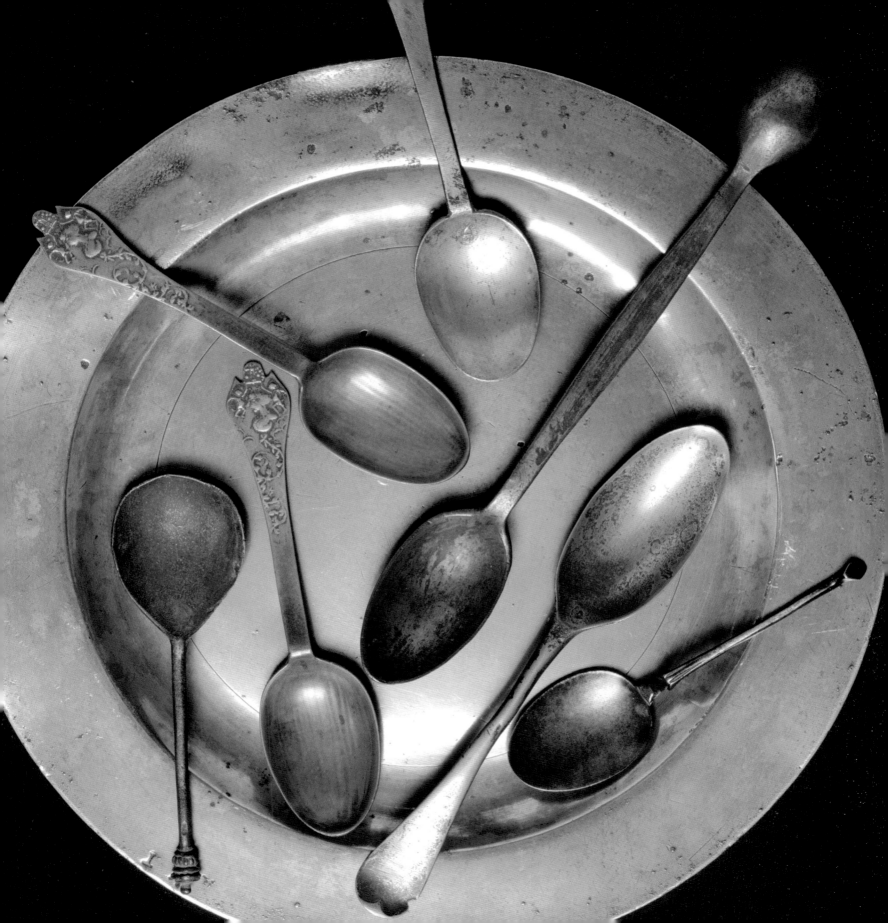

For the Kitchen

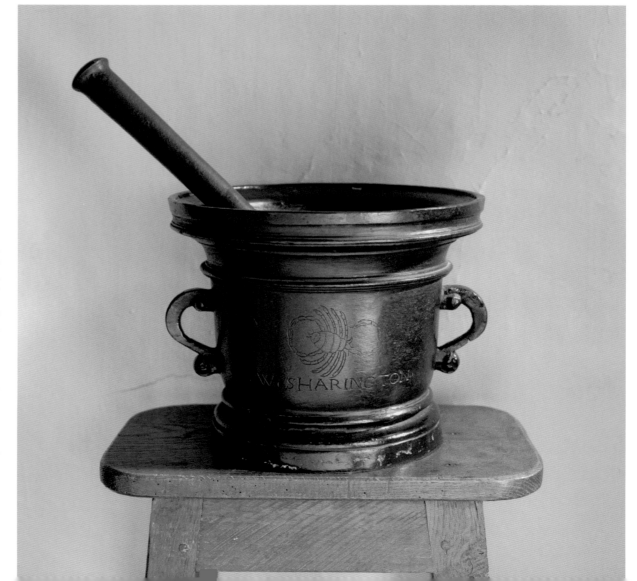

Pestle and mortar Recorded as being in the Kitchen at Lacock in a 1575 inventory, this pestle and mortar were used to grind herbs and spices. Made of bronze, they weigh a massive 100lb and are engraved with the name 'W Sharington' and a scorpion. William Sharington (c.1495–1553), whose crest this scorpion is, bought the Abbey in 1540 after it was dissolved and turned it into a house. It was unusual to have bronze kitchen equipment – early pieces were usually made from brass or pewter. *Lacock Abbey, Wiltshire*

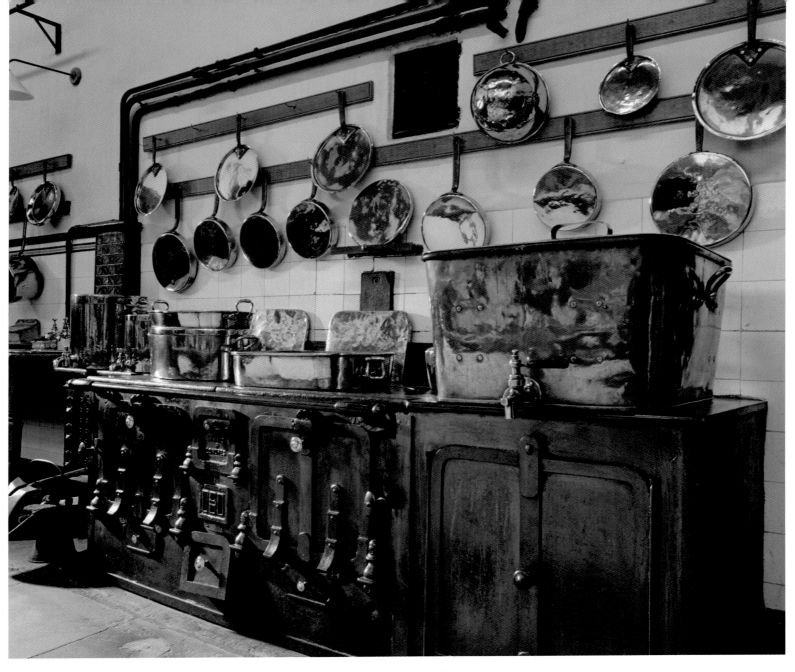

Batterie de cuisine (above). The term *batterie de cuisine* simply means 'kitchen equipment', and in a large country house this could include hundreds of pieces. Cooking vessels were made from copper sheet lined with tin, and had either cast brass loop handles or long iron handles, as can be seen on the frying pans and skillets hanging from the wall. The copper was lined with tin because copper can taint food, giving it an unpleasant taste, and verdigris, the green colouring that forms when the metal ages, is poisonous. *Lanhydrock, Cornwall*

Copper moulds (left). The 1st Lord and Lady Penrhyn, Edward Douglas-Pennant (1800–1886) and Juliana Dawkins-Pennant (1808–1842), entertained on a lavish scale, so these ornamental moulds would have been put to good use. They would have been used for cold puddings such as blancmanges and ice-cream, and also for pastry and sponges and even savoury dishes. *Penrhyn Castle, Gwynedd*

Stairs, Screens and Gates

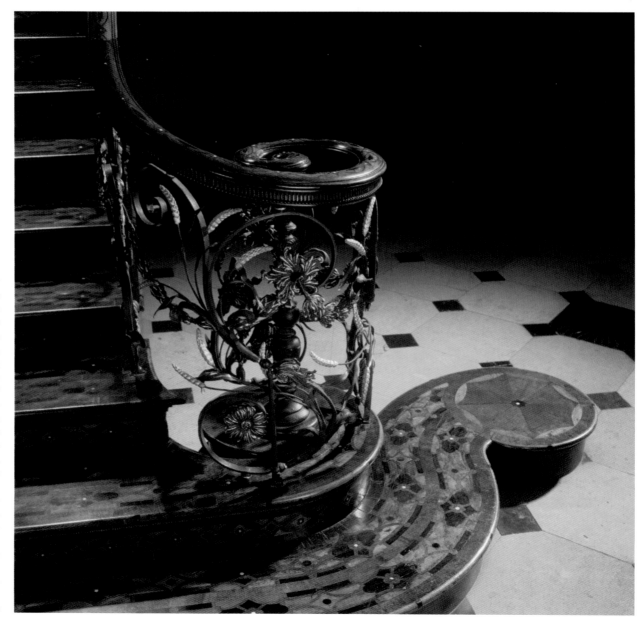

18th-century virtuosity The wrought-iron balustrade of this extraordinary staircase, c.1768, has been put together as a series of elaborate curving scrolls, linked by a continuous garland of gilded husks and delicate ears of corn. The various elements are so fragile that the vibrations made when someone ascends the stairs causes them to rub against each other, resulting in a gentle rustling sound. This has led to the legend that the staircase sings. Unfortunately the craftsman who produced this remarkable tour de force is unknown. *Claydon House, Buckinghamshire*

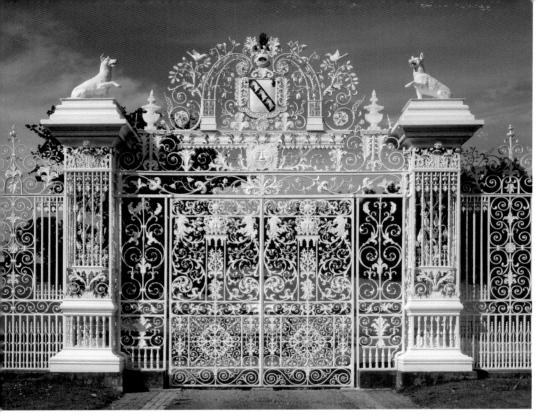

Baroque ironwork (top). Among the many distinctive features of this spectacular gatescreen are the exuberant overthrow (the section above the gates) emblazoned with the arms of Chirk Castle's owners, the Myddeltons, and the open piers topped with wolves and containing exotic wrought-iron plants. This Baroque masterpiece was made between 1712 and 1719 by Robert and John Davies of Bersham. *Chirk Castle, Wrexham*

Early 18th-century (bottom left). The grand wrought-iron screen at the end of the canal has been attributed to Robert Davies, of Croesfoel, near Wrexham. Dating from the early 18th century, the gatescreen was brought from nearby Stansby Park in 1908 by Erddig's owner, Philip Yorke II (1849–1922). *Erddig, Wrexham*

High Victorian (below). Detail of the filigree wrought-iron screen in the chapel at Tyntesfield. It was made by the firm of metalworkers Barkentin & Krall, and designed by the architect of the Chapel, Arthur Blomfield (1829–1899). Blomfield was a prolific designer of High Church churches, and built the Tyntesfield Chapel between 1873 and 1875. *Tyntesfield, North Somerset*

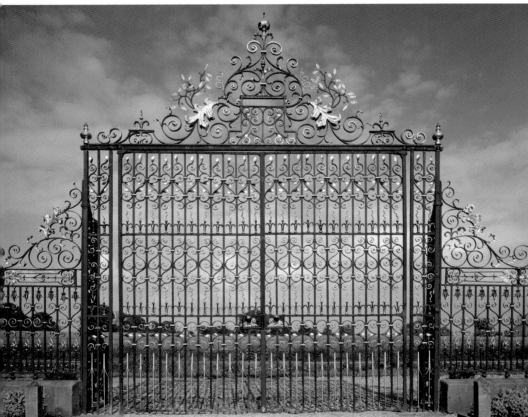

Miniatures

16th and 17th Centuries

Unknown Gentleman (right). Painted in 1658 by Samuel Cooper (1609–1672), this tiny miniature shows a gentleman in armour with a landscape background. Cooper was one of the greatest miniaturists of the 17th century, and painted Charles II, James II and Oliver Cromwell, among many others. *Sheringham Park, Norfolk*

The Green Closet at Ham House (left). This room was designed to display cabinet pictures and miniatures, and it has remained architecturally unchanged since c.1672. Its single window faces north to minimize the harmful effects of natural light on the delicate colours of the miniatures and small cabinet paintings. The miniatures are hung from copies of the original gilt and lacquered pins. The ceiling painting was done by Franz Cleyn (1582–1658). No miniatures can be seen in this view, taken before a recent rehang. *Ham House, Surrey*

Lord Dacre (above). John Hoskins (died 1664/5), Cooper's teacher, painted this miniature of Richard, 13th Baron Dacre in 1630. He was the first husband of Dorothy, daughter of Lord North, who married as her second husband Chaloner Chute, Speaker of the House of Commons and purchaser of The Vyne in 1653. *The Vyne, Hampshire*

Mars and Venus (above left). This copy of a miniature by Peter Oliver (c. 1594–1647) is based on a painting by Titian that was in the Earl of Arundel's collection and is now in the Kunsthistorisches Museum in Vienna. Besides painting original portraits, Oliver made copies of works by Correggio and Holbein as well as Titian. His work was held in such high regard that Charles II visited his widow to buy some of the miniatures she still owned. *Kingston Lacy, Dorset*

Edward Herbert, 1st Lord Herbert of Chirbury (left). Regarded as an outstanding work among all British miniatures, this portrait by Isaac Oliver (d. 1617), father of Peter, depicts Lord Herbert (cf. page 303) as a melancholy knight and lover. Oliver was born in Rouen of Huguenot parents and came to England in 1568, becoming Hilliard's great successor. Earl of Powis, *Powis Castle, Powys*

18th-Century Miniatures

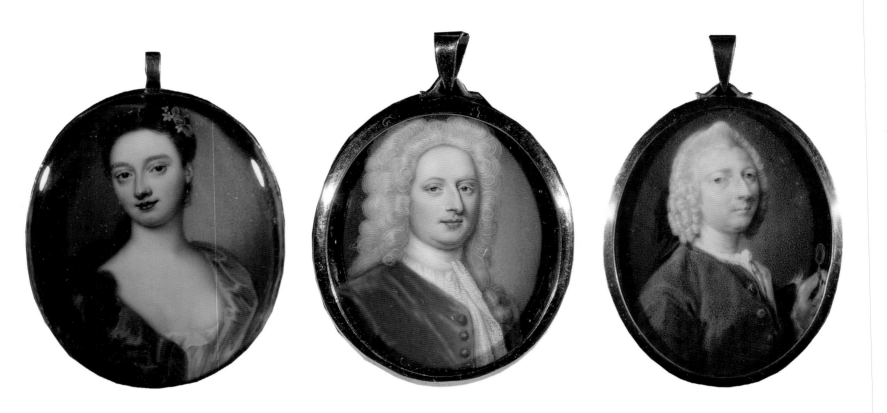

Lady Firebrace (above left). Painted in enamels by Christian Frederick Zincke (1683/4–1767), this portrait of Bridget Evers was made to commemorate her marriage in 1737 to Sir Cordell Firebrace, owner of Melford Hall. Zincke was born in Dresden and came to England in 1706, establishing a royal and distinguished clientele as one of the greatest enamellists of the 18th century. *Melford Hall, Suffolk*

Anthony Chute (centre). This portrait of the owner of The Vyne between 1722 and 1754 was painted by Christian Frederick Zincke (1683/4–1767). Anthony Chute's main interest appears to have been horses, though he was elected MP for Yarmouth on the Isle of Wight in 1734. He acquired a good portion of the 18th-century fittings and furniture in the house. *The Vyne, Hampshire*

John Chute (right). A case of miniatures at The Vyne contains this portrait of John Chute holding his spectacles, by Pompeo Batoni (1708–1787). As the youngest of his father's ten children, John Chute was unlikely to have inherited. He spent many years in Italy, and this portrait was almost certainly painted in Rome. John Chute was one of the 'Committee on Taste' that helped Horace Walpole to create the 'little Gothic castle' of Strawberry Hill. *The Vyne, Hampshire*

Charles I This miniature copy of Van Dyck's famous equestrian portrait of Charles I was painted by Bernard Lens III (1682–1740) when it was at Blenheim Palace. Lens copied oils and miniatures, painted miniatures on vellum and was the first British artist to paint on ivory. *Croft Castle, Herefordshire*

19th-Century Miniatures

Venus and Cupid

(left). This enamel was copied by Henry Bone, RA (1755–1834) from an original painting then thought to be by Paolo Veronese (1528–1588). Born in Truro, Henry Bone is the best-known English enameller. He painted decoration for watches and jewellery as well as numerous copies of full-scale paintings. *Kingston Lacy, Dorset*

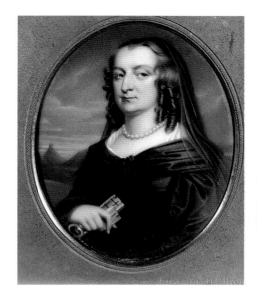

Lady Bankes (top left). This miniature by Henry Bone, RA (1755–1834) is one of 55 enamel miniatures bought at auction by William Bankes in 1836. Henry Bone had offered a set of 85 to the nation for £4,000, but the offer was declined. William gave most of them to his brother, the Rev. Edward Bankes, but after his flight abroad in 1841, Edward had a fit of conscience and returned them to Kingston Lacy. *Kingston Lacy, Dorset*

William John Bankes (top right). This miniature by George Sandars was done in 1812, the year William was one of the leading lights of the London season. Most of Kingston Lacy's collection of miniatures are in a case in the Drawing Room. *Kingston Lacy, Dorset*

William Gibbs and his two eldest children (bottom right). Sir William Ross, RA (1794–1860), who was Queen Victoria's Miniature Painter in Ordinary, painted three charming family groups depicting, separately, William Gibbs and his wife with two and three children respectively, and one of two sons. The two children here are Dorothea and Antony, who inherited Tyntesfield on his father's death in 1875. *Tyntesfield, North Somerset*

Mosaics

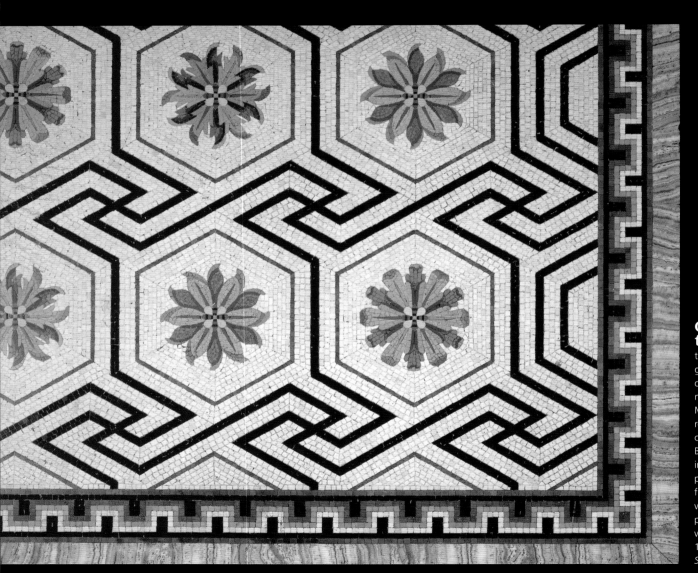

Ormolu marble table top This mosaic table top is mounted on a gilded fruitwood base and is one of a pair, c.1790. They are made in the style of Giuseppe Mario Bonzanigo, who is widely recognised as the finest 18th-century Italian furniture maker. Bonzanigo made *boiseries* – intricately carved wood panelling – and large pieces of furniture in Louis XVI style and worked extensively for royal palaces, being appointed official wood carver to the Crown in 1787. *Attingham Park, Shropshire*

Satyr and maenad Detail of part of a floor featuring the figures of a drunken satyr embracing a maenad (maenads were female worshippers of Dionysus, the Greek god of wine and intoxication, and his Roman equivalent, Bacchus). Mosaic floors in Roman villas were a great status symbol and the floors at Chedworth, which all use four or five colours, were produced by a famous workshop based in Corinium (Cirencester). *Chedworth Roman Villa, Gloucestershire*

Pietra Dura & Micromosaic

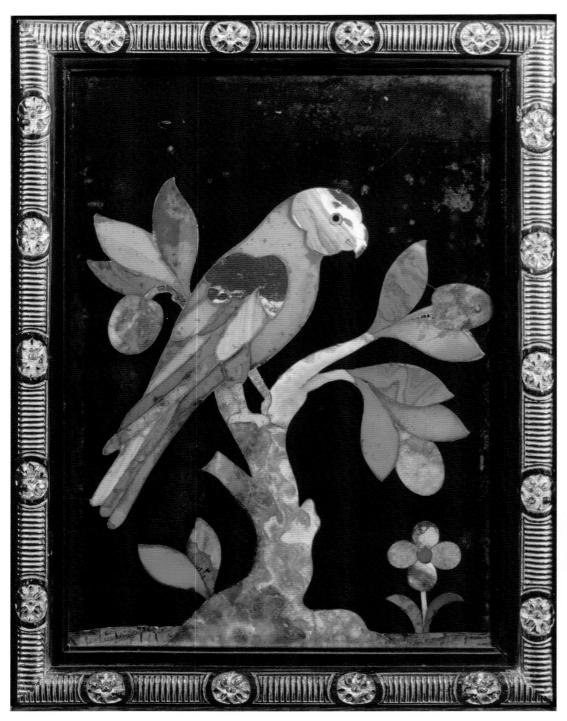

Pietra dura cabinet

(left). Pietra dura, which translates as 'hard stone', is a technique first used in Italy in the 1500s, which uses small, highly polished, coloured pieces of marble and semi-precious stones inlaid to create a pattern. The underside of the stones are grooved so that they lock together. This parrot on his tree is just one panel of many in the monumental Florentine cabinet, c.1620, which stands on a low base at Charlecote, designed by the collector William Beckford (1760–1844).
Charlecote Park, Warwickshire

Table

(below). This detail shows the square central section of a circular Italian mosaic table featuring views of Roman monuments. The striking green border is made from malachite.
Charlecote Park, Warwickshire

Florentine skill (top).
Set with lapis lazuli, jasper and agate, plus many other semi-precious stones, this stunning table top was made c.1600 in the Florentine workshops of the Grand Duke Ferdinand de Medici. It was probably bought by the 2nd Earl of Powis while he was on his Grand Tour in 1775–1776.
Powis Castle, Powys

Lucy table top
(bottom). Edge of the top of the Lucy table bought in 1824 from the London dealer Thomas Emmerson. Its base was constructed to match a 16th-century table which came from the collection of William Beckford and which was bought by George Hammond Lucy in 1823. Beckford had designed the oak base of his table in the Gothic style and included the Latimer cross, which looks very like the Lucy arms.
Charlecote Park, Warwickshire

Scagliola

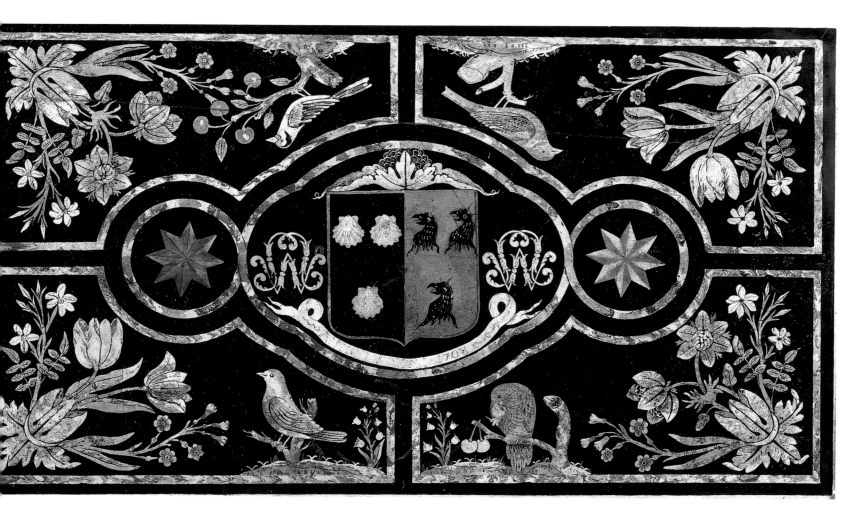

Strickland table This table top was made in 1708 for Winifred Trentham, Lady Strickland, and bears her monogram and the Trentham and Strickland coat of arms in the centre. Scagliola is made from selenite (a type of gypsum), which is pulverized and made into a plaster. It is then painted, fired and polished until it resembles pietra dura (inlaid coloured pieces of marble and semi-precious stones). *Sizergh Castle, Cumbria*

Walpole arms (right). This Italian scagiola table top bears the coat of arms of Sir Robert Walpole (Prime Minister 1721–1742), as well as his motto, 'To do what we feel'. It sits on a base, c.1730, in the style of the great designer William Kent (1685–1748). *The Vyne, Hampshire*

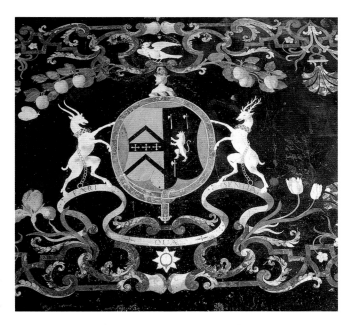

Landscape (below). Signed and dated 1754 by Don Petro Belloni, this table top is one of a pair commissioned by Sir Matthew Fetherstonhaugh during his Grand Tour of Italy. There are only five documented table tops by Belloni, who was active between 1740 and 1760 and was the assistant to Don Enrico Hugford (1697–1771), the Abbot of Vallombrosa monastery, near Florence. Don Hugford is credited with refining the art of scagliola, taking it to a new level of skill. *Uppark, West Sussex*

Sacred Mosaics

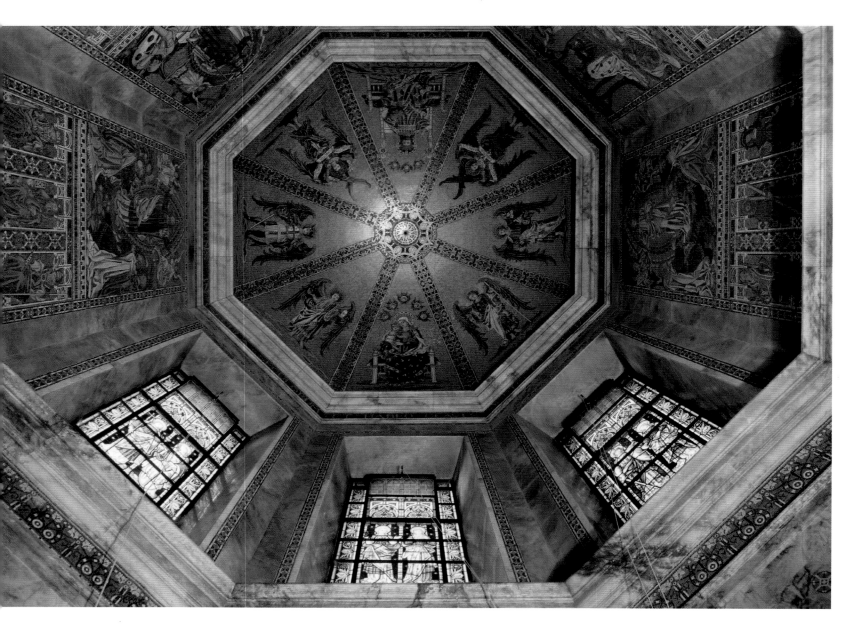

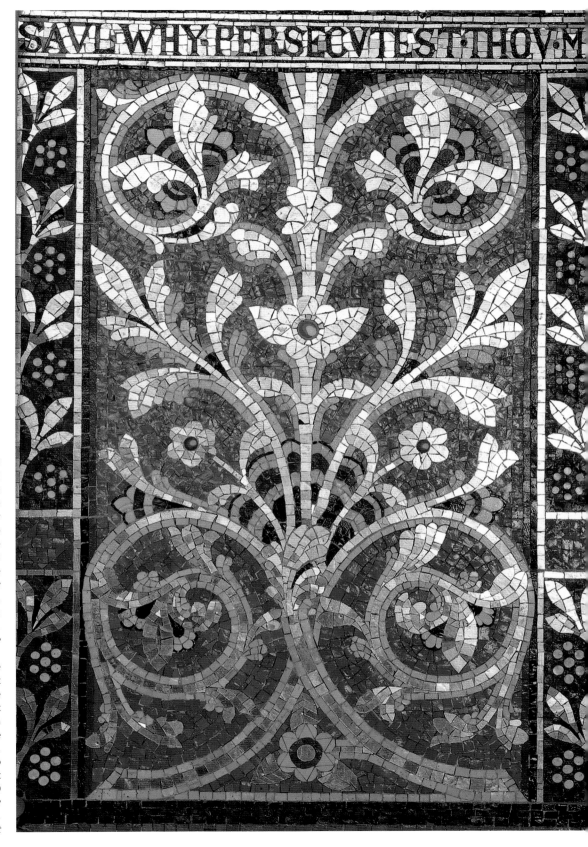

SAVL·WHY·PERSECVTEST·THOV·M

Octagon Temple dome (left). The colourful mosaics decorating this dome were designed by Claydon & Bell. The temple itself dates from the early 18th century and is by Giacomo Leoni. The mosaics in the dome show Our Lord and the Blessed Virgin enthroned with the archangels, while the tiers below feature scenes from the life of Christ, above a series of seated saints, then stories from the Bible lower down.
Cliveden, Buckinghamshire

Murano glass (right). The panel of which this is a detail is part of a triptych behind the altar in the chapel of the High Victorian house. It is by the award-winning Venetian company Salviati & Co. The company's founder, Antonio Salviati, was hugely skilled in Murano glassmaking, and revived skills that had fallen into disuse for about 200 years, making his company very successful and world-famous.
Tyntesfield, North Somerset

20th-Century Revival

Gwynne mural (left). Made entirely of glass, this mural was created by the architect and designer Patrick Gwynne (1913–2003) to decorate the outside of his home. The orange tiles form a plan of the house, while the black lines read 'Patrick Gwynne Homewood', although the pattern is so abstract it is hard to decipher the words. *The Homewood, Surrey*

Anrep angel
(right). Close-up of part
of the angel by the
Russian artist Boris Anrep
(1883–1969). Anrep, who
was closely associated
with the Bloomsbury
Group, devoted himself
to mosaic, producing
many major works, the
most famous of which are
his monumental mosaics
at the National Gallery,
Westminster Cathedral
and the Bank of England.
Mottisfont Abbey,
Hampshire

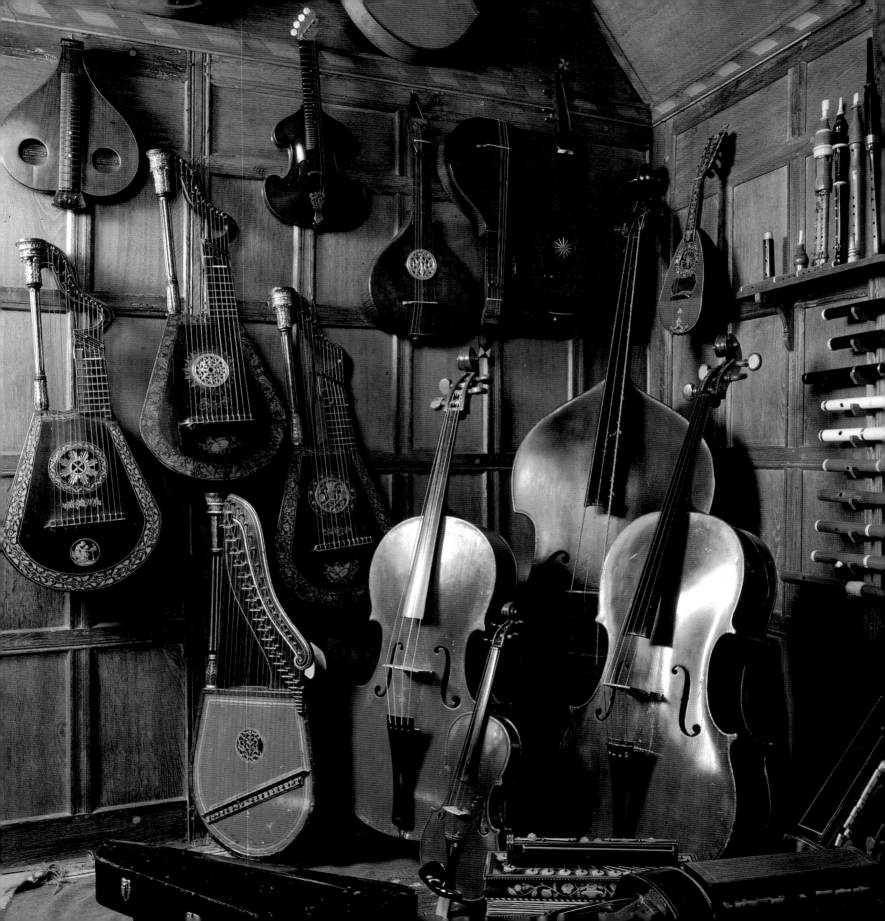

Musical Instruments

Charles Paget Wade Collection

Music Room (left). This corner of the Music Room contains just a part of Charles Paget Wade's collection of musical instruments, including a 19th-century double bass and cellos, bowed zithers and English guitars. *Snowshill Manor, Gloucestershire*

Square piano (top right). The keyboard of a Longman & Co square piano, c.1800. Pianofortes only became fashionable in the late 18th century and at that time James Longman's company was one of only two companies which manufactured them in England. Having previously been in partnerships with Francis Broderip (from 1776 to 1798) and Muzio Clementi (from 1798 to 1801), John Longman continued in business alone, trading from 131 Cheapside until 1816. *Snowshill Manor, Gloucestershire*

Remains of a dragon's-head buccin (bottom right). The so-called *buccin à tête de dragon* was a type of trombone popular with French military bands at the beginning of the 19th century, deriving its name from the decorative treatment of its bell joint. *Snowshill Manor, Gloucestershire*

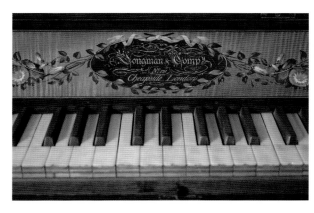

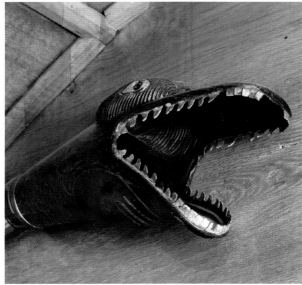

Paget Wade

Charles Paget Wade (1883–1956) was an architect, artist-craftsman and poet, who inherited the family sugar estates in the West Indies while still in his twenties. The income from these estates enabled him to devote his life to amassing his enormous and varied collections.

Wade was only interested in hand-made objects, feeling that society was in danger of neglecting its proud past in favour of a future of mass production and materialism. He started collecting in 1900, then in 1919 he bought Snowshill and set about restoring the house following the principles of the Arts and Crafts movement – namely using high-quality materials and skilled traditional craftsmen. He then started to fill Snowshill with his enormous and wide-ranging collections. He even moved into a neighbouring cottage in order to make more space for his numerous objects.

The Music Room at Snowshill Manor (opposite) has a Latin inscription carved over the door which may be translated: 'Man is carried to Heaven on the wings of music'.

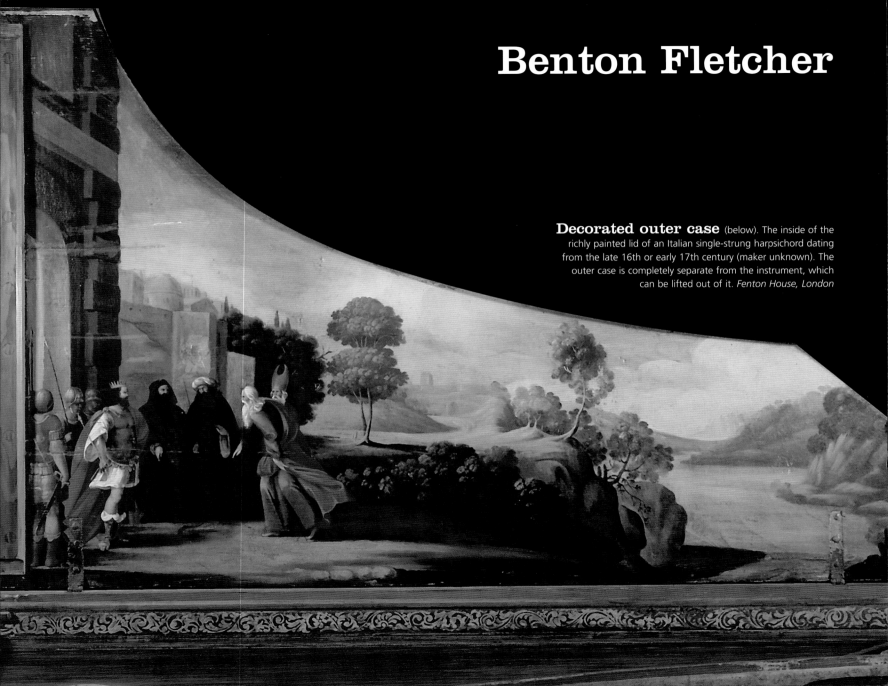

Benton Fletcher

Decorated outer case (below). The inside of the richly painted lid of an Italian single-strung harpsichord dating from the late 16th or early 17th century (maker unknown). The outer case is completely separate from the instrument, which can be lifted out of it. *Fenton House, London*

Kirckman harpsichord (right). Fenton House's Blue Porcelain Room contains the 1777 double-manual harpsichord, made by Jacob and Abraham Kirckman, the latter a naturalized Englishman, originally from Alsace. Built with all the usual English features, including a nag's head swell, which allowed players to create the crescendo and diminuendo that were required to perform the new keyboard music being written with the piano in mind. *Fenton House, London*

Major Benton Fletcher and his collection

Major George Henry Benton Fletcher (1866–1944) was passionate about early music and came to believe that it could only be appreciated fully if played on the instruments for which it was composed. As soon as he finished his Army active service in 1918 he began to search out early keyboard instruments. This quest became the main interest in his life and lasted until 1937, when he presented his collection, which includes harpsichords, clavichords, virginals, harps, lutes and a hurdy-gurdy, to the National Trust. However Major Benton Fletcher was not satisfied with simply rescuing the instruments; instead he was determined that the early keyboard instruments that he collected be restored and kept in good playing order. He was particularly concerned that they be accessible to students.

The collection has been housed in Fenton House in London since its owner, Lady Binning, bequeathed the property to the National Trust in 1952. Students are still encouraged to practise on the instruments and concerts are held regularly.

Early piano (right). The nameboard of this instrument bears the legend *Johannes Broadwood Londini Fecit 1774* but this inscription has clearly been at least partially re-worked and the disposition of the lettering suggests that a further word – possibly what would be the anachronistic word '*Patent*' – seems likely to have been accidentally or deliberately erased. There being no sufficiently near-contemporary example with which to make a meaningful comparison, it cannot be said that this is not what a Broadwood square of 1774 would look like, if such a thing survived. Features of the instrument, however, have prompted comparisons with squares of the 1770s by other makers, and a strong case has been made to associate the piano with the work of one such maker in particular. Assuming this identification were correct, the questions which remain are who inscribed the nameboard and whom was it intended to deceive. *Fenton House, London*

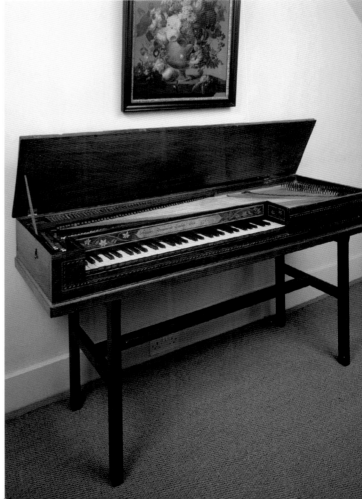

Organs

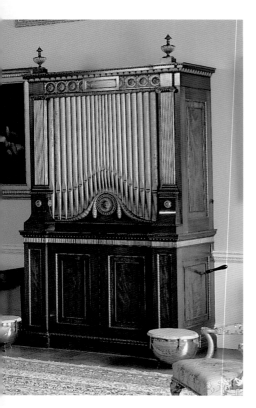

Adam case The case of this organ was designed by Robert Adam (1728–1792) – the most prominent English country-house architect in Georgian England – and built around the innards of a second-hand instrument in 1795. *Kedleston Hall, Derbyshire*

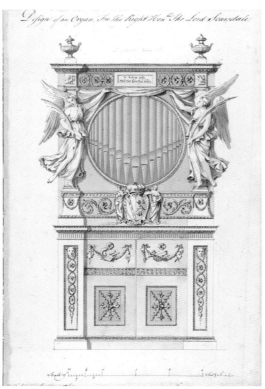

'Design for an organ' This pen-and-wash drawing is by Robert Adam and illustrates his intended design for the organ case at Kedleston. In the event, the case that was built was a great deal simpler (see left). The drawing is dated 1762. *Kedleston Hall, Derbyshire*

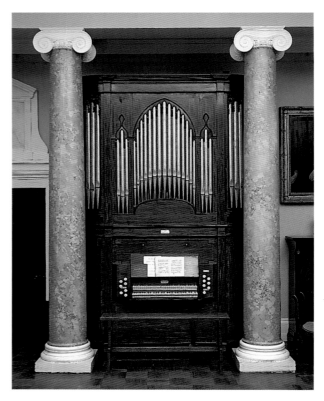

William Gray This chamber organ was built in 1807, during a period at which the work of William Gray (c.1756–1821) was becoming particularly well regarded. The instrument started life with only one manual, the second being added, together with a slide-in pedal board and a primitive pneumatic action to twenty poor-quality second-hand Bourdon pipes, during a regrettable re-build in 1901. *Killerton, Devon*

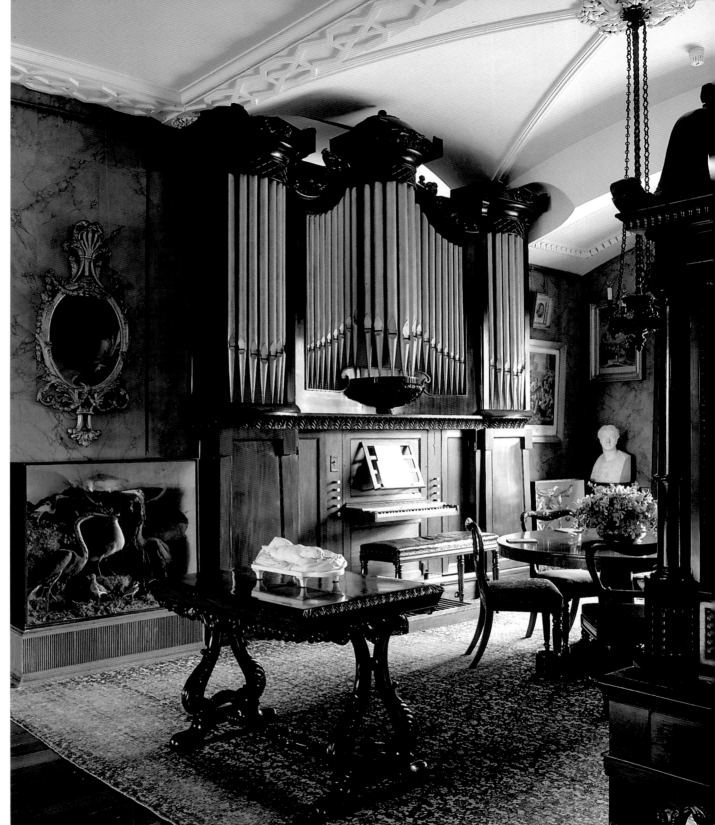

Bishop barrel organ In 1822, on the recommendation of Samuel Wesley (1766–1837), Walter McGeough (1790–1866) commissioned an organ for the Argory from James Davis (1762–1827). Davis 'having declined proceeding with it himself', the instrument was actually built by James C Bishop (c.1783–1854), who completed it in 1824. It is an organ of considerable significance, not least in view of its massive barrels (305mm in diameter and nearly two metres long) and the fact that Wesley arranged the music and oversaw the pinning. Three of the barrels survive (three others were most unfortunately lost in a fire in 1898) to afford convincing evidence of the fidelity and effect with which a musical performance could be preserved and presented again and again, in the days before acoustic recording. *The Argory, County Armagh*

Harpsichords and Pianos

Inlaid harpsichord This elaborately marquetried harpsichord was made in 1742 by the Swiss-born Burkat Shudi (1702–1773). Shudi came to London in 1718 as a journeyman joiner and, probably soon after his arrival, found work in Oxendon Street with the harpsichord maker Hermann Tabel. Exactly when Shudi left his employer is not known but he was certainly in business on his own account by 1729, the year in which he signed the earliest of his instruments still extant. He went on to make harpsichords for many of the most important figures of the time, including the Prince of Wales, Frederick the Great of Prussia and the Empress Maria Theresa of Austria. He was also a personal friend of George Frideric Handel (1685–1759). This is the fourth oldest of his instruments known to survive. *Chirk Castle, Wrexham*

'Manxman' piano

(right). The oak cabinet of this 'Manxman' piano is decorated with floral plaques and medallions and inlaid with chevron banding. This model of piano came by its curious name because the designer of its prototype, Mackay Hugh Baillie Scott (1865–1945), lived on the Isle of Man. Baillie Scott, who was an architect as well as a designer, was one of the leading lights of the Arts and Crafts movement, and it was another leading member of the movement, Charles Robert Ashbee (1863–1942) who designed this example. It was manufactured by John Broadwood & Sons, a firm that had been making pianos since the late 18th century and which had become involved in the Arts and Crafts movement in the 1890s. *Standen, West Sussex*

Steinway grand (left). This Steinway grand piano was decorated in the Manhattan studio of Cottier & Co for the mother of the 1st Lord Fairhaven (1896–1966), the owner of Anglesey Abbey. Daniel Cottier (c.1837–1891), the renowned stained-glass artist, was the pioneer of modern stained glass. Originally from Scotland, he moved to London in 1870, and then, in 1873, opened branches of his glass and interior design studios in Sydney and New York. He was a leading member of the Aesthetic Movement, which pushed against the boundaries of the Victorians' strict moral codes. The Aesthetes believed that art should not attempt to convey moral or sentimental messages; instead it need only be beautiful. *Anglesey Abbey, Cambridgeshire*

Natural History and Geology

Shells

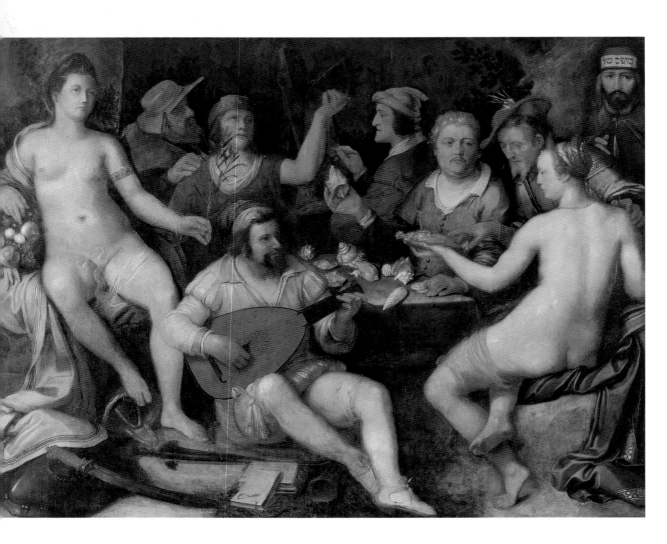

'The Arts' (left). This allegorical portrait by Cornelis van Haarlem (1562–1638) of the celebrated Dutch shell collector and patron of the arts Jan Govertsz van der Aar (1544–1612) shows him seated holding a shell. The other figures represent his other interests, such as music, painting and sculpture. *Lacock Abbey, Wiltshire*

Shell homage (opposite, top left). This shell decoration was created in the 18th-century style by Gordon Davies in 1978. It recalls the shell grotto made by Lady Fane, wife of the owner of Basildon, at the dower house in the mid-18th century, when decorating rooms with shells was a popular pastime for ladies of leisure. The grotto was removed in the 1790s. *Basildon Park, Berkshire*

Shell picture (opposite, top right). This early 18th-century English oval chaplet of shells mounted on wires encircle the arms of the Coventry family. *Antony, Cornwall*

Shellwork box (opposite, bottom right). The shells on the inside lid of this box are set in a decorative pattern. It is part of one of the many collections amassed by Miss Rosalie Chichester, the last owner of Arlington. *Arlington Court, Devon*

Curiosities (opposite, bottom left). Collection of 18th-century souvenirs housed in a 'cabinet of curiosities'. It includes many shells and semi-precious stones, all collected by the Parminter family during their ten-year Grand Tour of the Continent at the end of the 18th century. *A la Ronde, Devon*

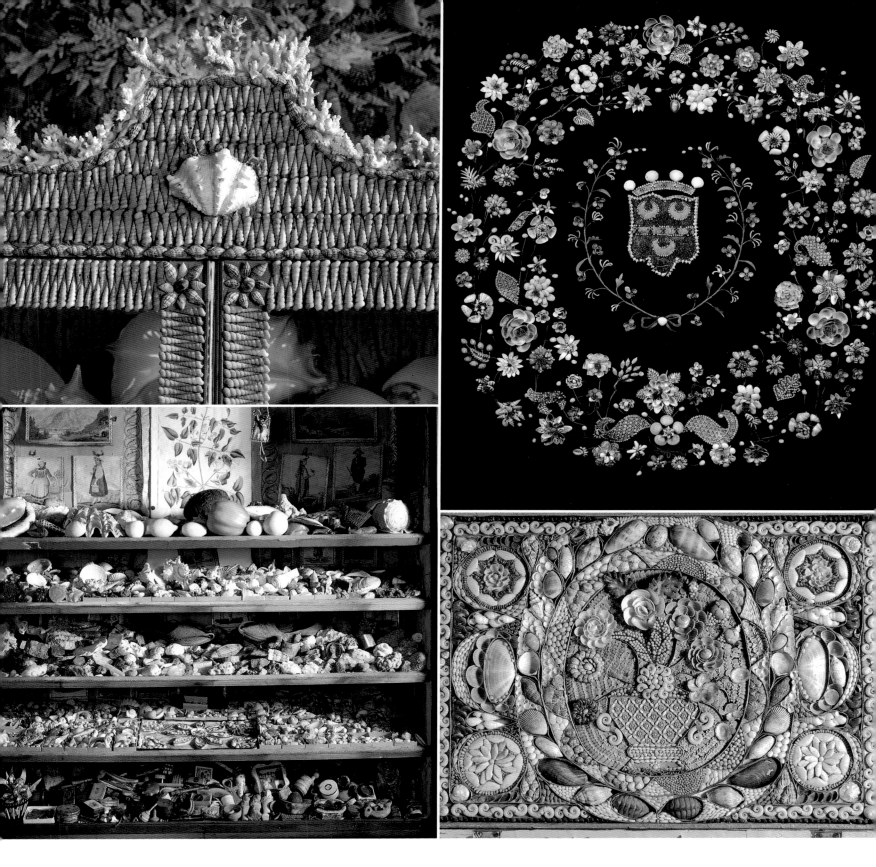

Specimens
(left). This selection of geological specimens, collected by Sir John Harpur Crewe (1824–1886) in the 19th century, includes colourful minerals and carved stone. Sir John, like his father before him, took great interest in the natural world, especially geology and ornithology, and added to the collections already filling every corner of the house. *Calke Abbey, Derbyshire*

Geology

Fox Talbot selection (top right). William Henry Fox Talbot (1800–1877), although better known as a pioneer of photography, was fascinated by every aspect of the natural world, from astronomy to geology and botany. This selection of geological specimens was amassed with the help of his son and heir Charles Talbot (1842–1916). *Lacock Abbey, Wiltshire*

Taxidermy

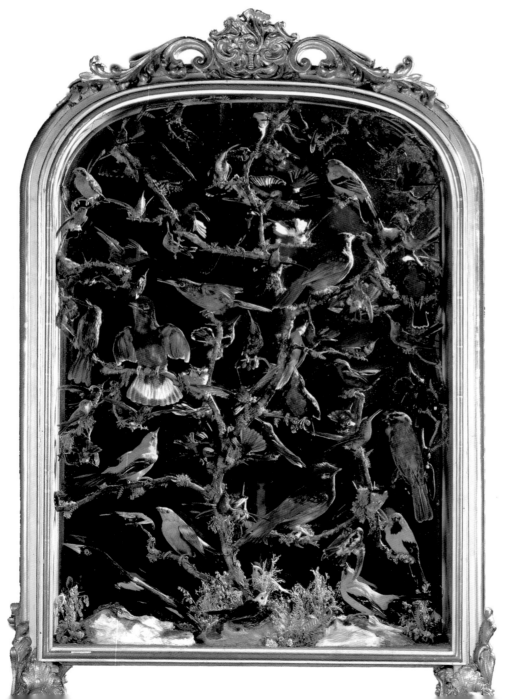

Firescreen The colourful stuffed birds contained in this white and gilt firescreen, c.1840, come from Central and South America. The birds may derive from the collection made by Clive of India's daughter-in-law, Henrietta Herbert, wife of Clive's son, the 2nd Lord Clive, later created Earl of Powis. *Powis Castle, Powys*

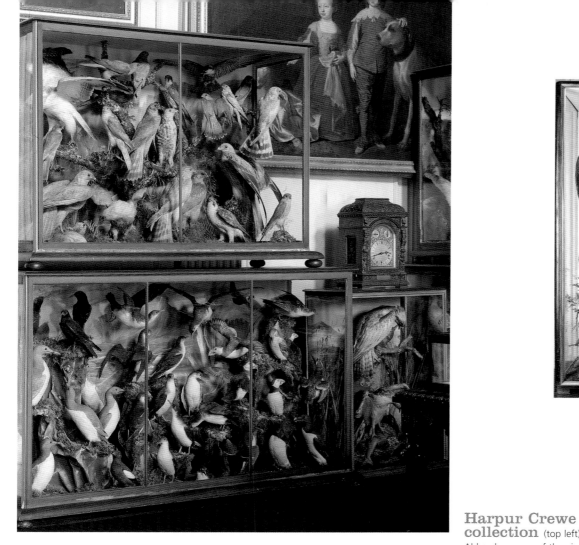

Tableau (above). Two buzzards perched on a rock with a rabbit in the Entrance Hall.
Llanerchaeron, Ceredigion

Harpur Crewe collection (top left). Calke Abbey has more of the air of a private museum than a home, with display cases lining every spare space. The main collector was Sir Vauncey Harpur Crewe (1846–1924), who, like his father and grandfather before him, was fascinated by the natural world. He devoted his life to collecting birds and butterflies, turning the park into a private bird sanctuary. At the time of his death there were several thousand exhibits at the Abbey.
Calke Abbey, Derbyshire

Bird Corridor (left). The cabinets in the Bird Corridor at Felbrigg contain a variety of stuffed birds collected by Thomas Wyndham Cremer (1834–1894), the father of Wyndham Cremer Cremer (1870–1923), who became the owner of the property.
Felbrigg Hall, Norfolk

Paintings

Flemish

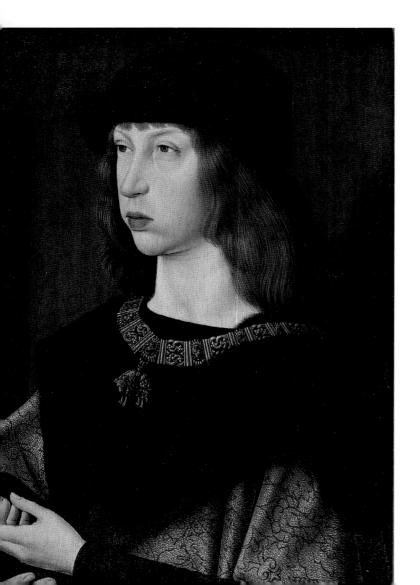

Philip the Fair (far left). Attributed to the Master of the Magdalen Legend (active late 15th and early 16th century), this portrait of the Archduke of Austria (1478–1506) was painted by a Flemish artist working in Brussels. Philip the Fair was made governor of the Low Countries in 1494, later becoming Philip I of Spain. *Upton Hall, Warwickshire*

Saint Ambrose and Saint Augustine (left). These are wing panels from a Flemish 16th-century altarpiece (one of four wing panels) at Oxburgh Hall, after treatment by the Hamilton Kerr Institute, University of Cambridge. *Oxburgh Hall, Norfolk*

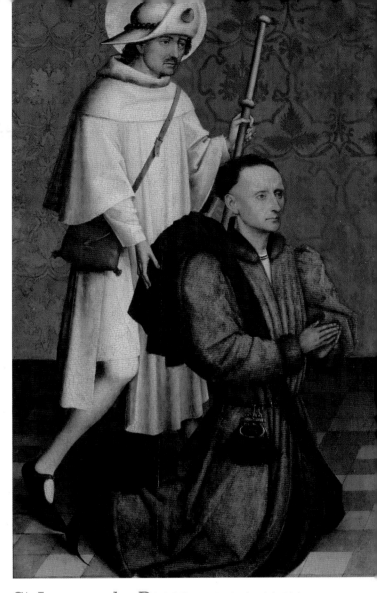

A Head from the 'Descent of the Cross' This is thought to be a bust-length copy by a Flemish 16th-century workshop of the original in the Prado, Madrid, by Rogier van der Weyden, which was painted for the Chapel of the Archers in Louvain. It was bought by Wilbraham Egerton (1781–1856) while he was in the Low Countries in 1816. A great collector, he travelled widely in Europe and India. *Tatton Park, Cheshire*

St James and a Donor Hanging in the Little Dining Room, this wing of an altarpiece is attributed to Rogier van der Weyden (1399–1464). The saint stands in a white robe with a purse on his hip, a cockle shell on the upturned front rim of his hat, and a staff in his left hand – all symbols associated with St James. *Petworth House, West Sussex*

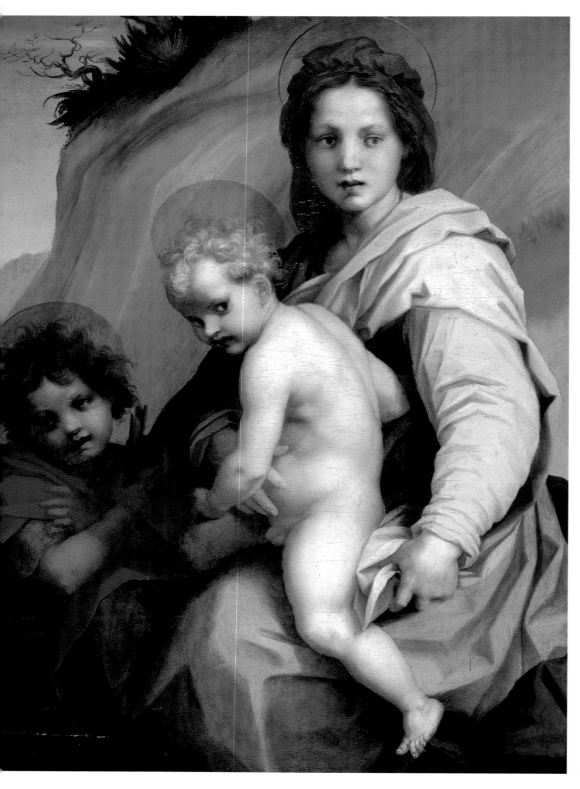

Renaissance

The Madonna and Child with St John

Painted by Andrea Del Sarto (1486–1531), the picture is generally described as the Madonna del Fries, after Count Josef von Fries who bought the picture in Italy in the 1780s. It was bought by Baron Lionel de Rothschild in 1870.
Ascott, Buckinghamshire

The Miracle of the Founding of Santa Maria Maggiore (above). Attributed to Pietro Perugino (c.1450–1523), this is part of a predella to a lost altarpiece, probably painted in Florence c.1475. It depicts the miraculous fall of snow on 5 August 352 which traced the plan of Santa Maria Maggiore in Rome, as foretold in a vision of the Virgin Mary to Pope Liberius.
Polesden Lacey, Surrey

The Holy Family with the Infant St John in a Landscape (right). This picture from the circle of Raphael (1485–1520) was the prize acquisition by William Bankes while in Spain in 1813; he bought it from a French commander who had looted it from the Escorial. It had also been owned by Charles I, who had bought it with the bulk of the Gonzaga collections from Mantua in 1626–1628. Bankes commissioned the frame with medallions of previous owners.
Kingston Lacy, Dorset

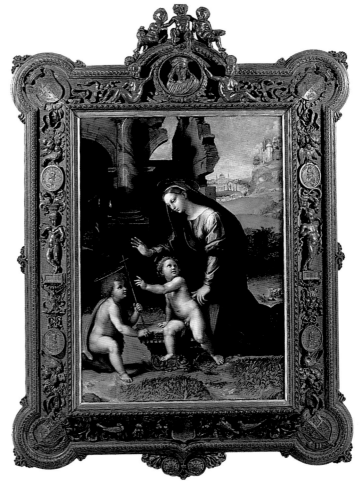

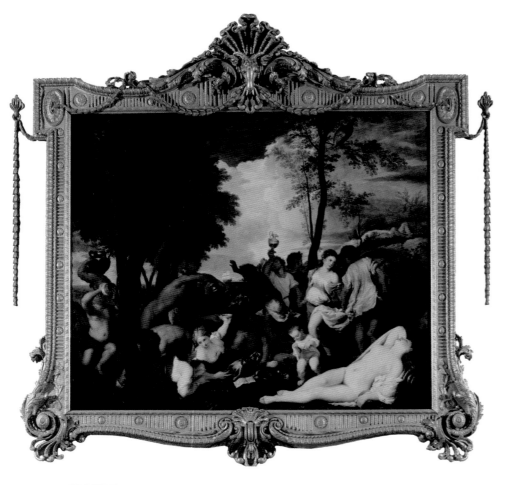

Venetian

The Andrians (above left). This is a good, probably 17th-century, copy of the picture by Titian (c.1485–1576) in the Prado, Madrid. Described in the writing of the Greek sophist Philostratus, this bacchanal is exemplified by the naked nymph brazenly offering herself to the viewer. An alternative title is *The Stream of Wine on the Island of Andros* – Bacchus's wine replaces spring water. The sheet music reads: 'Who drinks and does not drink again does not know what drinking is.' *Saltram, Devon*

The Judgement of Solomon (left). This unfinished painting by Sebastiano del Piombo (c.1485–1547) takes as its theme the story in the Book of Kings about the way Solomon determined which of two harlots was the real mother of a disputed child. It was bought by William Bankes in 1820 from the Marescalchi Collection in Bologna. *Kingston Lacy, Dorset*

Nicolò Zen (top left). This portrait by Titian (c.1485–1576) was bought from the Marescalchi Collection by William Bankes in Bologna in 1820. It has recently been identified as Nicolò Zen (1515–1565), a member of the Venetian Council of Ten, ambassador and writer.
Kingston Lacy, Dorset

Portrait of a Man (bottom left). This Titian portrait is kept in the Smoking Room at Ickworth. It is an original early work, but is damaged.
Ickworth, Suffolk

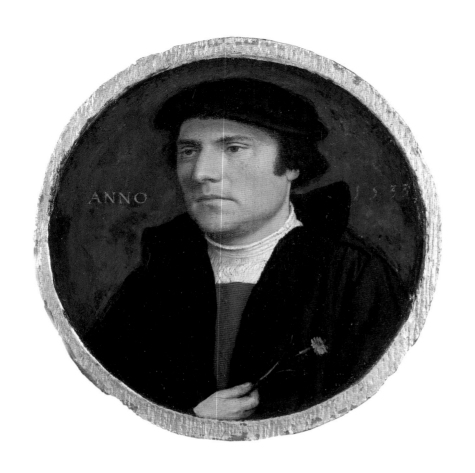

Tudor

A young Man with a Pink (left). It used to be suggested that this painting, dated 1533, is a self-portrait of Hans Holbein the Younger (1497/8–1543), but it is more likely to be of an Englishman or of a member of the Steelyard Corporation of German merchants of the Hanseatic League. Holbein received commissions for portraits as well as moralizing paintings for the Corporation's hall, following his arrival in England for a second period in 1532.
Upton House, Warwickshire

The Family of Sir Thomas More (below left). This painting by Rowland Lockey (fl. 1593–1616) in 1592 is an invaluable copy of the original tempera by Holbein, since the latter was destroyed by fire in the 18th century. Sir Thomas sits beneath the clock in black robes next to his father, John More, in red. This copy has been at Nostell since the 18th century, while a second, updated copy by Lockey hangs in the National Portrait Gallery.
Nostell Priory, West Yorkshire

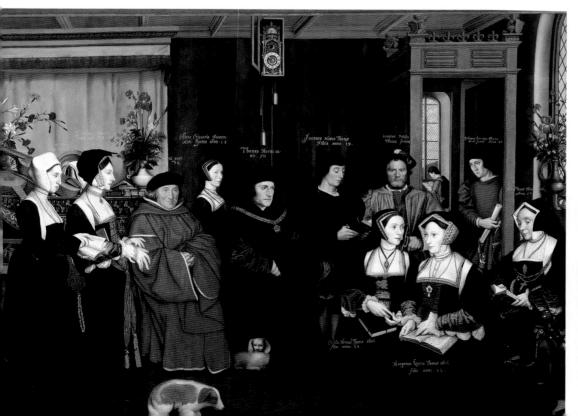

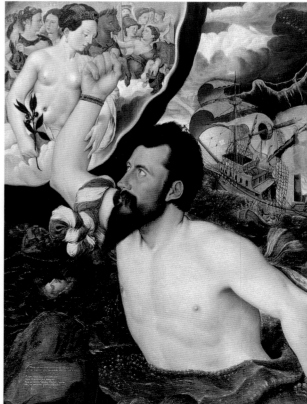

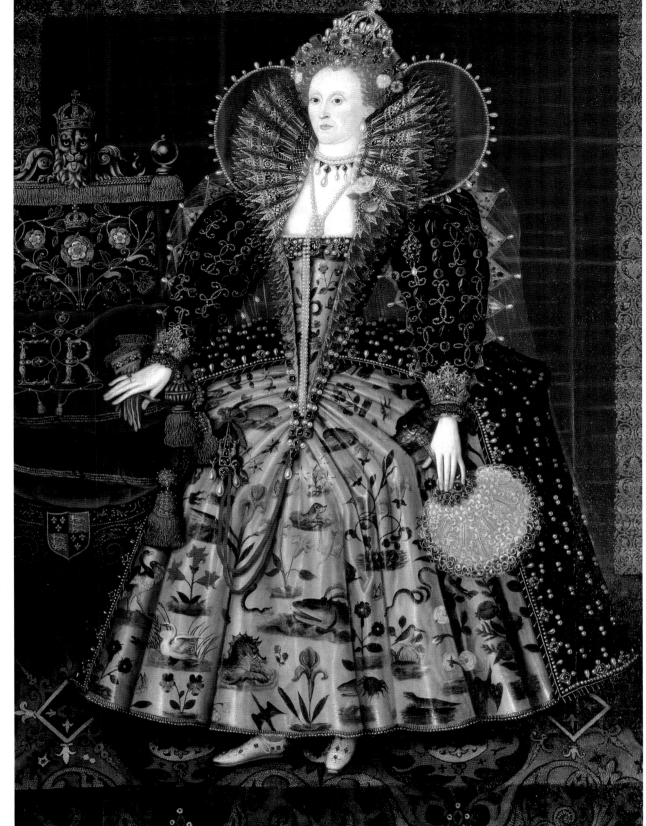

Queen Elizabeth

(right). Painted after 1588 and showing the Queen in a rigid and hieratic pose, this portrait is thought to be the picture brought to Hardwick from London in 1599 and to be by Nicholas Hilliard and his apprentice, Rowland Lockey. Payments for two 'picturs' were made to both by Bess of Hardwick in 1592.
Hardwick Hall, Derbyshire

Sir John Luttrell

(near left). This allegorical portrait of Sir John (1518/19–1551) is one of the most unusual and puzzling of Tudor images. It may refer to the peace treaty of 1550, by which France recovered the port of Boulogne, since he had helped to capture it in 1544. He is shaking his fist in disapproval of its return. The original, painted by Hans Eworth (?c.1520–?1573) in 1550, is in the Courtauld Institute, London, and this copy was made in 1591.
Dunster Castle, Somerset

Baroque

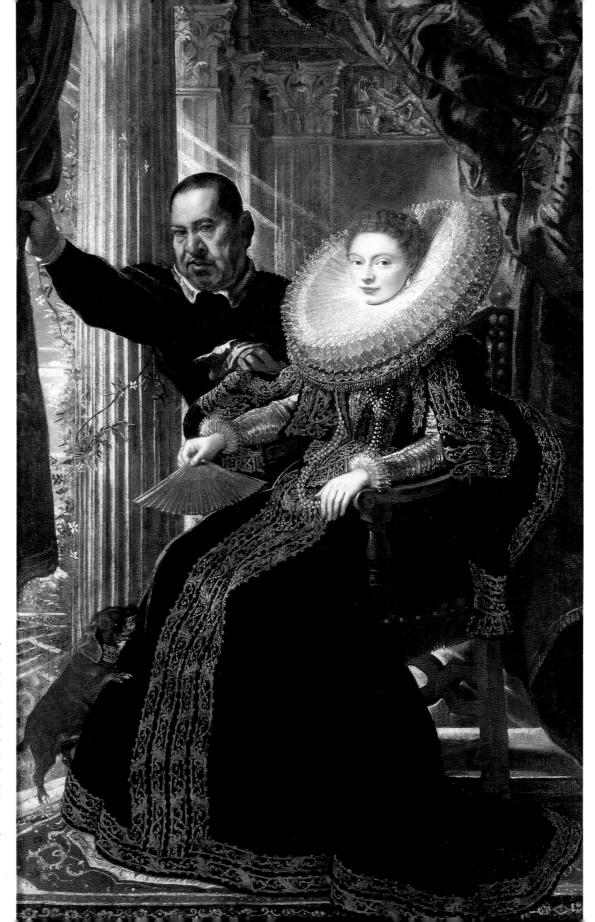

Marchesa Maria Grimaldi and her Dwarf This portrait by Sir Peter Paul Rubens (1577–1640) is thought to be of the marchesa Maria Grimaldi, since the letters on the dog's collar may be a garbling of 'MARIA' and her father, the marchese Carlo Grimaldi, lent his villa at Sampierdarena to Rubens and his employer, Duke Vincenzo I Gonzaga of Mantua, in 1607. *Kingston Lacy, Dorset*

The Adoration of the Magi (top left). Dated 1605 and signed by Ludovico Cardi (also known as Cigoli) (1559–1613), this picture was commissioned for the Albizzi Chapel in San Pietro Maggiore, Florence. It was acquired by Sir Richard Colt Hoare in 1790, shortly after demolition of the church. *Stourhead, Wiltshire*

The Holy Family with St Francis (bottom left). Attributed to Annibale Carracci (1560–1609), this picture was in the collection of the financial genius, philanthropist and collector John Julius Angerstein (1735–1823), whose collection formed the basis of the National Gallery in 1824. *Tatton Park, Cheshire*

An Allegory with Venus, Mars, Cupid and Time (below) No literary source has been found for this subject which Guercino (1591–1666) painted twice, but its theme is love and its dangerous consequences. When Venus was dallying with Mars, she was trapped with him under a net by her cuckolded husband, Vulcan, and thus exhibited to all the other gods and goddesses. *Dunham Massey, Cheshire*

Baroque Murals

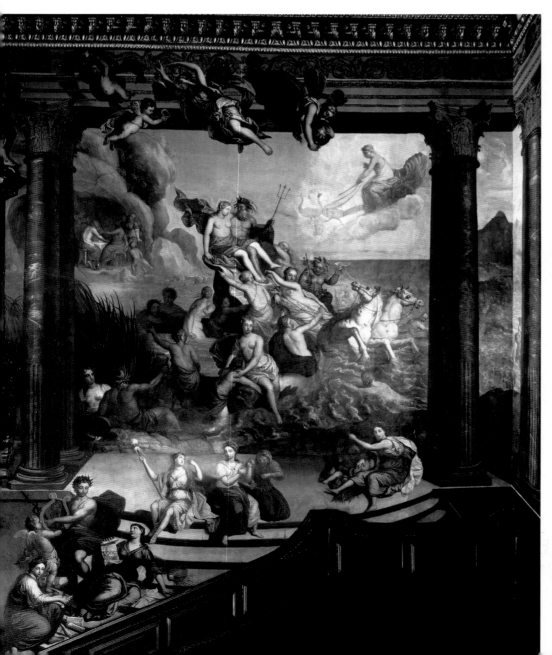

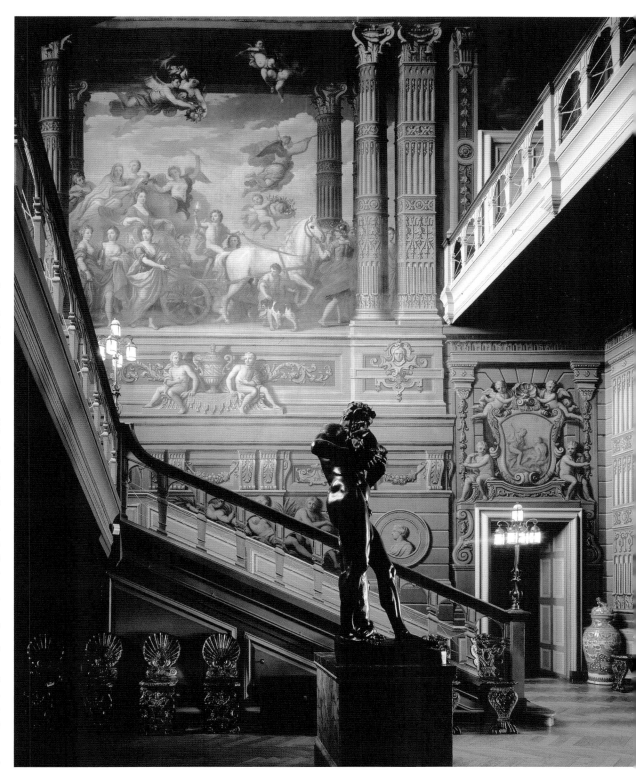

The Triumph of Neptune and Amphitrite (far left). This mural by Gerard Lanscroon (active 1677–d.1737) was commissioned by the 2nd Marquess of Powis to decorate the walls of the Grand Staircase at Powis. Lanscroon was a pupil of Antonio Verrio, who painted the ceiling of the Grand Staircase in the 1670s. *Powis Castle, Powys*

Banquet of the Gods (top left). The central panel of the Music Room ceiling at West Wycombe is based on Raphael's Banquet of the Gods in the Villa Farnesina in Rome. With the paintings in the coving, it was done by Giuseppe Mattia Borgnis (1701–1761) for Sir Francis Dashwood, 2nd Baronet. *West Wycombe Park, Buckinghamshire*

Charles II (bottom left). This is a rare fragment from the plaster ceiling of the King's Drawing Room at Windsor Castle, which was destroyed during Sir Jeffry Wyatville's alterations in the early 19th century. Painted by the leading mural painter of the late 17th century, Antonio Verrio (1639–1707), it depicts Charles II (1630–1685). *Packwood House, Warwickshire*

Triumph of the Duchess of Somerset (right). This exceptionally grand staircase was conceived by the 6th Duke of Somerset as a transition from the state apartments on the ground floor to the bedrooms. The murals were painted by Louis Laguerre (1663–1721) and incorporate a depiction of the Duchess riding in a triumphal chariot. *Petworth House, West Sussex*

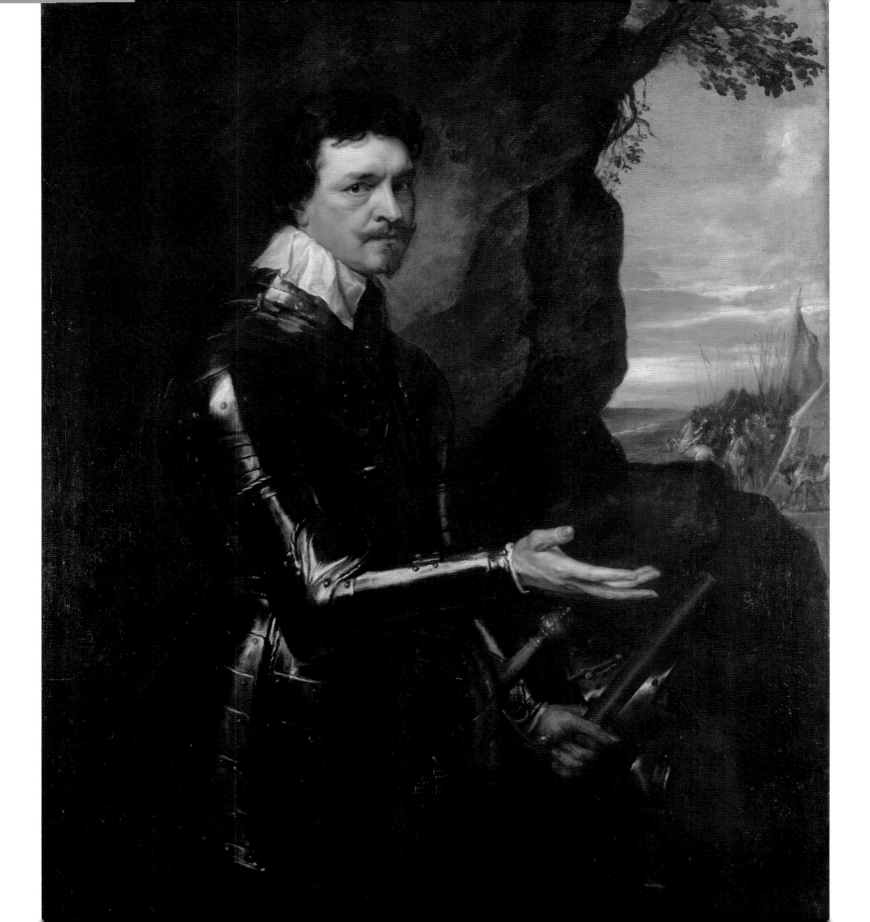

Van Dyck

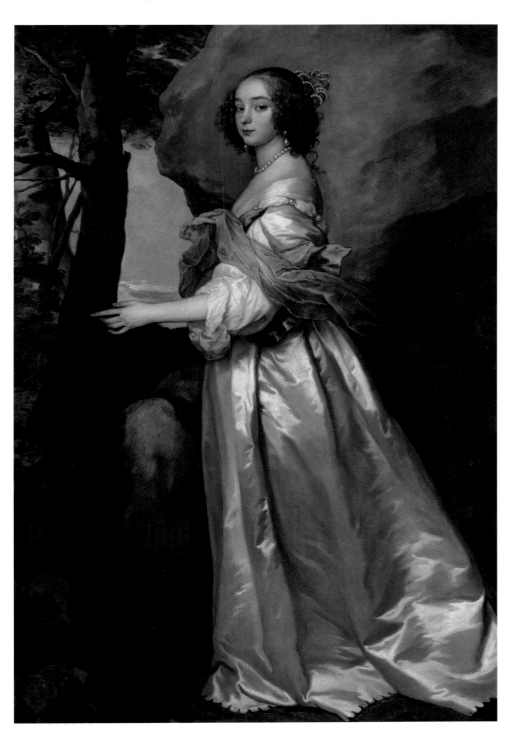

Van Dyck

Anthony van Dyck (1599–1641) is well represented at Petworth House in Sussex. Among the 14 portraits there are an unfinished picture of King Charles I on horseback, a full-length portrait of Thomas Wentworth, 1st Earl of Strafford, Charles's great minister whom the king abandoned to execution by Parliament (far left), and the unusual posthumous one of Henry Percy, 9th Earl of Northumberland, who is shown resting his head against his hand to suggest deep thought. At Knole is one of the loveliest portraits of a young woman by Van Dyck: Lady Frances Cranfield, Countess of Dorset is shown in a poetic landscape setting (left). Van Dyck is renowned as one of the greatest of all portrait painters, developing his skills as a pupil and assistant of Rubens, and strongly influenced by Titian. His first visit to England was in 1620–1621, when he spent a few months working for the Earl of Arundel, but in 1632 he moved to London to become court painter to Charles I, who knighted him later that year. He remained in England for most of the rest of his life, dying in London in 1641, but he was always on the lookout for other opportunities. He made several visits to the Continent, one to Paris in the hope of securing a commission to decorate part of the Louvre, which went to Poussin. Though he was given little opportunity for anything but portraiture, Van Dyck made drawings and watercolours of the English countryside for his own pleasure.

'Fine Painting'

Adoration of the Magi Attributed to Hieronymous Bosch (c.1450–1516), this is a high-quality variant of the central panel of Bosch's triptych of the Epiphany of c.1495 in the Prado, Madrid. The kings are presenting their gifts to the child, while rather insidious characters, thought to represent the old order, look on from the decrepit stable. *Petworth House, West Sussex*

The Virgin and St Anne

(left). One of eight exquisite little pictures at Petworth by Adam Elsheimer (1578–1610), which were once in the London home of the assassinated Duke of Buckingham. It is thought they may have been painted to adorn a cabinet. *Petworth House, West Sussex*

The Four Elements: Air

(left). This is one of four paintings on copper derived from the set of Elements painted for Cardinal Federico Borromeo by Jan Brueghel the Elder (1568–1625). The figures here were painted by Hendrick van Balen (1575–1632) and the other elements by his son, Jan Brueghel the Younger (1575–1632). Air is personified by the figure of Astronomy. Nothing is known about the provenance of this set, which came to Kingston Lacy after 1905. *Kingston Lacy, Dorset*

Spanish

Prince Baltasar Carlos (left). The only son of Philip IV of Spain, Prince Baltasar Carlos (1629–1646) is depicted here by Velázquez (1599–1660) as a hunter. It may have been acquired in Paris in the 1820s, having been looted from a Spanish palace during the Napoleonic Wars. *Ickworth, Suffolk*

The Disrobing of Christ (below). This startling piece of painting could only be the work of El Greco (1541–1614). This is a greatly reduced version of his second major commission, for the altarpiece in the Sacristy of Toledo Cathedral, and was possibly an autograph replica of the altarpiece rather than the model for it.
Upton House, Warwickshire

Camillo Massimi (above). Regarded as the finest of William Bankes's Spanish pictures, this portrait by Velázquez (1599–1660) depicts the patron, collector and friend of Poussin in his habit as private chamberlain of Pope Innocent X. Velázquez has employed a technique almost never adopted in Spain, using ultramarine (ground lapis lazuli) to produce the rich colouring of the habit. Bankes bought the picture from the Marescalchi Collection in Bologna in 1820. *Kingston Lacy, Dorset*

Urchin mocking an Old Woman eating Polenta (right). This picture of a boy teasing an old woman by Bartolomé Esteban Murillo (1617–1682) was probably bequeathed to William Blathwayt by his uncle, Thomas Povey. Pictures of street children in Murillo's native Seville were painted largely for a foreign clientele and usually had a more cheerful mood. It is unusual in that the boy is directly addressing the viewer, leading to the suggestion that it may be based on a Spanish proverb. *Dyrham Park, Gloucestershire*

Dutch Genre Painting

An Officer making his Bow to a Lady

(above left). This scene painted c.1662 by Gerard ter Borch (1617–1681) is probably intended to suggest an idealized brothel, and the old woman in the background a procuress, but these fine settings were meant to be ambiguous. *Polesden Lacey, Surrey*

A Lady receiving a Letter

(left). Painted by Ludolf de Jongh (?1616–1679), this scene of a well-lit entrance hall in a grand house employs a favourite motif of de Jongh – the pair of gambolling dogs. We are to assume that the letter is a love letter, emphasized by the picture on the end wall of Diana and Actaeon with its allusion to cuckoldry. *Ascott, Buckinghamshire*

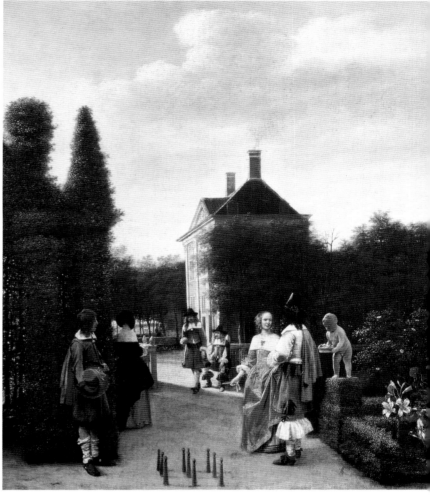

The Game of Skittles (above). This picture by Pieter de Hooch (baptized 1629, d. 1684) is one of 84 surviving paintings by this Rotterdam-born painter; there are two other versions of this picture. Many of his best works were done during a relatively short period in Delft between c.1655 and c.1661, when he moved to Amsterdam where this painting was executed c.1665. *Waddesdon Manor, Buckinghamshire*

A View down a Corridor (left). This unmistakably Dutch interior by Samuel van Hoogstraeten (1627–1678) was admired by Pepys when it hung in the London home of Thomas Povey, William Blathwayt's uncle and mentor. The illusionist perspective of successive doorways is enhanced by the painting being hung in the Gilt Leather Closet at Dyrham, continuing a perspective through an enfilade of rooms on the east side of the house.
Dyrham Park, Gloucestershire

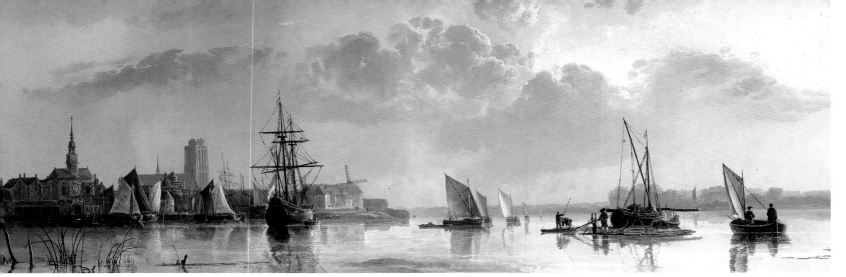

View of Dordrecht

(above). Located on the channel between Antwerp and the sea, Dordrecht was the native city of the painter Aelbert Cuyp (1620–1691), and he has depicted the city in time of peace after the end of the Thirty Years' War in 1648 – hence the absence of warships. Cuyp is celebrated for his treatment of light, and this example was described by Anthony Blunt as 'one of the most romantic renderings of light effects in the whole of Dutch painting'.
Ascott, Buckinghamshire

The Interior of the Church of St Catherine, Utrecht (right).

Painted by Pieter Jansz Saenredam (1597–1665), the view down the nave and left aisle shows two kneeling men rubbing a stone. The church was founded in 1471 for the Carmelites and completed in 1551. Saenredam's paintings of Utrecht were based on drawings done in 1636.
Upton House, Warwickshire

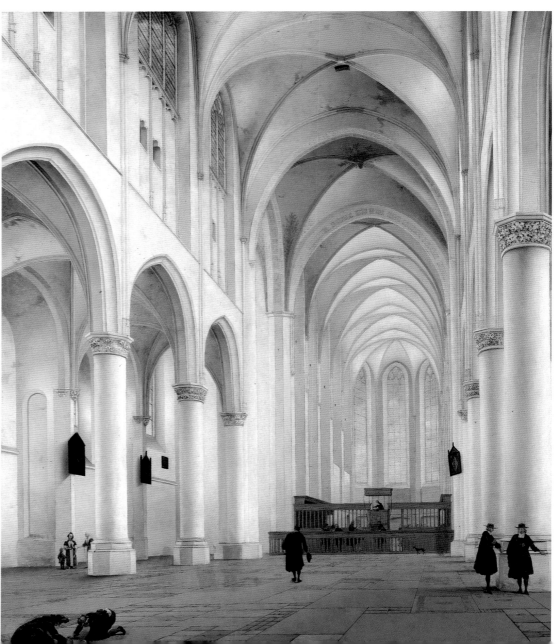

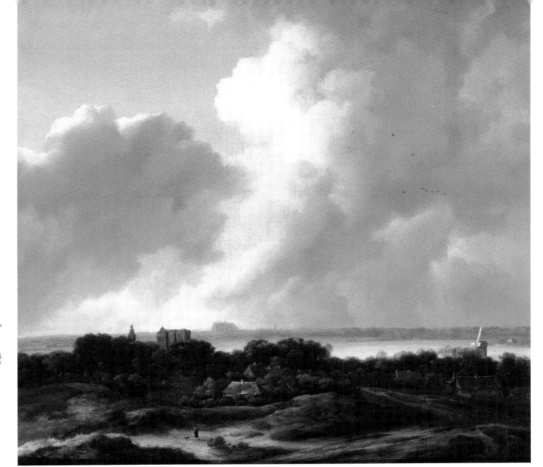

Dutch Landscape

Le Coup de Soleil (above right). This view of the dunes of Overveen looking towards Haarlem was painted by Jacob van Ruisdael (1628/9–1682). The Grote Kerk stands out on the horizon with a castle in the left foreground and a windmill on the right. The flat landscape beyond is fleetingly lit by sun breaking through the clouds, hence the picture's title.
Upton House, Warwickshire

Cottages beside a Track through a Wood (right). Meindert Hobbema (1638–1709) achieved popularity in Britain in the later 18th century, and his rural landscapes have been sought after by collectors ever since, particularly those of his most active and mature period in the 1660s. Though they give the impression of capturing a particular place, this was not the case.
Ascott, Buckinghamshire

Ideal Landscape

Classical Landscape (above). Painted by Gaspard Poussin (or Dughet, 1615–1675). Brother-in-law of the more famous Nicholas Poussin, Dughet was considered a member of the French School, as his brother-in-law taught him to paint and his work closely resembles that of his teacher, although the pupil is acknowledged as being more romantic in style. *Osterley Park, Middlesex*

The Father of Psyche Sacrificing at the Temple of Apollo (right). Claude Lorraine (1600–1682). Also known as Claude or Le Lorrain after his birthplace in what later became part of north-eastern France, Claude was one of many northern European artists drawn to Italy. By the 1630s, Claude had such a reputation that he was often imitated because of his style, which combined classical ideas of beauty and harmony with a sensitive and acute observation of nature. Claude's contribution to landscape art was his masterly treatment of light, ranging from strong, dramatic lighting effects in his early work to more gentle use of light in his later landscapes. This painting of 1663 is one of a pair at Anglesey Abbey, both by Claude (the other is called *Landscape with the Arrival of Aeneas at Pallan-teum* and was painted in 1675), which are regarded as amongst the greatest pictures to be imported from Italy at the time of the French Revolution. *Anglesey Abbey, Cambridgeshire*

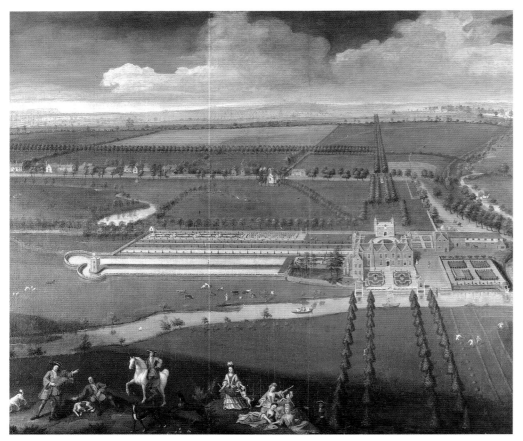

Views of the Country House

Charlecote Park (top left). Painted c.1695–1700, this unattributed view of the Lucy family home shows the Elizabethan west front, before it was extended towards the river in the early 1830s. It is also a valuable record of the formal garden that was swept away in 1760. The group picnicking in the foreground includes Colonel George Lucy and his first wife, Mary.
Charlecote Park, Warwickshire

Beningbrough Hall (bottom left). Painted by John Bouttats (b. 1708) and Thomas Chapman in 1751, this picture was bought in 2005 with Art Fund support to return it to the house. It shows wings which are thought never to have been built. It is unclear how Bouttats and Chapman divided responsibility for the painting.
Beningbrough Hall, North Yorkshire

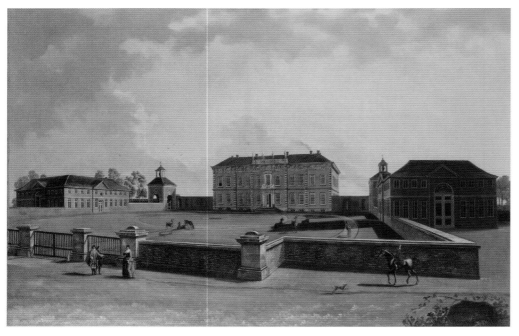

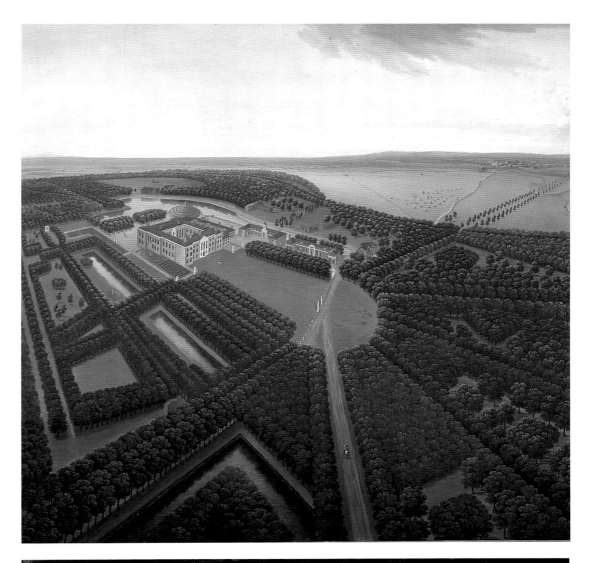

Dunham Massey (top right). The home of the Earls of Stamford is one of the best-recorded estates in paint. Besides a series of four paintings executed in 1751, John Harris the Younger painted two later landscapes in 1769, and the Jacobean house was painted in 1697 by Adriaen van Diest (1655–1704). This view is from the south-west, and much of the planting shown still survives. *Dunham Massey, Cheshire*

Lacock Abbey (bottom right). John Piper (1903–1992) painted this view in March 1942 when he was at nearby Bath to record bomb damage. His diary recorded: 'LCC School in residence, and some paying guests.' The painting was bequeathed to the National Trust by the architectural historian Alec Clifton-Taylor. *Lacock Abbey, Wiltshire*

Still Life

Still Life of Fruit and Flowers (above). This oil-on-metal painting by Jan van Huysum (1682–1749) shows grapes, pomegranates, redcurrants and carnations. Jan van Huysum was the most distinguished flower painter of his day, and a self-portrait hangs in the Ashmolean Museum, Oxford. *Dudmaston, Shropshire*

Painted flowers (left). A whole set of flower paintings now form part of the frieze decoration of the Cartoon Gallery, which was carried out for the 1st Earl of Dorset in the early 17th century. *Knole, Kent*

Still Life with a Basket of Peaches and Plums (top left). Fewer than fifty works by the French artist Jacques Linard (1597–1645) are known, and of them few are in England. *Snowshill Manor, Gloucestershire*

Still Life with Crab, Apricots, Bread and a Bowl of Summer Fruits (bottom left). Though born in Westphalia, Peter Claesz (c.1597–1661) spent most of his life in Haarlem where he and Willem Heda became the leading exponents of the *ontbijt* or 'breakfast piece', using an almost monochromatic palette and relying on subtle light and texture for effect. Claesz's son Nicholaes Berchem became a famous landscape painter. *Nostell Priory, West Yorkshire*

Birds

An Ostrich This, a pendant of a cassowary, and other pictures by Francis Barlow (c.1626–1704) were in the Onslow house at Clandon Park by 1721, but some of them were originally painted for nearby Pyrford Court, which was bought in 1677 by the son of Sir Richard Onslow, 1st Baronet. *Clandon Park, Surrey*

Three Studies of an Owl
Attributed to Jan Brueghel the Elder, in whose works two of these studies are used, and who spent some time in Italy, this picture is known to have an Italian provenance, since the back of the frame has an inscription, 'shipped from leghorn 1778', and a 'Study of Owls from Leghorne' appears in an 18th-century inventory of the contents of Clive of India's house in Berkeley Square, London. *Earl of Powis, Powis Castle, Powys*

View of a Park with Swans and Ducks
One of three paintings at Belton by Melchior d'Hondecoeter (1636–1695) which came to the house in 1873 after having been cut and adapted to fit another house in England. Born in Utrecht into a family of artists, Melchior d'Hondecoeter was a prolific painter of domestic and exotic birds as well as still-life subjects. *Belton House, Lincolnshire*

Conversation-Pieces

The Hervey conversation-piece (above) The commissioner of this lively picture by William Hogarth (1697–1764) stands in the centre. John, Lord Hervey points to an architectural plan and is surrounded by Whig friends. Presenting the plan is Surveyor of the King's Works, Henry Fox, with his brother Stephen Fox seated at the table. Allusions to the Rev. John Theophilus Desaguliers's scientific treatise on balance is made by his precarious position on the chair and to his interest in optics by the telescope. Wearing a red coat is the 3rd Duke of Marlborough, and beneath the statue is Thomas Winnington, Paymaster-General. The picture is thought to have been painted between 1738 and 1741/2. *Ickworth, Suffolk*

The Belton conversation-piece (right). Here, the commissioner, Sir John Brownlow, Viscount Tyrconnel, is standing on the left behind an idealized representation of the picture's painter, Philippe Mercier (1689–1760). The invalid Viscountess Tyrconnel is being wheeled by a page, and the surrounding figures are family members. *Belton House, Lincolnshire*

William Hogarth

Hogarth (1697–1764) became the outstanding English painter of his day, after an impecunious childhood that gave him a familiarity with the seedier sides of life he later depicted and satirized. He first trained as an engraver but also studied painting under Sir James Thornhill, whose daughter he married. Hogarth first achieved success through his conversation-pieces of the early 1730s, though these were soon eclipsed by the satires for which he is most famous. The Trust displays major works by Hogarth at Upton House: *The Four Times of Day: Morning* and *Night* are full of caustic observations of London life and mores. The very different *Gerard Anne Edwards in his Cradle* is a portrait of the son of Lord Anne Hamilton and the eccentric heiress Mary Edwards of Kensington.

Grand Tour Landscapes

View of Verona from the Ponte Nuovo This picture by Canaletto's nephew and pupil, Bernardo Bellotto (1720–1780) was probably painted while he lived in Venice, before moving to Dresden to become painter to Frederick Augustus II of Saxony, King of Poland. The view is taken from the Ponte Nuovo over the Adige looking upstream to the north, with the Visconti fortress of Castel San Pietro in the middle distance and the tower of Sant' Anastasia on the left. The picture once hung in the London house of Clive of India in Berkeley Square. A companion piece, looking in the other direction and showing the Ponte delle Navi itself, hangs in the National Gallery of Scotland, Edinburgh. *Powis Castle, Powys*

Bacino di San Marco, Venice (top left).

This early picture by Canaletto (1697–1768) is a view looking towards the Doge's Palace with the entrance to the Canale della Guidecca and Dogana on the left and a glimpse of a shaded S. Giorgio Maggiore on the right. As so often with Canaletto's pictures, the view is more than the eye could encompass in a single focus, so he had to make adjustments to the perspective. *Upton House, Warwickshire*

The Stables of the Villa of Maecenas at Tivoli (bottom left).

The Swiss artist Abraham-Louis Ducros (1748–1810) was greatly favoured by Colt Hoare, who declared that he painted watercolours like oil paintings. The Column Room at Stourhead is hung with his watercolours of Rome and the Campagna. The so-called Villa of Maecenas was the foundations of an ancient temple complex, but was mistakenly thought to be the house of the famous patron of the poets Horace and Virgil. *Stourhead, Wiltshire*

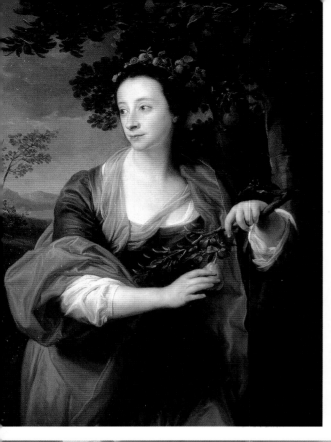

Sarah Lethieullier, Lady Fetherstonhaugh

(far left). The daughter of Christopher Lethieullier and Sarah Lascelles, Sarah Lethieullier married Sir Matthew Fetherstonhaugh in 1746. This and a companion portrait of her husband were painted in 1751 by Pompeo Batoni (1708–1787) while they were on a Grand Tour of France and Italy in 1749–1751. They and others in their party were among Batoni's earliest British patrons. *Uppark, West Sussex*

Samuel Egerton (near left).

This portrait was painted in Venice in 1732–1734 by Bartolomeo Nazzari (1699–1758) shortly after Egerton had been apprenticed by his uncle, Samuel Hill, to the merchant and art dealer Joseph Smith, a patron of Canaletto and later British Consul. In the background are the Dogana and the Church of the Redentore. Egerton inherited Tatton Park on the death of his uncle in 1758. *Tatton Park, Cheshire*

The Earl-Bishop (bottom left).

In this pastel, Hugh Douglas Hamilton (1736–1808) has depicted the 4th Earl of Bristol in a corner of the Borghese Gardens known as the Pincian Hill, looking down over Rome. Hamilton was an Irish artist who worked in Rome from 1782 to 1791 and specialized in pastel portraits of Grand Tourists. Sadly the Earl-Bishop's magnificent art collection was never to reach Ickworth, the bulk of it being confiscated by Napoleonic troops in Rome in 1798 and dispersed at auction six years later, and the remainder left by him to a second cousin in Ireland. *Ickworth, Suffolk*

A Punch Party (right). This

1760 painting by Thomas Patch (1725–1782) caricatures the 5th Earl of Stamford and his companions at Mr Hadfield's Inn in Florence. Located near S. Spirito, it was much frequented by English on the Grand Tour. The artist has painted a caricature bust of himself on the right-hand wall. Patch had settled in Florence in 1755 and made a living from topographical pictures and copies of old masters for the subjects of his caricatures to take home. *Dunham Massey, Cheshire*

Grand Tour Portraits

Female Artists

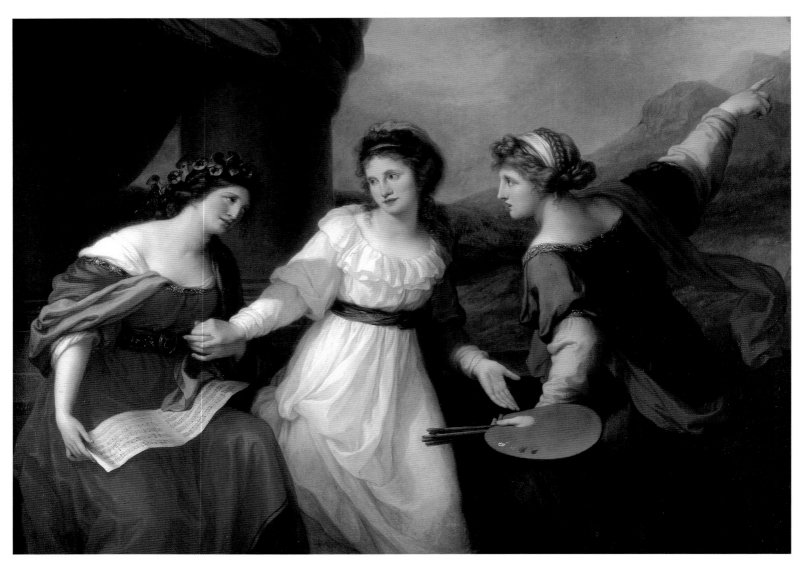

Angelica Hesitating between the Arts of Music and Painting The Swiss-born painter Angelica Kauffman (1741–1807) was a child prodigy, receiving her first commission at the age of eleven. Besides her gifts as a painter, she also had a beautiful singing voice and played a number of instruments, and this self-portrait shows the struggle she had to choose between her talents. Her first picture of this subject was executed in Milan in 1761, but she returned to it 30 years later at the behest of James Forbes of Stanmore Hill, Middlesex, for whom she painted this picture in Rome. Forbes had made his money through the East India Company and had enlarged a house built by the Duke of Chandos. *Nostell Priory, West Yorkshire*

Elisabeth Vigée-Lebrun (above). This 1791 self-portrait of the French artist (1755–1842) was commissioned by the 4th Earl of Bristol, better known as the Earl-Bishop. The painting she is working on is of her adored but unsatisfactory daughter, Julie. Of the day she was born, her mother wrote: '…I never left my studio and I went on working…in the intervals between labour pains.' Other versions of the painting show her working on a portrait of Marie Antoinette. *Ickworth, Suffolk*

Lady Elizabeth Foster (left). This 1786 portrait by Angelica Kauffman (1741–1807) depicts the favourite daughter of the Earl-Bishop. She became the wife of the Irish MP John Foster, but the marriage proved a disaster. She lived in a *ménage-à-trois* with the 5th Duke and Duchess of Devonshire, and after the Duchess's death she married him, in 1809. *Ickworth, Suffolk*

Horse Painting

The Council of Horses John Ferneley Senior (1782–1860) of Melton Mowbray painted hunting scenes and horse paintings of the highest quality, but this is a rarity among his work. It was painted in 1850 for Sir John Harpur Crewe and illustrates one of John Gay's *Fables*, written in 1727, describing how a proud unbroken colt, the beautiful bay horse standing on the left, refused to be broken in and advised the other horses not to work for Man. All the horses agree until an old horse, the large dark brown horse with four white stockings and a white face, steps forward and rebukes the young colt, who submits after the speech by the old and wise horse. *Calke Abbey, Derbyshire*

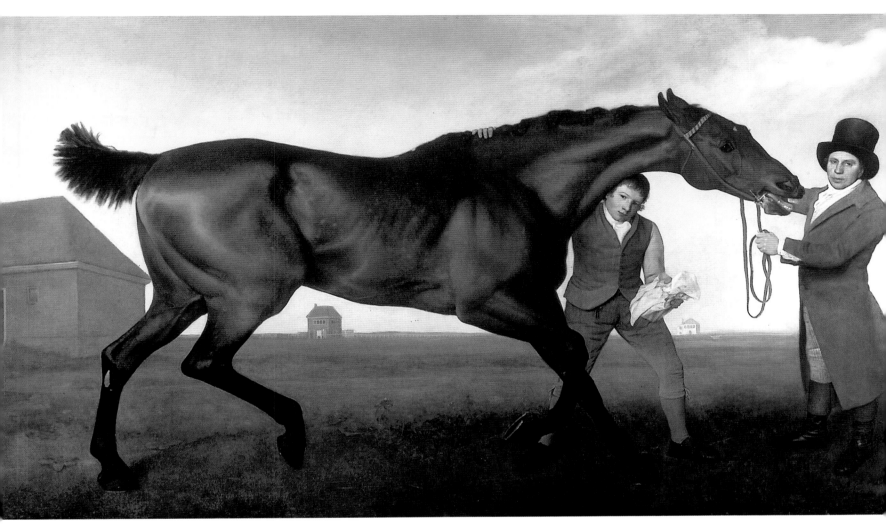

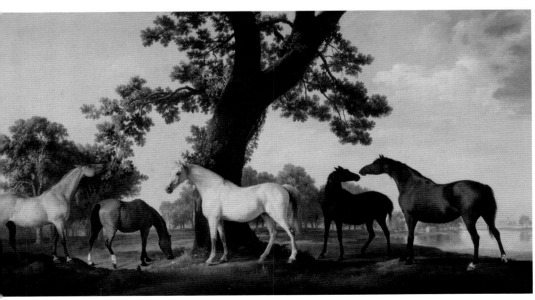

Hambletonian: Rubbing Down (above). This racehorse was owned by Sir Henry Vane-Tempest, who commissioned George Stubbs (1724–1806) to paint this portrait and a portrait of the race. It shows the exhausted thoroughbred being rubbed down after the match with Joseph Cookson's 'Diamond' at Newmarket in 1799. The picture was exhibited at the Royal Academy in 1800 but Stubbs had to sue the baronet for payment. *Mount Stewart, County Down*

Five Brood Mares (left). George Stubbs (1724–1806) was painting similar pictures of mares and foals during the 1760s and '70s. While some were portraits of particular horses, others were imaginary variations on the theme, and it is thought that this is one of the latter. There is, however, some evidence that the subjects could have been the Duke of Cumberland's, since the setting appears to be Windsor Great Park, where the Duke had his stud. *Ascott, Buckinghamshire*

Grand Manner

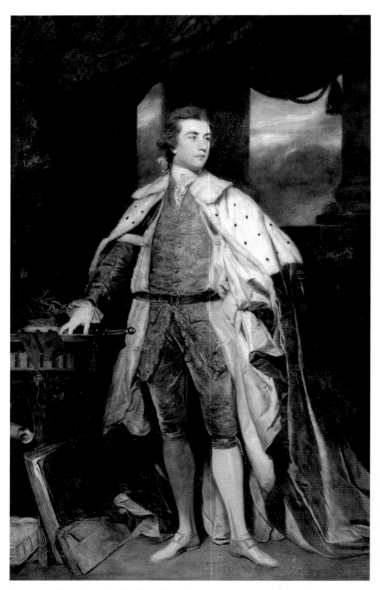

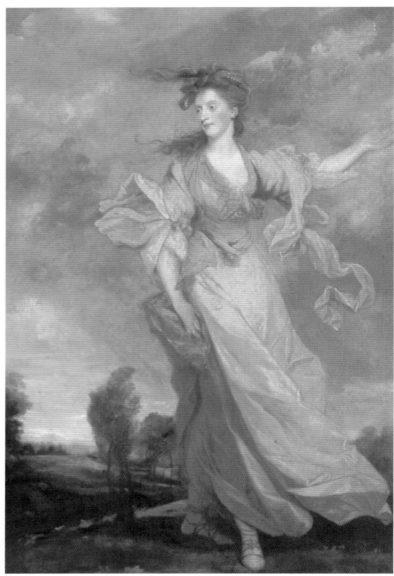

John Frederick Sackville, 3rd Duke of Dorset
The Duke was one of the most generous patrons of Sir Joshua Reynolds (1723–1792) who painted this portrait in 1769 for 150 guineas. He became Ambassador to France from 1783 until the Revolution. *Knole, Kent*

Lady Jane Halliday Painted in 1778–1779 by Sir Joshua Reynolds (1723–1792), the subject was born Jane Tollemache in 1750 and eloped with John Delap Halliday, marrying him, possibly at Gretna Green, in 1770–1771. This picture was formerly at Ham House. *Waddesdon Manor, Buckinghamshire*

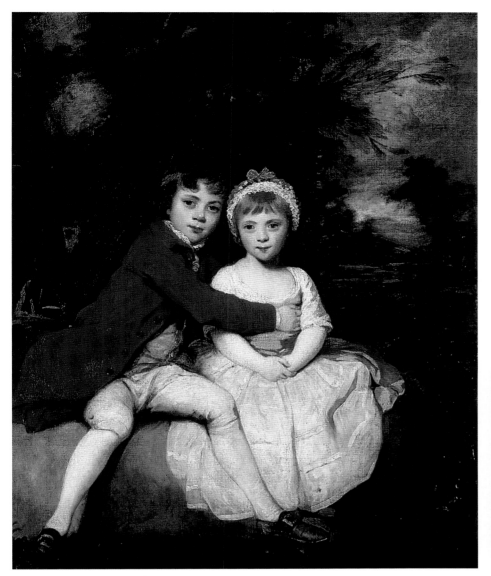

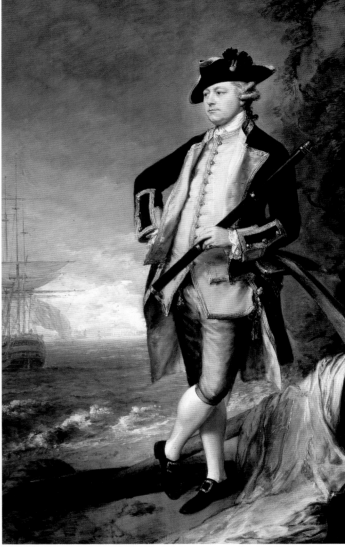

John Parker and his Sister Theresa as Children (above left). John Parker, the future Earl of Morley, and his sister sat numerous times during 1778 and 1779 for Sir Joshua Reynolds (1723–1792). A Whig supporter of Parliamentary reform, John Parker married Lady Augusta Fane. After their divorce in 1809, he married Frances Talbot, an accomplished amateur artist, a number of whose pictures are at Saltram. Theresa Parker married George Villiers, son of the 1st Earl of Clarendon. *Saltram, Devon*

Commodore the Hon. Augustus John Hervey (above right). As a younger son, John Hervey had had to make a career and he became a diligent naval officer, ending his career as Vice-Admiral of the Blue. The cross-legged stance chosen by Thomas Gainsborough (1727–1788) was favoured by every portrait painter of the day. John Hervey succeeded his older brother to become 3rd Earl of Bristol in 1775. *Ickworth, Suffolk*

Joshua Reynolds (1723–1792)

Joshua Reynolds became the greatest portraitist of his day and the first president of the Royal Academy, helping to raise the stature of art and artists in society. He quickly achieved pre-eminence in his profession: by the age of 36 he had 150 sitters a year, so it is hardly surprising that the Trust's houses have rich holdings of his work, with particularly strong collections at Knole, Saltram and Petworth. Reynolds was born only four miles from Saltram in Devon, and ten portraits by him hang on its walls.

Regency Portraits

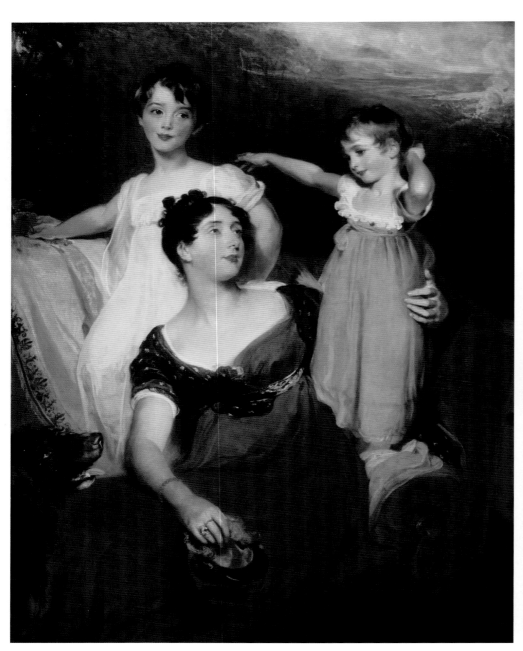

Lydia, Lady Acland with Two Sons (left). Sir Thomas Lawrence (1769–1830) was the outstanding portrait painter of his generation and was commissioned to paint Lady Acland and her children in 1814–1815 to celebrate her recovery from an illness. She is shown with her two eldest sons, Tom, aged five, and Arthur, aged three, with their spaniel, Bronte. *Killerton, Devon*

George IV (below). This domestic portrait of the king by Sir Thomas Lawrence (1769–1830) is an apparently autograph reduction of the life-size portrait in the Wallace Collection that was painted, like it, for the King's mistress, Elizabeth, Marchioness Conyngham, in 1822. The King is still wearing mourning black two years after his father's death. *Croft Castle, Herefordshire*

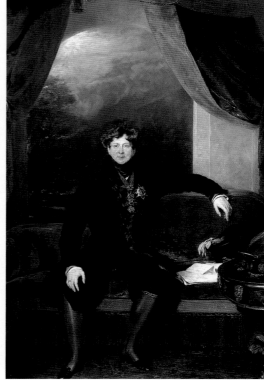

The Macdonald Children In this painting by Sir Henry Raeburn (1756–1823), the eldest of the Macdonald children, Reginald George, wearing red, sits on a rock in the act of snapping his fingers with his brother Robert, watched by the youngest boy, Donald. Reginald George Macdonald of Clanranald became the 19th Chief of Clanranald and 7th of Benbecula at the age of five. *Upton House, Warwickshire*

Mrs Jordan This pastel portrait of the actress and mistress for 21 years of the Duke of Clarence, later William IV, was done in 1801 by John Russell (1745–1806). Born near Waterford in Ireland, she enthralled West End audiences for nearly thirty years. Debt forced her to flee to France in 1814, where she died in poverty two years later. *Fenton House, Hampstead, London*

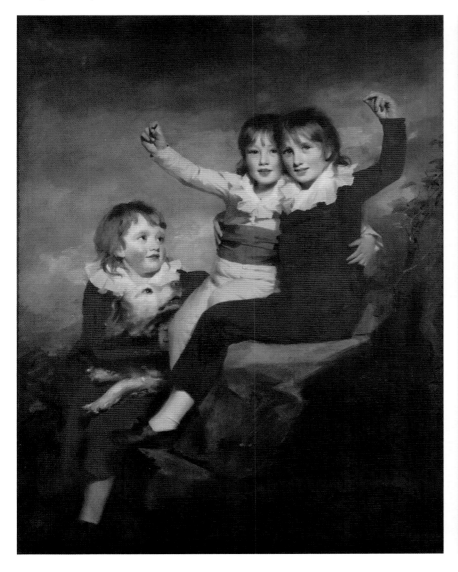

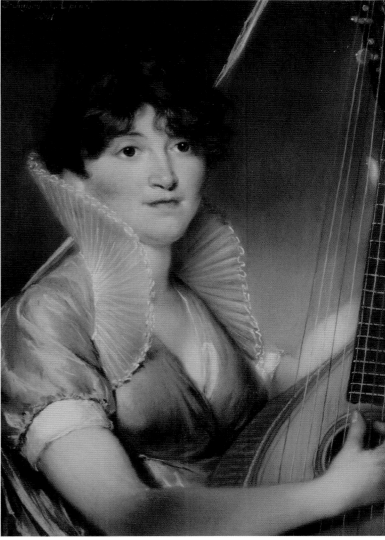

Landscape

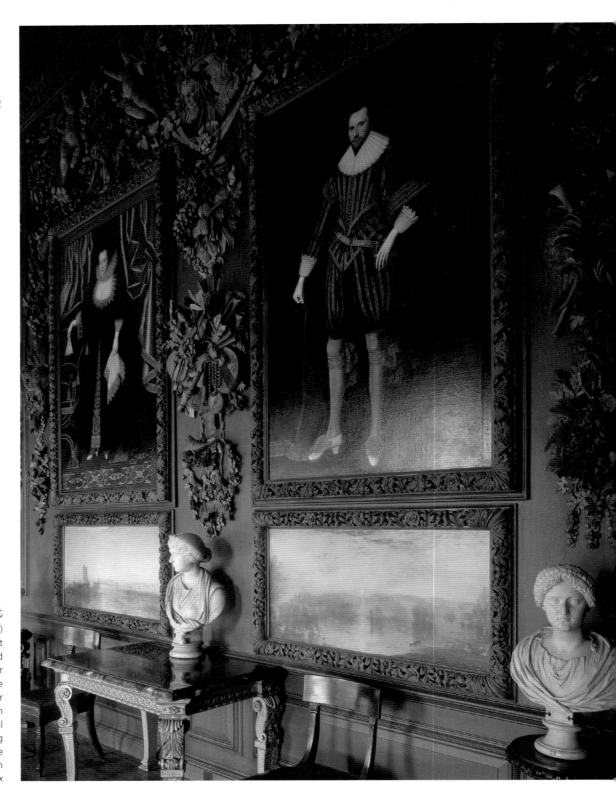

Turner landscapes at Petworth J M W Turner (1775–1851) spent time at Petworth in the 1820s as the guest of Lord Egremont, whose patronage had brought him much recognition. There, Turner made over 100 drawings, and for the house itself he painted, among other things, four landscapes. These are now on permanent loan from the Tate gallery and hang in their original positions within the Grinling Gibbons panelling in the Carved Room, where they formed the basis of a major 10-year restoration which finished in 2002. *Petworth House, West Sussex*

Shipping on the Canal at Calais: Morning Effect

(top left) Richard Parkes Bonnington (1801–1828) lived in Calais from the age of 15, before moving to Paris where he shared a studio with Delacroix and returned to England with him in 1825. Bonnington was overloaded with work, leading to a breakdown of his weak constitution and early death from consumption shortly before his 26th birthday. *Knightshayes Court, Devon*

The Opening of Waterloo Bridge

(bottom left). John Constable (1776–1837) almost certainly witnessed the opening of John Rennie's bridge across the Thames by the Prince Regent on 18 June 1817. He painted this scene c.1820–1825, possibly in the hope of gaining royal patronage. He failed to win this, perhaps because he was obviously less interested in recording the royal embarkation at Pembroke House than capturing the effects of sky and water; but he went on anyway to paint a slightly different version of the composition, which he exhibited at the Royal Academy in 1832 (Tate Britain). *Anglesey Abbey, Cambridgeshire*

Portraits of Servants

Thomas Rogers, Carpenter No house in Britain has such a vivid set of servant portraits as Erddig. Thomas Rogers began his 73 years of service at Erddig in 1798, trying his hand as pig boy, thatcher's assistant and slater before becoming a carpenter. In 1815 he was saved from a press gang by Simon Yorke. He is shown here in 1830 in the joiners' shop with his tools as a backdrop. When Thomas retired at the age of 90, his tools passed to his son James who took over as carpenter. With typical generosity the Yorkes paid for Thomas's funeral – and provided the Erddig carriages – when he died four years later.
Erddig, Wrexham

John Meller's Coachboy (top left)
Though one of the coachboys working at Erddig in the 1730s was black, there is now some doubt whether this late-18th-century picture depicts an Erddig servant at all. Infra-red reflectography has revealed the inscribed identity of one John Hanby, aged 25, about whom nothing is known. *Erddig, Wrexham*

Edward Prince, Carpenter (top right)
Painted in 1792 by John Walters of Denbigh, Edward Prince succeeded his father as carpenter by 1779 and had his own son working for him. On the right, held in place by a pair of dividers, is a scroll of verse; it was a tradition for successive Yorkes to write poems to record the qualities of their servants. The late-17th-century house is seen in the distance. *Erddig, Wrexham*

The Dudmaston Gamekeeper
(right). His name is lost but the Dudmaston Gamekeeper, portrayed with his spaniel and a dead partridge, can be identified in another painting in the house depicting the Wolryche Hunt. *Dudmaston, Shropshire*

Interiors

The Travellers' Breakfast (top right). This group portrait reputedly depicts many of the contributors to *The London Magazine* and members of Sir Charles Abraham Elton's family. The recipient of the bill from the writer Charles Lamb is the artist himself, Edward Villiers Rippingille (1798–1859). Coleridge is holding out a boiled egg for Wordsworth to sniff, while Dorothy Wordsworth sits at the table with folded hands. Robert Southey ogles Lucy Caroline, Charles Abraham's daughter, pouring out tea while her father looks on. To the right, her twin sister, Caroline Lucy, laughs as an ostler tries to extract a tip from an old lady. On the left, Julia Elizabeth prods a porter with an umbrella. Another Elton daughter, Laura Mary, leans against an old lady at the foot of the stairs, while her mother clasps her young sons. *Clevedon Court, North Somerset*

1st Lord Armstrong of Cragside (bottom right). The Northumbrian artist Henry Hetherington Emmerson (1831–1895) portrays a slippered Sir William reading in the dining-room inglenook. The cast of the light indicates that the picture was done after electricity was introduced to the house in 1880, the first country house to be so equipped. Sir William had made a fortune from his engineering genius. *Cragside, Northumberland*

A Chelsea Interior Robert S. Tait (fl. 1845–1875) must have been one of the first painters to use photography as an aid to painting; he took a series of exposures around the Cheyne Row home of Thomas and Jane Carlyle before beginning work on this 1857 picture. His work irritated the historian's wife: 'that weary artist…took the bright idea last spring that he would make a picture of our sitting room – "to be amazingly interesting to posterity a hundred years hence"… The dog is the only member of the family who has reason to be pleased with his likeness as yet.' *Carlyle's House, London*

WHATSOEVER · THY · HAND · FINDETH · TO · DO · DO · IT · WITH · THY · MIGHT ·

In the NINETEENTH CENTURY, the Northumbrians show the World what can be done with Iron and Coal.

Images
of Work

Iron and Coal (left). This is one of eight murals illustrating 'the history and worthies of Northumbria' for the Central Hall at Wallington. To paint the eight canvases between the arches of the north and south walls, they chose William Bell Scott (1811–1890), Director of the Newcastle School of Design. This montage celebrates Newcastle's industrial prowess and includes a locomotive and the High Level Bridge designed by Robert Stephenson, a gun from Armstrong's works and an anchor and pump made by Hawks, Crawshay. *Wallington, Northumberland*

Excavation of the Manchester Ship Canal (above right). The Egerton family of Tatton had long been associated with canal-building when the 3rd Duke of Bridgewater was appointed Chairman of the Manchester Ship Canal in 1887, and he commissioned this picture of the place where construction began with the turning of a sod by a spade which is still kept at Tatton. *Tatton Park, Cheshire*

Hullo, Largesse! A Harvest scene in Norfolk (right). William Maw Egley (1826–1916) was staying with John Rose at Reedham Old Hall, Norfolk during harvest time in 1860. Anyone visiting an East Anglian farm during harvest was traditionally obliged to give harvesters a present, or 'largesse', which they acknowledged with the cry that forms the title of this work. Rose commissioned the picture for which Egley charged £200, and it came to Scotney in the 1950s. *Scotney Castle, Kent*

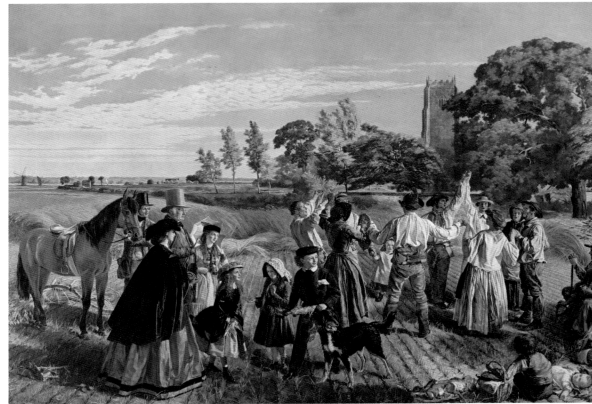

High Victorian Portraits

Jane Elizabeth 'Jeanie' Hughes, Mrs Nassau Senior
(near right). The strong colouring in this portrait by George Frederic Watts (1817–1904) reflects the influence of the Pre-Raphaelites. Watts met Jeanie Senior at a house-party in London and came to admire her concern to do good through practical action; she later became the first female Inspector of Workhouses and Pauper Schools and helped Octavia Hill, one of the three founders of the National Trust, with accounts of her housing schemes.
Wightwick Manor, West Midlands

John William Spencer, 2nd Earl Brownlow
(far right). The 3rd Baron and 2nd Earl Brownlow died at the age of 25 before he had a chance to make his mark on Belton. This portrait was painted by G F Watts (1817–1904).
Belton House, Lincolnshire

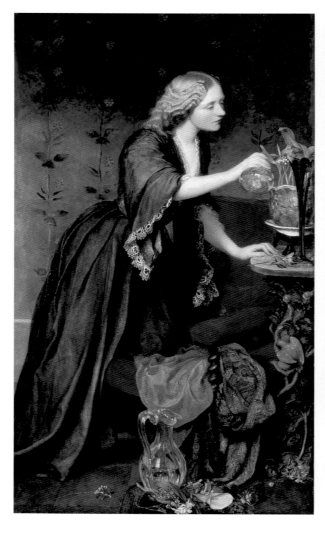

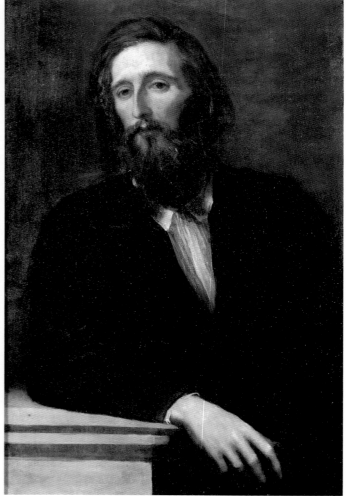

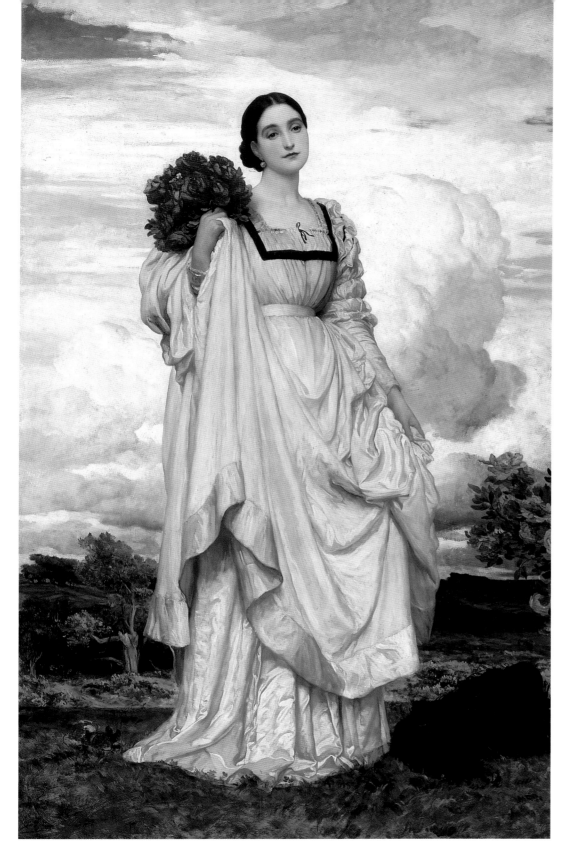

Lady Adelaide Talbot, Countess Brownlow

It was the 2nd Earl's younger brother who became 3rd Earl in 1867 and commissioned this 1879 portrait of his wife by Lord Leighton, PRA (1830–1896). This is regarded as perhaps the finest of Leighton's female portraits, with an autumnal background of the Cust house at Ashridge, Hertfordshire. Lady Adelaide was described by Lady Paget as the 'most beautiful of three sisters, every one of them the salt of the earth'. She was one of the older generation of aesthetically minded aristocrats known as 'the Souls', and with her husband chose to reinstate many of the features that make Belton such a remarkable Caroline house. *Belton House, Lincolnshire*

Edward Burne-Jones

Sir Edward Burne-Jones (1833–1898) was a largely self-taught painter, illustrator and designer, though influenced by William Morris with whom he founded a decorative arts company in 1861. National Trust houses contain works on paper by him at Bateman's, Smallhythe Place and Wallington, tapestry based on his design at Standen, murals at Red House, and the series of four large canvases and ten connecting scenes that make up *The Legend of the Briar Rose* at Buscot Park. But the largest holding of Burne-Jones's work is at Wightwick Manor. Among the collection of pictures by the Pre-Raphaelites and their associates are chalk drawings and paintings by Burne-Jones, including one of his best late works, *Love among the Ruins*.

Dream Worlds

The Arlington Court Picture (above). This remarkable watercolour by William Blake (1757–1827) was discovered by Trust staff on top of a pantry cupboard in 1949. Nothing is known of its provenance before it was brought to Arlington, probably by Colonel John Chichester in the early 19th century. The subject has been interpreted as an allegory inspired by the neo-Platonic interpretation of Homer's Odyssey, but this is arbitrary and the symbolism is personal to Blake.
Arlington Court, Devon

The Wedding Feast (left).
This is one of three wall-paintings by Sir
Edward Burne-Jones, commissioned by
William Morris. It was supposed to be a
cycle of seven paintings based on the
15th-century romance of Sir Degrevaunt,
published in 1844, but Burne-Jones
completed only three in the summer and
autumn of 1860. Here, the royal bride and
groom are portraits of the Morrises.
Red House, Bexleyheath, London

**Love among the
Ruins** (left). Painted by
Sir Edward Burne-Jones four
years before his death, the
subject is based on a
watercolour of 1870–1873,
but the rich yet muted colours
and the wistful depiction of
the ephemerality of love and
youth are typical of the older
Burne-Jones. *Wightwick
Manor, West Midlands*

Modern Murals

Rex Whistler mural (left) When the north wing of Plas Newydd was remodelled in 1935–1936, the 6th Marquess of Anglesey commissioned Rex Whistler to paint what was to be the last and most extensive of his large murals. The maritime setting of the house and the proximity of Snowdonia inspired a vast *capriccio* embracing mountain landscape, architecture, ships and the sea. The canvas was woven in France, and Whistler used a theatre workshop in Lambeth, so that the canvas could be raised or lowered as he painted from a platform. When it was completed in June 1937, it was taken to Plas Newydd and glued to the plaster walls of the Dining Room. This section of the mural shows Lord and Lady Anglesey's arms carved into the stone of the parapet, with Neptune's crown and trident carelessly propped against an urn.
Plas Newydd, Anglesey

Tea in the Hospital Ward The unique chapel in the village of Burghclere was created as a tribute to the memory of Lieutenant Henry W Sandham by his sister Mary Behrend and her husband. Lt. Sandham had died in 1919 as a result of an illness he contracted during the Macedonian campaign in the First World War. The red-brick chapel designed by Lionel Pearson was closely modelled on Giotto's Arena Chapel in Padua at the request of Stanley Spencer (1891–1959), whom the Behrends had commissioned to fill the chapel with paintings. Spencer created a cycle of paintings that drew upon his own wartime experiences to convey a sense of human companionship rarely found in civilian life. He began work on two small canvases in 1927 before the chapel was finished. Besides the eight arch-topped canvases and the eight smaller 'predellas', of which this scene of afternoon tea was one, Spencer had to paint *in situ* the uppermost sections of the walls and *The Resurrection of the Soldiers* on the end wall. The task was completed in 1932. *Sandham Memorial Chapel, Hampshire*

20th-century Portraits

Portrait of Virginia Woolf (top left). This oil-on-board portrait of the writer Virginia Woolf was painted c.1912 by her sister Vanessa Bell (1879–1961), seven years before Leonard and Virginia Woolf acquired Monk's House at auction for £700. Vanessa Bell painted many subjects in and around the house.
Monk's House, East Sussex

George Bernard Shaw (bottom left). This is one of three portraits of Shaw painted by Augustus John (1878–1961) in 1915. Over eight days, John did six portraits, but as Shaw wrote to Mrs Patrick Campbell, 'Unfortunately as he kept painting them on top of one another until our protests became overwhelming, only three portraits have survived.' Shaw was delighted with the results, seeming to be quite happy that John had captured him as an 'inebriated gamekeeper'. *Shaw's Corner, Hertfordshire*

Edward, 5th Lord Sackville (near left). Eddy Sackville-West (1901–1965) was a novelist and music critic who succeeded his father in 1962, but he never much cared for Knole, buying a house in Ireland in 1956 – 'Ireland suits my temperament'. This portrait of the confirmed bachelor was painted by Graham Sutherland (1903–1980). *Knole, Kent*

Nancy Astor Painted in 1908 by John Singer Sargent (1856–1925), this portrait was done two years after her marriage to Waldorf, 2nd Viscount Astor. Both Americans, though from different sides of the North–South divide, they created at Cliveden the centre of the political and literary society in which they moved. *Cliveden, Buckinghamshire*

Lady in Blue 'No one could call it a portrait, it is a fantasia in a characteristic subdued colour scheme,' was the view of Teresa, Lady Berwick, the subject of this 1933 painting by Walter Sickert (1860–1942). Lady Berwick knew Sickert through her father, who was a painter. *Attingham Park, Shropshire*

Modernism

The Past and the Present Max Ernst (1891–1976) used the diptych form to portray related, yet separate, visions of past and present. The imagery is very Surrealist in character, and the visual references to the inner workings of the mind relate to Ernst's interest in automatism, whereby unconscious and hallucinatory states were used to create works of art and literature. *2 Willow Road, Hampstead, London*

Standing Figures

(top right). Dated 1940, this is one of innumerable drawings by Henry Moore (1898–1986) on the theme of standing men and women. *2 Willow Road, Hampstead, London*

El Cine

(bottom right). In 1960 Sir George Labouchere was posted as British Ambassador to Madrid, where he began collecting contemporary Spanish art and particularly the work of the El Paso group, founded in 1957. Its members were trying 'to create a new spiritual state of mind within the Spanish artistic world'. This 1963 collage and watercolour was by Antonio Saura (1930–1998), a left-wing artist, and represents the ominous effect of a mob of people. *Dudmaston, Shropshire*

Photography

Fox Talbot

William Henry Fox Talbot This photograph is from a daguerreotype of William Henry Fox Talbot by Antoine Claudet (1797–1867). Claudet learnt the technique in Paris and became well respected as a technical and artistic master of the medium. *Lacock Abbey, Wiltshire*

Fox Talbot the Photographer

William Henry Fox Talbot moved to his ancestral home, Lacock Abbey, in 1826. In 1834, he experimented by coating paper with a solution of salt and silver nitrate. He found that when opaque objects such as fern leaves or lace were placed on the treated paper and exposed to the sun's rays, they left silhouettes behind. He christened his invention 'photogenic drawing'. He also discovered how to 'fix' these images using potassium iodide and conceived the idea of the 'negative' image, from which multiple 'positive' prints could be reproduced. However, he was distracted from publishing these discoveries by other responsibilities; it was, for instance, largely thanks to his efforts in 1838 that Kew Gardens were saved from closure and established as the national plant collection.

In January 1839 Fox Talbot was alarmed to read reports that the Frenchman Louis Daguerre had managed to preserve images captured by a camera obscura. Fox Talbot rushed to show examples of his own work to the Royal Society, but in a sunless winter was unable to replicate his first experiments. Daguerre received public recognition as the 'father of photography' and lavish financial support from the French government for his work, while Fox Talbot got nothing. Despite these disappointments, he continued to refine his invention. He discovered he could reduce exposure times by treating the exposed paper with a chemical 'developer', which would 'fix' the image. He christened the result the 'calotype'. The daguerreotype was initially more successful than the calotype, as its greater clarity was more suited to portraiture – the commercial mainstay of the new medium – but because the calotype could generate multiple images from a single original, it was to have much greater commercial potential. In the 1850s Fox Talbot developed a more reliable process for reproducing photographs with printers' ink by engraving them on a steel printing plate. All the modern techniques of photogravure printing can be traced back to this invention.

Print from Fox Talbot's first negative of the oriel window in the South Gallery, Lacock Abbey

This image of a latticed window at Lacock Abbey, Wiltshire, is thought to be the first ever photograph, or 'sun picture' produced with a negative. William Henry Fox Talbot, first and foremost a scientist, was interested in the possibility of 'fixing' a mechanical image. He experimented with a camera obscura fitted with a convex lens, and silver chloride, a chemical darkened by light. As a label for this print, probably for his first exhibition of photographs at the Royal Institute, London, 25 January 1839, Talbot wrote 'Latticed Window (with camera obscura) August 1835. When first made, the squares of glafs [glass] about 200 in number could be counted, with the help of a lens.' *Lacock Abbey, Wiltshire*

Chambré Hardman

Rainy Day in Chester Edward Chambré Hardman, as well as being a commercial portraitist, produced artistic photographs such as this street scene showing Northgate Street, Chester. The high perspective and cropping is typical of modern photography of the early 20th century. *Mr Hardman's Photographic Studio, 59 Rodney Street, Liverpool*

The Merseyside Photographer

Edward Chambré Hardman (1899–1988) studied photography by correspondence course during his time in military service in India in 1917. He lived at 59 Rodney Street, Liverpool, from 1948 until he died in 1988, where he worked as a photographic portraitist and pictorialist photographer. His archive of over 140,000 images, as well as photographic equipment and documents, form a record of the people and events of mid-20th-century Liverpool. Chambré Hardman was well known for photographing the middle classes, people of high standing, and stars such as Margot Fonteyn and Michael Redgrave. Here he is shown wearing his trademark hat, holding a Rolleiflex camera, a twin-lens reflex camera introduced in 1928 that was popular due to its compact design, quality and flexibility. The photographer of this portrait, Mrs Hewlett, was the wife of Major Hewlett who ran the army photographic class Chambré Hardman taught in Chester.

Dance of Trees and Clouds

Chambré Hardman was well known for his artistic photographs and this image, with its poetic title, shows great technical and artistic competence. The image was made on an Eastman Nitrate Kodak negative using a large plate camera. Historically, photographs that combined land and sky were very difficult to capture due to the different light levels of each, and consequently required differing exposure times. It was common for photographers to combine or retouch negatives to produce an aesthetically pleasing image. This image skilfully catches the movement of the clouds as they loom overhead.

Mr Hardman's Photographic Studio, 59 Rodney Street, Liverpool

Country House Photo Album

Performance of *The Winter's Tale* (top left). 'Whenever our aristocratic amateur goes by rail or road to visit his other aristocratic friends, his Calotype chest forms, as a matter or course, a part of his luggage' (Cuthbert Beded, *Photographic Pleasures*, 1855). The 'Calotype chest' refers to the equipment required to make calotype photographs – it was very cumbersome. Country House photography is acknowledged as an influential strand of early photography. Photography became an ingrained part of house-party life until country house culture died out with the Second World War in 1939. Here a performance of Shakespeare's *The Winter's Tale* is acted out for the camera, forming an artistic document of a pleasurable afternoon. *Ormesby Hall, Cleveland*

'Bicycle antics' at Montacute (bottom left). This is a snapshot of women on bicycles at the end of the 19th century. The two-wheeled bicycle as we know it today was invented in 1839, the same year in which Louis Daguerre announced the invention of photography in France. As the design of the bike improved, so technological advancements made photography accessible to wealthy amateurs. Both were very popular modern pursuits. This photograph would have been part of a collection of photographs from the Phelips family at Montacute House, including portraits of family and friends, a record of the life of a wealthy family. *Montacute House, Somerset*

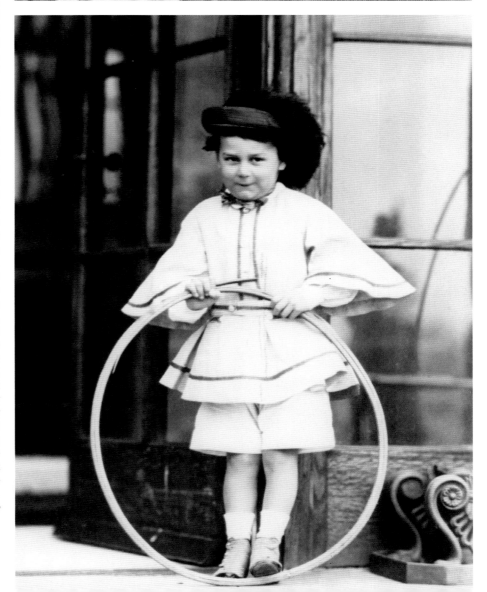

Household servants at Petworth House

(top right). Photographs made at country houses as documents and keepsakes were popular in the late 19th century. This photograph records the servants at Petworth House, lined up to promote their smart appearance and sheer number. Variations in uniform convey role and rank: the chef, for example, stands out with his white outfit and concentrated expression.
Petworth House, West Sussex

George William Henry Vernon (future 7th Baron), aged 4

(bottom right) This beguiling photograph of a young boy in the 1850s shows the future 7th Baron at Sudbury Hall in Derbyshire delicately framed in the doorway. His family had always owned Sudbury, his ancestor George Vernon re-creating it from the existing manor house in the late 17th century. This image is probably an albumen print. Albumen prints were invented in 1850 by Louis-Desiré Blanquart-Evrard, and involved coating a piece of paper with albumen, or egg white, and treating it with light-sensitive silver nitrate before exposing it to the negative. The effect is a glossy image that sits on the surface of the paper, showing a good level of detail. Part of the collection of Vernon family photographs, this is a carefully composed image that forms a record of family life at Sudbury. This young boy was to become Captain of the Yeomen of the Guard in the last Liberal administration of prime minister William Gladstone.
Sudbury Hall, Derbyshire

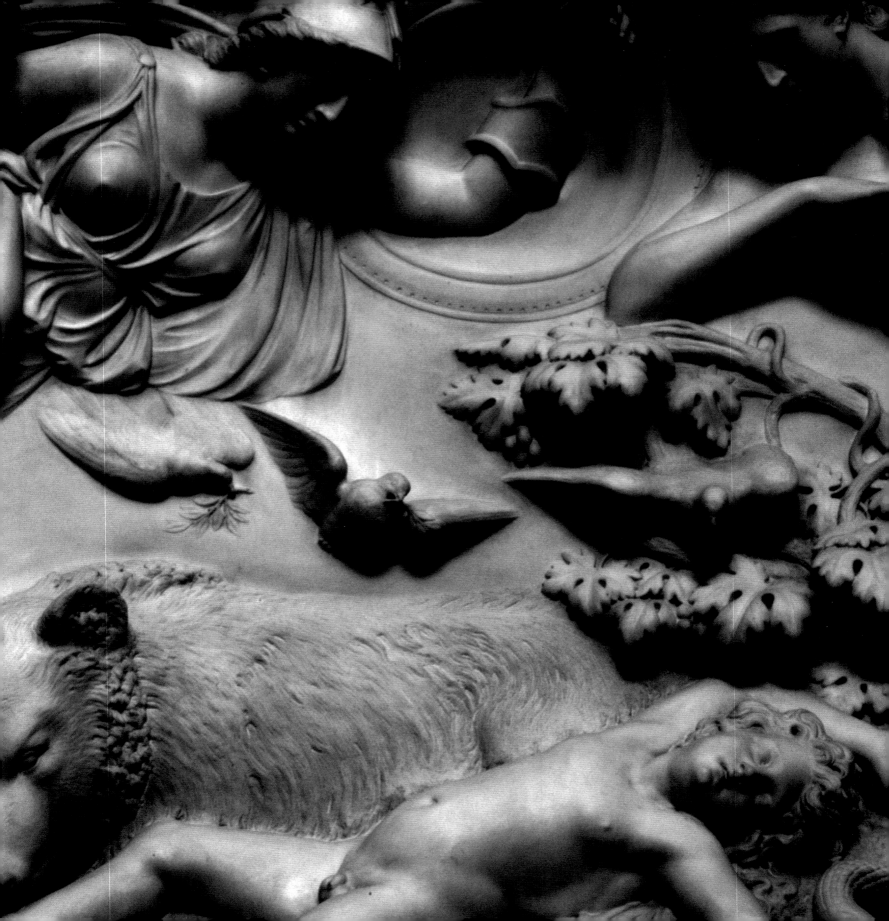

Sculpture

Greek

The headless lady

A figure from a very important Athenian grave monument of 350–320 BC. It would have formed part of a large relief with a standing figure on the left-hand side, who was probably clasping the seated lady's right hand. It was first recorded at Felbrigg in the Walled Garden in 1847 and described as 'A mutilated white marble statue, lately dug up on the plains of Troy.' The figure is a close contemporary of the Elgin Marbles, and it may be significant that Philip Hunt, chaplain to the Earl of Elgin, who encouraged the removal of the Parthenon sculptures to England, ended his days as vicar of nearby Aylsham in 1838. *Felbrigg Hall, Norfolk*

Fragment of a classical Greek tombstone (above). When Thomas Legh was in Athens in 1812, he discovered a number of stelae (tombstones) which he brought back to Lyme Park. They included this stele, probably from the 4th century BC, depicting theatrical masks, suggesting that it commemorates a playwright or actor. *Lyme Park, Cheshire*

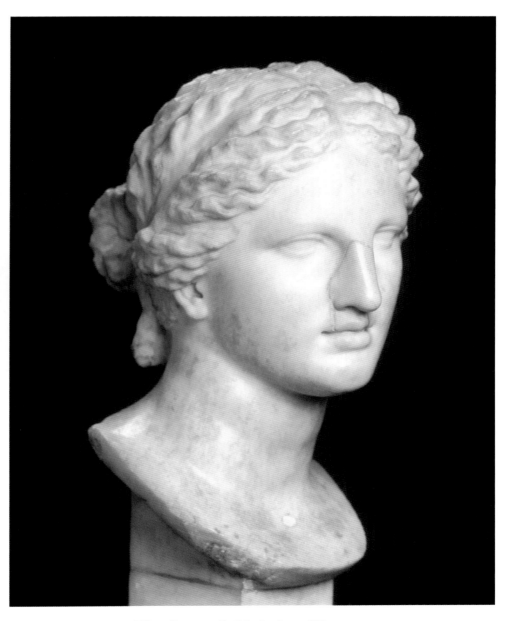

The Leconfield Aphrodite (above). This Parian marble sculpture has been attributed to Praxiteles (c.400–c.326 BC), one of the greatest of Greek sculptors. It was originally inserted into a full-length statue of Aphrodite (Venus), and the nose and upper lip have been restored and the surface repolished by a mid-18th-century restorer. The groove across the top of the head probably held a decorative bronze fillet. The head took its name from its owner, Lord Leconfield, when it first achieved fame, in the 19th century. *Petworth House, West Sussex*

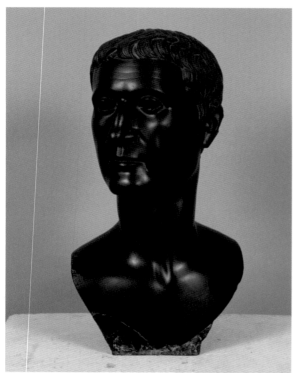

Roman

Clive of India's cat (top). Representations of cats are rare in Roman art, and this piece – if genuine – was probably derived from a lost Greek original. It was made between the 1st century BC and the 2nd century AD. *Powis Castle, Powys*

Roman bust (above). This green basalt bust used to be thought to depict Mark Anthony, but more probably shows a high Romano-Egyptian official. It was bought by William John Bankes in 1828. *Kingston Lacy, Dorset*

Endymion sarcophagus (detail, right). A Roman marble sarcophagus of c.230 from the Villa Borghese in Rome showing Luna descending from her chariot towards Endymion, over whom Somnus pours a sleeping potion. *Cliveden, Buckinghamshire*

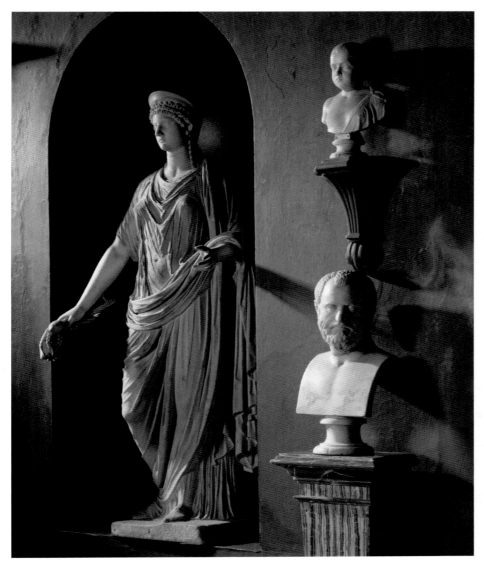

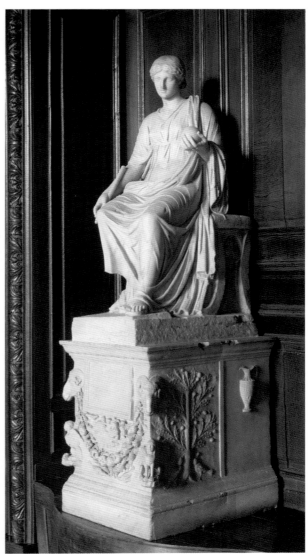

'Agrippina as Ceres' This Parian marble statue is a Roman adaptation of a Greek original of the late 5th century BC. It was restored by Bartolomeo Cavaceppi (1716–1799) who added the nose, arms and the attributes of Ceres, the goddess of agriculture (the corn in the right hand). It has traditionally been called 'Agrippina as Ceres', and the face resembles that of Agrippina the Younger. *Petworth House, West Sussex*

The marble group of a Muse seated upon a Funerary Altar This is a composite sculpture made in the 18th century from a probably Italian 1st- or 2nd-century body and a different head. The right arm and left hand are 18th-century replacements. The altar is a fine example of c.AD 100 and was formerly in the Mattei Collection in Rome. *Powis Castle, Powys*

Medieval

Carved wooden figure (right). Paycocke's is a 16th-century half-timbered merchant's house with extremely rich wood-carving and panelling fit for a rich merchant, made wealthy by the East Anglian wool trade in the 15th and 16th centuries. Coggeshall was also famous for its lace, examples of which are displayed in the house.
Paycocke's, Essex

Bristol High Cross (opposite). Erected at Stourhead in 1765, this is a medieval monument of several dates. It was erected in Bristol in 1373, the year Bristol acquired county status, and features statues of kings John, Henry III, Edward III and Edward IV, among others. The figures are some of the oldest sculpture of this type surviving outside churches and cathedrals in the UK. Such crosses usually marked the location of the marketplace in a town. Bristol's High Cross stood at the crossroads of four major streets leading into the city: the High Street, Broad Street, Corn Street and Wine Street.
Stourhead, Wiltshire

Renaissance and Baroque

Terracotta medallion of the Roman Emperor Probus
(above). Probably made in the workshop of Giovanni da Maino in the 1520s, this is one of the
earliest examples of Italian Renaissance sculpture in the country. It resembles similar medallions
made for Hampton Court at the same time. How it came to The Vyne is unknown, but it is
possible that John Chute obtained it after the Tudor 'Holbein' gate in Whitehall was demolished
in 1759–1760. It was Probus (d. 282) who authorized the introduction of vines into Britain.
The Vyne, Hampshire

The Cesarini Venus (right). This small (42.5cm [16¾in] high) bronze statuette
by Giambologna (Giovanni Bologna, 1529–1608) is a reduced version of the marble carved for
G G Cesarini and now in the Palazzo Boncompagni-Ludovisi in Rome. This bronze belonged to
Louis XIV, whose collection number is incised in it. This is among the finest pieces in Lord
Fairhaven's important collection of small bronzes. *Anglesey Abbey, Cambridgeshire*

Apollo and the Nine Muses (above). This alabaster overmantel, with the royal arms and initials in the upper corners, was originally at Chatsworth, and was probably made for the High Great Chamber there in the 1570s. The 6th Duke of Devonshire brought it to Hardwick. Apollo represented the rational, creative side of Man's nature, here expressed in music. Alabaster, an almost translucent stone, is very soft, enabling it to be carved into elaborate forms. It is soluble in water so cannot be used outdoors.
Hardwick Hall, Derbyshire

Bronzes

Charles I (near right). This gilt bronze bust by Hubert le Sueur (active 1610–1643) was sold from Whitehall Palace in 1650 and first recorded at Stourhead in the mid-18th century. Le Sueur is best known for his equestrian statue of Charles I in Trafalgar Square.
Stourhead, Wiltshire

General James Wolfe (far right). A 19th-century bronze cast of an original plaster bust, now in the Public Archives of Canada, by Joseph Wilton (1722–1803) who sculpted the soldier's monument in Westminster Abbey, erected in 1772. He is shown attired in classical garb, with epaulettes in the shape of wolf heads. Decay had prevented Wilton from taking a death mask of Wolfe's face, nor were there any lifetime portraits of him as a grown man. However, a servant of Lord Gower, who bore a striking resemblance to Wolfe, served as a model.
Quebec House, Kent

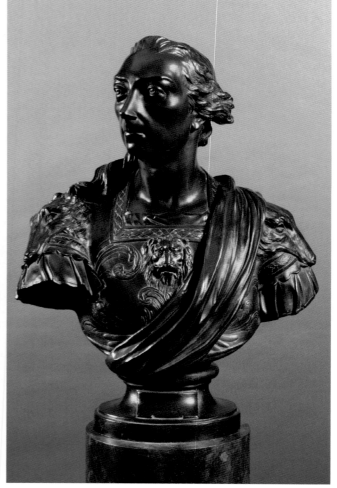

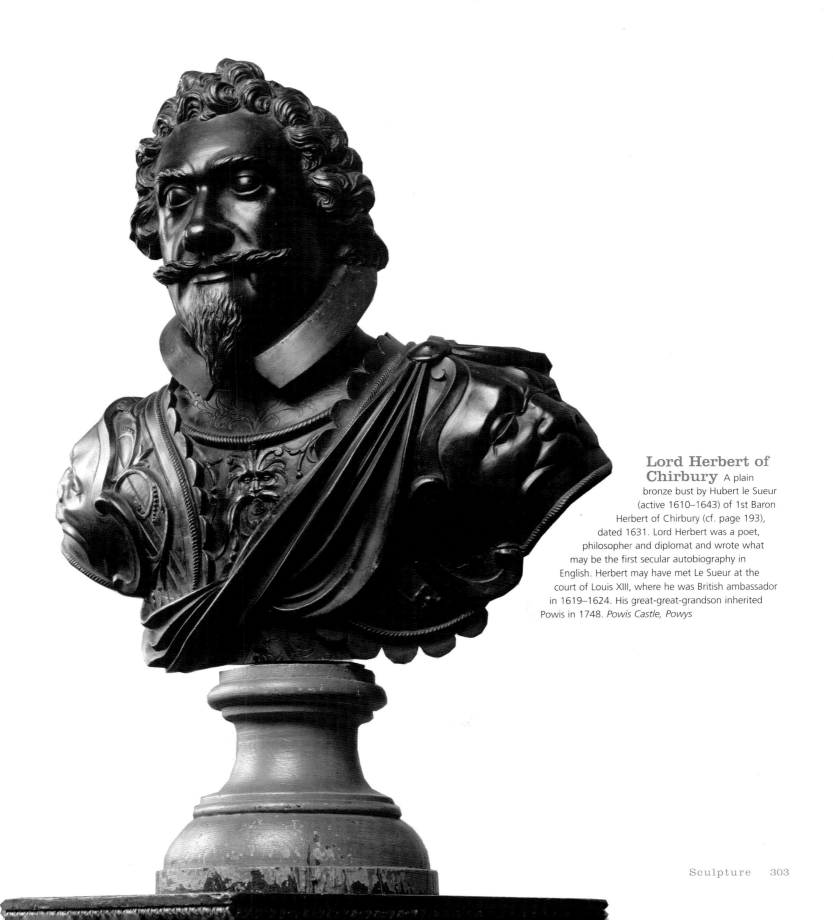

Lord Herbert of Chirbury A plain bronze bust by Hubert le Sueur (active 1610–1643) of 1st Baron Herbert of Chirbury (cf. page 193), dated 1631. Lord Herbert was a poet, philosopher and diplomat and wrote what may be the first secular autobiography in English. Herbert may have met Le Sueur at the court of Louis XIII, where he was British ambassador in 1619–1624. His great-great-grandson inherited Powis in 1748. *Powis Castle, Powys*

Marble

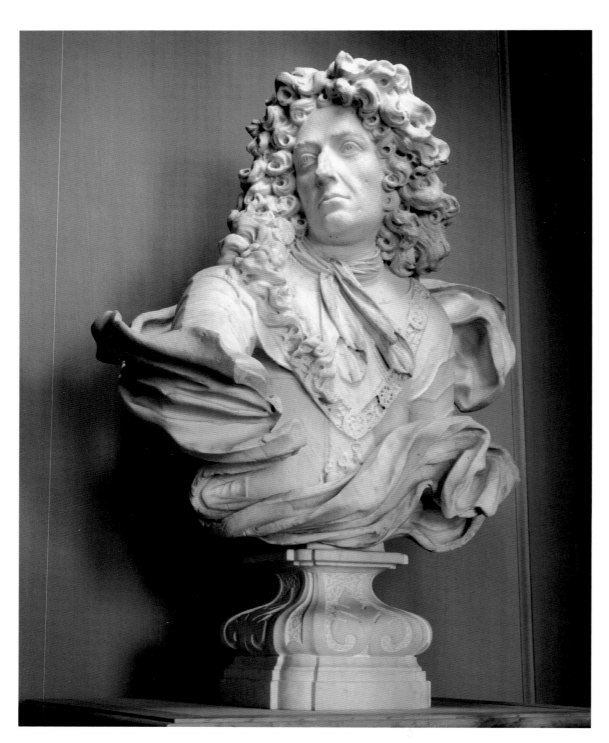

Marble bust of William III or James II This is thought to be the 'marble head representing the late King William' for which the 7th Duke of Somerset paid £6 in 1724, though the nose is a replacement and it may be a portrait of James II. It was executed by Honoré Pellé, a Catholic Provençal sculptor who worked in Genoa and Modena before and after coming to England, where he carved two busts of Charles II. This Baroque image of kingship was inspired by Bernini's bust of Louis XIV at Versailles. Collection of Lord Egremont, *Petworth House, West Sussex*

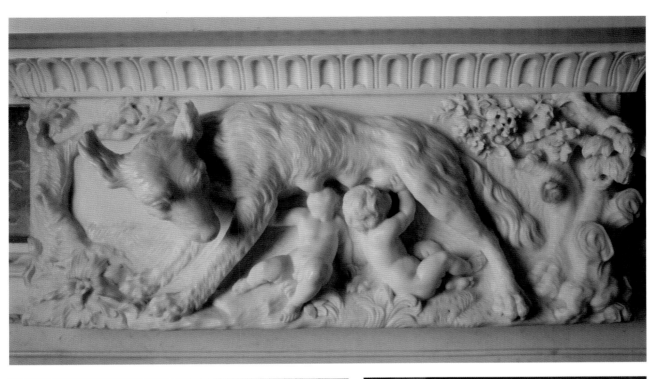

Romulus and Remus plaque

(top left) The craftsman Thomas Carter the Elder (d. 1756) was responsible for the marble chimneypieces in the Saloon and the Stone Hall at Uppark, which contain plaques superbly carved with classical subjects. This is the marble frieze in the Saloon showing the story of Romulus and Remus, the twin brothers who founded Rome. *Uppark, West Sussex*

Monument to the Speaker (far

left) This monument, or cenotaph, is one of the noblest works of late-18th-century English sculpture. It is located in the Tomb Chamber, designed by John Chute to honour his 17th-century ancestor, John Chute, who was Speaker of the House of Commons during the Commonwealth. Designed by Thomas Carter the Younger (d. 1795), the monument comprises a tomb chest incorporating panels with coats of arms supporting a life-size figure of the Speaker reclining on a woven-straw mattress (as in many early 17th-century English tombs). *The Vyne, Hampshire*

Sir John Throckmorton

(left) This marble bust of sir John Throckmorton, 5th Baronet, is by the Irish sculptor Christopher Hewetson (1737–1798) and is dated 1800. It was finished after Hewetson's death by Cristoforo Prosperi. *Coughton Court, Warwickshire*

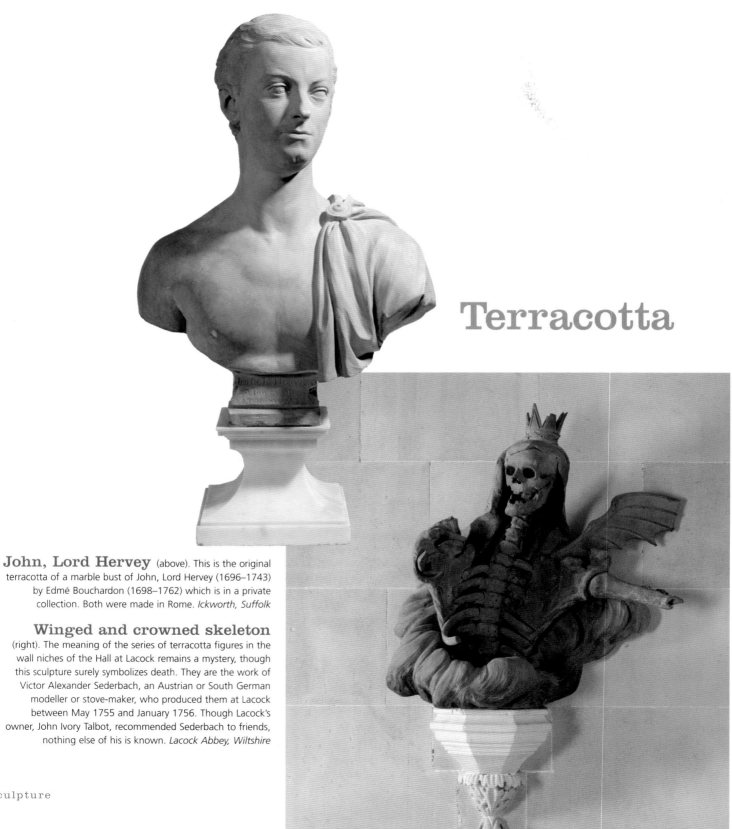

Terracotta

John, Lord Hervey (above). This is the original terracotta of a marble bust of John, Lord Hervey (1696–1743) by Edmé Bouchardon (1698–1762) which is in a private collection. Both were made in Rome. *Ickworth, Suffolk*

Winged and crowned skeleton (right). The meaning of the series of terracotta figures in the wall niches of the Hall at Lacock remains a mystery, though this sculpture surely symbolizes death. They are the work of Victor Alexander Sederbach, an Austrian or South German modeller or stove-maker, who produced them at Lacock between May 1755 and January 1756. Though Lacock's owner, John Ivory Talbot, recommended Sederbach to friends, nothing else of his is known. *Lacock Abbey, Wiltshire*

Hercules (near right). On the Library desk at Stourhead stands this small terracotta model of Hercules, made by Michael Rysbrack (1694–1770) before Henry Hoare II commissioned the large marble statue that stands in the Pantheon at Stourhead, completed in 1756. Rysbrack left the model to Hoare in his will in 1770. The Flemish-born sculptor settled in England c.1720, and for the next two decades he was the country's leading sculptor, executing, among other things, William Kent's design for the monument to Sir Isaac Newton in Westminster Abbey. *Stourhead, Wiltshire*

Terracotta group (far right). This group on the chimneypiece in the Tower Drawing Room is by Clodion (1738–1814), a French sculptor whose real name was Claude Michel. He trained at the French Academy in Rome where he stayed for nine years before forging a reputation for his small statuettes and terracotta figures, often based on classical subjects and especially those associated with Bacchus. *Waddesdon Manor, Buckinghamshire*

Richard, Viscount Cobham

(below right). This terracotta bust of Richard, Viscount Cobham by Peter Scheemakers (1691–1781) stands on a marble table in the Dining Room at West Wycombe Park. Scheemakers settled in England c.1720, and apart from a two-year visit to Rome he remained in England until his retirement to Antwerp in 1771. Collection of Sir Edward Dashwood, Bt., *West Wycombe Park, Buckinghamshire*

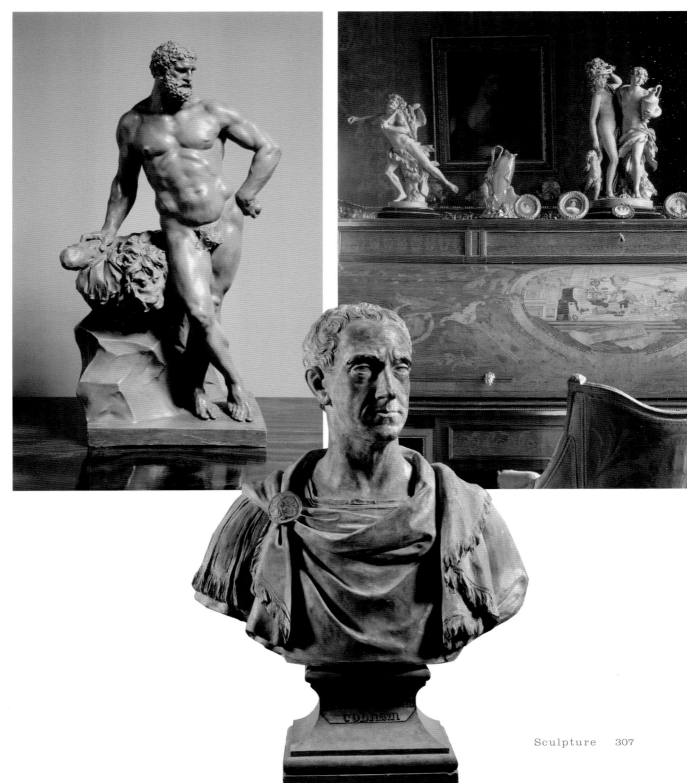

Neo-Classicism

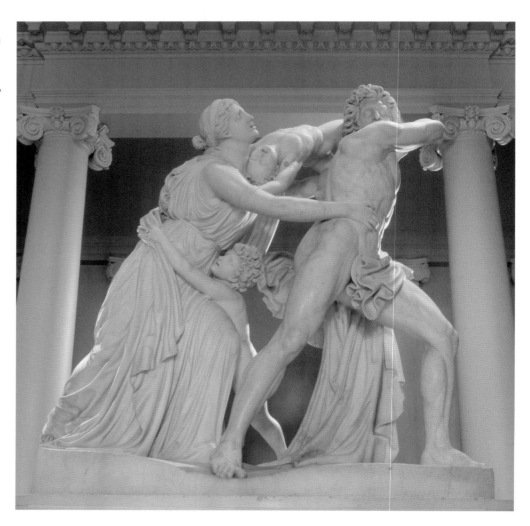

The Fury of Athamas This colossal marble group by John Flaxman (1755–1826) was commissioned by Frederick Hervey, 4th Earl of Bristol, also known as the Earl-Bishop, in Rome in 1790 for £600. It represents the scene from Ovid's Metamorphoses, when Athamas, driven mad by the gods, snatches his infant son Learchus from the arms of his mortal mother Ino, and dashes out his brains upon a rock, watched in terror by their other child, Melicertes. The sculpture was confiscated with the rest of the Earl-Bishop's collection by the French in 1798 and bought back by the 1st Marquess in the early 1820s. On receiving the commission, Flaxman wrote to Sir William Hamilton: 'I shall be detained here three years longer by the noble patronage of Lord Bristol, who…has reanimated the fainting body of Art in Rome.' In fact it took Flaxman much longer to finish the work, and after its completion, he complained that he was seriously out of pocket.
Ickworth, Suffolk

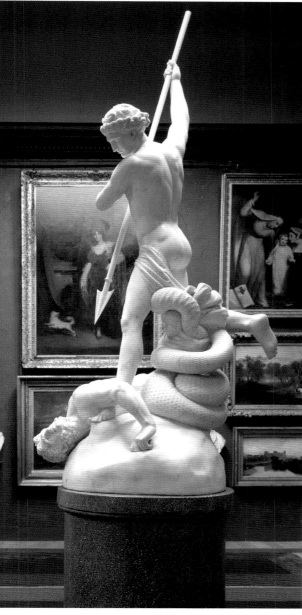

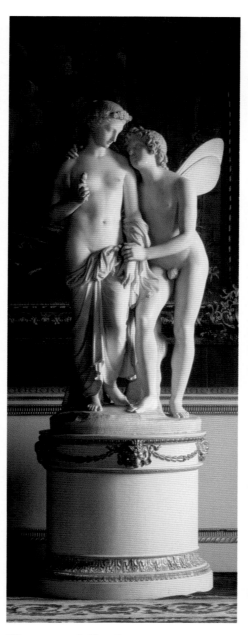

St Michael overcoming Satan This masterpiece by John Flaxman (1755–1826) was the supreme sculptural commission by the 3rd Earl of Egremont, who later recorded that he 'gave Flaxman the order and the subject, and the attitude according to the picture by Raphael' in the Louvre. Ordered before April 1817 and finished in 1826, it was carved (apart from the spear) from a single block of marble at a cost of £3,500. *Petworth House, West Sussex*

Flora and Zephyr The neo-classical sculptor Richard Wyatt (1795–1850) worked in Rome in the style of his master, Canova, and produced this marble group in 1834, when it was shown at the Royal Academy. It was commissioned by the 1st Lord Wenlock for Escrick Park in Yorkshire and bought for Nostell by Charles Winn after Lord Wenlock's death. *Nostell Priory, West Yorkshire*

Nymph and Cupid (above). Detail of sculpture by Sir Richard Westmacott RA (1755–1856) in the North Gallery at Petworth. *Nymph and Cupid* was first exhibited in 1827 as 'Cupid Made Prisoner' and is typical of the mythological works produced by Westmacott during the 1820s, heavily influenced by Canova and contemporary Italian sculpture. *Petworth House, West Sussex*

Early
19th
Century

Sir Joseph Banks (opposite). This bust of the great English botanist Sir Joseph Banks was sculpted in 1837 by Sir Francis Chantey (1781–1841). Banks accompanied James Cook's 1768–1771 expedition around the world in a ship equipped at his own expense. *Petworth House, West Sussex*

The Dream of Horace (above). This unusual subject was chosen by the 3rd Earl of Egremont and is taken from Horace's *Ode to Calliope* (the Muse of Epic Poetry). The relief by Sir Richard Westmacott, RA (1775–1856), exhibited at the Royal Academy in 1823, depicts a sleeping boy (Horace) protected by Venus, Minerva and Apollo against wild animals. Thus protected, he need not fear the distant barbarians, even 'the cruel race of Britain'. The face of Venus (far left) was taken from 'the mistress of some man about in society'. *Petworth House, West Sussex*

"Quel giorno più non vi leggemmo avante."

Victorian Sculpture

MARY AGNES

Paolo and Francesca (top). This plaster group is taken from Canto V of Dante's *Inferno*, in which Francesca da Rimini describes how she and her lover Paolo Malatesta read of the equally illicit passion of Lancelot for Guinevere. The doomed couple had been a popular subject for artists throughout Europe since the 1790s, including Dante Gabriel Rossetti, who was the friend and mentor of the sculptor Alexander Munro (1825–1871). Munro exhibited the group at the 1851 Great Exhibition, and it was later bought by Dr Henry Acland, who gave it to the Trevelyans for Wallington. A marble version, dated 1852, which once belonged to Gladstone, is in the Birmingham City Art Gallery. *Wallington, Northumberland*

Mary and Agnes (bottom). This framed plaster relief was created by Sir George Frampton (1860–1928). One of the most important sculptors of his generation, Frampton was strongly drawn to the Arts and Crafts movement. His best-known works are the bronze of Peter Pan in Kensington Gardens and the statue of Edith Cavell in St Martin's Place, London, near the National Portrait Gallery. *Standen, West Sussex*

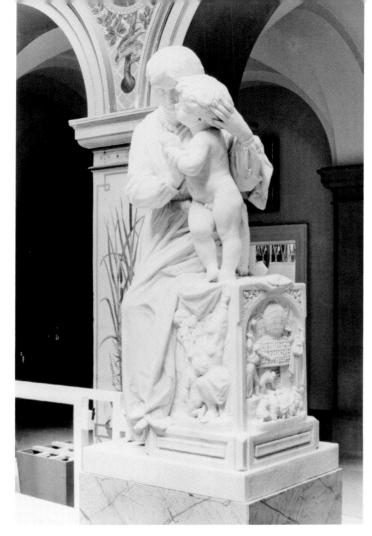

Civilization or The Lord's Prayer

(left). The Pre-Raphaelite sculptor Thomas Woolner (1825–1892) became a friend of Pauline Trevelyan in a rather odd way: she heard that he had referred to people with titles as 'maggots' and set about 'taming' him. He was soon a guest at Wallington, and this group was the principal commission from the Trevelyans. Sculpted between 1856 and 1867, it was intended to provide the focal point for the decoration of the Central Hall. The subject was chosen after much discussion: a mother teaches her young son to recite the Lord's Prayer. Woolner chose a woman as teacher because 'the position of women in society always marks the degree to which the civilization of the nation has reached'. The plinth has contrasting scenes of barbaric violence. *Wallington, Northumberland*

Dame Mary and Charles I

(right). In about 1838 William Bankes met Baron Carlo Marochetti (1805–1867) in Paris to discuss the creation of a shrine to his ancestors in the Loggia of the Marble Staircase. However, it was not until November 1853 that the contract for three statues at a cost of £2,500 was signed. Bankes died before the figures of Chief Justice Sir John Bankes, Dame Mary Bankes (the redoubtable defender of Corfe Castle) and Charles I were cast in bronze. 'Brave Dame Mary', on the left, holds the sword and key of Corfe Castle. Charles I sits above a bronze relief of the siege of Corfe Castle, based on a drawing by William Bankes. *Kingston Lacy, Dorset*

Garden Sculpture

The Temple of British Worthies (above). William Kent based this temple on his own unexecuted design for Lord Burlington's garden in Chiswick. It has its origins in the Renaissance and Baroque gardens of Italy where busts of Roman emperors stood in a series of niches. Lord Cobham's choice of figures here was blatantly political, with the eight on the left celebrated for their ideas and the eight on the right those revered for their actions. *Stowe Landscape Gardens, Buckinghamshire*

Equestrian statue of George I (left). Viscount Cobham demonstrated his loyalty to the new, and none too secure, Hanoverian regime by this, one of the first commissions for his formal gardens at Stowe. *Stowe Landscape Gardens, Buckinghamshire*

Lead statue (left). The many lead statues and urns on the terraces at Powis were an attractive advertisement for the family's lead mines in Montgomeryshire, which had helped to rescue its finances in the early 18th century. This statue is from the workshop of the Flemish-born sculptor John van Nost (d. 1711/13). Lead exposed to the elements corrodes, so statues and ornaments are sometimes painted, as here, to resemble stonework. *Powis Castle, Powys*

The Fountain of Love (left). Among the many sculptures acquired by Lord Astor is this colossal fountain carved in Rome in 1897 by Thomas Waldo Story (1855–1915), son and pupil of the American dilettante sculptor William Wetmore Story. According to the 1st Lord Astor's note of 1920, 'The female figures are supposed to have discovered the fountain of love, and to be experiencing the effects of its wonderful elixir.' The fountain is made of Siena and Carrara marble and tufa. *Cliveden, Buckinghamshire*

Modern

T E Lawrence

(top right). 'Lawrence of Arabia' thought highly of this 1926 bronze bust of him by Eric Kennington (1888–1960): 'magnificent; there is no other word for it. It represents not me, but my top-moments, those few seconds in which I succeed in thinking myself right out of things… It hangs tightly together as a most convincing portrait of a person very sure of himself.' It was presented to the National Trust by Lawrence's friend R V Buxton.
Clouds Hill, Dorset

Virginia Woolf

(bottom right). A fig tree in the garden of Monk's House frames a cast of Stephen Tomalin's unfinished bust of the writer.
Monk's House, East Sussex

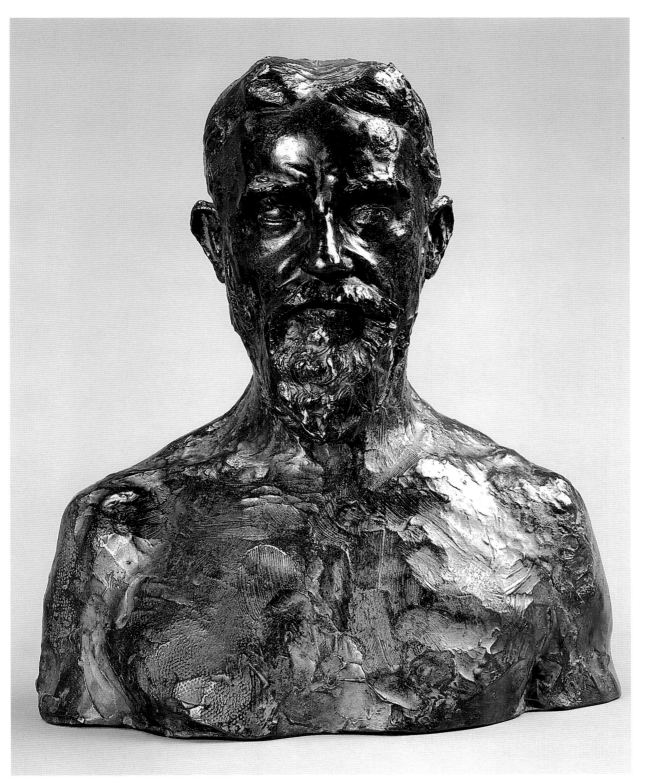

George Bernard Shaw

This bust was made by Auguste Rodin (1840–1917) in 1906, an event recorded by Rodin's secretary, the poet Rainer Maria Rilke: 'Shaw as a model surpasses description. He has the power of getting his whole self into his bust which will have to represent the whole Shaw that Rodin has before him.' Shaw sat daily to Rodin at Meudon, Rodin's villa on the outskirts of Paris. *Shaw's Corner, Hertfordshire*

Stained Glass

Surviving Fragments

The Virgin and St John (left). Stained-glass panel representing the Virgin and St John. The 15th-century English glass is from the church of St Peter Mancroft in the centre of Norwich. The house still features remarkable amounts of original stained glass of the period. *Felbrigg Hall, Norfolk.*

Roundel (right). The month of September is represented by a man sowing seed in this 16th-century Flemish roundel. When Graham Baron Ash (1889–1980) restored and partly rebuilt Packwood House, he filled it with 16th- and 17th–century pieces of furniture, art and stained glass, creating an intriguing 20th-century re-creation of domestic Tudor architecture and interiors. *Packwood House, Warwickshire*

Armorial panel (right). The coat of arms depicted in this panel belongs to the Lucy family in 1588. The Lucys have lived at Charlecote since the 13th century and built the present house in the 1550s. This is one of a series of panels in the window that trace the Lucy line back to medieval times. Repairs to the glass were carried out by the renowned stained-glass artist, designer and heraldry expert Thomas Willement (1786–1871), known as the father of Victorian stained glass. The maker of the original Elizabethan glass was Nicholas Eyffeler, a German who was brought to Warwick by Sir Thomas Lucy II (d.1605), who became his patron. *Charlecote Park, Warwickshire*

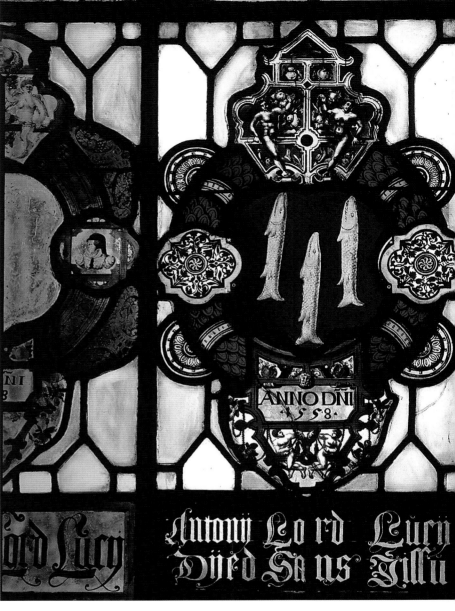

St Anne and Cleophas (left). When William Howe Windham (1802–1852), of Felbrigg Hall, was redecorating his Great Hall in 1842 he took various pieces of stained glass from the church of St Peter Mancroft in Norwich (as well as making copies of several others) and placed them in the windows of the room. St Peter Mancroft had a huge amount of medieval stained glass, all dating from the middle of the 15th century and, in spite of Windham's purchases, retains 42 panels to this day. This English panel dates from c.1450 and depicts St Anne – traditionally believed to be the mother of the Virgin Mary – with her second husband, Cleophas. *Felbrigg Hall, Norfolk*

The Chapel at The Vyne

Catherine of Aragon Detail of stained-glass window depicting Catherine of Aragon.
The Vyne, Hampshire

Queen Margaret of Scotland
Detail of stained-glass window depicting a landscape through an arch and Henry VIII's sister, Queen Margaret of Scotland, in an elaborate Renaissance setting.
The Vyne, Hampshire

Henry VIII Detail of stained-glass window depicting Henry VIII kneeling with his patron saint, Henry II of Bavaria. *The Vyne, Hampshire*

The Vyne

Of a magnificence unrivalled outside the royal palaces of Tudor England, this early 16th-century stained glass is similar to that commissioned by Henry VIII for the chapel at King's College, Cambridge, made in 1515–1517 and 1526–1547. The glass at The Vyne was probably originally commissioned by William Sandys for the Holy Ghost Chapel, Basingstoke in the 1520s, and was possibly a complete cycle of the lives of Christ and the Virgin.

Sacred and Profane

Van Dyck style (left). Detail of window stained and painted by John Rowell (1689–1756) before 1732, located in Speaker Chute's Memorial Chapel. The depiction of the adoration of the shepherds is after a painting by Sir Anthony van Dyck. Rowell was so pleased with his handiwork that he mentioned it in his first advertisements (published 1733). The Vyne's owner, John Chute (1701–1776), bought the piece from Rowell's widow soon after his death. *The Vyne, Hampshire*

Flemish roundel (left). In 1812–1813 the architect and landscape designer Humphry Repton (1752–1818) constructed the Servery at Uppark. He planned the room so that its stained-glass window (of which this is a section) would be seen from the adjoining dining room. This late-16th-century roundel is the oldest section – all the other panels are signed and dated 1813 by the maker W Doyle. The figures below are based on the Elgin Marbles. *Uppark, West Sussex*

Putti and goat (below). This lunette of painted glass dates from the 19th century. It was almost removed in the 1960s when the house was being redecorated. At that time such Victorian whimsy had become deeply unfashionable and West Wycombe's owner, Sir Francis Dashwood (1925–2000), sought advice from Nancy Lancaster (1897–1994), as to whether he should dispense with the roundels. Luckily Lancaster, a celebrated 20th-century arbiter of taste and owner of the influential firm of decorators Colefax & Fowler, stated firmly that it should stay. *West Wycombe Park, Buckinghamshire*

19th-Century Stained Glass

Willement masterpiece The Grand Hall at Penrhyn Castle, which houses this magnificent window, was completed by 1826 and almost ten years later the early 19th-century's greatest stained-glass artist, Thomas Willement (1786–1871), supplied the windows. This is one of the largest, and is signed by Willement and dated 1835. It counts among his greatest work, incorporating the signs of the zodiac alternating with roundels illustrating the twelve months of the year. *Penrhyn Castle, Gwynedd*

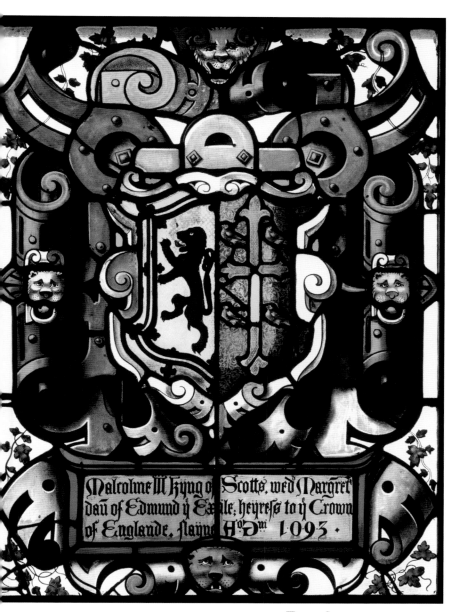

Neo-gothic The heraldic stained glass in the upper lights of the mullioned windows of Chirk Castle's Cromwell Hall was installed by A W N Pugin (1812–1852) in the 1840s, when he remade the room in the Gothic Revival style. They show the arms of the Myddelton family, who had commissioned Pugin's work, and were made by Hardmans of Birmingham. *Chirk Castle, Wrexham*

Royal arms Detail of one of Thomas Willement's 19th-century stained-glass windows, depicting the arms of King Malcolm III of Scotland and his wife, Margaret. The original armorial glass in the window dates from Elizabethan times and was made by Nicholas Eyffeler. Willement (1786–1871) repaired this glass and made new pieces to match. *Charlecote Park, Warwickshire*

Morris & Co

'Spring' (top left). The architectural decorator and master of late 19th-century stained glass, Charles Eamer Kempe (1837–1907), depicted the four seasons in stained-glass panels. These illustrate William Morris's collection of poems *The Earthly Paradise* (published 1868). *Wightwick Manor, West Midlands*

Morris and Norman Shaw

(bottom left). One of a set of stained-glass panels of the four seasons, supplied by William Morris in 1873. This figure represents Spring. It is contained within a monumental inglenook fireplace in the Dining Room at Cragside, which was designed in 1870–1872 by the influential architect Richard Norman Shaw (1831–1912). *Cragside, Northumberland*

'Si je puis' (bottom right). Morris & Co

(previously Morris, Marshall, Faulkner & Co) was established as a result of the design and decorative work carried out on William Morris's home, Red House. Meaning 'If I can', 'Si je puis' was Morris' Medieval-style motto, harking back to his interest in Medieval romance and courtly love that he acquired while at Oxford University. These panels, dating from around 1850, are some of the earliest examples of Morris stained glass. *Red House, Bexleyheath, London*

'Love' and 'Fate' (opposite, top left and right). These stained-glass panels were designed by Pre-Raphaelite artist Edward Burne-Jones (1833–1898) in about 1863 and inserted into a window in a passageway. Burne-Jones, who had become a close friend of William Morris at Oxford, was very interested in the art of stained-glass making and was influential in the revival of the craft. *Red House, Bexleyheath, London*

Farmyard birds (opposite, bottom left and right). The flying duck and goose are part of a charming series of glass panels depicting farmyard birds, the work of the architect of the Red House, Philip Webb (1831–1915). Webb, one of the leading proponents of the Arts and Crafts Movement, was still in his twenties when he designed the house for his friend William Morris. He put an immense amount of effort into every detail – from handles and fastenings to more decorative elements, such as these glass panes. *Red House, Bexleyheath, London*

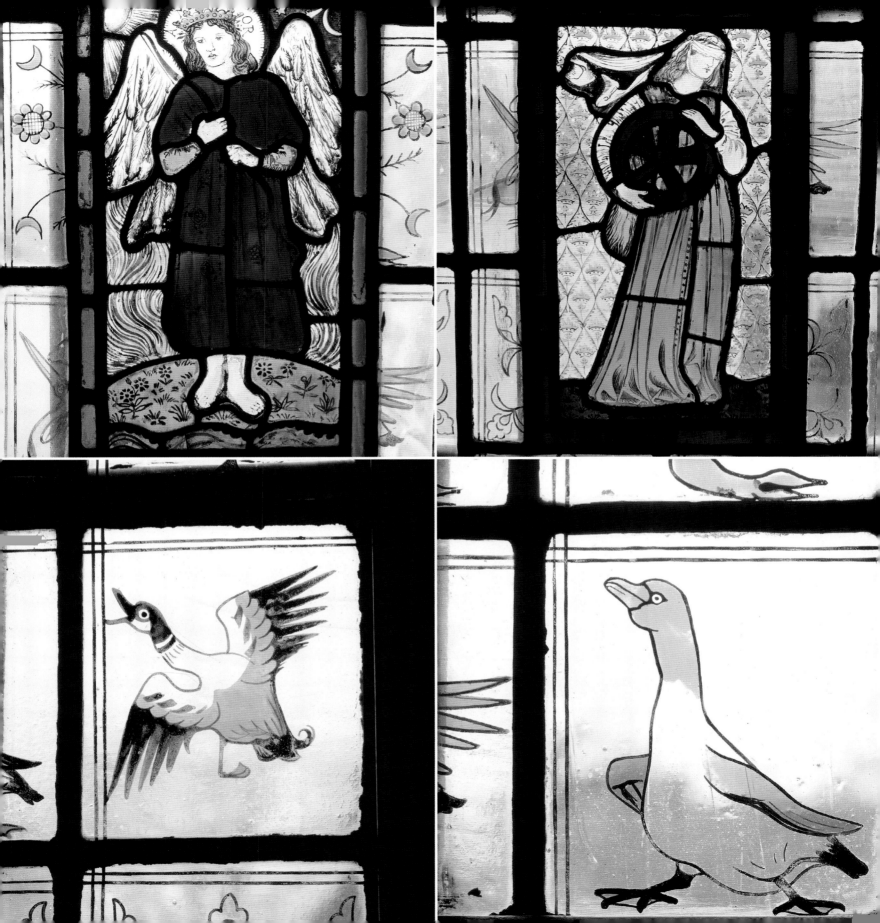

Textiles

Early Tapestries

Story of Ulysses (left). One of a set of eight Flemish tapestries depicting the story of Ulysses. Dating from the mid-16th century, they were bought by Elizabeth, Countess of Shrewsbury (1527–1608), usually known as Bess of Hardwick, to cover the bare walls of her High Great Chamber. Tapestries were extremely highly valued during the 16th century, partly because they added colour and pattern to a property, but also because they softened the appearance of grey stone walls and helped create a warm, comfortable atmosphere. The tapestries in the set all have the Brussels marks as well as the marks of various weavers – none of which are identifiable apart from that of Nicholas Hellinck. *Hardwick Hall, Derbyshire*

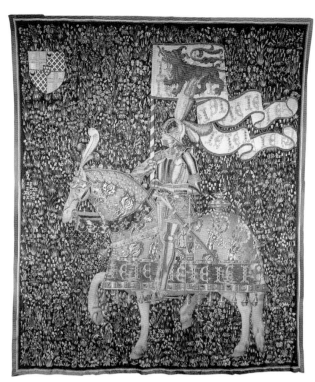

Late 15th century (left). Called a *millefleurs* tapestry because of its background of numerous tiny flowers, this highly decorative tapestry was woven in the workshop of Wuillaume Desreumaulx, c.1481–1482. It was commissioned by the townspeople of Tournai as a gift for the French nobleman Jean de Daillon, Seigneur de Lude, whose coat of arms appears in the top left-hand corner. *Montacute, Somerset*

Tournai tapestry (below). Part of a tapestry depicting a Venetian ambassadorial mission to Cairo or Istanbul. It is dated 1545 and is believed to have been woven in Tournai. The expressive narrative style of the piece is typical of the tapestries that were being produced by the workshops of that town during the mid-16th century, many of which were woven specifically for export throughout western Europe. *Powis Castle, Powys*

Hardwick Hall and
Oxburgh Hall Needlework

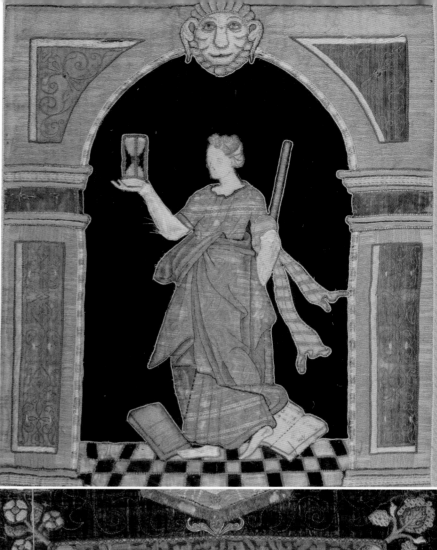

Cushion cover (opposite). This late-16th-century English cushion cover is listed in a house inventory as the 'Fancie of a Fowler'. Silk and metal threads have been combined to create a rich, varied effect. *Hardwick Hall, Derbyshire*

Velvet panel (above left). The initials on this cut-pile velvet panel stand for Elizabeth Shrewsbury, otherwise known as Bess of Hardwick (1527–1608). It is one of a set of eight, each relating to Bess and her family. The initials are worked in gold twist and the appliqué work is cut from gold and silver cloth. *Hardwick Hall, Derbyshire*

Liberal arts (above right). The figure featured in this late-16th-century piece is a personification of Arithmetic, part of a set of velvet panels depicting the Liberal Arts. Each figure is placed within an arch and wears pseudo-classical dress. *Hardwick Hall, Derbyshire*

Royal work (right). This is part of a series of appliqué panels made between 1569 and 1584 by Mary, Queen of Scots and Bess of Hardwick. At the time Mary was being held prisoner and her warder was the Earl of Shrewsbury, Bess's husband. The two women passed much of the time stitching. Most of the panels depict animals and birds, many of which are symbolic. This panel has a stronger hidden message: the hand pruning the vine and the motto, which translates as 'Virtue flourishes with a wound', represents the fruitful Mary cutting down the barren Queen Elizabeth. *Oxburgh Hall, Norfolk*

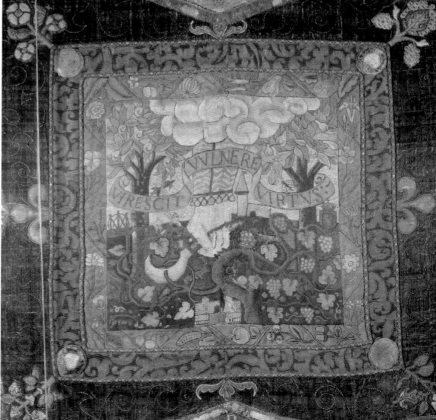

Early English Tapestries

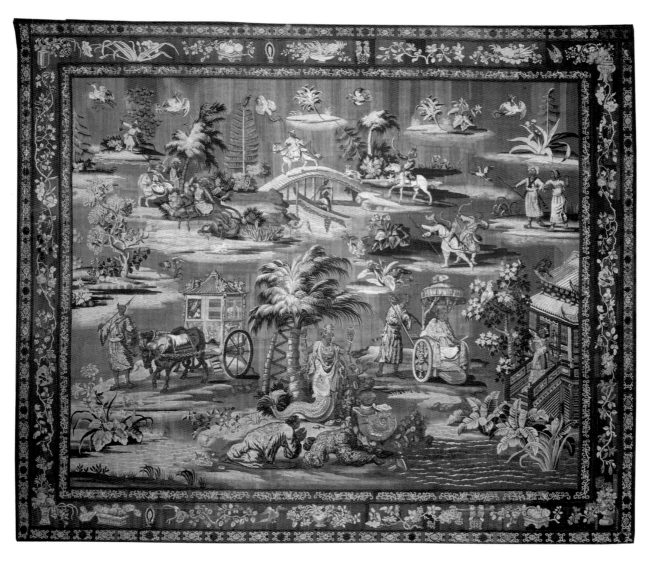

'Indian' miniatures (left). John Vanderbank (1689–1727), Chief Arras Worker of the Great Wardrobe, created this spectacular Indian-themed tapestry in 1691. An 'arras' was a wall hanging made of heavy handwoven fabric with a pictorial design on it. *Belton House, Lincolnshire*

Chinoiserie riders (opposite, top right). Made by the Soho factory under the direction of John Vanderbank, this tapestry was probably commissioned by Edward Chute sometime before 1754. *The Vyne, Hampshire*

Harvesting scene (opposite, top left). This late-17th- or early 18th-century tapestry was also woven at Soho. Later sold, it was bought back in the 1970s for Antony by Sir Richard Carew Pole. *Antony, Cornwall*

Hero and Leander (opposite, bottom right). Made in the workshops at Mortlake established by James I in 1619, this tapestry was designed by their chief designer, Francis Cleyn, some time in the 1670s or 1680s. *Cotehele, Cornwall*

Playing boys (opposite, bottom left). Panel from a set of four tapestries, based on paintings by Caravaggio. One panel is initialled 'FP', standing for Francis Poyntz, who ran a workshop at Hatton Garden. *Hardwick Hall, Derbyshire*

Stumpwork

Three dimensions This wonderful piece, one of six pictorial panels embroidered on silk, dates from the mid-17th century. The technique used to create this three-dimensional effect is called stumpwork, and originated in German and Italian ecclesiastical embroidery. In order to get the raised appearance, padding was used to fill out sections of the design. This padding could be made from anything from cut-up pieces of silk to hair or wool. Stumpwork was extremely popular from c.1625 to the end of the century and was the next needlework step young girls took after working on samplers. The stumpwork they produced would then become part of their dowry. *Trerice, Cornwall*

Classical inspiration (above). This portrait of a lady surrounded by scenes from Ovid's *Metamorphoses* has been worked in silks on a white satin background. The piece was probably intended to cover a casket; in fact kits were available with the design painted on the fabric as a guide to the embroiderer. The practice of placing a portrait in a central oval was also very widespread. *Fenton House, London*

Raised-work casket (right). The embroidered scenes on this writing and jewel case, 1660–1685, are probably based on the Judgement of Paris and are worked in floss silks in a style known as raised work. It contains several compartments, as well as some secret drawers, and would have been kept on a lady's dressing table. In raised work, the expensive thread was simply laid across the top of the material in touching rows, then held in place by a small stitch at the end of the row or couching stitches running across them. *East Riddlesden Hall, West Yorkshire*

Montacute Samplers

Victorian work
Cotton sampler with silk embroidery from the second half of the 19th century. By this time samplers had become a class of embroidery in their own right, and were used to demonstrate the embroiderer's proficiency, rather than just an *aide-memoire* for different stitches. Such 19th-century samplers were mainly executed in cross stitch and petit point and featured a combination of religious verses and motifs, along with the alphabet. Here four sets of the alphabet have been worked in different styles.
Montacute, Somerset

Spot sampler (right). Dated 1670 and with the name 'Elizabeth Branch' embroidered on it, this spot sampler has floral sprays, animals, birds and insects plus a selection of patterns worked in a variety of stitches. Early samplers such as this were also known as samp-clothes or sam cloths, and contained a variety of stitches, patterns and designs as an aid to memory. Girls would add to their sampler as they learned new needlework techniques. A 1530 dictionary defined a sampler as 'an exemplar for a woman to work by'. Skill with a needle and thread was considered a vital part of education, as well as a mark of refinement. The 17th century is often referred to as the golden age of sampler-making throughout Europe. *Montacute, Somerset*

Pattern booklet (below). Embroidery and alphabet sampler book. This pattern booklet contained girls' names and repetitive patterns, as well as numbers and alphabets, and would have been used as a guide to practise by. *Montacute, Somerset*

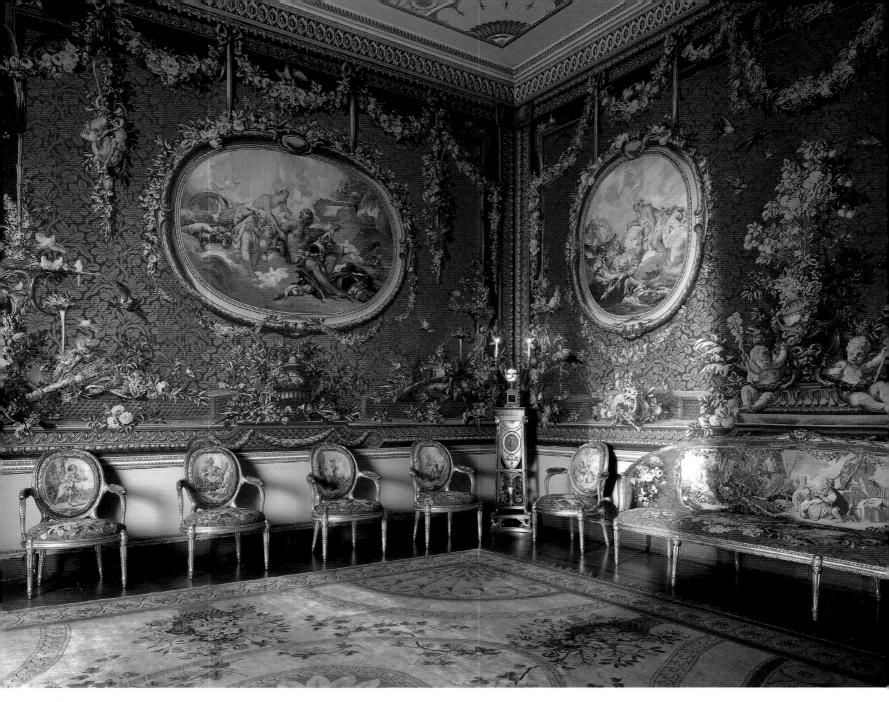

Rococo (above). These medallion tapestries designed by François Boucher (1703–1770) were woven at the Gobelins manufactory (in 1775–1776). The designs for these tapestries were originally made for Madame de Pompadour in 1750–1751.
Osterley Park, London

18th-Century Tapestries

War series (right). 'Embuscade', one of the Arts of War set of tapestries woven in Brussels by Le Clere & Van der Borch, following cartoons by Lambert de Hondt, c.1710. The borders depict various martial trophies. Military subjects were very popular at this time, possibly due to the number of European conflicts. *Cliveden, Buckinghamshire*

Royal gift (below). Entitled 'Peter the Great triumphing over the defeated Swedish army at Poltawa in 1709', this tapestry was given to Sir John Hobart, 2nd Earl of Buckinghamshire (1723–1793), by Catherine the Great in 1765. *Blickling, Norfolk*

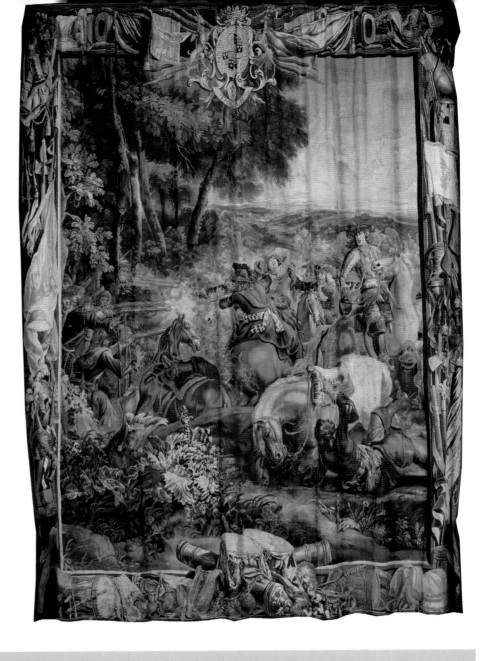

Tapestry and Art For centuries woven wall hangings have been used as an important means of decorating affluent homes and significant buildings. The ancient Greeks and Romans used them to illustrate their myths of heroes and great deeds. In the 14th and 15th centuries, tapestry emerged as a vital element in interior decoration. Initially weavers drew on religious themes for their inspiration. Later they depicted tales of ancient heroes, romance, history and hunting. During the Middle Ages and throughout the Hundred Years War (1337–1453), France was the world's most important producer of tapestry. During the war, however, many pieces were lost and eventually the tapestry artists moved north into Flanders to escape the unrest. The workshops that they set up in Arras, Tournai, Antwerp, Brussels and neighbouring towns exported many thousands of tapestries throughout western Europe – Henry VIII alone owned more than two thousand pieces when he died in 1547. Later an English tapestry workshop was founded by the crown at Mortlake in 1619, in an attempt to break the Flemish monopoly. This was followed in the late 17th and early 18th centuries by other smaller workshops, whose work is referred to collectively as Soho tapestry. Tapestries always had a practical purpose, namely keeping out draughts and the cold, yet their aesthetic dimensions – texture, pattern, colour and image – were just as important. They created a level of civilized comfort, enlivened interiors and fed the imagination with their vivid depictions of countless bible stories and stirring allegorical, historical and mythological designs.

Carpets

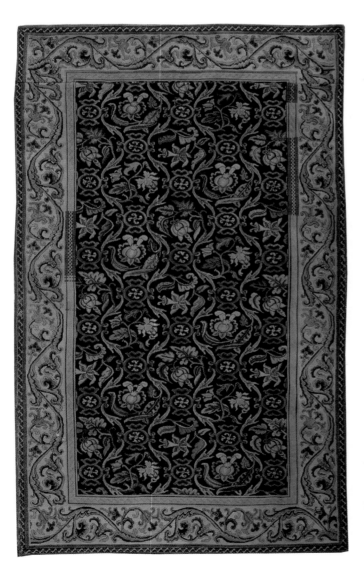

Turkish carpet (near left). Anatolian knotted-pile carpet from the second half of the 16th century. This is one of 32 original Turkish (referred to as Turkey or Turkie) carpets mentioned in a Hardwick inventory of 1601. During the time of Elizabeth, Countess of Shrewsbury (1527–1608) – Bess of Hardwick – such carpets would have been used to cover tables. *Hardwick Hall, Derbyshire*

Turkey-work (far left). Dating from the early 17th century, this extremely rare English Turkey-work carpet has a floral design. The term 'turkie work' is used for English carpets knotted in emulation of the ones imported from Turkey (here meaning the Middle East), and which often incorporated English rather than Middle Eastern motifs, such as the flowers used in this carpet. It was especially popular in the 17th century, when it was used for upholstery and table covers as well as carpets. *Knole, Kent*

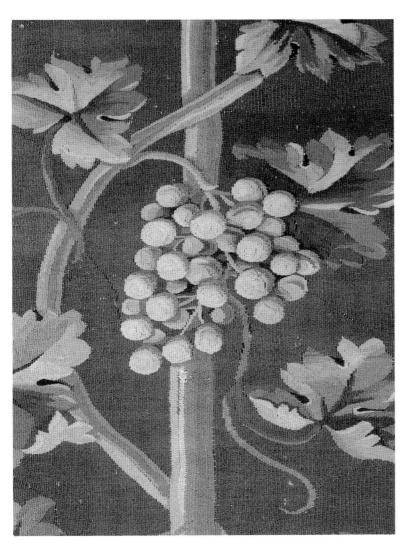

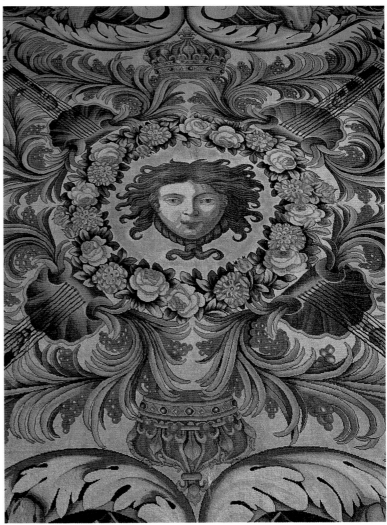

Aubusson detail John Cust, 1st Earl Brownlow (1779–1853) commissioned this Aubusson carpet during a visit to the factory in 1839. Aubusson had been producing tapestries and furniture coverings since the 16th century, and was granted the title 'Royal Manufactory' in 1665. In 1743 the workshops began to manufacture pile carpets for the nobility. *Belton House, Lincolnshire*

Head of Apollo Centre of a Savonnerie carpet made for Louis XIV in 1683. One of a series of 93 carpets started in 1665 for the Long Gallery at the Louvre, it became redundant when Louis abandoned Paris for Versailles. The chief designer for this series was probably Charles Le Brun (1619–1690), whom Louis XIV made *Premier Peintre du Roi* (First Painter to His Majesty) in 1662. *Waddesdon Manor, Buckinghamshire*

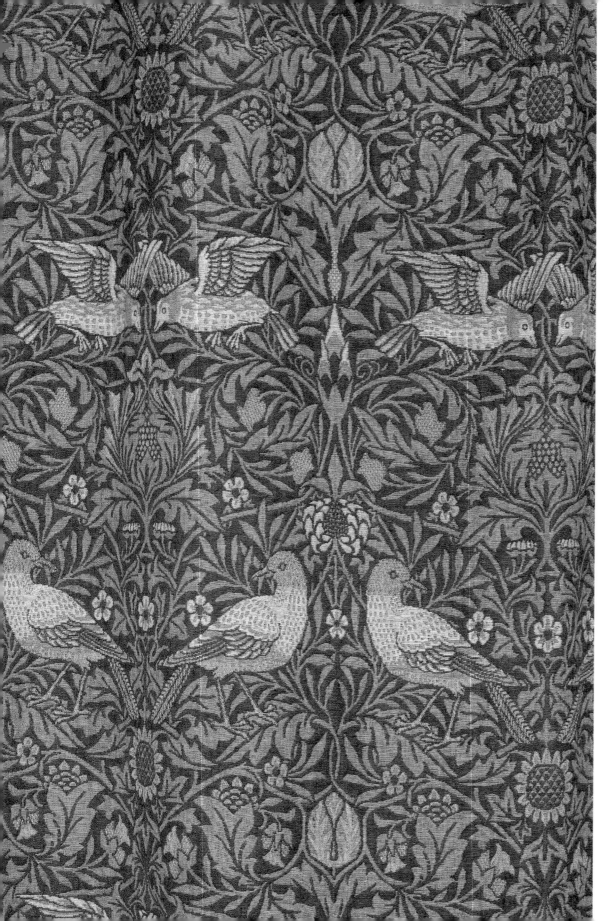

The Morris Revival

'Bird' hanging (left). William Morris (1834–1896) used the theme of birds repeatedly. This hanging is made from woven woollen double cloth and he designed it in 1878 for the drawing room at Kelmscott House, London, his home between 1878 and 1896. *Standen, West Sussex*

Dearle carpet (opposite, top left). Wool carpet designed by William Morris's assistant, John Henry Dearle (1860–1932), who became the Art Director of Morris & Co after Morris died. *Standen, West Sussex*

'Artichoke' (opposite, top right). Margaret Beale (1847–1936), the owner of Standen, embroidered this hanging with her daughters, c.1896. The intricate design, here executed in silks on a linen background, is by William Morris. *Standen, West Sussex*

'Tulip and Rose' curtains (opposite, bottom left). by Morris & Co. Theodore Mauder, a Wolverhampton paint and varnish manufacturer, built the manor from 1887 and, influenced by John Ruskin, furnished it with original Morris & Co wallpapers, fabrics, furniture and fittings. *Wightwick Manor, West Midlands*

'The Angel and the Trumpet' (opposite, bottom right). The artist and writer Herbert Horne (1864–1916) designed this curtain fabric for the Century Guild, one of the most important late-19th-century Arts and Crafts organisations. *Stoneacre, Kent*

20th-Century Textiles

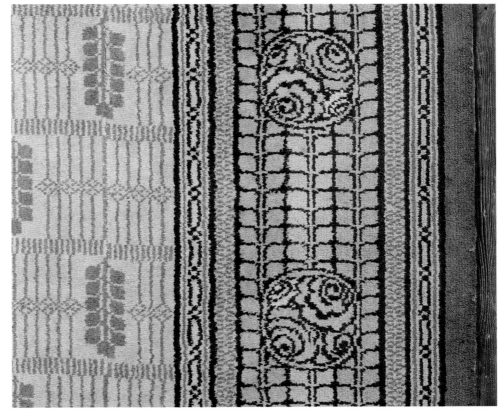

Dufy florals (opposite). Close-up of the bold black-and-white curtain fabric designed by the artist Raoul Dufy (1877–1953) in 1919. Dufy is especially well known for his cheerful paintings, often featuring yachts and Riviera parties, all executed in bright, vivid colours. Yet he was also an illustrator and applied artist who produced a large number of tapestries, as well as fabric and ceramic designs. This dramatic monochrome pattern was radical for its day and stood out as being strikingly modern when the room was photographed for *Country Life* in 1930. *Coleton Fishacre, Devon*

Jazz age (top right). An abstract swirl from the border of a Marion Dorn-designed carpet. Dorn (1896–1964) came to England from the USA in 1923 and soon became famous for her interior decoration, innovative textile designs and 'sculpted' carpets. She helped design some of the most celebrated interiors of the Jazz Age, including Claridges and the Savoy. *Coleton Fishacre, Devon*

Mackintosh style (bottom right). Close-up of a section of machine-made Axminster carpet in the style of Charles Rennie Mackintosh (1868–1928). The Scottish architect Mackintosh was very involved in the Arts and Crafts movement, as well as being the main exponent of Art Nouveau in Scotland. Mackintosh also worked in interior design, furniture, textiles and metalwork. This carpet was fitted by Captain Thomas Powell Lewis (1860–1940) in the 1920s. Captain Lewis modernized the house when he inherited it, introducing electricity and modern plumbing. *Llanerchaeron, Ceredigion*

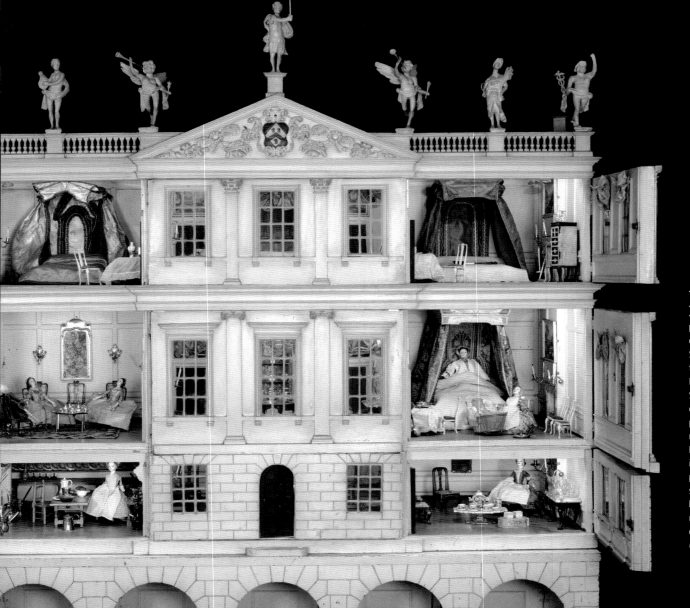

Uppark doll's house H G Wells once played with this c.1735–1740 doll's house, brought to the Sussex house of Uppark by the marriage in 1746 of Sir Matthew Fetherstonhaugh to Sarah Lethieullier, whose coat of arms decorates the pediment. It is one of the two most important 18th-century British doll's houses (the other is depicted opposite). The pictures are oil paintings, the silver is real and hallmarked, but its greatest value is in the record of unchanged 18th-century interiors.
Uppark, West Sussex

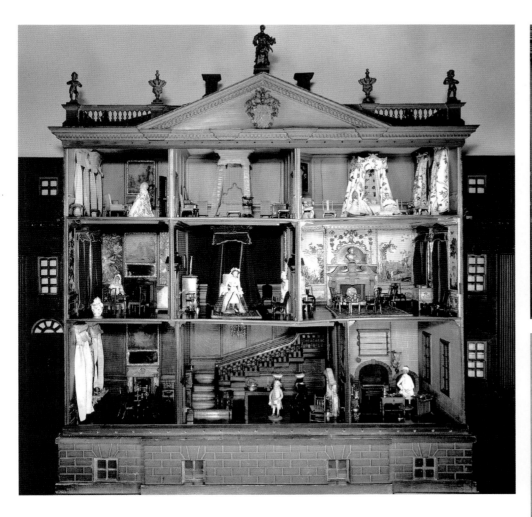

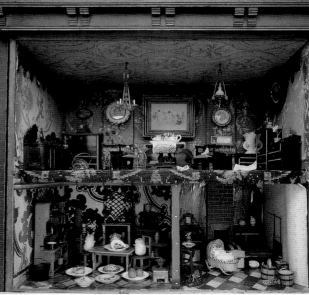

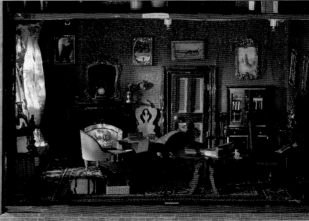

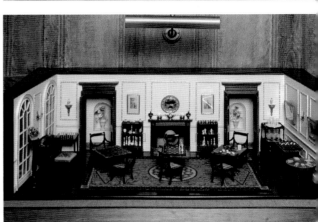

Nostell Priory doll's house (above). Like the Uppark doll's house, the detail and quality makes this closer to an architect's model than a child's toy, and it has been attributed to Thomas Chippendale. The basement, Ionic pilasters and pediment are similar to Nostell Priory, where the doll's house is displayed in the South Passage. *Nostell Priory, West Yorkshire*

Beatrix Potter's doll's house (top right). Very different in style is the homely interior of the doll's house in the Treasure Room of Beatrix Potter's home at Hill Top in Near Sawrey. Though it is not the house featured in *The Tale of Two Bad Mice*, it does contain the very doll's house food that Hunca Munca and Tom Thumb stole. *Hill Top, Cumbria*

The Hammond doll's house (centre right). Unusually, this doll's house of 36 rooms displayed in the Common Room at Wallington depicts human activity, here in the form of a man who is asleep on the chaise-longue in the Library. The 77 dolls have china faces and represent a family and staff of the 1880s. *Wallington, Northumberland*

The Regency Games Room (bottom right) The remarkable collection of miniature rooms at Nunnington Hall was created by Mrs F M M Carlisle, who commissioned skilled craftsmen to create appropriate settings for the furniture-makers' samples she collected. They were made between 1933 and 1970. *Nunnington Hall, North Yorkshire*

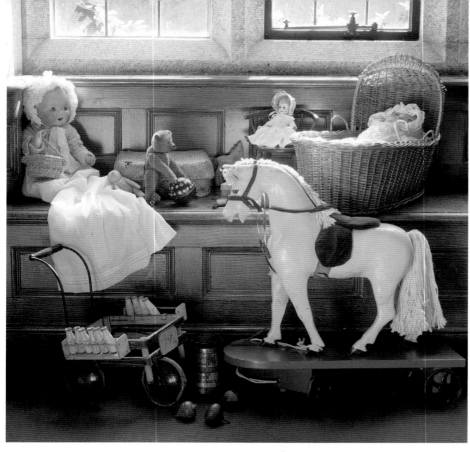

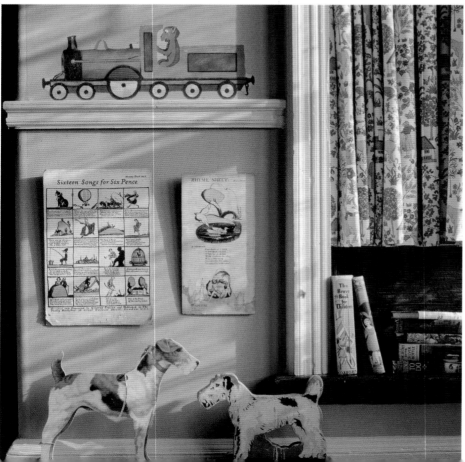

Nurseries

Night Nursery toys (top left). The toys in the Night Nursery at Lanhydrock reflect the young age of the room's three or four occupants: a horse on a wheeled trolley, dolls and a hand-propelled milk cart with miniature bottles. *Lanhydrock, Cornwall*

Dogs and steam locomotive (bottom left). Most of the toys in the Day Nursery at Wightwick date from the 1930s and '40s, though the locomotive on the dado suggests an earlier date. *Wightwick Manor, West Midlands*

Wooden toys and alphabet (opposite, top left). A basket of wooden toys and alphabet on a board in the Children's Bedroom of the Wordsworth family home in the 1770s, when William Wordsworth was growing up with his four siblings. *Wordsworth House, Cumbria*

Toy farmyard (opposite, top right). The figures and fences in this farmyard scene were made c.1920 of cast lead, in common with most toy soldiers and figures of the time. *Nunnington Hall, North Yorkshire*

Rocking-horse head (opposite, centre left). This enormous rocking horse was formerly at Bockleton Court near Fencote in Worcestershire. It even has panniers for additional riders. *Berrington Hall, Herefordshire*

Child's alphabet (opposite, centre right). This wooden child's alphabet was designed by Ernö Goldfinger for Paul and Marjorie Abbatt, the leading progressive manufacturers of children's toys and equipment. *2 Willow Road, Hampstead, London*

The Day Nursery (opposite, bottom left). The day nursery at Lanhydrock was a common room, where the children played and ate their meals with nanny. On the chest of drawers is a rather curious doll standing at a piano. *Lanhydrock, Cornwall*

Toy figures (opposite, bottom right). On the table in the Day Nursery is a set of finely carved walnut animals for a Noah's Ark made in Berne in 1856, a sequence of Russian dolls, Halma board game and playing cards. The doll's house in the background was made c.1902. *Lanhydrock, Cornwall*

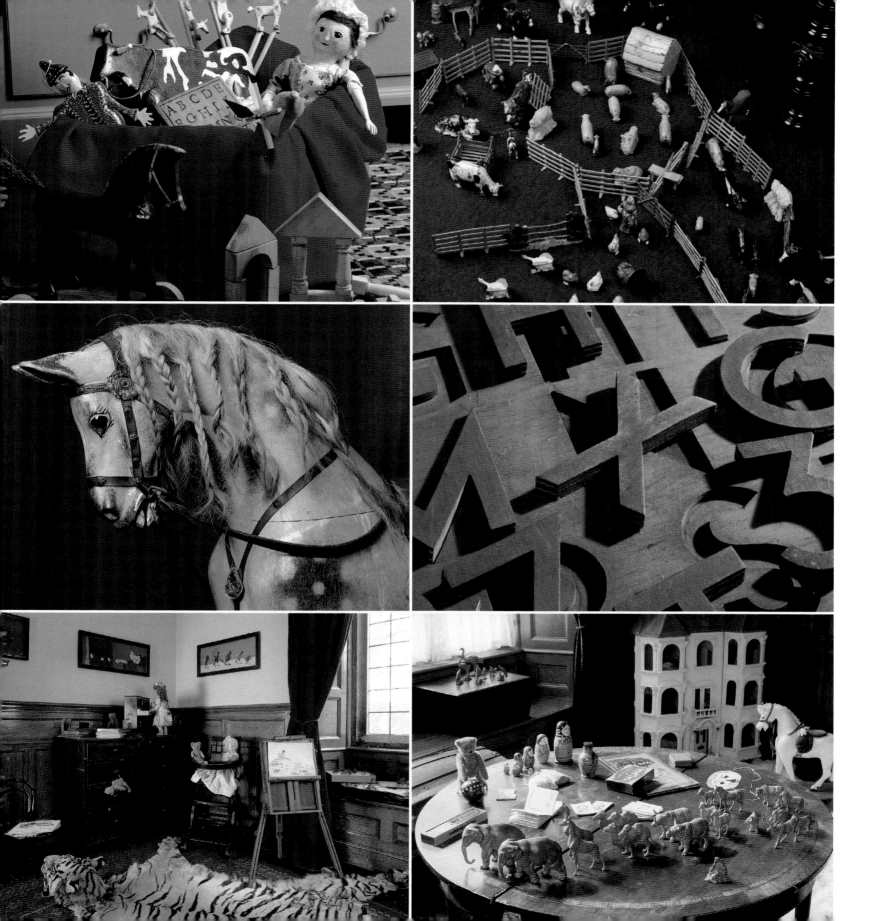

Dolls & Teddies

Wax doll's head (above). Little is known about this 10-inch high wax doll dressed in an elaborate silk and lace costume with a blue cloak and a pin-tucked bodice, in Mermaid (the name of the room). *Snowshill Manor, Gloucestershire*

Beatrix Potter's dolls (left). These two 19th-century French dolls are said to have been those used as models for Jane and Lucinda in *The Tale of Two Bad Mice*, who return from a 'drive in the doll's perambulator' to find a scene of devastation wrought by Tom Thumb and Hunca Munca. *Hill Top, Cumbria*

Eyeless teddy bear (above) This bear, called Richard, belonged to Lord Wraxall and lived in the Day Nursery at Tyntesfield. Lord Wraxall (1928–2001) spent most of his bachelor life at Tyntesfield after leaving the army in 1954. *Tyntesfield, North Somerset*

Transport

Carriages

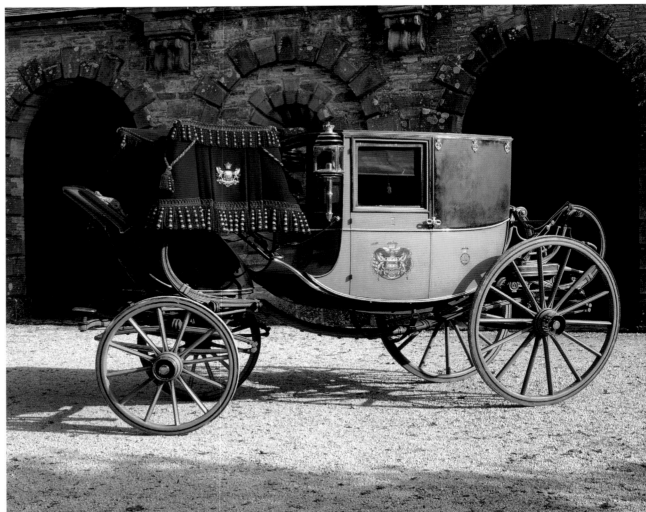

The state chariot of the Earl of Craven (right and below). The large collection of carriages at Arlington Court includes this magnificent example, built c.1830 by Adams & Hooper, later Hooper & Co, undoubtedly one of London's finest coachbuilders. The dark blue hammer cloth with red trimmings carries the Earl's silver-plated coat of arms, which is also painted on the doors and the front and back panels. All exterior furniture including lamps, door handles, head plates, pin bead and axle caps, is silver-plated, as are the fittings on the pair horse state harness which is displayed with it. *Arlington Court, Devon*

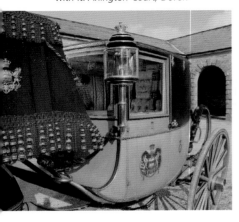

The Britzschka chariot of the Earl of Lichfield

(top right). This chariot, possibly the best surviving example of an early 19th-century travelling carriage in the country, was built in 1829 by Adams & Co, Haymarket, London. It was used for long-distance travel in Britain and on the Continent, the dormeuse boot extending from the front of the body allowing the occupants to lie at full length and sleep while they travelled. The first Earl was in the spa town Graffenburg in Austria when the contents of Shugborough were sold in 1842, ostensibly to take the water for his gout, but more probably to escape the shame of the debts that made the sale necessary. He must have travelled in this carriage because, if it had remained at Shugborough, it would have been included in the sale. The illustration shows the hind boot with the 'rumble seat' that carried two servants, usually a valet and a lady's maid. The fittings on the seat rail show that a folding leather head (carriage terminology for hood) was originally fitted to protect them from the weather. *Shugborough Hall, Staffordshire*

Coach of the Lucy family

(bottom right). This coach, built c.1845 by Wyburn & Meller, 121 Long Acre, London, would have been used for important family occasions and for short-distance travel. It was originally equipped with town and travelling furniture, so that it could be easily converted for either use, but unfortunately little has survived. Its interior is lined with corded silk and Melton cloth with 'broad laces' incorporating the Lucy family armorial devices in white worsted on a cerise silk ground. *Charlecote Park, Warwickshire*

Bicycles

Penny-farthing bicycle (left). Hanging in the Hundred Wheels attic of the south front of Charles Wade's home is a large collection of bicycles. The size of the front wheel on these 'penny farthings' grew to achieve higher speeds in the absence of gearing, but made them extremely unstable. On long descents it was advisable to hook one's legs over the handlebars in the hope of landing on one's feet if you 'came a cropper'. At the time of their use, these bicycles were known as 'ordinaries'; 'penny farthing' was a derogatory term adopted only when they had become obsolete. *Snowshill Manor, Gloucestershire*

Penny-farthing crank (below). The direct-drive crank and pedals on the 52in (132cm) front wheel of a bicycle, with an oil lamp fitted between the spokes. Braking was effected by applying backward pressure on the pedals. *Snowshill Manor, Gloucestershire*

Boneshaker bicycles (above left). 'Boneshaker' was a term applied to any early bicycle before the invention of the pneumatic tyre and its application by a Scottish vet, John Dunlop, towards the end of the 19th century. One of the examples at Snowshill has a wooden frame as well as wooden wheels. *Snowshill Manor, Gloucestershire*

Cars

Mrs Greville's fleet of cars (above). The fleet of cars belonging to the Hon. Mrs Ronald Greville outside the 'Motor House'. The cars were doubtless used to collect high-society guests from the railway station for her many weekend gatherings; there was usually a full house from Friday to Monday between June and August. *Polesden Lacey, Surrey*

Morris Ten Four (left). Manufactured at Cowley in Oxfordshire from 1932, the name derived from the use of four cylinders which produced ten horsepower. It was available in various forms, with fixed or sliding-head and a Special Coupé, and a Tourer was added for the 1933 season. *Dunham Massey, Cheshire*

Acknowledgements

Many thanks to Grant Berry, Emily Burningham, Siân Evans, Oliver Garnett, Anna Groves, Chris Lacey, Anthony Lambert, Sophie Leighton, Alan Parris, Lucy Peel, Vicky Skeet, John Stachiewicz, Diana Stone, Adrian Tinniswood, and all those at the National Trust and elsewhere who have helped to compile this weighty tome.

Picture Credits

Gten/Edward Potten : 29, 32, 37, **NT**/Orford Ness : 25 (top), **NT**/Robert Thrift : 301, **The National Trust, Waddesdon Manor**/ John Bigelow-Taylor : 58, 114, 343 (right), Eost & MacDonald : 54, Mike Fear : 21 (left), 142, 163 (bottom), 307 (top right), Hugo Maertens : 78, **NTPL**/Matthew Antrobus : 298, James Austin : 86 (right), 156 (right), 160, 306 (top), Clare Bates : 83 (right), 89, Bill Batten : 10, 49 (top right), 75 (left), 105 (bottom left), 109, 110 (left, bottom right), 128 (left), 131 (right), 151 (right), 152, 177 (right), 192 (left), 268, 309 (left), 340, John Bethell : 79 (left), 102, 131 (left), 154 (bottom right), 157 (top), 163 (top), 204, 227 (top), 258 (top right), 302 (left), 333 (top right), John Boothroyd : 183 (bottom left), Andrew Butler : 310 (right), 358, Michael Caldwell : 132, 133, 180 (right), 324, Nick Carter : 57, 286, 287, Graham Challifour : 334, Vera Collingwood : 83 (left), 296 (right), Peter Cook : 146 (bottom), 147 (bottom), A C Cooper : 272 (top), Joe Cornish : 280, Stuart Cox : 13, 43 (bottom), 113 (right), 207, 209 (top & bottom), 292/293, 309 (right), 310 (left), 311, 352 (right), 356 (left & right), Eric Crichton : 138 (top & bottom right), 316 (bottom), Derek Croucher : 315 (bottom), Prudence Cuming : 258 (top left), Graham Edwards Photography : 33 (left & right), 37 (top), Andreas von Einsiedel : 2, 17, 18 (left & top right), 19, 20, 23, 40, 44, 48, 49 (top & bottom left), 59 (right), 60 (top & bottom), 62 (left), 71, 72, 76 (centre), 77, 80 (top), 81, 82, 84, 90, 91 (top & bottom right), 94, 95 (top right), 103, 104, 105 (top left), 107 (top left & right, bottom left), 108, 110 (top right), 111, 115, 116, 117 (top), 118 (left), 119 (top right), 120 (left), 122 (bottom), 123, 125, 127 (left), 129 (right), 134, 135, 141 (bottom left), 147 (top), 148, 149, 157 (centre), 159, 161, 164 (top), 165, 166, 172, 173 (centre), 174 (left), 175 (bottom left), 176, 177 (left), 182, 184 (left), 185 (bottom right), 188, 189 (top & bottom),

190, 191 (bottom right), 208, 213, 217 (top left), 219 (top), 220, 221 (top left & right), 235, 295 (left), 296 (top left), 297 (left), 297 (right), 303, 305 (top), 306 (bottom), 308, 309 (centre), 323 (top), 326 (bottom left), 345 (bottom right), 349 (left & right centre), 350 (top, & bottom), 351 (bottom left & right), 355 (bottom), 357 (top), Stanley Eost/Fairhaven Collection : 300 (right), Mark Fiennes : 27, 51 (bottom), 65 (bottom), 75 (right), 138 (left), 333 (bottom right), Roy Fox : 35 (right), 59 (top left), 251 (top), 282 (top left), Geoffrey Frosh : 217 (bottom left), 349 (top right), 352 (left), Christopher Gallagher : 191 (top), 234 (left), David Garner : 91 (top left), 95 (top left), 96, 97 (left), L & M Gayton : 345 (top right), Jonathan Gibson : 42, 56 (left), 68 (left), 124 (bottom), 344, 345 (top left), 355 (top), Dennis Gilbert : 140, 141 (top & bottom right, top left), 150, 178, 179 (bottom), 206, 212 (right), 346, 351 (centre right), John Hammond : 18 (bottom right), 22 (left & right), 26 (left), 31 (right), 34 (left & right), 36 (left & right), 38/39, 41 (bottom), 43 (top), 53, 66 (right), 67 (bottom left & right, centre), 74, 75 (centre), 79 (centre), 80 (bottom), 85 (top & bottom), 87 (left & right), 88, 92, 93 (top), 112, 113 (left),117 (bottom left), 122 (top), 127 (right), 137 (left), 144 (top & bottom), 145 (left), 146 (top), 156 (left), 164 (bottom), 167 (right), 169 (top & bottom left & bottom right), 173 (top & bottom), 174 (right), 175 (top left & right), 179 (top), 181 (bottom), 183 (top left & bottom right), 185 (top right), 192 (right), 193 (bottom left), 194 (left), 195 (left), 197 (bottom), 198, 201 (top), 202, 211 (bottom), 212 (centre), 214, 215 (left), 216, 217 (top right), 218, 222/223, 225 (left), 226, 228 (top), 230 (right), 231, 233 (bottom left & right), 234 (top & bottom right), 237, 239 (top & bottom), 240 (left & right), 242 (top & bottom), 243 (left & right), 244 (top), 245 (bottom), 247, 249 (top), 250 (right),

252, 253 (top), 254, 255, 256, 257 (bottom), 260, 262, 263 (bottom), 264 (left), 266 (left & right), 269 (top), 270, 271 (bottom, top left & right), 275 (top & bottom), 276 (left & right), 277, 278, 279 (top), 282 (bottom left), 283 (left & right), 285 (bottom), 302 (right), 305 (bottom right), 307 (bottom), 316 (top), 317, 318 (left & right), 319 (left), 323 (bottom), 325 (right), 328/329, 330, 331 (bottom), 332, 333 (top left), 335 (top & bottom left), 336, 337 (bottom), 341 (left & right), 342 (right), 343 (left), 345 (bottom left), 347 (top & bottom), E Chambré Hardman Collection : 288 (both), 289, Jerry Harpur : 314 (left), Richard Holttum : 285 (top), Matthew Hollow : 248 (bottom), 250 (left), 251 (bottom), 284, Angelo Hornak : 31 (left), 41 (top), 55 (left), 64 (left & right), 145 (right), 157 (bottom), 158, 171 (left), 203 (bottom), 230 (top), 241 (right), 245 (top), 249 (bottom), 257 (top), 261 (left & right), 267 (left), 304, 335 (bottom right), 342 (left), Christopher Hurst : 49 (bottom right), 79 (right), 93 (bottom), 229 (bottom), 244 (bottom), 246, 253 (bottom), 258 (bottom), 269 (bottom), Horst Kolo : 70, 153, David Levenson : 162, Tymn Lintell : 6, 312 (top), Nadia Mackenzie : front cover, 25 (bottom), 46 (right), 47, 51 (top), 52 (right), 56 (right), 61, 62 (right), 63, 67 (top), 68 (right), 69 (top & bottom), 73, 76 (left & right), 98/99,105 (top & bottom right), 106, 107 (bottom right), 120 (right), 121, 124 (top), 126, 129 (left), 136, 139, 151 (left), 167 (left), 168, 170, 171 (right), 180 (left), 181 (top), 183 (top right), 185 (left), 187, 205, 211 (top), 212 (left), 215 (right), 217 (bottom right), 221 (bottom left), 294, 305 (bottom left), 322, 326 (bottom right), 327 (top right & left, bottom right & left), 348, 351 (top & centre left), 353, 354 (left & right), Rob Matheson : 55 (right), 65 (top), 265 (left), 273, Nick Meers : 299, Robert Morris : 24, 97 (right), James Mortimer : 52 (left), 100, 101, 203 (top), 300 (left), 313 (bottom), Paul Mulcahy : 296 (bottom left), Andra Nellin : 26 (right), Brenda Norrish : 154 (top right), 186, NTPL : 50, 95 (bottom right), 143, 184 (right), 224 (right), 230 (left), 233 (top), 238, 263 (top), 281, 282 (right), 290 (both), 291 (both), 307 (top left), 312 (bottom), 313 (top), 331 (top), 359, Erik Pelham : 169, 195 (right), Richard Pink : 338, 339 (top & bottom), Patrick Prendergast : 128 (right), 130, Geoffrey Shakerley : 124 (centre), Ian Shaw : 199, 315 (top), Andrew Smart/A C Cooper : 45, Robert Thrift : 301, Chris Titmus : 224 (left), Brian Tremain : 59 (bottom left), Rupert Truman : 191 (bottom left), 314 (right), Charlie Waite : 21 (right), Frederick Warne & Co, Ltd, 1904, 2002. Reproduced by permission of Frederick Warne & Co, Ltd : 35 (left), J Whitaker : 46 (left), 295 (right), 349 (bottom right), Mike Williams : 118 (right), 119 (bottom), 137 (right), 154 (left), 155, 351 (top right), Derrick E Witty : 30, 66 (left), 86 (left), 117 (bottom right), 119 (top left), 193 (top left & right), 194 (centre & right), 196, 197 (top left & right), 200 (left & right), 201 (bottom), 210, 225 (right), 227 (bottom), 228 (bottom), 229 (top), 232, 236, 241 (left), 248 (top), 259, 265 (right), 267 (right),

272 (bottom), 274, 279 (bottom), 319 (right), 320 (left & right), 321, 325 (left), 326 (top), 335 (top right), 337 (top)

Anglesey Abbey, The Fairhaven Collection (The National Trust) : 247, 269 (bottom), 300 (right), **Arlington Court**, The Chichester Collection (The National Trust) : 278, **Ascott**, The Anthony de Rothschild Collection (The National Trust) : 226, 242 (bottom), 244 (top), 245 (bottom), 263 (bottom), **Attingham Park**, The Berwick Collection (The National Trust) : 283 (right), 309 (centre), **Belton House**, The Brownlow Collection (acquired with the help of the National Heritage Memorial Fund by The National Trust in 1984) : 253 (bottom), 255, 276 (right), 277, **Calke Abbey**, The Harpur Crewe Collection (acquired with the help of the National Heritage Memorial Fund by The National Trust in 1985) : 262, **Charlecote Park**, The Fairfax-Lucy Collection (The National Trust) : 248 (top), **Chirk Castle**, The Myddelton Collection (The National Trust) : 83 (right), **Clandon Park**, The Onslow Collection (The National Trust) : 252, **Clevedon Court**, The Elton Collection (The National Trust) : 272 (top), **Cliveden**, The Astor Collection (The National Trust) : 283 (left), 296 (right), 315 (bottom), **Cragside**, The Armstrong Collection (acquired through the National Land Fund & transferred to The National Trust in 1977) : 272 (bottom), **Croft Castle**, The Croft Collection (accepted in lieu of tax by HM Treasury and transferred to The National Trust in 2004) : 195 (left), 266 (right), **DACS** : 22 (left), 280, 281, 282 (right), 283 (right), 284, 285 (right), **Dudmaston**, The Labouchere Collection (The National Trust) : 146 (top), 271 (bottom), (accepted in lieu of tax by HM Treasury and allocated to The National Trust in 1998) : 250 (right), 285 (right), **Dunham Massey**, The Stamford Collection (The National Trust) : 233 (bottom right), 249 (bottom), 259, **Dunster Castle**, The Luttrell Collection (The National Trust) : 230 (right), **Dyrham Park**, The Blathwayt Collection (acquired through the National Land Fund & transferred to The National Trust in 1961) : 241 (right), 243 (left), **Erdigg**, The Yorke Collection (The National Trust) : 270, 271 (top left & right), **Felbrigg Hall**, The Windham Collection (The National Trust) : 294, **Ham House**, The Dysart Collection (purchased by HM Government in 1948 & transferred to The National Trust in 2002) : 192 (left), **Hardwick Hall**, The Devonshire Collection (acquired through the National Land Fund & transferred to The National Trust in 1959) : 163 (top), 231, 301, **Hill Top**, Cover illustration from The Tale of Benjamin Bunny by Beatrix Potter © Frederick Warne & Co, Ltd, 1904, 2002. Reproduced by permission of Frederick Warne & Co, Ltd : 35, **Ickworth**, The Bristol Collection (acquired through the National Land Fund & transferred to The National Trust in 1956) : 240 (right), 254, 258 (bottom), 261 (left & right), 265 (right), 306 (top), 308, **Kingston Lacy**, The Bankes Collection (The National Trust) : 193 (top left), 196, 197 (top left &

Index

Figures in *italics* indicate illustrated items.